THE BRITISH ARCHAEOLOGICAL
ASSOCIATION
CONFERENCE TRANSACTIONS
For the year 1981

VII

MEDIEVAL ART
AND ARCHITECTURE
at Gloucester and Tewkesbury

1985

Previous volumes in the series

I. Medieval Art and Architecture at Worcester Cathedral
II. Medieval Art and Architecture at Ely Cathedral
III. Medieval Art and Architecture at Durham Cathedral
IV. Medieval Art and Architecture at Wells and Glastonbury
V. Medieval Art and Architecture at Canterbury before 1220
VI. Medieval Art and Architecture at Winchester Cathedral

*Copies of these may be obtained from W. S. Maney and Son Limited,
Hudson Road, Leeds LS9 7DL or from
Oxbow Books, 10 St. Cross Road, Oxford OX1 3TU*

ISBN Hardback 0 907307 12 4
Paperback 0 907307 13 2

PRINTED IN GREAT BRITAIN BY F. CROWE AND SONS LIMITED
11 CONCORD ROAD, NORWICH

CONTENTS

LIST OF ABBREVIATIONS AND SHORTENED TITLES

in use throughout this volume. See also individual contributions.

Archaeol. J.	*Archaeological Journal.*
BAA CT	*British Archaeological Association Conference Transactions.*
B/E	N. Pevsner *et. al.*, ed., *The Buildings of England (Harmondsworth various dates).*
Bony (1937) 'Deux élévations...'	J. Bony, 'Tewkesbury et Pershore, deux élévations à quatre étages de la fin du XIᵉ siècle', *Bull. mon.* XCVI (1937), *281–90.*
Bony (1937) 'A propos...'	J. Bony, 'A propos de Tewkesbury et Pershore', *Bull. mon.*, XCVI (1937), *503–4.*
Bony (1959)	J. Bony 'La chapelle épiscopale de Hereford et les apports Lorrains en Angleterre après la Conquête' *Actes du XVᶜ International Congrès de l'histoire de l'art* (Paris, 1959), 36–43.
Bull. mon.	*Bulletin monumental.*
CA	*Congrès archéologique de France.*
Clapham (1952)	Sir A. W. Clapham, 'The Form of the Early Choir of Tewkesbury and its Significance', *Archaeol. J.*, CVI Supplement for the year 1949 (1952).
Gem (1978)	R. D. H. Gem 'Bishop Wulfstan II and the Romanesque Cathedral Church of Worcester', *BAA CT*, I (1978), 15–37.
Hist. et Cart.	*Historia et Cartularium Monasterii Sancti Petri Gloucestriae* ed. W. H. Hart Rolls Series, XXXIII, I (1863).
JBAA	*Journal of the British Archaeological Association.*
McAleer (1982)	J. P. McAleer 'The Romanesque Transept and Choir Elevation of Tewkesbury and Pershore', *Art Bulletin*, LXIV (1982), 549–63.
McAleer (1983)	J. P. McAleer 'The Romanesque Choir of Tewkesbury Abbey and the Problem of the "Colossal order"', *Art Bulletin*, LXV (1983), 535–558.
RCHM	Royal Commission on Historical Monuments.
RIBA	Royal Institute of British Architects.
Trans. BGAS	*Transactions of the Bristol and Gloucester Archaeological Society.*

Preface

The present volume of Transactions, the seventh in this series, is very different from its companions. Unlike other collections of papers and unlike the conference itself, it devotes much consideration to a single topic: the reconstruction and exposition of the designs of two major Romanesque churches. The decision to publish in one volume several different and often contradictory interpretations of these buildings calls for some comment. As is immediately evident, much research on the material remains of the abbeys of Gloucester and Tewkesbury has been undertaken over the last 15 or 20 years. Rather than see the results scattered in various periodicals over a number of years, the Council of the British Archaeological Association agreed that they should be collected here. The fact that papers not given at the conference have had to be commissioned has been a major factor in the time lapse between the previous volume and the present one. From the diversity of opinion presented in these contributions it is hoped that the eventual outcome will be a resolution of at least some of the apparent discrepancies.

We would like, on behalf of the Association, to record our thanks to the National Westminster Bank for financial assistance and to George Carter for designing the cover.

Finally it is our sad duty to record the death of David Verey who spoke at the conference on 'Gloucester Cathedral in the nineteenth century'. His knowledge of the architecture of Gloucestershire will be evident to readers of the relevant volumes of The Buildings of England and his book on Cotswold Churches.

T. A. HESLOP
V. A. SEKULES
Hon. Editors

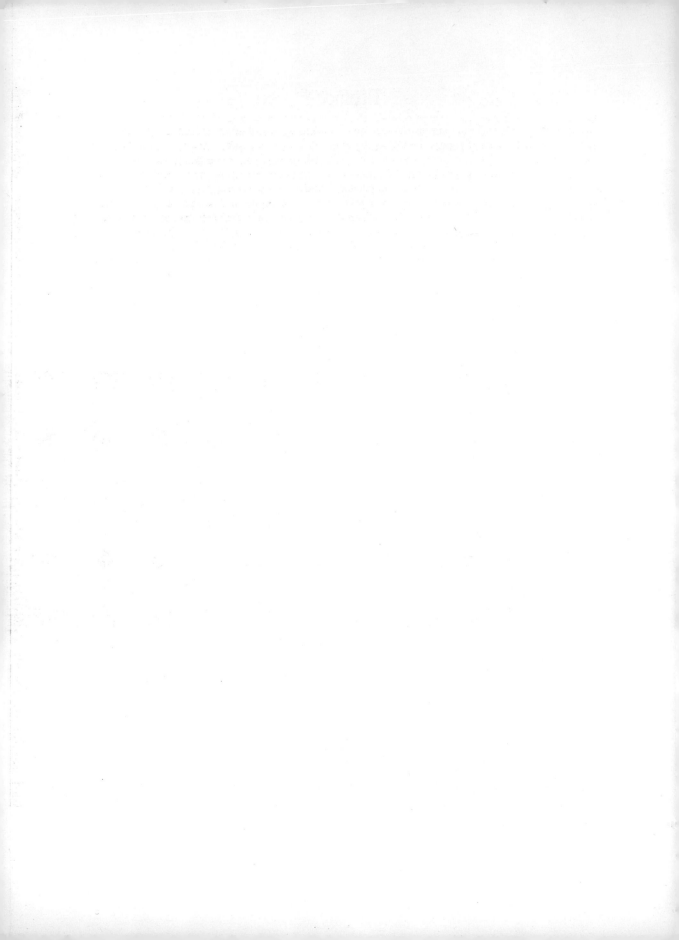

A *Said to have been the Chapter House.* K *Chapel of Robt. Fitz Hamon, the second Founder.*

B *St. Margaret's Chapel.* L *Monument of Lord & Lady De Spenser.*

C *St. Edmond the Martyr's Chapel.* M *Old Stalls.*

D *St. Faith's Chapel.* N *Tomb of Guy D'Obrien.*

E *Chapel, name unknown.* O *Figure of an emaciated Monk.*

F *The Vestry.* P *Chapel of the Holy Trinity.*

G *Entrance from the Cloister.*

H *Effigy in Armour unknown.*

I *Countess of Warwick's Chapel.*

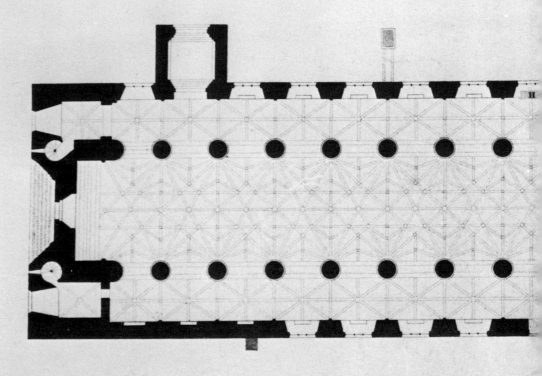

Scale

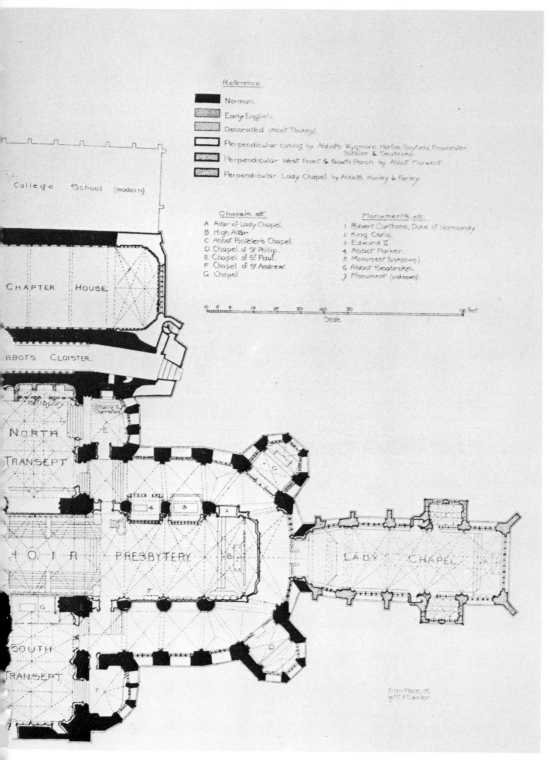

Gloucester Cathedral, groundplan: from *The Builder* (7th December 1891)

GLOUCESTER CATHEDRAL
GROUND PLAN.

LAVATORY.

Old Water Tank.

CLOISTER GARDEN.

Well

THE DEANERY.

SLYR

Carols · afory · this · Wall

NORTH AISLE.

N A V E.

ORGAN

SCREEN

C

SOUTH AISLE.

Font

PORCH

viii

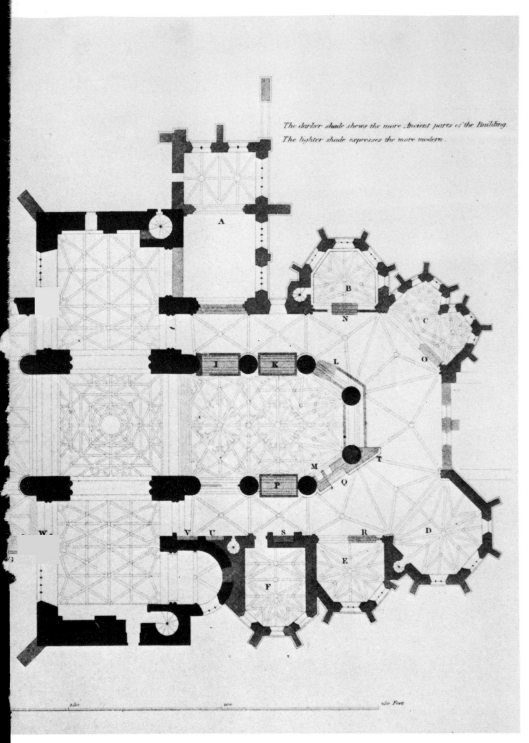

The darker shade shews the more Ancient parts of the Building.
The lighter shade expresses the more modern.

Tewkesbury Abbey, groundplan: from *Vetusta Monumenta*, Society of Antiquaries of London,
V (1835)

A Note on the Historiography of Tewkesbury Abbey

By Eric Fernie

A number of articles on the history of Tewkesbury Abbey offer reconstructions of features which might have formed part of the Norman church. The genesis of some of these reconstructions, in particular the four-storey elevation, the suspended tribune and the barrel vault, turns out on investigation to be somewhat surprising, highlighting the divide between what might be called metropolitan and local perspectives on history.

Two articles of fundamental importance in this historiography are M. Jean Bony's contribution to the *Bulletin Monumental* for 1937 and that of Sir Alfred Clapham which appeared after his death in 1951 in a memorial supplement to the *Archaeological Journal*.[1]

Bony reconstructed the elevation of the choir with four storeys, deriving the general arrangement of the aisle storey, the tribune and the triforium wall passage from the interior and the clearstorey from the exterior of the east wall of the transept at Tewkesbury, and the stumpy piers of the main arcade from those in the choir at Gloucester. Clapham refined this with the proposal that the tribune was of the suspended type like the examples at Romsey, Jedburgh and Oxford.

Each of the two scholars acknowledged the help of the other. Bony noted that a four-storey elevation had already been suggested in Clapham's book on post-Conquest English architecture, published in 1934.[2] Clapham in turn said 'In its general lines there is no reason to quarrel with this interpretation (the four-storey elevation) which M. Bony was the first to analyse and comment upon'.[3]

The literature on the Norman abbey is not, of course, restricted to these two papers. There are literally dozens of notes, reports and articles in pamphlets and booklets and in the journals of local societies such as the Woolhope Naturalists' Field Club and the Clapton Architectural Club. Most of these are, as one might expect, ephemeral and overenthusiastic, the tone being caught in the claim of one contributor that, of the twenty-eight great crossings of Norman England, that of Tewkesbury is surpassed in size by only eighteen.

At first sight this also appears to be the measure of a description of the church delivered to the Bristol and Gloucestershire Archaeological Society in 1926 by the ex-sacrist W. G. Bannister, since he began by calling attention to the fact that the tower of the abbey was *'one square foot* larger than the great tower of St Albans' (the emphasis is his).[4] However, when it came to reconstructing the choir, this is what Mr Bannister had to say:

'The Norman choir had an apse, as at present, the six pillars are still there but 3 ft higher than they were originally...The semicircular arches reached a height of 21 ft at the crown...the triforium arches ...were 12 ft high...(and) about 1 ft 6 in above these (were) the openings of a narrow passage in the thickness of the wall...Some 8 ft or more of plain wall above this the outer roof of the aisles (abutted) ...and the cill of the clearstorey was reached. These windows were – and are – 6 ft 6 in high and 22 in wide, with flat cills and straight jambs, and came down over the pillars instead of over the centres of the arches. When the present vaulting was put in they came in the pocket of the vault and were preserved...On a dull day the choir had a dim religious light in very truth',[5]

This reconstruction is, in all essentials, the same as Jean Bony's, but it is eleven years earlier.

Something similar appears to have happened in the case of the suspended tribune. The volume of transactions for the years 1946 to 1948 of the same Bristol and Gloucestershire Archaeological Society contains a note on the elevation of the choir.[6] Its author, the Rev. E. G. Benson, was not a member of the society and contributed nothing else to its journal, yet despite this relative anonymity, in the space of five pages he reconstructed a tribune linked to the arcade below, thus anticipating Clapham.

He noticed that the Norman masonry on the choir face of each pier extended above the level of the Norman capital and that the capital was restricted to the aisle face of the pier. From this he concluded

that the choir piers were, on their choir faces, higher than the arcade. Three other observations then suggested that they rose to the same height as the piers in the nave. These are as follows: (1) the piers in the choir have the same diameter and intercolumniation as those in the nave; (2) the Gothic passage at the base of the clearstorey windows in the choir lies at the same height as the capitals of the piers in the nave; and (3) there are remains of a cylindrical face high up on the eastern side of the eastern piers of the crossing. Lastly, Benson pointed to Oxford as a model for his reconstruction.

How is one to explain these two apparent premonitions? There is, of course, no question of either Bony or Clapham making unacknowledged use of the ideas of others as (to point to nothing more) their own references to each other's work make plain, but could the opposite have happened? It is possible for instance, that Bannister was present as sacrist on an occasion when a group of architectural historians visited Tewkesbury in the early 1920s. Yet even if this were the case, Bannister reported the existence of 'clerestory windows' over the piers in the choir, which Bony did not mention. Even though these are not windows at all, but air vents built with and for the roof space above the Gothic vault, what Bannister did was to set them in a reasonable place in the argument.

Similarly, in the case of the suspended tribune, it is certainly possible that the Rev. Benson accompanied Sir Alfred Clapham on a visit to the church, but one point tells against this. Benson's hypothesis is expressed with clarity and consistency, an unusual result when a layman (to use an inapposite term) attempts to reproduce from memory the argument of a professional, and in this instance a peculiarly complicated argument, as many will acknowledge who have attended lectures on the subject.

The Victoria History of the County of Gloucester, published in 1968, may provide a solution to this puzzle. The author, Miss Margaret Tomlinson, ackowledged that her account of Tewkesbury Abbey 'draws generally on the *Transactions of the Bristol and Gloucestershire Archaeological Society, Gloucester Church Notes*, 1902, and L. Gough, *Short Guide to the Abbey Church...at Tewkesbury*, 1959', rather than on Bony and Clapham.[7] In other words local histories, such as county histories, draw on local sources, so that there are in effect two sequences or redactions of publications, the art-historical as against the antiquarian, or the metropolitan in contrast to the local; the two are often unaware of one another.

The suspended tribune is now an accepted part of the elevation of Tewkesbury, but the four-storey elevation has retreated before the increasing insistence with which a barrel vault over the main space has been proposed. This idea is still, so to speak, on probation. There is incontrovertible evidence for a masonry barrel vault at Pershore, but at Tewkesbury cases can be made both for wood and for stone.[8]

Like many people, including myself, Sir Nicholas Pevsner could not make up his mind on this subject of the vault. Contrast 'The Pershore transept in all probability had a four-tier elevation, i.e. a small triforium and a clerestory, as was, it seems, the case also at Tewkesbury. The case is not proven, and it is possible that there was no clerestory in these buildings and a tunnel vault instead, as was done so often in France' (1968), with 'There is no indication of a Norman nave vault (at Tewkesbury), nor of an intention to vault' (1970).[9]

Before 1968 no-one had suggested in print that the main spaces were intended to be vaulted, with the sole exception of John-Louis Petit, a Gloucestershire ecclesiastic writing in 1848 who said that while the church probably had a wooden roof, it could have been 'left open, as at Ely, or boarded into a plain cylindrical vault. No kind of vaulting would better carry out the idea of the present Norman nave than a cylindrical one of stone, such as we see in the White tower, in London, and in some churches in the south of France. But is is not common in large English churches. We may not notice however that the roof of the porch is cylindrical...(and that the arch from the nave aisle into the transept) is a half-arch abutting against the pier of the tower; from which it appears probable that the original vault was semi-cylindrical'.[10]

Pevsner said of this author, 'as a scholar Petit doesn't count' and 'Finally as a writer Petit doesn't count either'.[11] This judgement was based on Petit's *Remarks on Church Architecture* of 1841 and not

on the monograph on Tewkesbury of 1840, but even if it is in general terms justified, the inclusion in the above quotation of an idea which has been revived for debate over a century later indicates that such sources may contain much which is of value.

Bannister, Benson and Petit represent another strand in the writing of architectural history from that of Bony, Clapham and Pevsner, one that is unjustly ignored although perhaps happily not always exposed to searching analysis.

After proposing that the four-storey elevation, the suspended tribune and the vaulted main span are all ideas which have an independent origin in this strand, I am delighted to be able to say that nowhere in *Gloucestershire Notes and Queries* or the *Transactions of the Caradoc and Severn Valley Field Club* is there any mention of the possible relevance of Vitruvius to the plan and elevation of Tewkesbury Abbey, a connection which has been proposed in lectures by Peter Kidson. On the other hand Commendatore Rivoira, writing before 1925, asserted that Vitruvius's basilica at Fanum, with its columns rising through two storeys, lay behind the examples of this feature at Tournus and Winchester.[12] Since there is no giant order now evident at Winchester, could he have confused it with Romsey?

THE HISTORIOGRAPHY OF TEWKESBURY ABBEY: A POSTSCRIPT

The foregoing essay on the historiography of the abbey between 1920 and 1950 is printed here as it was delivered to the conference in 1981. That conference (and in particular the arrangements attendant upon the publication of its transactions) has presented the opportunity, and almost the need, to attempt a postscript outlining the contributions which have been made in the succeeding three and a half decades, that is up to, but not including the present volume. During this period Tewkesbury Abbey has attracted an extraordinary amount of attention, much more attention, indeed, than that accorded it in the preceding thirty years, yet this has been accompanied, until very recently, by an almost complete absence of publication. It may be that, aware of the variety of debate which has surrounded the subject and of the consequent impossibility of unravelling who was responsible for which idea, scholars with an interest in the church have elected not to set their views down in print.

In order to clarify what has happened in this period, three central points will be considered separately, namely (1) the giant order, (2) the four-storey elevation and high vaults, and (3) the sources.

(1) The giant order

In 1937 Bony reconstructed the elevation of Tewkesbury after the manner of that at Gloucester, with columnar piers in separate storeys. In 1949 Clapham replaced this with a giant order. At the Courtauld Summer School in 1962 J. Philip McAleer proposed a return to Bony's arrangement. Most scholars have, however, continued in the 1960s and 1970s to accept Clapham's idea, though in varying forms.

Peter Kidson has suggested that the elevation may be derived in part from Vitruvius's description of his basilica at Fanum,[13] which would require a wooden floor to the gallery and unvaulted aisles. Clapham's reconstruction was based on the assumption that the curved scars rising from the lower imposts represented the remains of the arches of the eleventh-century arcade. In support of there having been a wooden floor, Kidson has argued that these scars are instead the untidy finishing off of the springing points inserted to support the new higher arcade in the 14th century.[14] After a thorough examination of the mortar and joints, Richard Morris has, however, concluded that the scars do represent 11th-century work which has been cut back. In addition, that there were vaults over the aisles before those of the 14th century has been incontrovertibly established by the remains of the top of an aisle vault uncovered by Richard Halsey in the north gallery,[15] and by the scar of a webbing line in the north aisle wall pointed out by Malcolm Thurlby.[16]

(2) The four-storey elevation

Bony proposed the four-storey elevation and Clapham and Kidson accepted it, in conjunction with a wooden ceiling over the main space.[17] The possibility that there were vaults has, however, elicited a great deal of support, and if there were barrel vaults it follows that there would be no clerestory and hence no four-storey elevation. In 1962 at the same Summer School, McAleer, following in the footsteps of Petit a century before, suggested that the building was vaulted.[18]

Around 1970, Christopher Wilson reconstructed groin vaults over the eastern arm, like the vaults he had proposed at Gloucester. He also noted the remains of barrel vaults over the transept arms at Pershore,[19] but concluded that there was insufficient evidence for them at Tewkesbury. Shortly after this, the author took up the idea that there had been barrel vaults over all the main spaces, and attempted to persuade both Kidson and Wilson of the correctness of this view. The lines of fire damage observed by Thurlby on the north and east walls of the south transept (and equivalent marks on the east wall of the nave of Pershore) make barrel vaulting into a near certainty.[20]

Clearly, the Vitruvian connection conflicts with the presence of vaults. Kidson has answered this by pointing out that all the vaults could have been secondary, the result of a 12th-century campaign, like the ribbed vault of the chapel off the south transept.[21]

(3) The Sources

Tewkesbury (with Gloucester and Pershore) is so unusual among surviving 11th-century English churches that its design cannot easily be explained, even with the aid of Vitruvius, as a purely Anglo-Norman phenomenon. As a consequence writers have turned to parts of the Continent other than Normandy, Bony and Kidson pointing in particular to Burgundy and Lotharingia.[22] Alongside these it is worth calling attention to the possibility of influence from the Poitou. This is based on the popularity in the region of cylindrical piers, of barrel vaults, and of arches springing out of walls without a supporting order. All of these features occur at, for example, St-Savin-sur-Gartempe and Ste-Croix at Loudun. The second of these churches also has a choir with a plan indistinguishable from that of Tewkesbury, and, while it has no giant order, it has the distinction of being a dependency of St-Philibert at Tournus in Burgundy which does.[23]

In 1982 J. Philip McAleer brought to a close the period of the self-denying ordinance regarding publication on Tewkesbury,[24] producing a succinct account of the case for barrel vaults and against a four-storey elevation. This, with the four contributions in the present volume of transactions, changes Tewkesbury into one of the most extensively examined of Anglo-Norman churches, not only in discussion, but also in print. Given these circumstances and those which accompanied the work of Bony and Clapham in the 1930s and 1940s Tewkesbury can justly claim a unique ability to attract attention of such historiographic interest and complexity.

REFERENCES

(see also LIST OF ABBREVIATIONS AND SHORTENED TITLES, iv above.)

1. Bony (1937), 'Deux élévations...' 281–90 and 'A propos...' 503–4; Clapham (1952), 10–15.
2. Bony (1937), 'Deux élévations...' 281, n. 1. Bony notes that Clapham's suggestion was based on an observation by John Bilson.
3. Clapham (1952), 11.
4. W. G. Bannister, in 'Spring meeting at Gloucester'. *Trans. BGAS*, XLVIII (1926), 12.
5. Ibid., 12–13.
6. E. G. Benson, 'What was the original apse of Tewkesbury like?', *Trans. BGAS*, LXVII (1946–8), 399–404.
7. VCH *Gloucestershire*, VII (1968), 156, n. 74. Clapham's article is mentioned in n. 5 on p. 160.
8. Various positions for and against these views have been taken at different times over the last fifteen years by, among others, Peter Kidson, Christopher Wilson, Malcolm Thurlby, Richard Halsey and myself, and see below *passim*.

9. N. Pevsner, B/E, *Worcestershire* (1968), 14; D. Verey, B/E, *Gloucestershire: the Vale and the Forest of Dean* (1970), 363. The text of the second reference is Verey's, but it carries Pevsner's imprimatur.

10. J. – L. Petit, *The Abbey Church of Tewkesbury* (1848), 22, 39.

11. N. Pevsner, *Some Architectural Writers of the Nineteenth Century* (1972), 100.

12. G. T. Rivoira, *Roman Architecture* (1925), 85.

13. Kidson, in P. Kidson, P. Murray and P. Thompson, *A History of English Architecture* (1962), 54, says only that the origins of the giant order at Tewkesbury are to be found in classical architecture, but, having made references to Vitruvius in a number of lectures (including those delivered at Bath in 1962 and at the Abbey itself in 1970), he makes specific mention of this point in the second edition of the book (1979, 57).

14. In correspondence with the author in 1968.

15. See the paper on this in these Transactions.

16. The presence of original walling in this bay is indicated in the plan in *The Builder*, (1894). With this may be mentioned a second vault scar above the arch leading from the south aisle of the choir into the transept.

17. In the 1962 edition of Kidson, Murray and Thompson, Kidson accepted the four-storey elevation. In the 1979 edition he describes the elevation as three-storeyed, but only in effect, since there may have been a storey at clerestory level, though without any windows.

18. See above, n. 10. Bony (1959), 43 proposes half-barrels over the side aisles of the nave and the galleries of the choir.

19. See the acknowledgement in R. Stalley and M. Thurlby, 'A note on the architecture of Pershore Abbey' *JBAA*, series 3, XXXVII (1974), 113, n. 2. See also Clapham's description of Pershore, in VCH *Worcestershire*, IV (1924), 160.

20. McAleer (1982), 556 – 7, also noticed the fire marks at Tewkesbury.

21. Peter Kidson in conversation with the author. The chapel above has a much simpler semi-dome. This may be original, like the barrel vaults over the north porch and the locutory.

22. Bony (1937), 289 – 90, and (1959), 42 – 3; Kidson (1962), 54.

23. Additional support for this view is provided by the similarity noted by Halsey between the aediculae on the facade (or at least those parts of them which are original) and those at Ste-Marie at Saintes (Charente-Maritime), and by the parallel pointed out by Thurlby between the openings in the blind arcading on the transepts at Tewkesbury and those acting as vents above the vaults at Souillac (Lot).

24. Except, of course, for the brief comments in Kidson (1962) and (1979).

The Abbey Church of St Mary at Tewkesbury in the Eleventh and Twelfth Centuries

By Peter Kidson

Until comparatively recently what might have been described as the 'official' view of the Norman abbey of Tewkesbury was a conflation of the views of the eminent French scholar Jean Bony, and the late Sir Alfred Clapham. In a paper published in the *Bulletin Monumental* for 1937,[1] Bony proposed that in its original form the choir elevation had been conceived in four storeys. This conclusion emerged from a comparison of the nave with the eastern walls of the transepts. The nave has, and was presumed always to have had, three storeys: a very high arcade, an independent triforium passage, and a clearstorey. Inside, the clearstorey is now largely obscured by the 14th-century vault, and the rest is occupied by 14th-century windows. These have effectively removed any trace of Norman clearstorey windows. But outside, the Norman clearstorey is clearly represented by a band of continuous arcading. Originally, this must have extended right round the building. It has survived, much restored, along the north side of the nave, on both sides of the south transept, and on the east side of the north transept. The sections on the eastern walls of the transeps contain disturbances which have been construed as blocked-in windows.

The internal elevation of the eastern walls of the transepts differs from that of the nave in one important respect. Instead of the very high arcades opening into the side aisles, there were two comparatively low arches, one superimposed above the other. The upper of these evidently belonged to a gallery around the choir. In other words the choir had two storeys where there was only one in the nave; and if the passage and clearstorey remained unchanged, it followed that the choir must have had four storeys altogether. Some confirmation of this analysis could be found at Pershore, and possibly also at Evesham.

This was a very important deduction. Four storeyed elevations are of course a well-known feature of early Gothic cathedrals in France such as Noyon or Laon. Here was evidence that there were Romanesque precedents for such dispositions. Moreover it was not just the mere fact of there being four storeys at Tewkesbury. The fourth storey came about because what in most Norman buildings was a clearstorey passage had become detached from its clearstorey and turned into a triforium, just as at Laon. Anyone interested in the general proposition that early Gothic grew out of Anglo-Norman Romanesque could find much encouragement in this rather precise analogy.

Bony's version of Tewkesbury was emended by Clapham in a short paper published posthumously in 1952.[2] In the transepts the walls are articulated by high, blind arcades which in a sense correspond to the high arcades of the nave. Bony did not discuss whether this veritable giant order had been present in the choir. Clapham argued that this was the case. He suggested that the cylindrical piers around the choir, which quite certainly belong to the first period of construction, originally rose to a much higher level than at present, close to the top of the gallery, where they were joined in a manner analogous to arrangements found in the easternmost bays of the nave of Romsey, the choir of Jedburgh, or at Oxford Cathedral. Such a use of the giant order to link two storeys of an elevation had several interesting pre-Romanesque parallels on the Continent and subsequently was to have a long and fruitful history in the west of England. For good measure Clapham's interpretation offered an ostensibly plausible explanation for certain curious details on the surviving masonry of the Romanesque piers. This made it all the more convincing. Taken in conjunction with the four-storeyed elevation, it conjured up impressions of Tewkesbury as a surprisingly precocious and sophisticated design. Far from lying on the edges of outer darkness, the English west country appears to have been a region as congenial to architectural invention in Romanesque times as it was later; and Tewkesbury soon took a place second

only to Durham among Anglo-Norman contributions to the major achievements of the Romanesque style.

It was left to Bony in 1958 to round out the picture by drawing attention to the role of the Bishop's Chapel at Hereford as a convenient link between the west of England and 11th-century Burgundian buildings such as Tournus, which were obvious sources for the use of the giant order in Romanesque architecture.[3]

So far as I am aware, the credit for re-opening the whole matter of Tewkesbury when it seemed to have been so satisfactorily settled, belongs to the American scholar Philip McAleer. In the course of conversations during the Courtauld Summer School of 1962, McAleer convinced me that Clapham had not produced the final answer to the archaeological problems of the choir; and subsequent reflections have led me to doubt whether there was in fact anything that could be called a genuine four-storeyed elevation. The main purpose of this paper is to set out my reasons for questioning the Bony-Clapham hypothesis, but I have added some speculations about the ultimate origins of the giant order in mediaeval architecture which I hope will not be entirely out of place. The result is an assessment of the historical significance of Tewskesbury that is perhaps somewhat less epoch-making, but not necessarily less interesting.

To begin with the four-storeyed elevation: the question at issue is whether there really was a clearstorey; or more precisely, whether there were any clearstorey windows in the Romanesque building. Evidence relevant to the answer is to be found both in the nave and in the transepts. The answer does not have to be the same. The bulk of the nave manifestly belongs to a second campaign of construction, the break being represented externally by the disappearance of a rudimentary plinth and a change of masonry on the north side, and internally by the step which separates the nave proper from the liturgical choir. On the other hand such breaks often signify nothing more than a convenient pause. Differences between nave and choir may well have been anticipated from the start; and in any case, the distribution of clearstorey windows would almost certainly be bound up with the presence or absence of vaults. This makes the implications of the evidence peculiarly disconcerting. It can be said at once that any Norman clearstorey windows must have been integrated into the blind arcading that ran round the building at clearstorey level. It follows that they would have been very small indeed, virtually negligible as a means of lighting the interior. This in itself is perhaps not a decisive argument. Such windows, set within similar arcading, can be found, for instance at Sequeville en Bessin. But at Tewkesbury there are several other improbabilities. The arcading was almost entirely restored when the present parapet was made at the end of the 17th century, but there is no reason to suppose that the intervals were altered then, or at any other time. The 14th-century windows do not coincide happily with this arcading. Not only were they too big for it, but they have a different rhythm. Each window seems to have required the removal of two colonnettes and three arches. But they occupy different positions in the spaces thus created. Moreover, although the present windows are set at regular intervals and are symmetrical with the Norman elevation inside, there are sometimes two, and sometimes three arcades left on the exterior walls between them. From this it can be shown that any earlier windows compatible with the arcading cannot themselves have been equidistant from one another. We therefore end up with a situation in which hypothetical clearstorey windows would have had to be absurdly small, irregularly placed, and generally out of phase with the rest of the Norman building. While none of this is entirely beyond the limits of possibility, the amount of special pleading required to square it with the existence of an orthodox clearstorey seems inordinate and unacceptable.

There is another argument. The fact that there is a separate triforium passage at Tewkesbury should alert us to the suspicion that we are dealing with something out of the ordinary, at least in a Norman context. To jump to the conclusion that the elevation was organised like that of Laon is to be guilty of anachronism. At the time Tewkesbury was designed it is far more likely that the passage was roofed over and made independent because there was no proper clearstorey to which it could be attached.

Scepticism about the practical value and even the existence of clearstorey windows in the nave can be

confirmed by the residual traces of the aisle windows. The original shapes of these survive only where the aisles meet the west front; but along the south wall exactly in the middle of the recesses of the blind arcading and therefore of each bay, straight joints can be observed below the 14th-century enlargements, where the first windows have been blocked in. These prove that most if not all of the aisle windows were unusually tall. (Nothing similar has survived on the north side.)

It seems clear that all the effective lighting in the nave was from the side and not from above. Now the normal reason for leaving out clearstorey windows in a large 11th or 12th-century church was the presence of a vault, and the combination of high arcades and prominent side windows at Tewkesbury might lead us to suppose that we are dealing with a barrel-vaulted hall-church of a type well known in western France. But this is where the obvious conclusion fails to coincide with the evidence. For as soon as we ask whether there was a Romanesque vault over the nave of Tewkesbury, the answer must be no. There are no actual traces, there are no indirect signs, and much that is inconsistent with the idea. Perhaps the greatest single factor is the size of the span. The nave of Tewkesbury is very wide, considerably wider than Durham. For its date a vault over it would have been a feat of staggering precocity. If it had ever been built it would have had to spring from a level above the triforium passage and to have reached a height well beyond that of the 14th-century vault. Some trace of it might have been expected to have survived on the west face of the crossing tower; but there is nothing. Nor is there any sign of interest in buttressing, which such a vault might be supposed to have engendered. Indeed, there is not a single recognisable buttress or buttressing feature in any part of Romanesque Tewkesbury. The fact that the springers of the 14th-century ribbed vault are as low as they are, i.e. more or less immediately above the columns of the main arcade, and below the triforium, which is the only place where they can be effectively buttressed, is eloquent acknowledgement of how utterly unsuited the Romanesque design was for the purpose of receiving a vault. The only compromise that might be considered is the possibility of a wooden vault, perhaps with a bevelled or segmental profile. It should be noted however that the few remaining corbels high up on the walls of the side aisles could just as well imply open-work timber trusses, and similar constructions cannot be ruled out for the main span. Such as it is, the evidence seems to indicate a building without either clearstorey windows or a vault. It is not necessary to speculate further to realise that in spite of specific affinities, it did not conform to an established type of design, but must have been decidedly odd, without being particularly 'advanced' or adventurous.

If there were no clearstorey windows in the nave, it would be extremely unlikely that any ever existed in the eastern parts of the building. It is true that on the eastern walls of the transept there are disturbances in the masonry between the colonnettes of the external arcading, and these have been identified as blocked-in windows. The disturbances occur under the third arches from the north and south ends of the transept arms, and the fact that they correspond to one another is reinforced by their respective positions on the vertical axis through the arches that opened into the original transept chapels. This is precisely where one might have expected to find clearstorey windows. However, this hardly proves the case. If there were windows over the chapels there ought also to have been windows over the aisles and galleries; but there are no equivalent disturbances in the appropriate positions. Moreover, windows on the east sides of the transepts ought to have been matched by windows on the west. Here again there are no traces. The upper part of the west wall of the north transept has been rebuilt and the Norman arcading has entirely disappeared; but on the south the arcading is still there and there is no sign of any windows, blocked or otherwise. In only one of the disturbed areas, that on the north transept, is there anything that could reasonably be called a straight-joint, and this falls short of the shape of a complete window.

Examination of these high walls from inside ought to put the issue beyond doubt; and so in a sense it does, though perhaps not as conclusively as a tidy argument would require. In the south transept, there are no signs of any splays whatsoever. In the north there are splays. They are largely faced with brick, which proves that at least in part they are post-mediaeval. But on one side several stone courses form an

angle, which seems to imply that the wall did not continue in the same plane when it was built. There could have been an opening at this point, but it is unlikely to have been an ordinary window if only because it was the only thing of its kind in either transept. It could have been a ventilator for the roof space above a lower ceiling. On the other hand there could have been some quite exceptional reason for its presence about which we now know nothing. In any case the evidence has been confused by later alterations and repairs.

The conclusion that there were no clearstorey windows in the transepts almost certainly means that the same was true of the choir. Here the question can be asked again: was there a vault? The objections that seemed to rule out a hypothetical nave vault apply also here, and they ought to be equally effective. However attention has been drawn to certain tell-tale features in the exposed masonry of the eastern face of the crossing tower below the present 14th-century vault. These are taken to be residual traces of a dismantled vault. The features in question form a shallow curved course roughly concentric with the curve of the crossing arch. They clearly require some sort of explanation; and as the tower was never seriously altered after it was built, they ought to belong to the first period of construction. Whether they prove that there was a Norman vault over the choir is another matter. The crux of the argument is once again the triforium passage. In the choir this no longer exists; but its position can be deduced from the surviving stretches in the transepts, which turn toward the choir before they drop to the 14th-century level. If the line of masonry on the tower really does represent the curve of an earlier vault, its springing level would appear to have been well below the top of this passage. Moreover, although the galleries themselves have disappeared, their roof-lines incised into the transept walls show that they had only the flimsiest covering, and the angles at which they were pitched seem to rule out the presence of any buttressing elements in the gallery roofs. There is a further difficulty. As a rule, Norman architects did not use wall ribs. They simply built their vaults up against walls. So the form in which the ghosts of defunct Norman vaults commonly disclose themselves is as a line on a wall between two different kinds of masonry. On occasion they may have bonded the web of the vaults into the wall, but then it would be represented by the full thickness of the vault. Now the feature on the east side of the crossing tower at Tewkesbury is more than a mere line, and less than the thickness of a vault. If it is anything to which a name can be given, it is surely a trimmed-off wall-rib. Altogether the most satisfactory way of explaining all the discordant indications of the evidence would be to postulate some sort of timber imitation vault, with something less than a semicircular section, but sufficient rise to occupy the part of the elevation normally given up to a clearstorey.

The question of vaults at Tewkesbury brings us back to Clapham. Although the principal burden of his argument was to locate Tewkesbury in the sequence of giant-order buildings, the most ingenious and deservedly well known part of his hypothesis was his reconstruction of the choir aisles. For these the giant order theory required not only tall, cylindrical piers, but arches peeling off them at the appropriate level to span the aisles and to form arcades. These arches would define the aisle vault compartments. There was no difficulty about arches over the aisles. The cylindrical piers have shallow imposts projecting toward the aisles at the right height, and three of the original responds survive on the aisle walls opposite. The arcades linking pier to pier were not quite so straightforward, but Clapham thought he had found the answer in the form of curved joints and related disturbances rising from the afore-mentioned imposts, well to the rear, i.e. toward the aisle or ambulatory side of the piers. He took these to have been left when the Norman arcades were trimmed off during the 14th-century alterations. If he was right, he not only solved the awkward archaeological problems which these features presented, but used them to provide striking, even exaggerated confirmation of one of the basic requirements of the giant order elevation.

The neatness and economy of Clapham's interpretation has commanded general assent. If it has not been subjected to rigorous scrutiny this has been largely because there is a widespread conviction that no satisfactory alternatives can be found. But this does not mean that Clapham's arguments were conclusive in every detail. On the contrary, they can be criticised at two levels. In the first place it may

be doubted whether the "trimming-off" theory is really adequate to explain all the joints and disturbed masonry that are at odds with the regular coursing of the cylindrical piers. And secondly, it may be asked whether the solution that Clapham came up with is credible as a piece of architectural design.[4]

The 'trimming off' theory can be presented in two versions. In the first it may be presupposed that because what has been trimmed off came right down to the impost, it must have been the middle or main order of the arcade arch. This would imply that the arcade itself was not aligned with the axes of the arcade piers, but set well back toward the aisles and ambulatory. Such an arrangement would have been quite extraordinary. It would also raise a number of awkward questions, not least of which would have concerned the thickness of the arcade, and the placing and support of its secondary orders. The only ways of avoiding such difficulties would be to suppose either that the arcade arches were lop-sided, or that they were totally different from every other arch at Tewkesbury. Both assumptions seem wildly gratuitous. On the other hand it could be and has been argued that the arcade arches were placed symmetrically, as might be expected, but that no trace of the main order has survived because it reached the cylindrical piers at a level higher than anything which has survived. The trimmed-off traces represent only the secondary or outer order, which, although above the main order in one sense, would also extend down to a lower level, because it was further back in relation to the curve of the pier. This is undoubtedly a very clever argument, but it leaves one glaring loose end. If there was a secondary order on one side of the arcade arch surely there ought to have been one on the other side as well? However, it is beyond question that there cannot have been any secondary order on the side facing into the choir, because if there had been, it also would have reached down to the level of the impost, and had to be trimmed off. There is not the slightest trace of evidence that any such operation was ever performed, so at the very least, this version of the theory also requires lop-sided arches, and there are no more better reasons than in the other case for accepting such special pleading.

If we decline to indulge in such flights of fancy and confine our attention to the evidence actually before our eyes, namely the pieces of stone in the cylindrical piers which are clearly not part of the regular Romanesque coursing, it is soon apparent that a single explanation will not suffice. Several do have rough surface tooling which suggests that something really has been hacked away, while others have a smoother finish and bear mouldings which are all of a piece with the profiles of the 14th-century rear-arches of the present arcades. It is perfectly possible that 14th-century mouldings were freshly carved on projecting pieces of Romanesque masonry but it can equally be argued that the moulded stones were actually put there in the 14th century. If we examine carefully the tooling where cutting away can reasonably be postulated, this alternative becomes a distinct likelihood. For in some cases there are three stones placed one above another and the tooling moves in a different direction on the surface of each stone. How anyone allegedly trimming off a redundant arch could contrive to leave such an eccentric finish requires a lot of explanation. It surely makes much better sense to suppose that the stones in question only reached their present location in the 14th century as part of a tidying-up operation, after the new rear-arches had been put in place. This would also offer a way round other difficulties, such as the tooling being more obviously Romanesque than 14th-century, and the stones themselves being rather too small for genuine voussoirs.

The drift of this line of thought leads toward the somewhat drastic conclusion that the evidence which Clapham took to prove the existence of Romanesque arcades, really belonged to the 14th century. From this it would be only a short step to the inference that there were no Romanesque arcades at all, and therefore no Romanesque vault. I must confess to having considerable sympathy for such a theory. However, as a simple, straightforward explanation it will not do. It founders on the existence of quite incontrovertible evidence that there was a vault over the choir aisle before the present one, and that this earlier vault was almost certainly of a Romanesque date. The evidence consists of residual traces of rubble and mortar visible below what would have been the gallery floor, and above the Gothic vault,[5] and a tell-tale curved line on the north wall of the choir aisle. This seems to put the issue beyond all doubt. Whatever the difficulties, Clapham must have been right.

But was he? It is one thing to concede that there was a Romanesque vault over the choir aisles, and quite another to conclude that such a vault was part of the original design. The only other surviving Romanesque vault in the abbey, that in the south transept chapel, was manifestly a later insertion. The ribs of the apse, which emerge from the walls, without benefit of shafts or capitals, are grafted on to an already existing transverse rib; and the pattern which they form has its closest parallels at Kilpeck and Ellestone, neither of which can be dated much before the middle of the 12th century. Moreover this re-modelling of the south transept chapel can only have preceded by a few years the complete reconstruction of the equivalent chapel on the north transept. Here the vault was already Gothic in character. There is no sign that in either case it replaced an earlier vault. All this indicates that a fairly extensive campaign of works was undertaken at Tewkesbury during the second half of the 12th century, in which vaulting played a major part.[6] It is not beyond the limits of credibility to suggest that the vaults in the choir aisles may have belonged to the same campaign.

There are two arguments which can be put forward in support of such a view. The first concerns the line which preserves the shape of the Romanesque vault on the north choir wall. It turns on how we interpret the various kinds of masonry that can be identified in the walls of the earliest parts of the building. It seems clear that during phase one two sorts of masonry were used: blue lias and ashlar. An outcrop of lias lies along the western edge of the Cotswolds; i.e., it was the local stone, and quarrying it must have presented no problems. It was used for the perimeter walls of the choir, interspersed with occasional levelling courses of ashlar. Otherwise ashlar was used for articulating features like wall-shafts. By and large ashlar was used more extensively as the building proceeded westward and by phase two, that is the nave, it had completely replaced lias for ordinary walls. The change can well be seen on the exterior of the north aisle wall, where the plinth of phase one stops, and with it the lias. But in the eastern parts of the building we can be fairly confident that where there is lias with levelling courses, we have the original fabric. Extensive areas of such masonry have survived on the south side of the choir, and this reaches right up to the top of the aisle wall. There is also a patch on the north side, in the bay where the vault-line occurs. Here, however, the situation is more complicated. The lias extends no further upwards than the capitals of the adjacent wall-shafts. Above that there seems to have been continuous ashlar to the line of the vault; then at the very top the lias reappears. In view of what can be seen on the south side, it is difficult not to regard the ashlar as an inserted patch rather than an integral part of the original wall. But as it conforms to the shape of the vault, it was clearly contemporary with the vault, so the vault should also be an insertion.

By way of comment it may be noted that in the south choir aisle where the extensive stretch of lias wall has survived there is no tell-tale curved line around a patch of ashlar and no trace of a wall-shaft in positions where a pre-planned vault would require them. This creates problems for all theories but at the very least it seems to prove that there was no consistent approach to the problem of vault construc-tions.

By itself, this argument is not conclusive. But it gains considerably in force when it is put alongside the second argument, which is concerned with what happened on the opposite side of the aisle, i.e. where the vault and the arcade met. At this point we may recall the other reason for questioning Clapham's reconstruction: namely whether it was credible as the preconceived solution of the architec-tural problem. This is perhaps dangerous ground. What for one person may seem a stroke of genius will strike another as sheer ineptitude. In the present instance, however, it is not so much a question of passing an aesthetic judgment, as trying to decide whether the evidence for the vault is better explained as something conceived at the outset and executed as the building went up, or as something inserted into an already standing structure. It may be said at once that if the vault was a later addition, the signs would be very much as we find them. Whatever else they may indicate, the vertical joints on the Romanesque piers mark the limits beyond which no vault encroached; and this is precisely how an inserted vault would have fitted. What is disconcerting about Clapham's view is the extent to which it requires the cylindrical piers to stand proud. If the design was thought out that way, no one else who

experimented with giant order elevations in the 12th century chose to follow this particular lead. It was either an improvisation or an eccentricity. Between those two alternatives, the former makes perhaps less demand upon our credulity.

Here then is the solution which I propose to adopt. The choir aisle vaults belonged essentially to a campaign of works that occupied much of the second half of the 12th century. They were part and parcel of an effort to smarten up what had been in its day a large and pretentious church, but which had been overtaken by developments elsewhere. These developments were mostly concerned with vaulting, whereas the initial preoccupation of Tewkesbury was with the giant order. The rest of this paper will be taken up by an attempt to reconstruct the original conception of the choir elevation, and to suggest the probable source of mediaeval interest in this particular architectural feature.

The minimum indisputable components of the original choir elevation are the cylindrical piers and transverse arches across the aisles. These can be deduced from the responds. There were no arcades, and it is not even certain that there was a gallery, at least in the sense of there being a floor on which to walk. The transverse arches may have been no more than bracing struts of a kind often found in Romanesque churches. At Tewkesbury this particular issue turns on the date of an opening in what would have been the party wall between the upper chapel on the south transept and the adjacent gallery. Through this arch was the only known access to the gallery from the ground. If it was original then the gallery was also original; if it was made when the vaults were put in, then the gallery was part of the 12th-century renovations. On the whole some sort of primitive gallery seems more likely than no gallery at all. The fact that there were upper chapels on the transepts strongly suggests that there were also upper chapels around the east end. These would have needed a gallery for access.

The task of reconciling the presence of a gallery with the absence of an arcade is perhaps not as difficult as it might seem. There is one kind of gallery that would satisfy all the conditions required by the evidence: namely a platform of wooden planks resting on the transverse arches. Although not a single instance of such an arrangement has survived in England, there is no shortage of written evidence that timber floored galleries abounded both here and on the Continent. At Gernrode in East Germany a 10th-century example is still standing. At Gernrode, however, the wooden galleries are not associated with a giant order. This was the unusual feature of Tewkesbury, and one that would benefit from the justification of a plausible model. Something of the right kind seems once to have existed in Saint-Germain at Auxerre. Here an early 11th-century nave with tall cylindrical piers like Tournus, was remodelled, according to M. Vallery-Radot, after fires which occurred in 1064 and 1075.[7] It was finally destroyed in 1811 but we know quite a lot about it thanks to one pair of cylindrical piers that have contrived to survive, Cotron's 1652 description, and some of Dom Plancher's curious drawings. Collectively these indicate a building with cylindrical piers about thirty feet high; a clearstorey; and a series of diaphragm arches under the tie-beams of the roof. The evidence does not appear to be entirely consistent, but Cotron specifically states: 'collaterales in duas veluti contignationes dividuntur, et solum superiori parte concameratae': 'the side aisles are divided as if into two storeys and vaulted only in the upper part'. Plancher's drawing shows how this worked; a series of transverse arches in the aisles mark the level of the gallery floor, and there are groined vaults above. The wooden floor of the gallery is not actually shown. Perhaps the planks had been removed before Plancher saw it. But Cotron's description does not make sense without it. So here we have at least one documented instance of precisely the kind of gallery which the Tewkesbury evidence seems to require. Moreover Saint-Germain is clearly relevant to Tewkesbury in the matter of cylindrical piers. The dates are roughly right, and the general affiliation with Tournus is very satisfactory in view of the well known links between the Bishop's Chapel at Hereford and Tournus. We seem to have the makings of a nice nexus of connections between the west of England and a region to the south-east of 11th-century France perhaps centred on the archdiocese of Lyon.

The matter cannot be left there, however. There remains the anomaly of the Tewkesbury clearstorey. Inconveniently, Saint-Germain had a clearstorey, and unless the whole argument which led to

the conclusion that this feature was missing at Tewkesbury was wrong, we are not entitled to say without more ado that Tewkesbury was simply an outlying member of a Burgundian group of churches. The omission is too fundamental to be dismissed as an insular variant on the principal theme. Yet in a sense it must be taken seriously as a variant. I would like to suggest that we are dealing here with alternative interpretations of Vitruvius's description of his one and only contribution to non-military architecture – the basilica at Fanum, which appears near the beginning of Book V of *De Architectura*. Vitruvius's remarks on basilicas in general are both cryptic and vague and what he tells us about his own building is not exactly a model of clarity. The only thing that emerges for certain is that he did not follow his own precepts. Nevertheless there are several respects in which his statements seem to provide the starting point for both churches under discussion.

The account of Fanum can be interpreted as follows.[8] The central space of the basilica, literally the space covered by the roof in the middle, the *mediana testudo*, is 120 feet long by 60 feet wide. Around this central space there is an aisle, *porticus*, which is 20 feet wide between outer wall and columns. The columns are unbroken in height, *altitudinis perpetuis*, and they are no less than 50 feet high, and 5 in diameter. These are certainly columns on the grand scale and it is here that Vitruvius departs most radically from his general recommendation, which is to make the columns only as high as the aisles are wide. In the context of Fanum, these would have been no more than 20 feet high, which as we shall see in a moment was the height of the gallery floor. In other words, the general formula seems to envisage two superimposed orders of columns whereas Vitruvius himself used a species of giant order. Later on he makes the point even more explicit when he speaks of the columns as rising unbroken to the beams of the roof: 'ipsae vero columnae in altitudine perpetua sub trabe testudinis'.

Behind the columns, *post se*, are what are called *parastaticae*. These are 20 feet high, 2½ wide, and 1½ deep. These have been described as pilasters, although the dimensions suggest something more bulky, like engaged half-columns. Their function is to carry the joists of the gallery floors: 'trabes in quibus invehuntur porticum contiguationes'; and the logic of the building clearly requires that these *parastaticae* should be placed against the aisle walls, with some corresponding support or socket at the same height on the aisle side of the columns. Here we have what must surely be the ultimate source and authority for the arrangements at Tewkesbury and St-Germain: wooden galleries in conjunction with a giant order. Above the first set of *parastaticae*, i.e. in the galleries, are more of them, slightly smaller, i.e. 18 feet by 2 by 1. These seem to do two things. One is to receive the beams supporting what is called the *cantherius*, and the other is to take the roofs of the gallery, the *tecta porticum*, which are set lower than the main roof, *summissa infra testudinem*. *Cantherius* is an obscure technical term which so far as I know only occurs once in the sense used here. Literally it means a nag or beast of burden – which in this context must have been extended to serve as a collective name for the principal rafters of the main roof. If so, then there was in effect just one gable spanning the 100-foot width of the building. But this interpretation is confused by two obscurities. First, it is not made at all clear how the *tecta porticum* is related to the *mediana testudo*. It is evident that two different kinds of roof are involved, although both are certainly made of wood. *Testudo* I take to be a continuous ceiling, perhaps curved or bevelled, whereas *tecta* would be open timbered. This might suggest that the *tecta porticum* were all part of the system of trusses to which the *cantherius* belonged, with the central part being concealed by the *testudo*. On this interpretation, *tecta* and *testudo* would meet at the *trabs testudinis* above the main colonnades; and *infra*, as it applied to the relation of the *tecta* to the *testudo* would be simply a matter of their respective positions under the *cantherius*.

But there is a further complication. After describing the upper *parastaticae*, Vitruvius goes on to say: 'Reliqua spatia inter parastaticarum et columnarum trabes per intercolumnia luminibus sunt relicta'; the remaining space between the *trabes* of the supports – it is not specified whether in the aisles or galleries – and the *trabes* of the main columns is given up to lighting through the intercolumniations. This has conveyed to most readers the impression that in the 12 feet or so above the galleries there were openings or windows as in an orthodox Christian basilican church. The implications of this, however,

seem to conflict with the explicit statement made earlier, that the *parastaticae* of the galleries carried both the roofs of the galleries *and* the *cantherius*. If there was a clearstorey, the main roof could not reach the *parastaticae* of the galleries, and there would have been only one function for these to perform. On the other hand, if there was a continuous roof it is difficult to see how any lighting could be effected through the remaining space between the two sets of *trabes*. This particular difficulty would disappear, of course, if *trabes parastaticarum* referred to the lower supports in the aisle. The lighting would then be through the galleries.

I do not pretend to know the correct solution of this paradox insofar as it concerns what Vitruvius actually meant, and for the moment further exegesis can be left to Vitruvian scholars. In the present context the relevant point is that any architects in the early Middle Ages who chose to consult Vitruvius for help in the design of their churches – as some clearly did – could just as easily conclude that a clearstorey was not necessary as that it was. The former decision would entail lighting from the side, whether through aisles, galleries or both. Once this necessary degree of flexibility has been established, we can proceed to the hitherto unsuspected conclusion that readings of Vitruvius lay behind a number of experiments in mediaeval church design. The range and variety of these experiments seems to have been considerable. Apart from the giant order itself, they may have extended to the sudden pre-occupation with galleried churches which occurred during the 10th and 11th centuries. A whole range of questions and lines of enquiry are opened up, not least where it all began. It may be suspected that Cluny was involved. There was certainly a copy of Vitruvius in the library at Cluny centuries later, and it may well have been there from the earliest days of that foundation.

The general heading under which Vitruvius could be expected to have caught the attention of medi-aeval architects was of course their widespread and varied interest in things Roman. This was particularly acute during the Romanesque period. Motives clearly ranged from quite specific purposes of propaganda both secular and ecclesiastical, through less well defined aspirations toward monument-ality, to the almost capricious selection of precedents for their own sakes. All things equal, such tendencies would be strongest where Roman remains were most prominent; but texts, or the knowledge of texts, could extend their manifestation into areas where the possibilities of Roman archi-tecture were otherwise not conspicuous. This gives a certain piquancy to the appearances of the giant order throughout Romanesque church designs in the west of England. It has become customary to think of them as importations from the Continent, and so they well might be. But it is also worthwhile remembering just how little is known of the public buildings of, say, Roman Bath, and so perhaps to reserve judgment on the question of origins. Such caution would certainly be appropriate in the case of Tewkesbury. The foregoing arguments have been advanced in an attempt to follow through the impli-cations of evidence as it is presented by a single building, without reference to extraneous factors. While from the point of view of strict method this is as it should be, the final conclusion has to be at least historically consistent with similar deductions from other buildings . A full discussion of the role of vaulting and the giant order in the Romanesque architecture of the west of England would no doubt have to include reference to Pershore, Gloucester, Evesham, Worcester and Bath as well as Tewkesbury, but that would immeasurably extend the scope of the argument. It would also introduce speculative elements which would be out of place in the present context and have therefore been deliberately excluded.

ACKNOWLEDGEMENTS

This is a revised version of a lecture first given at Tewkesbury Abbey in May 1971. It was one of a series presented in connection with the appeal launched as part of the celebration of the 500th anniversary of the battle of Tewkes-bury. It was given again, virtually unchanged, at the Gloucester Conference of the B.A.A. in 1981, where it came in for some well-justified criticism.

Among those who have tried to keep me on the straight and narrow, I would like to mention with gratitude Eric

Fernie, Richard Gem, Richard Halsey, Richard Morris, and Christopher Wilson. To Jean Bony I owe a more particular debt. On two occasions I have enjoyed the benefit of examining Tewkesbury in his company. His formidable eye and keen sense of the implications of what he sees set standards of argument that it is a pleasure to acknowledge, if not always easy to emulate. However, while it now owes much to the specific comments of friends and colleagues, no attempt has been made to take into account all the ingenious suggestions that must have been put forward over the last few years during which Tewkesbury seems to have become the focal point of a small archaeological and art-historical industry.

REFERENCES

(See also LIST OF ABBREVIATIONS AND SHORTENED TITLES, iv above.)

1. Bony (1937), 'Deux élévations...' See however Bony's emendations in *French Gothic Architecture of the 12th and 13th centuries*, (University of California Press 1983), 482.
2. Clapham (1952), 10 – 15.
3. J. Bony, 'La chapelle épiscopale de Hereford et les apports lorrains en angleterre après la conquête', *Actes du XIX Congres international d'Histoire de l'Art* (Paris 1959) and *'Relations artistiques entre la France et les autres pays depuis le haut Moyen Age jusqu'à la fin du XIXᵉ siecle'* (Paris 1959), 36 – 43.
4. In fairness to Clapham it has to be recognised that he chose not to publish in his lifetime the theory to which his name has become attached. Whether he had reservations, and if so on what grounds, are not known.
5. My attention was drawn to this evidence, first by Richard Morris, and later by Richard Halsey.
6. Other works at Tewkesbury that indisputably belong to the 12th century are the upper parts of the central tower, and whatever restorations were made necessary by the fire of 1178. This seems to have consumed the monastery rather than the church, but insofar as the latter was affected the south transept bears the mark of the flames. Economy of hypothesis might require as many of these operations as possible to go together. If vaulting was a general consideration at this time, the choir itself ought to have been included in some way or other.
7. For the documents relevant to Saint-Germain at Auxerre, v. *CA*, Vol. 58 (1958), 26 ff.
8. Vitruvius, *De Architectura*, Bk. V, CI, 6 – 7. 'Non minus summam dignitatem et venustatem possunt habere comparationes basilicarum, quo genere Coloniae Juliae Fanestri conlocavi curavique faciendam, cuius proportiones et symmetriae sic sunt constitutae. Mediana testudo inter columnas est longa pedes CXX lata pedes LX. Porticus eius circa testudinem inter parietes et columnas latas pedes XX. Columnae altitudinibus perpetuis cum capitulis pedes L, crassitudinibus quinum, habentes post se parastaticas altas pedes XX, pedes IIs, crassas Is, quae sustinent trabes, in quibus invehuntur porticum contiguationes. Supraque eas aliae parastaticae pedum XVIII, latae binum, crassae pedem, quae excipiunt item trabes sustinentes cantherium et porticum, quae sunt summissa infra testudinem, tecta. Reliqua spatia inter parastaticarum et columnarum trabes per inter-columnia luminibus sunt relicta'.

Tewkesbury Abbey: some recent observations

By Richard Halsey

In September 1979, the series of tiled roofs over the north choir aisle projecting east from the north transept of Tewkesbury Abbey, were replaced with new lead flats to the design of the Abbey architect, Neil Birdsall.[1] Before the new roofs were constructed, I was given the opportunity to investigate the area temporarily uncovered. In the awkward space and restricted time available, it was only possible to remove the infilling of the roof space down to the top of the north choir aisle vault, in a small triangular area in the corner formed by the north choir clearstorey and north transept east wall (Pl. IIIA). No stonework was removed and the loose infill was simply shovelled back into the excavated space.

Despite the remodelling of the choir in the 14th century and subsequent repairs,[2] the junction of the Romanesque north choir wall with the east wall of the north transept is substantially intact. Indeed, the Romanesque choir walling is visible from the top of the north choir aisle vault up to the heavy 14th-century clearstorey sill, for about 2 ft 11 ins (0.89 m) east of the north transept.[3] Above this sill level, there are a number of Romanesque courses turning the corner, though they extend little further. At this level, all the east wall is Romanesque work affected by the 1178 fire, though the arch opening from the ex-choir tribune into the north transept is now filled with a *c.* 1260–70 circular traceried window.[4] The whole of the southern jamb of this Romanesque arch was revealed,[5] the stonework coursing through with the north choir wall (Pl. IIIB).

Below the lowest course of Romanesque ashlar on both choir and transept walls is clear evidence of a lias slab floor. That the floor was in position before the insertion of the circular traceried window is certain, because the infill of yellow mortar sits on top of a broken slab of lias, set within pink mortar that is itself beneath the lowest ashlar of the Romanesque jamb. As the slabs are laid at a uniform level below the lowest Romanesque course of both choir and transept, with no signs of insertion, it must be presumed that this flooring is primary. Any subsequent flooring would surely have been laid up to the existing walling or chased into it – in which case a ragged edge would be visible above and below the floor slabs.[6] The mortared rubble replacing the subsequently removed lias (Pl. IIIc:*B*) is creamy coloured, like the 14th-century vault and wall mortar (which is not as yellow as the mortar of the *c.* 1260–70 infill). However, the mortar above it (Pl. IIIc:*C*) and within the lowest joint of the revealed jamb is distinctly pink, like the Romanesque wall mortar throughout the church. I suggest that this pink mortar above the lias floor is waste from the 11th-century building work carried out above this floor, and the dark line visible about 6 ins (0.15 m) above the lias slabs, most distinct on the lowest course of the choir wall, is associated with dirt and mortar waste.[7]

More surprising is the presence of pink mortar in the top of the revealed vault (Pl. IIIc:*A*) indicating this to be Romanesque work in situ. The very limited area exposed – barely 2 ft (0.61 m) east of the north transept east wall – is probably as much above the broad 14th-century pointed arch added to the east of the Romanesque arch leading from the north transept into the north choir aisle, as it is above the awkwardly rising 14th-century vault between this arch and the first vault bay (Pl. IIID). However, as Romanesque walling survives in situ on either side of the aisle entrance for about 5 ft (1.52 m) east of the east face of the east wall of the north transept, it can only be presumed that the underside of the Romanesque vault was simply re-faced to blend better with the new choir aisle vaulting to the east.[8] A similar broad extra arch also of 14th-century date can be seen on the aisle side of the quadrant arches between each nave aisle and transept arm and another can be seen in place of the Romanesque barrel vault, in the lower chapel of the north transept. It is unlikely that a Romanesque outer order has been replaced in the choir aisle, as there is no sign of an arch springing from the surviving Romanesque ashlar projection on the back of each eastern crossing pier. Indeed, in the south aisle this projection

behind the south-east crossing pier shows the distinct curving line of a vault, similar to the vault scar on the north wall of the second bay of the north choir aisle, in having ashlar below the curve and rubble above. The western arches of both choir aisles at Pershore Abbey also have similar scars (Pl. IVA). It is clear, then, that the choir aisle vaults in both abbey churches continued right up to the arch between each aisle and transept arm.

If, as seems most probable, there was a Romanesque groin vault over the rectangular area now covered by the 14th-century quadripartite rib vault (which, it should be noted, springs from Romanesque supports on three of its four corners), then a Romanesque transverse arch can be expected where now exists a 14th-century transverse arch. Despite being shown as Romanesque on various plans,[9] the first shafted respond on the north choir aisle wall courses perfectly with the Gothic arch through to the chapel off the north transept. However, a Romanesque shaft could have existed here. There is no equivalent shaft in the south aisle, as there is an early 14th-century canopied tomb recess to a height of about 8 ft (2.44 m). At this point, the 14th-century vault springs from a corbel that is strangely mis-shaped, as though originally designed to line up against an existing feature. As this area of wall has apparently been much re-faced in the Gothic rebuilding and disturbed by the insertion of the tomb, a Romanesque shaft could have been removed, rather than truncated like the paired Romanesque shafts of the entrance arch. More telling though, is the existence of 11th-century moulded corbels on the aisle side of the western responds of the Romanesque choir arcade. Why do they project so far from the half-cylindrical shape if not to support a transverse arch like the corbels on all the other choir piers?[10] The assumption must be that originally, a length of barrel vault filled the distance between the westernmost transverse arch and the arch to the transept arm. This is, of course, precisely the arrangement that now exists in the apsidal chapel off the east side of the south transept, which generally seems to be deliberately echoing the aisle entrance (for instance, in the use of double shafted responds behind the wall plane to support a broad undecorated arch).

It is presumably the top surface of this length of Romanesque barrel vault that I discovered, below 14th-century mortar make-up. As suggested above, the old vault must have been retained in situ for convenience and 'underpinned' next to the entrance arch by a broad ashlar arch and beyond, perhaps, re-faced in coursed rubble by the 14th-century builders. This cannot have been an easy operation given the use of centring but was presumably considered the best option at that time. If this is the case, why were the floor slabs removed and replaced with rubble very similar to that over the rest of the 14th-century east end vaults? The flooring at this end of the tribune might have been removed in the 1260s, as there is a stone tabling to receive the top of a roof immediately below the circular traceried window and just 2 ft 10½ ins (0.88 m) above the lias floor. On the choir wall, the surviving chase for this tabling begins to descend across the Romanesque stones, but is absent from the 14th-century stonework. It must therefore, have had a very short life, c. 1270 to c. 1330. Use of the upper chapel off the north transept must have ceased after the late 12th-century rebuilding of the lower chapel (perhaps subsequent to the 1178 fire?), although access to the choir gallery from the north-east transept staircase could still have been possible, over the top of the chapel vault (Pl. XVIC). However, if the glazing of the gallery openings facing into each transept can be taken as evidence for all the choir tribune openings having been glazed in the mid 13th century, then the choir aisle and ambulatory vaults must have been covered by a continuous double-pitched roof, running parallel to the choir wall. There must also have been some sort of valley gutter against the base of the Romanesque tribune openings and so the tribune floor would have had to have been removed then.[11] Without further evidence of the previous forms of the east end, the presence of Romanesque vault mortar sandwiched between layers of 14th-century mortar remains a puzzle.

The order of building in the Romanesque choir campaign would therefore seem to have been:

a. Erection of the transept and choir walls to the level of the projected crown of the vault, but without ashlar to the areas to be covered by the vault;

b. The erection of the vault;

c. The laying of a lias floor on top of the vault;

d. The construction of the walls at tribune level and above in ashlar, overlapping the edge of the lias floor.[12]

Not enough survives of the Romanesque choir wall to give any indication of the scale of the tribune openings, but they would surely have been the same height as the transept upper chapel arch, which spans roughly the same distance. From the lack of any sign of vaulting on the external east faces of the north and south transepts,[13] despite the clear survival of Romanesque rooflines, it must be presumed that there were no tribune vaults (such as exist at Gloucester) but isolated stone arches could have been employed.[14] The choir tribune would then look very like the almost contemporary choir tribune at Durham Cathedral.

THE CHOIR VAULT

Dr McAleer has already drawn attention to the 'continuous cutting following a semicircular line' on the east face above the eastern crossing arch and concluded it to be evidence of an original vault over the Romanesque choir (Pl. IVB).[15] With the erection of a scaffold in March 1984 for the purpose of decorating the choir vault, it was possible to examine this scar more clearly[16] and confirm that this curve delineates the upper surface of a vault, approximately 2 ft (0.61 m) thick at its apex. Between this line and the extrados of the crossing arch are courses of ashlar with 11th-century tooling but clearly re-used and patching the thickness of the removed vault.[17] The original vault was set into the wall between two arches, the lower, on which the underside of the vault 'rested', being the outer order of the eastern crossing arch. The upper 'relieving' arch, originally obscured from view, was much less finished. It only survives in the haunches of the old vault, partially obscured by the existing 14th-century vault haunches. The crown of this relieving arch has been removed, no doubt to facilitate the erection of the present vault, whose ridge is about a foot (0.31 m) above the apex of the Romanesque vault. What remains of this arch, though, shows it to have been built of large blocks with smaller stones arranged as voussoirs towards the springing point (Pl. IVC). This is best seen on the south side, which is less obscured by the later vault than the north side, a result of the slightly asymmetrical placing of the 14th-century vault against the Romanesque crossing arch. It is worth noting in this context that the north crossing arch at Tewkesbury has the remains of a similar feature, with a few smaller stones at its springing point.

This method of building a main span vault can be paralleled at the only main span Romanesque barrel-vault to survive in England, over the Chapel of St John, at the Tower of London. Although there is no lower arch visible at the junction of the vault with the west wall, a relieving arch of large blocks can be seen above the vault (Pl. IVD).

At Pershore Abbey, the use of large blocks and small voussoirs can be seen on the pointed relieving arches over each arch within the crossing, however, these arches are clearly not built in conjunction with a crossing vault.[18] Dr McAleer has summarised the evidence for Romanesque vaulting over the main spaces at Pershore,[19] but there is no visible evidence for these vaults having had upper relieving arches as at Tewkesbury. The Gothic vaults of the south and east arms obscure the relevant areas, and the west face (now external) is far too disturbed for any very sound conclusions to be drawn. What exists, in my view, argues against the existence of a Romanesque nave vault. The north face is now covered by a roof, but photographs and drawings of the north transept vault stub previous to the building of the roof in 1862, do not show any relieving arch above the vault.

The Pershore vault stub is struck from a diameter equal to the full width of the north transept, 29 ft 6 ins (8.99 m), and springs from a level directly above the wall passage.[20] As the stilted north crossing arch is much narrower than the transept, the semi-circular curve of the vault does not relate to it very well. At Tewkesbury, the choir vault appears to have sat neatly on top of the eastern crossing arch, but

the relieving arch above the vault is clearly not sprung from the same diameter, as the thickness of the vault at the apex is greater than at its springing point. The radius of the relieving arch must be about the same as the crossing arch but drawn from a centre above that of the crossing arch, presumably a distance equal to the thickness of the vault at its apex, about 2 ft (0.61 m). Therefore, the relieving arch meets the extrados of the crossing arch at the diameter of the former, which is approximately the springing point of the vault (Fig. 1). Though I was unable to measure the extrados of the crossing arch, the chancel vault would seem to spring from a level equal to the top of the wall passage in the eastern wall of each transept arm. This method of superimposing arches is very likely that used for the east and west crossing arches themselves, which certainly have a thicker gap between the two orders at the apex than at the springing.[21] This may also be the method employed for creating the lower arches of the giant order elevation of the choir.

As it is only the east crossing arch that bears this scar, even though much Romanesque masonry survives above all the other arches, it must be questioned whether Romanesque vaults were ever built over the other main spaces. Dr McAleer has outlined the fabric change visible in the upper east and west walls of both transepts arms, noting that 'the change in masonry also coincides with the upper termination of a pinkish discoloration of the masonry, apparently owing to a fire in 1178. The discoloration extends up to, but nowhere above, the voussoirs of the wall passage openings'.[22] In fact, there is fire-staining on the end wall of the south transept, higher than the arches of the wall passage. On the south wall, the staining occurs around and above the two windows (which are substantially Romanesque with Gothic heads and tracery) though it is not visible on the top five Romanesque courses. On the walling above the south crossing arch, there is a particularly distinct curving fire line running parallel to the crossing arch across a number of horizontally coursed stones (and interrupted by Victorian repairs). Again, though, there is no reddening of the top four Romanesque courses. The fire-staining on the east wall certainly runs along the middle of horizontal stones on a level with the

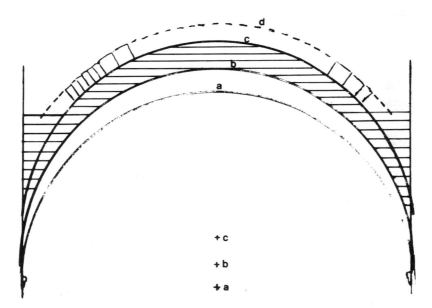

FIG. 1. Proposed geometry of the eastern crossing arch and Romanesque choir vault. A: is the intrados of the crossing arch, B: the extrados, C: the topside of the vault and D: the extrados of the relieving arch over the vault. The shaded area is the extent of the vault, based on the Tower of London Chapel vault.

arches of the wall passage. Therefore, the covering of the transept was arched, following the shape of the crossing arch and it was plastered, which would account for the mid-course staining. But it was not bonded into the end walls like the choir vault, or even constructed like the choir aisle vaults, with the ashlars immediately below the vault acting as a wall-rib or ledge on which to sit the rubble webbing. Can this covering therefore, have been of stone? It is surely more probable that it was a lath and plaster barrel ceiling on a wooden frame.

There is no similar fire-staining evidence in the north transept, and neither transept arm appears to have lost its roof to fire, as there is very little fire-staining above this ceiling line, especially on the crossing-tower faces covered by the steeply-pitched roofs. However, the east wall of the tower above the choir vault (now external) is very reddened, whereas the choir piers show no evidence of burning.[23] This must indicate that in the choir, the stone vault contained the fire in the roof space, while in the transept arms, the plaster ceiling contained the heat below, that is, within the church. So, although there is ample structural support in the transept walls for a stone vault, I consider that the lack of bonding evidence precludes its existence and for the same reason suggest that it is unlikely that the nave was stone vaulted. Plaster ceilings would be visually consistent with the stone choir vault and consistent with the remaining physical evidence. A vault in stone may well have been intended at the outset – even in the nave – given the colossal thickness of the piers, and it was for this reason that there were no Romanesque clearstorey windows.[24]

THE CHOIR ELEVATION

Dr McAleer has demonstrated the discrepancies in Sir Alfred Clapham's short article and has proposed an alternative three-storey choir elevation, without a giant order, but with a corbel to the aisle, set at a lower level on the columnar pier than the capital of the main arcade facing into the choir. Clapham's 'cut-back arch springers' are re-interpreted as 'the voussoirs of a rear order' against which the aisle/ambulatory vault abutted.[25]

Whilst I welcome and accept Dr McAleer's clarification of the aisle side of the choir piers, I see no reason to abandon the giant order. McAleer's proposed reconstruction creates a layered choir elevation with an essentially horizontal accent, whereas the existing transept and nave elevations are surely striving to create as vertical and towering effect as can be achieved with such thick walls and piers. The truly colossal height of the external receding arches of the west front also demonstrate the main interests of this designer. The use of linked storeys on the internal east and gable walls of both transept arms can only be interpreted as creating a visual link between the nave and choir elevations (reflecting the latter), and such linking is a nonsense without a giant order to the choir. Finally, the peculiarly awkward segmental arch proposed in his reconstruction of the main arcade, below a semicircular tribune arch, has no parallel in English Romanesque and is structurally unlikely as an arch form.

Using the transept east wall elevations as a guide both for features and for measurements, a reconstruction of the choir elevation, retaining the giant order, can be attempted (Fig. 2). This cannot be considered to be a definitive measured drawing, as some 'measurements' are really estimates and the levels of the completely absent upper areas are taken from the east walls of the transept.[26] The 42 ft 7 ins (12.98 m) height of the elevation (measured from the present floor level to the projected vault springing level) is also taken from the transept. Assuming the existence of a semi-circular vault, the height of the vault intrados from the floor would be 59 ft 5 ins (90.95 m).

On the evidence of the transept too, the lower arch between the aisle and main space was of just one order, i.e. it was a plain arch, which sprang from a point between 14 ft 3 ins (4.35 m) and 15 ft (4.57 m) above floor level. With only an average width of 12 ft (3.66 m) between the columnar piers on the line of their centres, the radius of this arch (if a semicircle) was 6 ft 4½ ins (1.94 m). Allowing for voussoirs of about 1 ft (0.31 m) in depth (as on the nave and transept now) the apex of the lower arch extrados was between 21 ft 7½ ins (6.59 m) and 22 ft 4½ ins (6.82 m) from the ground. By setting the rear order arch[27] at a lower level on the very back of the columnar pier its apex could visually coincide with much

of the broad lower arch when viewed from the main space. The aisle and ambulatory vault would then have a thickness of up to 2 ft (0.61 m), which is about the thickness of the vault over the east chapel of the south transept arm. If the lower, broad arch formed a semicircle with a diameter of 12 ft 9 ins (3.89 m) and was placed in line with the centres of the cylindrical piers, then its depth would be at the most 2 ft 4 ins (0.71 m) (which is about the same as the lower arches of the transept) and the rear order would have a depth of 1 ft (0.31 m).[28] A 2 ft 4 ins (0.71 m) depth would create a 'corner' at the springing towards the aisle, overhanging the curved surface of the cylinder. This 'corner' might have been supported on a short length of corbel in the same way as the rear order was supported at a lower level by a corbel that still exists (Fig. 3). This has the advantage of giving the lower arch of the giant order a definite finishing point. Alternatively, this arch could simply have died into the cylindrical surface, though there is no evidence of this on the existing Romanesque stonework around and above the cut-

FIG. 2. Proposed elevation of the choir.

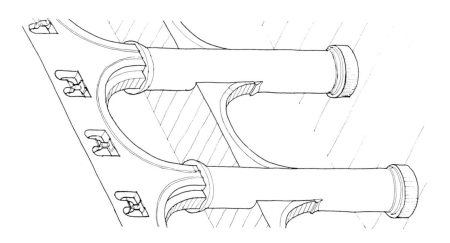

FIG. 3. Perspective views of the choir elevation from the mainspace and the aisle.

back voussoirs. Both treatments can be paralleled elsewhere in the building, for instance on the east and west arches of the crossing. The melting approach would seem, in my view, to be too imprecise for the general character of this church. In the upper floor of the Bishop's Chapel at Hereford (the nearest English building physically and chronologically to use a cylindrical pier that continues above the springing level of a main arcade), the arch died into the column. This arch was symmetrically placed on the column and of a similar depth, c. 2 ft 6 ins (0.76 m), to the putative Tewkesbury lower arch. However, the Hereford piers were barely 4 ft (1.22 m) in diameter as against the 6 ft 3 ins (1.91 m) diameter of the Tewkesbury piers. William Stukeley's drawing shows a simple horizontal 'melting' junction,[29] but there must have been a chamfering of some sort, otherwise the corners of the square order would overlap the pier curvature by 3 or 4 inches (0.08 m or 0.10 m) at either side.

Supporting evidence for the use of a single plain arch without mouldings can also be found in existing Anglo-Norman giant order elevations at Romsey, Jedburgh and Oxford. The lower arch is always the least decorated, so emphasising its subordinate position in the elevation. In the Tewkesbury transept, the tribune level arches have two orders with a corner roll moulding to the outermost (as the nave arches at the same level) but the lower chapel and aisle entrances are of one simple, broad, square-edged arch. Such conscious use of decoration suggests that the upper arch was considered to be the major of the two arches sprung from the same columnar pier. This in turn suggests that the nave elevation is the original elevation design and that because a tribune gallery was required (by the client?) the means were devised to include one in the choir.

SOURCES FOR THE TEWKESBURY GIANT ORDER

I am using the term 'giant order' in the sense long accepted in Classical architecture, that is, a column that rises through more than one storey of an elevation before supporting an arch. The eastern bay of Romsey Abbey nave shows this most clearly (Pl. IVE). An associated feature, in that it links storeys together, is the 'giant wall arcade', using either a proper order with capitals or, more often, simply a series of arched recesses. Somewhere between the two is the elevation of Etampes (Pl. IVF), where a large columnar pier is buried in the wall for its upper length. It is meant to read as a column, rather than as a large half-shaft, because the full column of the same curvature is visible at low level. In any attempt to trace the sources of Tewkesbury's giant order elevation, one needs to assume that the parent architectural tradition will include the use of tall columns of some scale. Such big columns will probably be in the form of columnar piers, made of coursed ashlar (as at Tewkesbury), rather than be monoliths or stacked drums of stone.

Three sources for the Tewkesbury giant order have been proposed in recent literature.

1. Burgundy, via Lotharingia and the Bishop's Chapel at Hereford, whose mason-architect is very likely the same man who designed Tewkesbury.

2. The Roman basilica, Tewkesbury being in particular an interpretation in Anglo-Norman Romanesque of the description by Vitruvius of the basilica he built at Fanum.

3. English post-Conquest architecture, the catalyst for the creation of the giant order being the Hereford Bishop's Chapel.

I wish to discuss each of these in turn, before making the case for:

4. Normandy-Loire. For stylistic and historical reasons, this region provides, in my view, the most likely sources for the giant order at Tewkesbury.

1. *Burgundy*

Professor Bony was the first to point to a link between the Tewkesbury giant order and the columns of the upper chapel of the Bishop's Chapel at Hereford[30] – an argument that is dependent on the Chapel's being in existence by the c. 1090 start of Tewkesbury.[31] Bony even suggests that the same

'Lotharingian mason' was involved, designing Tewkesbury after 'une assimilation plus poussée des méthodes de construction normands', that is, the thick wall technique.[32] He also traces the Chapel's structural details through to Burgundy, in particular the Tournus narthex.[33] Dr Kidson has also invoked the tall columns of Tournus (and St Abbondio, Como) and the putative giant order of St-Germain, Auxerre[34] as parallels for the use of a giant order at Tewkesbury.[35] The link from Burgundy to Hereford is provided for Bony by the patron of the Bishop's Chapel, Robert of Lorraine, though surely it was a building type that this client was after, rather than a style that recalled his homeland.[36]

Tournus is really quite an oddity[37] and with the parish churches that Bony mentions, belongs to the 'First Romanesque' period of Burgundian architecture centred on Cluny II in the early 11th century. Stylistically, these buildings are quite distinct from later 11th-century Burgundian Romanesque, centred on Cluny III, which is contemporary with Tewkesbury and Hereford and similarly uses ashlar, but does not use large columnar piers. Coupled with the lack of historical and other stylistic links beyond the superficial similarity of the columns at Hereford, Tewkesbury and Tournus, Burgundy must, in my view, be ruled out as a direct source for the giant order elevation.[39]

Turning briefly to Lotharingia, the use of big columns and vaults is very difficult to associate with the architecture of the Low Countries or Imperial Germany, despite the spectacular groin vaults of Speyer. Although tall wall-arcades are frequently used to articulate external walls, it is noticeable that this feature is as absent at Tewkesbury and Hereford as big columnar supports are in Germany and Lotharingia.[40]

2. *The Roman Basilica*

The use of columns might indicate a wish to create a specifically Roman basilican church. Their translation into a Norman thick-wall system of construction to facilitate vaulting, would have created columnar piers of a thickness never seen in Roman churches.[41] In this volume Dr Kidson raises the possibility that the designer of Tewkesbury's giant order knew the description by Vitruvius of his basilica at Fanum. If that was so, then surely Vitruvian measures would be followed. This is not the case, though it is true that the Tewkesbury piers are near enough ten radii high, when Vitruvius specifies the Fanum columns as ten diameters high.[42] In any case, the use of Vitruvian timber galleries, on stone transverse arches, cannot seriously be considered as an option in such a massively conceived stone building as Tewkesbury.[43] Given these practical changes due to Romanesque construction techniques, it is still not impossible that the Vitruvian description was known, if not by the designer then by the client, and that the Tewkesbury columnar piers are a conscious 11th-century 'revival' of a Roman basilica. The giant order would then become a necessity, allowing a tribune to be assimilated into an elevation using tall columns. The Hereford Chapel columns with their different springing levels might then have provided a technical solution.

3. *English post-Conquest architecture*

There is no need to go beyond 11th-century Anglo-Norman architecture for ashlar columnar piers of some girth, though unfortunately the probable precedents no longer exist.[44] Dr Gem has established that St Augustine's Abbey Canterbury had 'uniform slender columnar piers', of no more than 3 ft 6 ins (1.07 m) diameter, 'in the apse hemicycle and in the straight bays of the choir'. This was certainly complete by Abbot Scotland's death in 1087. He has further proposed that Worcester Cathedral (begun 1084) followed this arrangement too.[45] Before Tewkesbury, Shrewsbury Abbey (founded 1083),[46] Great Malvern Priory (begun 1085)[47] and St Peter's Abbey, Gloucester (begun 1089)[48] used columnar piers of increasingly large diameter; Gloucester and Shrewsbury being especially relevant as they have large columns at both main arcade and tribune levels.[49] Therefore, the creation of a giant order could have come from a wish to create a more impressive and architecturally more satisfying solution to the awkward aesthetic effects resulting from the superimposition of two big columnar piers

in an essentially vertically stressed elevation. The different springing levels on the Hereford Chapel columns provided the means.[50]

However, if a nave elevation using a very tall columnar pier rising through the equivalent height of both the main arcade and tribune storeys was the initial design, an earlier Anglo-Norman precedent is not apparently available, especially if other features of the Tewkesbury design are taken into consideration.[51] The lack of a clearstorey and the consequent reliance on tall aisle or gable-end windows for natural light; the low mural passage with small openings rather than an arcade; the probable intention to vault throughout; the lack of external articulation and the great width of the nave in relation to the aisles are all unusual features in main stream Anglo-Norman architecture, as represented by the churches of Caen, Winchester or Canterbury. Whilst it is true to say that the abbey of St Peter at Gloucester (begun 1089), barely 10 miles south of Tewkesbury, does share some of these characteristics (and in particular, the polygonal ambulatory plan), it too has non main-stream features.

I suggest that there could have been a further strand of architectural development in Normandy, with its basis around the Loire valley, that might account both for the design of Tewkesbury and the stylistic features of the Hereford Chapel.

4. Normandy-Loire

In his article on Tewkesbury, Sir Alfred Clapham drew attention to the church of the priory of St-Thomas at Epernon, about 15 miles north-east of Chartres. He dated the giant order in the choir to *c.* 1130 on stylistic evidence,[52] but I would favour de Dion's dating in the last quarter of the 11th century.[53] Epernon is about 30 miles north-west of Etampes and the church of Notre-Dame there has large columnar piers in the nave which, when first built in the early 12th century, probably supported lateral arches like Epernon. Like Epernon, the Etampes piers are not strictly a giant order, in that there was apparently no upper storey such as a tribune to be enclosed, though the huge blank wall that would result at Etampes is problematical in northern France *c.* 1125.[54] However, the clear intention at both buildings was to use a columnar pier as the principal element in the elevation. The mid 12th-century apse of St-Père-en-Vallée at Chartres uses small columns with two levels of capitals and the late 12th-century church at nearby Gallardon repeats this arrangement, suggesting some continuity of the concept in this area.[55]

The nave of St Thomas, Epernon shows the interest in the use of columns in the middle decades of the 11th century in northern Blois. The nave has columnar arcades of modest dimensions and the crossing vault is supported on columnar piers in the internal angles of the crossing piers. The latter feature can also be seen at St Martin, Angers of *c.* 1075.[56] There are further buildings in the Touraine and Perche where the crossing pier is formed by a column with added shafts, for example: La Trinité, Vendôme[57] and Marmoutier[58] (both churches with Papal consecrations in 1096, though probably built a good deal earlier); Ste-Croix, Loudun (founded 1062)[59]; and Nogent-le-Rotrou, abbey of St-Denis, consecrated in 1078.[60]

The chevet of Loudun (Pl. VA) is of great interest in that it uses columnar supports in a vaulted polygonal apse, and relies on indirect lighting from the aisle windows as at Tewkesbury. There are also two, more unusual parallels. The arches between the choir aisles and transept arms are supported on twin shafts, and, when the two arches of the arcade meet the crossing pier, only the inner order is received on a capital, the outer either melting into the pier or sitting on a small corbel-impost block. Loudun, equidistant from Tours and Poitiers, has some Poitevin features, such as the polygonal apse and ambulatory. St-Savin-sur-Gartempe, east of Poitiers, uses very tall columns for the eastern bays of the nave (*c.* 1090 – 1100) directly supporting a continuous barrel vault, a distinct rarity in France.[61]

The abbey church of St Denis at Nogent-le-Rotrou is of particular relevance, partly because of its border placing (in the comté of Perche, between the Loire and Normandy) and early date, but also because of its great scale and use of big columnar piers. Particularly striking as a comparison for

Tewkesbury is its placing of twin openings right on top of the double arches of the main arcade, a difficult feature to parallel in Anglo-Norman architecture of this date (Pl. VB). Regrettably, whatever upper storey or vault may have existed has long gone, but the Loire region has many examples of large-scale late 11th-century stone vaults.[62]

Spreading the net a little wider, the churches of Le Mans use columns (perhaps the Cathedral consecrated in 1120 had a columnar nave?),[63] and Dr Cameron[64] has convincingly linked the pre-1090 capital sculpture of Le Mans Cathedral to Ste-Genevieve in Paris.[65] Four western bays, added to this basilica *c*. 1100, use tall columnar piers, and three capitals from these piers have the same average diameter, 3 ft 9 ins (1.14 m), as the nave piers at Etampes.[66] Dr Cameron suggests a source in Normandy for some of the capital sculpture and M. Lelong has also linked some of his excavated details at Marmoutier to Normandy and England.[67] It was Marmoutier that supplied monks and builders for the Conqueror's new abbey at Battle (*c*. 1070), and the plan of John de Villula's new priory church at Bath (built after his accession as Bishop of Wells 1088) also suggests that he turned to his native Tours for inspiration.[68] Dr Gem in tracing the sources of the columnar choir of St Augustine's Abbey, Canterbury, also draws attention to St-Benôit-sur-Loire and Marmoutier, but concludes: 'these designs in the Loire region may be thought of as parallel to, rather than a source for, St Augustine's'.[69] As Mont-St-Michel (begun 1023), Rouen Cathedral (*c*. 1030) and Jumièges (1040) have ambulatory plans and the Rouen chevet and crypt show distinct parallels to Loire valley buildings, more features now associated with the Loire basin could be expected in Normandy – and especially on its southern borders – in the generation before Tewkesbury. Whether there were examples of large columnar piers in Normandy can only be a matter for speculation.[70] But considering such piers are being used in the second half of the 11th century over an area stretching from Paris to Le Mans, it would not be surprising to find columnar piers used on the borders of Normandy-Maine-Blois. It is precisely here that there seems to be a liking for piers with varied springing levels and here

Fig. 4. The area between the Seine and Loire rivers.

too, that historical links, beyond the mere observation that Maine had been under Norman control from 1063, can be made with Tewkesbury.[71]

A 13th-century chronicle of Tewkesbury attributes Robert Fitzhamon's patronage of Tewkesbury to the persuasions of Sybil, his wife and to Gerald of Avranches, the first abbot.[72] Sybil was the daughter of Roger of Montgomery, Earl of Shrewsbury and cousin of the Conqueror. Montgomery was a substantial monastic patron in England and Normandy,[73] particularly founding and building Shrewsbury Abbey, for which purpose he imported two masons, Reginald and Frodo, from Séez in southern Normandy.[74] Whether Sybil turned to her father for help with Tewkesbury is not recorded, and how the Bishop's Chapel at Hereford might fit into the sequence of events can only now be guessed. However, it is not difficult to parallel features found in the Chapel with buildings in the Loire[75] and the overall concept of Tewkesbury as a totally vaulted church with an elevation of large columnar piers seems to have more in common with the churches of the Loire basin than with Norman churches of the Seine basin. In view of the family links, it could well be that architectural ideas from the Loire filtered through southern Normandy on their way to Tewkesbury. The priory church of St-Denis at Nogent-le-Rotrou in Perche can supply parallels for some of the features at Tewkesbury that are not found in Seine/Normandy architecture and it is, I believe, the sort of building that the architect of Tewkesbury knew.[76]

THE GIANT ORDER IN ENGLAND

In his summing-up, Dr McAleer states:

'The origin, or at least the first appearance in England of the circular pier with two levels of arches most probably should be reassigned to the abbey church at Romsey....I feel that the apparent lack of influence or followers for some forty to fifty years and the changing nature of the design at Romsey cast the most significant doubts on Clapham's restoration of a "colossal order of two stories" in the choir of Tewkesbury'.[77]

A case has been made above for the reinstatement of the Tewkesbury giant order elevation in the choir, dating c. 1090–1102. Its only precursor in England was likely to have been the Bishop's Chapel at Hereford with its use of columnar piers with more than one springing level. McAleer's argument is further weakened when one considers that there are also a number of other candidates for giant order elevations earlier than c. 1140, the date given for the eastern bays of Romsey nave.[78] The nave of Abingdon Abbey (1100–17)[79] had large columnar piers according to William of Worcester. Excavations at Winchcombe Abbey,[80] St Mary's Priory, Coventry[81] and bomb damage at Exeter Cathedral[82] have revealed Romanesque capitals that belonged to columnar piers of some scale. We are never likely to know with certainty whether any or all of these columns belonged to giant order elevations. The Exeter capital, for instance, probably belonged to a simple, if tall, columnar pier like those of Shaftesbury Abbey nave of c. 1100.[83] But the pier forms of two further abbeys have a stronger claim. The nave of Evesham Abbey was built by Abbot Reginald of Gloucester (1130–49) and had columnar piers with a diameter of 5 ft 6 ins (1.67 m), with a small attached shaft towards the aisle.[84] A similar pier base, but with a diameter of 6 ft 6 ins (1.98 m) was used in the choir of Reading Abbey, founded by Henry I in 1121.[85] As at Tewkesbury, the Reading choir had a continuous colonnade, though there were three straight bays before the four-column hemicycle. At both Evesham and Reading, the attached shaft is less than a semi-circle, suggesting it was not conceived as a full structural member. The only English parallels for a columnar pier with a single attached shaft to the aisle are to be found in the transepts of the 'first generation' cathedrals at Ely and Winchester. There, the shaft receives a transverse arch, and the aisles are groin-vaulted. It is highly probable that both Reading and Evesham naves had rib-vaulted aisles. By c. 1125–30, it had become usual to have separate shafts on a pier for each arch of a rib-vault, or to create a sufficiently large capital to receive all the arches at the same level. The use of a sunken attached shaft at Reading and Evesham would therefore suggest that corbels were

being used to receive the diagonal ribs and this is precisely the arrangement of all the surviving examples of giant order elevations in England.

The Reading crossing piers are very elongated east-to-west like those at Tewkesbury but on plan have (like the crossing piers at Southwell Minster) half-drum terminations at both east and west ends. Reading and Tewkesbury have many measurements in their plans that are very close indeed, thus the circumstantial evidence for a giant order at Reading seems to be rather strong,[86] and from the comparison of the pier forms, Evesham seems to be a good candidate too.

The choir of Reading Abbey was presumably complete when its founder Henry I was buried before the altar in 1135.[87] If it had a giant order for its choir elevation, Romsey, also with royal connections, becomes easier to account for.[88] The royal link might also be invoked for the use of a giant order in the choir (c. 1140) at Jedburgh, a re-foundation by the anglophile King David of Scotland, c. 1138.[89] Reading was only finally consecrated in 1164, by which time the church of the Augustinian priory of St Frideswide had probably been started. This was only a small foundation and might well be expected to follow the forms established at the nearest great abbey churches at Reading and Abingdon.[90]

The existing examples of giant order elevations have such a geographical and chronological range, that it seems certain that other examples existed. Additional support for this view comes from the churches that attempt to use a columnar pier within a compound pier to link two storeys.[91] The early 12th-century nave at Lenton Priory, Nottingham, appears to have had very individual piers to the eastern bays, using a three-quarters drum of 4 ft 2 ins (1.27 m) diameter towards the main space.[92] I suggest that rather than being a short pier, like those at Southwell for example, this three-quarter drum rose up to the (presumed) middle storey to support an arch, not unlike Etampes or Epernon, which are roughly contemporary. Something similar also appears to have existed at Holy Trinity Priory, Aldgate in London, according to John Carter's engraving of c. 1798 (though there is some doubt as to which part of the church he was drawing).[93]

The Augustinian priory of St Peter, Dunstable (c. 1150) goes further.[94] Again, there is a large half-drum dividing the bays and rising to the tribune capital level. However, a half-shaft and shallow backing pilaster have been placed against the face of the drum, rising through and beyond its capital (Pl. Vc), although there is little likelihood of these shafts being added for stone vaults. Glastonbury Abbey (and following it, Waterford Cathedral in Ireland) can be seen as an Early Gothic version of these Romanesque elevations.[95]

In summary, then, there are a number of churches that certainly had large columnar piers in the early 12th-century which might have had giant order elevations and follow on from Tewkesbury, of which the strongest candidate is Reading Abbey. The use of such an elevation at so prestigious and apparently influential a building would obviously go some way to explain the otherwise rather disparate surviving examples. If the churches that incorporate a columnar linking element are also included (Lenton, Aldgate and Dunstable) then a continuous interest in large columnar piers rising through two storeys can be demonstrated in England in the 12th-century.

The demise of the giant order can be partly attributed to the necessity of articulating rib-vaults directly to their supporting members[96] though it is noticeable that the concept regains popularity in northern Europe (especially in northern France) in the late Gothic period, when mouldings are once again allowed to die away into piers without capital, impost or shaft to receive them.

CONCLUSION

The choir of the abbey church of St Mary Tewkesbury, begun c. 1090, was vaulted and had a three-storey elevation comprising vaulted aisles, timber-roofed tribune and unglazed wall-passage, with its aisle and tribune storeys linked towards the main space by a giant order of huge columnar piers. The sources for this type of elevation are not clear and perhaps will never be known for certain.

It is my belief that the basic elevation for the whole church used such piers in an attempt to imitate a

Roman basilica. A tribune had to be accommodated in the east end and a giant order system was devised to retain the tall columnar element. This could have resulted from an interpretation of Vitruvius' description of his basilica at Fanum or from adopting the concept of varied arch springing levels on one columnar pier, as exhibited on the upper floor of the Bishop's Chapel at Hereford (which was, in my view, an earlier commission for the Tewkesbury architect). It is very unlikely that any reference was made to Burgundy. I suggest that the architect of Tewkesbury had knowledge of the churches in the Maine-Normandy border area, where columnar piers are used, sometimes buried within a compound pier (e.g. Nogent-le-Rotrou) and sometimes part of a giant wall order (e.g. Epernon). More general stylistic parallels and historical links, through Sybil, wife of Robert Fitzhamon, lend support to this thesis. It is statistically very probable that more examples existed in the 12th century than now survive. Reading and Evesham appear to have the strongest claim. Given the importance of Reading as a royal house, the sheer geographical range of the surviving examples of both giant order elevations and related elevations using a columnar elements to link storeys can be explained.

ACKNOWLEDGEMENTS

I am most grateful to the Abbey architect, Neil Birdsall for affording me every opportunity to record repair work and especially to the Abbey staff and Mr Potter in particular, for all the help they have given. I am especially indebted to Pat Brown for figure III.

REFERENCES

SHORTENED TITLES USED
(See also LIST OF ABBREVIATIONS AND SHORTENED TITLES, iv above.)

DE DION (1871) – A. de Dion 'Chapiteaux de St Thomas d'Epernon' *Bull. mon.* XXXVII (1871), 627 – 35.
DRINKWATER (1954) – N. Drinkwater 'Hereford Cathedral, The Bishop's Chapel of St Katherine and St Mary Magdalene'. *Archeol. J.* CXI (1954), 129 – 137.
GEM (1982) – R. D. H. Gem 'The significance of the eleventh century rebuilding of Christ Church and St Augustine's Canterbury, in the development of Romanesque architecture' *BAA CT*, V (1982), 1 – 19.
HÉLIOT (1957) – P. Héliot 'L'ordre colossal et les arcades murales dans les églises romanes' *Bull. mon.* CXV (1957), 241 – 61.
KNOWLES (1972) – D. Knowles, C. N. L. Brooke, V. C. M. London *The Heads of Religious Houses, England and Wales 940 – 1216* (Cambridge 1972).
KIDSON (1979) – P. Kidson (with P. Murray and P. Thompson), *A History of English Architecture*, (London 1979), 2nd edn.
LELONG (1976) – C. Lelong 'Recherches sur l'abbatiale de Marmoutier à l'époque romane' *Comptes Rendus Acad. des Inscriptions et Belle Lettres*, (Nov-Dec 1976), 704 – 34.
ORDERIC VITALIS – *The Ecclesiastical History of Orderic Vitalis*, ed. and trans. M. Chibnall, (Nelson/Mediaeval Texts), cited by volume number.

1. The form of the replaced roofs (apparently from the G. G. Scott restoration) can be seen in McAleer (1982), 552, illus 7. It is hoped that further investigations can be undertaken as and when the rest of the ambulatory roofs are repaired.
2. A great deal of 'plastic stone' (stone-dust mortar) has been used on the stonework of the Romanesque arches around the *c.* 1270 windows, probably in the 1824 – 30 restoration. The obscuring of original joints and surfaces can make accurate identification of 'original' and 'later' stonework difficult.
3. This is the area referred to as within the 'crawl-space' in McAleer (1982), 557, note 32.
4. The 13th-century work is discussed by Dr R. K. Morris in this volume.
 The 1178 fire is recorded in the Annals of Tewkesbury, *Annales Monastici*, I, ed. H. R. Luard, (Rolls Series 1864), 52, 'Monasterium Theokesberiae incendio cum officinis conflagratur'.
5. The apparent chamfer or stop to the top corner of the lowest jamb stone is the result of accidental damage, perhaps occurring when the tracery window was inserted.

6. There are also two broken lias stones visible at approximately the right level, on the portion of the Romanesque tribune pier illustrated (upside down) in McAleer (1982), 558, Fig. 17 and discussed, 557.

7. It is unlikely to indicate any fire damage, as the stone is not reddened at this level – unlike stone higher up the choir wall.

8. *c.* 1330–1 rather than *c.* 1323; see R. K. Morris, 'Tewkesbury Abbey; The Despencer Mausoleum'. *Trans. BGAS.*, XCIII (1974), 146–9.

9. E.g. *The Builder* (1st December, 1894) and the VCH, *Gloucestershire*, VIII (1968), 157.

10. McAleer (1983), 546.

11. See Morris, below 96–7.

12. This is just as Gervase describes the re-building of the Canterbury Cathedral choir in 1175–6: *The Historical Works of Gervase of Canterbury*, I, ed. W. Stubbs, (Rolls Series 1879), 18–19.

13. Diagonal breaks exist in the coursing of the east face of each transept arm externally (close to the junction with the choir wall) and in the north transept, internally, between the first and second openings of the wall passage. This suggests that the transepts were a secondary build to the choir, crossing and two eastern nave bays, though not necessarily after any great interval of time. The north transept might well have been finished after the south transept, being away from the cloister.

14. McAleer (1982), 558 suggests that there is sufficient, if 'slender' evidence, from the 'fairly deep cuttings' around each glazed tribune opening to the transept, for a 'half-barrel vault over the gallery'. Taking the existing south transept upper chapel roof as the original roofline, then a deep horizontal chase (sometimes filled with thin stones) can be traced on both transept east walls externally, indicating that the original roofline was like that now existing on both transept arms of Romsey Abbey. As the Tewkesbury tribune was floored (unlike Romsey) and with such good access staircases (like Gloucester), a low external tribune wall with small windows can be expected. The tribune arch openings to the transept have very extensive fire damage (presumably of 1178?), much more than any of the arches to the vaulted transept chapels and choir aisle arches. This surely indicates that there was more to burn behind these arches, i.e. wooden roofs and not stone vaults. The jambs of the tribune openings have much less damage than the arches, again suggesting a wooden roof burning in situ for some time before falling onto the tribune floor (which action might, of course, have ruined the floor). The fire-staining on the vaulted upper chapel openings is not as bad as the damage to the tribune openings and could be the result of burning wooden screens set into the arches.

15. McAleer (1982), 557. My attention was first drawn to this feature by Dr Malcolm Thurlby.

16. The scaffold was not, unfortunately, erected close enough to the arch and wall face to allow measurements to be taken.

17. These infill courses are laid horizontally where replacing the crown of the Romanesque vault, but tip-up away from the crossing arch towards the remaining large stones of the upper relieving arch (which are still presumably carrying out their original function of distributing the tower weight towards the massive crossing piers). All the pointing in this area is now Victorian, but one or two of the exposed original joints in this relieving arch appeared to be of a pink mortar.

18. *The Builder* (February 19, 1897) and the *Building News* (February 5, 1892) have sections of the tower showing these arches, of which that over the north crossing arch is most applicable.

19. McAleer (1982), 559, acknowledging Christopher Wilson as having previously established vaults at Pershore.

20. The southern jamb of the first opening to the wall passage on the east side of the north transept still exists and the springing point of the vault stub is just one course above the abacus of the north-east crossing pier.

21. The north and south crossing arches have 'perfect' semicircles to each of their two orders.

22. McAleer (1982), 555–6. There is also a faintly curving line against the south face of the north-east transept staircase, that could also be taken as evidence for a Romanesque vault, because there is ashlar below the curve and rubble above like the similar area on the circular staircase in the south transept of Pershore. However, it is just as possible that this shape results from disturbance during the erection of the existing Gothic vault.

23. From the thickness of the stone tablings against the tower wall, the Romanesque roofs could have been covered with stone tiles (as the presently clay-tiled roofs were before Scott's restoration). The peculiar fire-stained shapes at low level on the eastern crossing piers are perhaps the result of the burning of wooden framing to the backs of the choir stalls. In view of the damage done to the tribune openings facing the transept, perhaps the tribune openings to the choir were just as heavily burnt?

24. McAleer (1982), 556–5.

25. McAleer (1983), 539–55.

26. For instance, 37 ft 3 ins (11.35 m) is the height of the wall passage sill in the south transept. 13 ft (3.96 m), the height of the existing aisle-side corbel, is an average for these corbels, though measured off the aisle/ambulatory floor which is lower than the sanctuary floor level (as I suggest it always has been). 20 ft 8 ins (6.30 m) is the height of the intrados of the stilted arch from the north transept into the north choir aisle.

27. I.e. the arch whose cut-back springing stones can still be seen on the piers below the 14th-century arches.

28. It is noticeable that the arches to the transept ground floor chapels and to the choir aisles from each arm of the transept vary in their east-to-west depth, within the range of 2 ft 2 ins/2 ft 8 ins (0.66 m/0.81 m). The chapel arch widths vary appreciably too, the north at 15 ft 4 ins (4.67 m) being 14 ins (0.36 m) narrower than the south.

29. Oxford, Bodl. Lib. Ms. Top. Gen. d. 13, reproduced in Drinkwater (1954), Pl. XII.

30. Bony (1959), 43. According to William of Malmesbury, the chapel was built by Robert of Lorraine, Bishop of Hereford 1079 – 95 (*Gesta Pontificum*, (Rolls series 1870), 300). It is known from the same author's *Vita Wulfstani* (Camden 3rd Ser., XL (1928), 61) that Robert was, with Abbot Serlo of Gloucester and Gerald of Tewkesbury, at Bishop Wulfstan's deathbed in 1095; whether they were anymore acquainted can only be surmised.

31. The erection of the abbey owed much to Robert Fitzhamon's patronage, according to William of Malmesbury (*Gesta Regum*, II (Rolls series 1889, 475) and *Gesta Pontificum, op. cit.*, 295) and Orderic Vitalis III, 228. Much of the property Robert donated resulted from his campaigns in South Wales *c.* 1088 – 1100 (*Dict.Nat.Biog.*, XIX (1889), 159 and Henry I's *c.* 1107 confirmation of lands, *Regesta Regum Anglo Normanorum* 1100 – 35, II (1956), no. 847). It seems unlikely that much money was really forthcoming until the early 1090s when Robert had consolidated his conquests and rents were collectable. Although the VCH, *Gloucs.*, VIII (1968), 158 states that 'the church was originally built between 1102 when the monks moved from Cranborne to make Tewkesbury their home and 1121 when it was consecrated', it is surely more likely that the monks arrived when there was enough built for the monastery to function properly. The eastern parts of the church might well have been built *c.* 1090 – 1102, followed by the nave and tower with the cloister. By 1105, various monastic offices were endowed, suggesting that the monastery was fully functional (VCH, *Gloucs.*, II (1907), 62). Nothing is known of the pre-Romanesque priory site or its possible effects on the re-building.

32. Features in common include deeply recessed main entrances flanked by staircases, columnar piers, internal wall arches framing the aisle windows, an apparent familiarity with vaulting techniques, and the lack of external articulation. These are individual enough together, in my view, for the Chapel and Tewkesbury to be considered the work of one man or workshop, though their relative chronology is uncertain.

33. For Tournus see J. Vallery-Radot, V. Lasalle and G. de Miré, *St-Philibert de Tournus* (Paris 1956). Other small Burgundian parish churches cited include Chapaize and St-Vincent-des-Prés, for which see Jean Virey, *Les Eglises Romanes de l'Ancien diocèse de Mâcon* (Mâcon 1935).

34. The plan and elevation of the western bays of St-Germain are conveniently published in *CA*, CXVI (1958), 26 – 39. One of Dom Plancher's 1652 drawings indicates a pier containing a sunken drum with corbelled capital and attached shafts (ibid., 34). However, it is difficult to interpret this drawing, especially in comparison with the sketchy nave section that indicates a columnar pier like those that still exist (ibid., 33), and looks like a Vitruvian-type of giant order (i.e. with a timber floor).

35. Kidson (1979), 55 – 6. See also above 12.

36. G. Bandman, 'Die Bischofskapelle in Hereford', in *Festschrift für Herbert von Einum* (Berlin 1965), 9 – 26 presents a convincing argument for an Aachen/Lotharingian source for the design of the Hereford Chapel.

37. Bony (1958), 38 – 9 has noted the singular position of Tournus.

38. Cluny II might have had columnar supports too. K. J. Conant's reconstruction in *Cluny; les églises et la maison du chef d'ordre*, (Mediaeval Academy of America, 1968), Fig. 42 – 5 seems to suggest this. However, Chapaize, Chatillon-sur-Seine and Tournus have all been used to re-create the Cluny II elevation and it is just as likely that a compound pier form, such as that at St Benigne, Dijon, was used.

39. For the same reason, the use of giant orders in Rouergue churches, which are more nearly contemporary with Tewkesbury, and of ashlar, can be dismissed as a source. See J. Vallery-Radot, 'Les églises romanes du Rouergue', *Bull.mon.* XCIX (1940), 5 – 68, where the historical link with Tournus is used to account for the appearance of big columns with varying capital levels.

40. Pre-1050 German churches, especially the Ottonian cathedrals like Strassburg (consecrated 1028) not surprisingly use Roman basilica-style columns. When a larger support is required, then a (frequently square) pier is created, rather than a bigger columnar pier. I have found no evidence for the existence of a giant order in Germany, or a support similar to that used in the Hereford Chapel, though tall wall-arcades are certainly common. More frequently, columns can be seen not in a colonnade, but as the minor pier form in an alternating system. This is probably the commonest use of columns in mid 11th-century Anglo-Norman architecture too, e.g. Jumièges and, perhaps, Westminster (R. D. H. Gem. 'The Romanesque rebuilding of Westminster Abbey', *Proc. Battle Conference*, III (1980), 33 – 60). Winchester Cathedral (begun 1079) choir and apse had columnar minors too, but of a much bigger diameter, 5 ft 4 ins (1.63 m) from the surviving base. There is no sign of any alternating system at Tewkesbury, Gloucester or Great Malvern, though Shrewsbury Abbey nave is organised as two groups of three bays.

41. It is highly improbable that any Roman columns stood to sufficient height in the late 11th century in Britain, to give a direct prototype – though the nearly 3 ft (0.9 m) diameter columns now in Gloucester City Museum are thought to have been still standing to some height *c.* 1100. Samuel Lysons draws an intriguing fragment discovered in Bath in 1790 (*Reliquae Britannico Romanae* (1803), vol. I, pt. II, pl. VIII). It is a drum from a column of about 1 ft 10½ ins (0.57 m) diameter with an attached corbel. It is now lost.

42. The Tewkesbury piers are 30 ft 10 ins (9.40 m) high including capital and base to the present floor level, which is a little under 10 radii of 3 ft 1½ ins (0.95 m). The positioning of the Tewkesbury tribune gallery floor bears no relation to the Vitruvian pilaster that supported the timber gallery beams at Fanum and there is no concordance in the plans.

43. The discovery of the choir aisle vault and stone tribune floor as primary features must now rule out the projected timber floor. The rib vault of the south transept chapel has also been considered crucial to the argument for timber gallery floors, being evidence of a late 12th-century vaulting campaign. This vault shows little sign of insertion and is

exceptionally crude for its proposed *c.* 1200 date (especially in comparison with the vaults of the rebuilt north transept chapels). It could equally, in my view, be of *c.* 1100 date, but re-cut with chamfered edges to the thick ribs, perhaps when the south-east window was inserted in the early 13th century.

Dom Plancher's sketch of the nave of St-Germain, Auxerre would seem to be the only Romanesque equivalent of Vitruvius' elevation at Fanum (see note 34 above), but this is by no means an accurate drawing and what it actually depicts is uncertain. It cannot be denied that the 11th-century nave had large ashlar columnar piers, as some still survive. I could see no evidence for a timber floor in the remaining fabric, though this may only mean that what survives was below the floor level.

44. Despite the occasional illustration of a column with various springing points in pre-Conquest manuscripts, e.g. Fig. 77 of Caedmon's Poems (Oxford Bodl.Lib.Ms. Junius XI), I think it highly unlikely that any pre-Conquest building used columns of any great scale or a giant order elevation, with the possible exception of Abbot Wulfric's Rotunda at Canterbury, 1049 – 61, (which might have had columns at first floor level, Gem (1982), 16) and the more distant possibility that a wooden stave church like Hopperstad (Norway) existed in England. It would be interesting to know what prompted Héliot (1957), 252 to consider a Saxon source for large columns.

45. Gem (1978), 26 – 8 and 33.

46. D. H. S. Cranage, *The Churches of Shropshire* (1912), 865 – 892.

47. VCH *Worcs.*, IV (1924), 123 – 130.

48. *Hist. et. Cart.*, 8 – 19.

49. Although the choir of Shrewsbury Abbey doesn't survive (and was probably rebuilt in the Gothic period, see Cranage above), it would seem unlikely (from the surviving nave elevation) that the choir had tall columns. As the founder, Roger of Montgomery was buried 'between the two altars' in 1093, (Orderic Vitalis, II, 149) the church was clearly far advanced by then. Another church that apparently used columnar piers of same scale was that of the alien priory at Monmouth, dedicated 1101/2 and begun before 1082 (K. E. Kissack, *Mediaeval Monmouth* (Monmouth 1974), 11 – 16). It was built by the Breton lord for monks from St-Florent, Saumur.

50. In a paper 'The Bishop's Chapel at Hereford, the rôle of patron and craftsman', Dr Gem has argued that the chapel is the result of an Anglo-Norman mason building from his client's description of Aachen chapel and that the use of columns follows through from Worcester and other Anglo-Norman churches. The different levels of the arches arises from the complexity of the construction and uses vaults in a manner known in Anglo-Norman architecture. This 'ad hoc' solution demonstrates the capabilities of the architect, rather than his knowledge of any specific Burgundian or German building. Dr Gem further accepts Bony's idea, that the same man designed Tewkesbury and Hereford, as 'entirely plausible' and suggests that Tewkesbury need look no further than Hereford for its use of split springing levels on one columnar pier. I am grateful to Dr Gem for allowing me to see his paper in advance of its publication by the Society of Antiquaries; it was delivered to a conference at the Victoria and Albert Museum in 1984.

51. A small arch within a taller arch of the same width is proposed for Worcester Cathedral transept clearstorey (Gem (1978), 30 Fig. 4), and this might have provided a visual prototype for a giant order elevation.

52. Clapham (1952), 12; pls. VIII and IXa.

53. The priory of La Trinité de Seincourt was given to the Benedictines of Marmoutier by Amaury, seigneur of Montfort and Epernon and confirmed by Henry I in 1052. The monks re-dedicated it to St Thomas, and Abbot Albert of Marmoutier (1032 – 64) added the choir and ambulatory, (de Dion (1871), 632 – 4). The apparently frequent use of chip-carving (especially on volute capitals), a cubic capital, the lack of arch mouldings, the alternation of the choir piers and the elongated apse-ambulatory plan all suggest, in the context of Norman and Ile-de-France architecture, a late 11th-century date. Héliot (1957), 250 suggests the first quarter of the 12th century. The church was demolished by 1867.

54. Lefèvre-Pontalis 'Les campagnes de construction de N. D. d'Etampes', *Bull. mon.*, LXXIII (1909), 5 suggests an 1125 – 50 date bracket for these nave piers, Héliot (1957) '1130 environ'. I believe these bays to be of *c.* 1120 – 35, with the early Gothic choir following almost immediately. There is little indication now if any Romanesque middle storey existed. External rooflines rule out a proper tribune, but could allow a pseudo-tribune or even a pierced wall. A more accurate dating might be possible if the date of the tall columns of Ste-Geneviève, Paris were known (see note 65).

55. Gallardon is 10 miles north-east of Chartres. For St Père, see P. Héliot, *Bull. Arch. des Comité des travaux hist. et scientific*, N.S. VI (1970 – 71), 117ff. An English source is suggested, 134 – 5.

56. G. Forsyth, *The church of St Martin at Angers*, (Princeton 1953), p. 122 – 27. Something similar appears to have existed in the north transept of Perrecy-les-Forges (Saône-et-Loire), *c.* 1060.

57. Abbé Plat, 'La Trinité, Vendôme', *Bull. archéologique*, (vol. for 1922), 31 – 66. A further example can be found at St-Martin de Tours *c.* 1096, according to Lelong (1976), 718 and the central piers of the ground floor of the west porch at St-Benôit-sur-Loire, *c.* 1060 have the same form.

58. Lelong (1976).

59. R. Crozet, 'Eglises romanes à déambulatoire entre Loire et Gironde', *Bull. mon.*, XCV (136), 62 – 73.

60. J. Pochou, 'L'abbaye de St-Denis de Nogent-le-Rotrou', *Cahiers Percherons* 1er Trim., (1959), 3 – 22.

61. It is probable that the outer arcade of the double aisled nave of Charroux was formed of very tall columns too. The inner arcade might even have exhibited some form of giant order; *CA*, LXXIX (1912, pt. II), 114 – 6. The church of Ste-Croix Poitiers also had columns to its nave in the 11th century, though whether they were on the scale of St-Savin or Civaux (to

the south-west of Poitiers) cannot be known; Fr. Eygun, 'Les fouilles de l'église de Ste-Croix, Poitiers', *Congrés Nat.Soc. de Savantes*, LXXXVII (1962), 217–27.

62. For instance, le Ronceray or St-Serge, Angers, where the technique of bonding the main space vault into the wall under an arch is similar to the methods used at Tewkesbury and the Tower of London, *Mons.Hist. de France*, XV no. 3 (1969), 41–60.

63. F. Salet, 'La Cathédrale du Mans', *CA*, CXIX (1961), 18–38.

64. J. Cameron. 'Les chapiteaux du XI siècle de la Cathédrale du Mans', *Bull.mon.*, CXXIV (1966), 356–7.

65. M. Vieillard-Trojekouroff, 'Les zodiaques Parisiens sculptés d'après Le Gentil de la Galaiserie', *Mém. de la Soc. des Antiqs. de France*, 9ᵉ Serie, IV (1968), 175–80 reproduces 18th-century engravings of the capitals and columns of the western bays of Ste-Geneviève. Some capitals are now in the Musée de Cluny, Paris.

66. There was no giant order at Ste-Geneviève as far as can be seen in the published drawings etc. However, the neighbouring church of St-Pierre de Montmartre *c.* 1147, has thin shafts supporting more than one level of capital. A further columnar pier can be seen at St-Martin des Champs, Paris, decorated with chevron and 'buried' in the eastern crossing piers of *c.* 1130.

67. Lelong (1976), 733.

68. For Battle see VCH *Sussex*, II (1907), 52. For Bath, VCH *Somerset*, II (1911), 70–71. Recent unpublished excavations in Bath have demonstrated that there was a short choir with ambulatory and chapels like the plans of Loire churches (and Battle, of course) rather than the elongated choir adopted by English post-Conquest churches with ambulatory plans, such as St Augustine's Abbey.

69. Gem (1982), 16. About contemporary with St Augustine's is the exceptional St John's Chapel in the Tower of London, which also has a continuous colonnade but this, 'represents, as it were, the east arm of a great church without transepts or nave' (Gem (1982), 16).

70. Mont-St-Michel and Rouen are mentioned by Gem (1982), 16 as possibly using columns and he also notes that the hemicycle of Jumièges has small columns. Minor columns are also found in the naves of Jumièges and Westminster (see note 40). Major Norman churches of which little is securely known include Coutances Cathedral (begun 1048), Bayeux Cathedral (consecrated 1077), Evreux Cathedral (consecrated 1076) and Séez Cathedral (begun 1060). The latter two are of added interest in being in southern Normandy.

71. David C. Douglas, *William the Conqueror* (London 1969), 223–9.

72. Brit.Lib.Ms. Cotton Cleo. C III, f. 220, quoted by Dugdale in *Monasticon Anglicanum*, III (1819) 59–60 and VCH *Dorset*, II 70–71; 'ad exhortationem bonae uxoris suae Sibiliae et abbatis de Cranborne, Giraldi'. For Gerald, see Knowles (1972), 73. Avranches Cathedral which collapsed in 1790, had a Romanesque ambulatory and chapels, Dr Coutan, 'L'ancienne cathédrale d'Avranches', *Académie des Sciences, Belles Lettres et Arts de Rouen* (1902).

73. Roger's patronage is listed by Orderic Vitalis, II, 143–8.

74. Sybil's uncle, Yves de Bellême was bishop of Séez, rebuilding his cathedral after 1060 because he had burnt it down in 1049. The link between Shrewsbury and Séez was strengthened by the first two abbots at Shrewsbury coming from Séez, Knowles (1972), 71.

75. Although detached shafts can be seen in the crypt of Rouen Cathedral, they are also present in many 11th-century Maine/Loire churches, especially in crypts. At Hereford, it is the upper Chapel that has them, the lower Chapel having no shafts, attached or detached. Such continuous orders and the various vault combinations can also be seen in Loire churches, like the crypt of La Couture, Le Mans. The use of columnar piers with varying arch springing heights at the 'crossing' of the upper Chapel also recalls the buried columnar crossing piers outlined above, e.g. Nogent-le-Rotrou, (Pl. VB). The possible contribution of the Loire churches to the development of Anglo-Norman Romanesque is clearly a much larger subject than can be considered here and Tewkesbury is only one church that seems to owe something to that region, either directly or through a Normandy intermediary.

76. Perhaps the most telling feature of Nogent-le-Rotrou, consecrated in 1078, is the colossal scale, with the aisles certainly less than a quarter of the overall width and a very broad main space. Although plain columnar piers are only used for the screen walls across each transept arm, the nave piers are quite tall, at the expense of the middle stage. The 'crossing' piers are formed of massive ashlar columns with added shafts and the hemicycle piers also have a buried column to them, like those in the apse of Norwich Cathedral. The arches of the hemicycle are of two orders, closely placed. The outer is distinctly stilted but of the same diameter as the inner, so giving the slightly expanding effect that appears in the Tewkesbury crossing arches. The outer order also merges into a pilaster backing the bay-dividing shafts without any capital or impost. It is not clear whether there was a clearstorey stage, though the heaviness of the existing string-course above the putative middle stage (that also encircles the drums of the crossing piers) indicates that no clearstorey stage existed. The openings between this string-course and the arcade order occupy as much of the available space as possible, their sills sitting on top of the outer arcade order in the manner of the wall-passage openings at Tewkesbury. What Romanesque windows do survive are set high in the ex-south aisle wall (admittedly above the roof of the north cloister walk) suggesting that the natural lighting came through from the aisle windows and not a clearstorey. The use of big aisle windows to light the main space without a clearstorey is especially common in 11th-century Poitevin architecture, but can be seen further north, e.g. at Loudun (*c.* 1060) and later, at Fontevrault (*c.* 1110) where a small clearstorey is also used. Nothing is known of the form of the west window(s) of Tewkesbury, but large western windows are again a feature of the Maine, for instance the cathedral at Le Mans.

77. McAleer (1983), 556 – 8.

78. Evesham Abbey choir built by Walter de Cérisy (abbot 1077 – 86) had solid walls and no ambulatory and Pershore Abbey choir appears from the remaining transept elevations to have been without vertical divisions and can be paralleled perhaps with Worcester choir as reconstructed by Gem (1978).

79. The nave was built by Abbot Faritius (1100 – 17). William of Worcester visited in 1480 and described 'columpne rotunditas in circuitu continent 5 virgas in navi ecclesie', see M. Biddle et al., 'The early history of Abingdon Berkshire and its abbey', *Med.Archeol.*, XII (1968), 26 – 69.

80. Amateur excavations in 1893 of the south nave arcade revealed 'parts of a large circular Norman capital and a circular base'. E. Loftus Brock, *JBAA*, XLIX (1893), 163 – 72. The central tower of Winchcombe was struck by lightning in 1091, but the Annals of Winchcombe also record the abbey as destroyed by fire in 1151, VCH *Gloucs.*, II (1907), 66.

81. Excavators record finding 'part of a pier capital...diameter 5 ft 11 ins...with carving similar to Southwell but more particularly St Peter's, Northampton'. T. F. Tickner, *JBAA*, New series, XXV (1919), 34 and B. Hobley et al., *Birmingham Arch.Soc.Trans.*, LXXXIV (1967 – 70), 93. The sculpture referred to could equally have looked like that at Hereford Cathedral and so belong to short, large columns.

82. The greater part of a scalloped capital belonging to a pier of *c.* 6 ft (1.82 m) diameter was found in the rubble after a bomb hit the south side of the choir in 1942. Exeter began to be rebuilt in 1117. It perhaps followed the Glorious Choir at Canterbury in having a continuous colonnade that ran across the 'transept', really lateral, tower chapels. The Glorious Choir begun 1096 had columns of perhaps 4 ft (1.22 m) diameter, but from Gervase's description they were not part of a giant order elevation.

83. Robert FitzHamon's daughter Cecily was abbess at Shaftesbury by 1107, Knowles (1972), 219. Wilson Claridge who excavated the nave *c.* 1900 suggested a diameter for the columns of about six feet, but the text and plan in RCHM *Dorset*, IV (North), 57 – 61 show piers with a diameter of 4 ft 6 ins (1.37 m). A further possibility for a giant order, perhaps on the scale of St Frideswide's Oxford, is Old Sarum, where Roger of Salisbury rebuilt the east end *c.* 1110 – 25. The pier forms are unknown, though the 1974 RCHM plan indicates columns, RCHM *City of Salisbury*, I (1980), 15 – 24.

84. *Vetusta Monumenta*, V (1835), pl. LXVII plan, LXVIII for the piers; VCH *Worcs.*, II (1906), 386 – 89.

85. Two piers bases remain *in situ* at Reading, belonging to the straight bays of the south choir arcade; the south-east crossing pier also survives. C. F. Slade, 'Excavations at Reading, 1971 – 3', *Berks.Arch.Jnl.*, LXVIII (1975 – 76), 29 – 37 gives a plan of the choir, suggesting in the text that the piers had a diameter 'of somewhere around 10 feet'. J. C. Buckler's manuscript notes, Brit.Lib.Add.Ms. 36400, A and B, written in 1878 are an invaluable source. Buckler gives the circular piers a diameter of 6 ft 6½ ins (1.99 m).

86. Richard Emerson also reached a similar conclusion when studying Reading in the late 1960s at the Courtauld Institute (personal communication). Although overall measurements cannot be made at Reading – the nave was buried for Civil War fortifications and is now in a park – from Buckler's account, the following comparisons can be given, (Reading first).

Width between eastern crossing piers:	33 ft 4 ins	33 ft 4 ins
Width between choir piers:	13 ft	12 ft 9 ins
Width of north choir aisle:	14 ft	13 ft 8 ins
Choir plinth width:	7 ft 6 ins	7 ft 9 ins
Width of south transept:	32 ft	32 ft 8 ins

87. Gervase of Canterbury (*op. cit.*, note 12 above), 95.

88. M. F. Hearn 'A note on the chronology of Romsey Abbey' *JBAA*, XXXIII (1969) and in *Gesta*, XIV/I (1975), 27 – 40 dates the eastern bays of the south nave aisle to *c.* 1140 – 5, with the north arcade east bays following. It is possible that these columns relate to a liturgical iconography (denoting an altar?) rather than be an abortive nave elevation. This idea arose in discussions with Eric Fernie; see 'The use of varied nave supports in Romanesque and Early Gothic churches' *Gesta*, XXIII/II (1984). Romsey could also be developing a local interest, in that Winchester Cathedral nave had a linking element similar and earlier than that used in the Romsey nave beyond the eastern bays. Winchester Cathedral was begun in 1079 and the new church entered in 1093. Only the nave apparently had the linking element (according to Willis's reconstruction), though I wonder to what extent it might reflect the choir, which had alternating piers, the minor and the four apse supports being columnar piers of *c.* 5 ft 4 ins (1.62 m) diameter. It is curious that the crossing piers rebuilt after the fall of the tower in 1107 include a segment of a circle of about this diameter, buried in the face towards the main spaces, as though attempting to bring these piers into the existing alternating system. R. H. D. Gem 'The Romanesque Cathedral of Winchester; patron and design in the eleventh century'. *BAA CT*, VI (1983), 1 – 12. The experimentation at Romsey with corbels and shafts might indeed indicate an unfamiliarity with creating a giant order system as McAleer suggests, but it can also be seen as another example of architectural invention/improvement on a given model.

89. The raising of the community to abbey status in 1154 (D. E. Easson, and I. Cowan, *Mediaeval Religious Houses, Scotland*, 2nd edn. (London 1976), 92) could well indicate the completion of the choir; RCAHM, Scotland, *Roxburgh*, I (1956), 194 – 209.

90. Reading is about 30 miles south-east of Oxford, Abingdon 10 miles south-west. For St Frideswide's see S. A. Warner, *Oxford Cathedral* (London 1924) and RCHM *City of Oxford* (1939), 35 – 41. Since 1546, the church of St Frideswide's Priory has served as both Oxford Cathedral and Christ Church College chapel.

91. Winchester nave is presumably earlier than Tewkesbury (see note 88) and Norwich Cathedral begun in 1096 is about contemporary. Both have an attached shaft running up next to the bay-dividing shafts to carry the outer arch of the tribune opening, uninterrupted by horizontal stringcourses, but clearly in the plane of the wall and not part of the bay-dividing system. I think it more than probable that the Hereford choir also had arches at tribune level supported by the nook-shafts of the colossal pilasters that divide the bays (removed in the 13th-century remodelling). However, the Norwich and Winchester elevations could be developed from Mont-St-Michel or another giant wall-arcade system, rather than a columnar pier giant order; see Héliot, (1957).

92. B. W. Beilby, 'Excavations at the Cluniac Priory, Lenton', *Trans. Thoroton Soc.*, LXX (1966), 55–62. Lenton was founded 1102–8 by William Peveral and became the most important monastery in Nottinghamshire. The first monks came from Cluny.

93. J. Carter *The ancient architecture of England* (1978), pl. XXI.

94. VCH *Beds.*, III (1912), 356–66. Only the seven western bays of the nave survive, the form of the east end is unknown. The first prior *c.* 1125 was Bernard, brother of Norman, founder prior of Holy Trinity Aldgate, Knowles (1972), 162. In a short visit note, *Archeol. J.*, CXXXIX (1982), 46–7, I suggested that these linked elevations, along with those of Jedburgh and St Frideswide's Oxford, might be an Augustinian 'house-style', using columnar and linking elements.

95. It is always possible, of course, that the pre-1184 church at Glastonbury had a giant order of some sort. With the existence of Romanesque masonry in the nave piers and transepts (using columnar elements in the crossing piers), is it possible that the choir piers of Sherborne Abbey are a re-cased giant order? RCHM *Dorset*, I West (1952), XI.VII/I, 200–6 and Supplement.

96. Bourges Cathedral can be seen as an early Gothic use of an elevation like Etampes and the columnar piers there have thin shafts added to visually support the ribs. St Frideswide's, Oxford demonstrates the aesthetic drawbacks, as its choir and transepts were originally totally rib-vaulted, the ribs springing from a half-shaft perched in the spandrel between the pseudo-tribune arches, above the upper capitals of the columns. Minor examples of small shafts carrying capitals below the level of the main capital can be seen throughout England in the 12th century, e.g. the west window shafts of Castle Rising parish church (Norfolk) and the internal west front passageway at Chepstow Priory. There are also examples of 'slipped' sections of capital, coping with arches of different levels converging on one pier, e.g. Ramsey (Hunts.) chancel arch, the nave piers of Fountains Abbey and the north aisle of St Hilda's Hartlepool (Durham).

The Elevations of the Romanesque Abbey Churches of St Mary at Tewkesbury and St Peter at Gloucester

By Malcolm Thurlby

The abbey churches of St Mary at Tewkesbury and St Peter, now the cathedral, at Gloucester are the best preserved and most studied Romanesque structures in the west country.[1] Certain planning details in both buildings show a close kinship; the choir of columnar piers terminating in a three-sided apse,[2] the elongation of the crossing piers on the main axis,[3] the aisleless transepts with two-storey eastern chapels,[4] and the tall columnar piers and triforium in the nave.[5] The later mediaeval remodelling of both structures has, however, obscured details of the 11th-century designs, with the result that there is no general agreement as to their original appearance.[6] For Tewkesbury it has been suggested that a wood-roofed four-storey elevation, comprising aisle, arcade, gallery, triforium and clerestorey, was employed in the choir and transepts, which was modified to three storeys in the nave with the omission of the gallery.[7] Against this it is mooted that three storeys, aisle arcade, gallery and triforium, reduced to two with the gallery omitted in the nave, were used in conjunction with a high barrel vault.[8] At Gloucester the idea of a high vault in the choir has long been propounded because of the ample abutment supplied by the quadrant vaults over the gallery.[9] The form of this vault and the design of the Romanesque church above the extant gallery have, however, not been determined. In the nave the Romanesque main arcade and triforium remain untouched while the clerestorey retains its original wall passage with sufficient detail to permit the reconstruction of a regular A:B:A rhythm with a central round headed window. But, the construction of the present nave high vault by the monks before 1242 leaves the form of the original Romanesque covering of the main span uncertain.[10]

Tewkesbury Abbey church was commenced after 1087 by Robert Fitzhamon.[11] In 1102 monks moved from Cranbourne, indicating that the choir, lower part of the crossing tower, transepts and first two bays of the nave were probably completed by that date.[12] A consecration in 1123 probably marks the completion of the church with the possible exception of the crossing tower.[13] The eastern arm of the building was largely remodelled in the 14th century,[14] although the decision to retain the lower section of the six 11th-century columnar piers means that the plan of the central vessel with two straight bays and the three-sided apse has been preserved. In the aisles only the north wall of the second bay from the west preserves its original stonework. The first bay of the north aisle was cut through in the 13th century for access to the new transept chapels. On the south side the first bay has been largely replaced, while the second was rebuilt in the 14th century with the erection of the vestry to the south. The ambulatory and radiating chapels are entirely 14th-century. The form of this part of the Romanesque fabric cannot therefore be precisely determined. Although there can be no doubt that an ambulatory existed, it is not known whether it would have had a polygonal outer wall with chapels off the east, north-east, and south-east bays like Gloucester, or whether, like St Werburg's, Chester, the aisles terminated in apses to the east presumably flanking a central Lady Chapel in the manner of the Romanesque cathedral at Winchester.[15]

In the article published posthumously in 1952 in volume 106 of *The Archaeological Journal*, Sir Alfred Clapham proposed the reconstruction of a giant order linking the aisle arcade and tribune in the Romanesque choir of Tewkesbury.[16] Commenting on the choir piers and responds adjoining the central tower, Clapham observed 'That the whole of this work, below the later capitals, belongs to the late 11th-century structure is apparent from the setting and tooling of the masonry of the piers themselves, which shew no alteration in treatment from the base upwards. The most significant feature to be noted is, however, the treatment towards the aisle and ambulatory. Here the existing 14th-century aisle-vaults spring from late 11th-century moulded corbelling, on the piers, 2 ft. below the 14th-century capital towards the presbytery. Furthermore, this corbelling has been roughly cut back to the

cylinder-surface where it had become purposeless. Also cut back to the cylinder-surface are the ashlar springers of an arch following the line of the arcade. These features occur on all the piers of the presbytery and apse.'[17] Clapham then proceeded to reconstruct the choir piers to the same height as those in the nave which have the same diameter and inter-columniation.[18] Careful examination of the tooling and setting of the piers and the west responds shows that Clapham's interpretation is accurate, for they display the vertical axe marks and broad mortar joints characteristic of the late 11th century which contrast with the finer joints and smoother dressing of the 14th-century stonework. This differentation has been noted by Benson who, remarking on the Romanesque masonry above the Decorated capitals of the west responds, observed that the tooling indicates a partly flat, partly curved wall.[19] Examination of individual stones confirms Benson's thesis. The facing of the west responds at the springing of the curve of the pier shows a change from diagonal tooling for the straight section to vertical for the curved. On the north side the eleventh full course above the 14th-century capital displays this very duality of tooling with the change corresponding to the exact point of the springing of the curve on the pier below. More importantly, on the south side the second and seventh stones above the 14th-century capital have diagonal and vertical tooling and can actually be seen to curve at the same point as the lower part of the pier (Pl. VIA). The placement of the second stone proves that the present 14th-century main arcade capital cannot be a replacement of a similar Romanesque member for there would not have been sufficient room between that capital and the curved stone in question for the springing of a large round-headed arch. The piers must therefore have continued uninterrupted on the choir side to a level now marked by the clerestorey string course, which, as it corresponds with the level of the Romanesque nave capitals, probably marks the placement of the original choir arcade capitals.

Clapham and Benson concur on the former existence of a round-headed arch springing from the corbels at the rear of each column two feet below the present Decorated arcade capitals.[20] Benson draws the parallel with Oxford Cathedral,[21] while Clapham offers a broader context in presenting analogues at Romsey, Jedburgh, Glastonbury, Dunstable, Waterford, and St-Thomas d'Epernon.[22] There is, however, one problem not analysed by either author. In all the parallel examples cited, and in Clapham's reconstruction drawing of Tewkesbury, the inner order of the arch springs from the corbel and stands proud of the columns. The junction of the arch springer and column is therefore vertical.[23] The junctions at Tewkesbury are, however, curved, as correctly shown in Clapham's Fig. 2, which means that the arch must have sprung from within the pier. This was necessary in order to provide the appropriate radius for the arch as a facing for the aisle groin vault, the marks of which are still visible on the outer wall of the second bay from the west on the north side. One may also question whether the facing arch was of three orders as suggested by Clapham. While absolute proof for another arrangement is lacking, the evidence at least suggests an alternative scheme. Of prime importance in this analysis is the form of the 14th-century remodelling. The arch facing the present ambulatory vault, which springs near the back of the pier, is quite distinct from the arch supporting the choir superstructure. The former may be referred to as the inner arch, and the latter as the outer. In an article of 1877 – 78 Blashill observed that 'the most remarkable thing about this is that the new aisle and chapels were built before they thought of building the new arches and the upper part of the choir.'[24] To my knowledge, Blashill's view has never been repeated, nor has it been generally accepted by other students of Tewkesbury.[25] I believe, however, that Blashill is quite correct in his observation, otherwise why have two separate curvatures for the inner and outer arches? On the south side the inner arches spring from the Decorated main arcade capitals, but those on the north have stilted springers which rest on the 11th-century corbels at the back of the piers.[26] Indeed, on the east side of the second northern pier and the west of the third the former Romanesque springers have not been crudely hacked back as on the south side, but have been carefully retooled with the 14th-century arch moulding. The 14th-century arch must therefore be read as a direct replacement of the Romanesque original, and as the new arch is of just one order it follows that the 11th-century arch must have been of that form (Fig. 1). In this respect it would have been like the arches leading from the transepts to the ambulatory

(Pl. VIIc), and also the main arcade in the closely related upper storey of the Bishop's Chapel at Hereford Cathedral.[27] The replacement of the Romanesque ambulatory and lower arcade arches marks the intended extent of the first phase of the 14th-century remodelling. Very soon, however, there was a change in plan and the present scheme was adopted. There cannot have been a great time lag between the two phases because the mouldings of the inner and outer arches are the same. The change was not without its difficulties, for there was clearly embarrassment at certain areas of plain masonry showing between the two arches. The lacunae are filled in the two bays of the north side, the north-east canted bay, and the west bay of the south arcade with rows of symmetrical flowers. The fact that the flowers are not used in all bays, and that those on the north side are different from those on the south indicates that they were not part of the original scheme. This theory is proven when one observes that their design takes account of the outer arch in that they diminish in scale towards the junction of the two arches.[28]

 The form of the upper part of the Romanesque choir must now be considered. It has been generally accepted that the inclusion of the triforium in the east wall of the transepts reflects the arrangement in the choir.[29] There is no reason to doubt this conclusion. Indeed, as the passage returns to the east in both cases before descending the steps to the level of the present clerestorey passage, one may be fairly certain that the choir scheme was analogous to that in the transepts. Above this clerestorey windows have been suggested, and Bannister has gone so far as to suggest that the openings above the present choir vault are none other than the former Romanesque clerestorey windows which were located not above the main arcade arches but in line with the piers (Pl. VIb).[30] There are three specific reasons to doubt Bannister's view, which, when read in connection with other evidence, will generally deny the former existence of a Romanesque clerestorey at least in the straight bays of the choir. First, it would be unusual to have clerestorey windows above the piers.[31] Second, the openings are not splayed. Third,

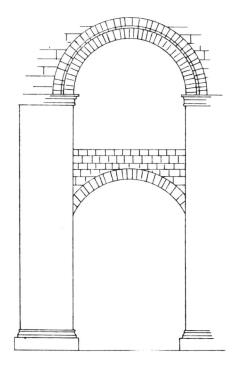

FIG. 1: Tewkesbury Abbey: reconstruction sketch of the giant order of the Romanesque choir.

the masonry of the jambs and heads of the apertures is quite untrustworthy, the coursing is irregular, brick is sometimes used for voussoirs, and the ashlar tooling has a sharpness more characteristic of the 19th century. Furthermore, there is a blocked Romanesque aperture in the east wall above the north transept vault in which only the lower right splay is original, the upper right and entire left splays being rebuilt in brick (Pl. VIc). Though in this case the aperture aligns with the chapel arches below, it is doubtful that it was ever a clerestorey window. The Romanesque masonry above the vault, including the jamb of the blocked opening, is crudely finished and quite unlike the neatly tooled ashlar below. The same contrast is evident above and below the barrel vaulted north porch of the abbey. This suggests that it was never meant to be seen and must therefore have always been above a vault. This point is reinforced by comparison with the masonry above the 15th-century south transept vault at Hereford Cathedral where a large Romanesque clerestorey window, set well below the top of the wall, is flanked by neatly finished stonework (Pl. VId). This Hereford window was one of three placed symmetrically in the lateral walls of the wood-roofed transept.[32] This is different to the arrangement at Tewkesbury where the small window, which may never have had an arched head, is at the very top of the wall. It was also the only opening in the east wall of the transept as is proven by inspection of the exterior blind arcade (Pl. VIe). The coursing is consistent throughout the arcade except in the third bay from the end, that is at the very location of the blocked opening in question. The same arrangement, with just the third bay from the end being a blocked aperture, is seen in the east wall of the south transept.[33] On the west wall of the south transept the coursing is consistent throughout its length and therefore there can never have been any windows. The west wall of the north transept is refaced and is therefore of no help in the matter. The placement of a clerestorey window in just one bay of one wall of each transept would be extremely unusual, and when this is taken along with the rough nature of the masonry connected with the opening it seems more likely that the Tewkesbury aperture lit the area above a barrel vault exactly as at Souillac (Lot)[34] (Pls VIf & VIIa), where the upper openings visible on

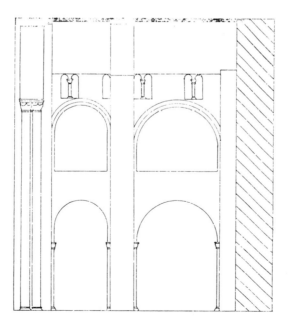

FIG. 2: Tewkesbury Abbey: reconstruction sketch of south transept east wall elevation with barrel vault.

the exterior of the transept east walls do not appear inside and must therefore light the roof space above the barrel vault. This typological parallel should also be seen alongside the many instances of an external blind arcade used in connection with barrel-vaulted main spans in Romanesque churches in central and western France.[35] Especially important is the church of Sainte-Croix at Loudun (Vienne) which, like Tewkesbury, has the very rare three-sided termination to the columnar piered choir, and preserves barrel vaults over the choir and transepts (Pl. VIIB).[36]

A high barrel vault at Tewkesbury would have sprung from immediately above the triforium where there is a change in masonry from Romanesque ashlar below to largely restored stonework above. Although there is no trace of the line of the vault on either the north-east stair turret or above the north crossing arch, reference to evidence in the south transept will confirm the former existence of such a vault. In the south transept immediately above the triforium of the east wall there is a change from Romanesque ashlar to partially restored 14th-century masonry analogous to that in the north arm, but in the south the break is accompanied by scorch marks on the Romanesque masonry from the 1178 fire (Pls. VIG & VIIC).[37] The fire damage may be followed in the original stonework in an arc above the south crossing arch (Pl. VIIIA), which may be equated with the trajectory of a barrel vault which sprang from immediately above the triforium at the exact point of the present change from Romanesque to 14th-century masonry. The former existence of such a vault would also explain the wide pilaster between bays one and two on the east side of the transept as a support for a transverse arch of the vault (Fig. 2). There is one small detail which, I believe, puts the reconstruction of a barrel vault beyond doubt. The scorch marks on the east wall do not always terminate exactly at the top of the Romanesque ashlar but in places actually run across the faces of the masonry blocks (Pl. VIG). Turning to the interior of the barrel-vaulted north porch of the abbey, one notices that the plaster finish of the vault encroaches slightly on to the top of the side walls (Pl. VIH). Given an analogous plastered barrel in the south transept, the slight spread of the protective coat of plaster onto the uppermost course of the side wall would explain the seemingly unusual termination of the fire marks. One further feature remains to be explained. Above the south crossing arch the termination of the fire mark is not accompanied by a change in masonry, except, of course, where the three upper stones on the left are the product of restoration (Pl. VIIIA). In fact, the Romanesque ashlar continues above the fire line to the present vault. The Romanesque barrel was therefore not bonded into the wall at this point but merely abutted it. Given the same lack of bonding in of the Romanesque vault webbing and the absence of fire damage in the north transept, it is no surprise that there is no trace of the former barrel above the crossing arch or on the stair turret. Such an arrangement may seem rather unusual, but exactly the same technique was employed in the aisles of the choir and nave, and over the main span of the nave at the related abbey of Pershore.[38]

In both the north and south choir aisles at Pershore, from immediately above the capitals of the west responds of the present 13th-century main arcade, one can see the line of the former Romanesque groin vault accompanied by a change in masonry on the projecting segment of the original crossing pier (Pl. VIIIB). Above the arches leading to the transepts, however, there is no change in masonry, the Romanesque ashlar carries right through to the present vault. The vault springers were therefore bonded into the pier while the webbing of the groins above the arches abutted the wall surface. That the vaults were in fact built is demonstrated by careful examination of the area above the arch leading from the south choir aisle to the south transept where between about thirty to sixty degrees to the right of the vertical, or, to put it more simply, between one and two o'clock, the mark of the vault can be seen cutting across Romanesque ashlar. Turning to the aisles of the nave of Pershore, a similar state of affairs is to be detected, which, because of fire damage, is of even greater interest in relation to the Tewkesbury south transept barrel vault. In both the north and south aisles in the angle between the eastern responds of the former nave arcade and the west wall of the transept next to the arch connecting with the nave aisles one sees the remains of the springers of the Romanesque groin vaults (Pl. IXB). Immediately above these vault fragments one sees the original Romanesque masonry which after four

courses on the north and three on the south bears the marks of fire. The fire damage then continues in an arc above the arches to the transept arms. On the north side, renewed masonry above and to the left of the arch prevents the continuation of the fire line to its full original extent, but on the south, with the exception of a restored section between twelve and one o'clock, the fire damage may be followed right through to the junction with the aisle wall. Just as above the south crossing arch at Tewkesbury, the fire marks are seen to cut across the original Romanesque masonry and, again as at Tewkesbury, they represent the point at which the vault abutted the wall. Interestingly, however, at Tewkesbury the fire line represents the intrados of the vault while at Pershore it marks the extrados, with the unmarked area of masonry immediately above the arch therefore corresponding to the former webbing of the vault. The masonry above the west crossing arch has been heavily patched but fortunately just above the springing point of the south side of the arch evidence for a former vault in the form of fire mark has been preserved, which, as in the aisles, represents the extrados of the vault (Pl. IXc). The form of the Pershore nave vault will be considered later.

Analogous constructional details are found on the east wall of the chancel at Halesowen (Worcestershire) parish church where the haunches of the former Romanesque barrel vault are marked by a change in masonry, from ashlar below to rubble above the vault.[39] But towards the apex of the arc, from about ten through to two o'clock, there is no such change, instead one finds consistent coursing of horizontal ashlar across the wall. The upper part of the vault therefore just abutted the wall as above the north and south crossing arches at Tewkesbury and the west crossing and the arches from aisles to transepts at Pershore. After four full courses the ashlar stops at a point coinciding with the former extrados of the vault webbing. The upper part of the wall is then executed with large rubble, as above the north transept and north porch vaults at Tewkesbury which similarly contrast with the neat ashlar below.

Corroborative evidence for barrel vaulting the transepts at Tewskesbury is found in the transepts of Pershore Abbey. The internal elevation of the east wall of the south transept at Pershore is closely akin to Tewkesbury, even to sharing the masonry break above the triforium, here from Romanesque ashlar to 14th-century stonework of the same character as the webbing of the present vault. It has been suggested that there was a Romanesque clerestorey above this break,[40] but, as at Tewkesbury, the evidence on the exterior of the fabric negates the theory. In spite of restoration, enough original masonry survives to determine that the Romanesque coursing is consistent throughout this area of wall, and therefore there could never have been any openings in it. The same is true of the west wall of the transept. Furthermore, inside the west wall there occurs the same break in masonry from Romanesque ashlar to 14th-century rubble at exactly the same level as on the east wall. That it was from this level that a Romanesque barrel vault sprang is indicated by three facts: first, the line of the barrel is seen to continue from its springing on the west wall of the transept in an arc on the south-west stair turret (Pl. VIIIc)).[41] Secondly, above the present south transept vault a section of the original vault webbing is preserved against the south wall (Pl. VIIId). Thirdly, in the stump of the north transept above the crossing arch there are distinct remains of the rubble webbing of a barrel vault as already observed by Clapham (Pl. IXa). This reading is confirmed by the fragmentary barrel vault in the north transept chapel of the stylistically related Ewenny Priory (Glamorganshire) where above the entrance arch from the transept, rubble webbing is seen like that above the north crossing arch at Pershore, while along the north wall of the choir the springing of the barrel vault is most distinct.[43] It is also of interest to note that a barrel with a rib vaulted east bay is still preserved over the main span of the choir at Ewenny.

The vaulting of transepts implies that the adjacent choir would have been similarly covered. Evidence for such a vault at Pershore has been swept away by the rebuilding of the choir probably after the fire of 1223 and its subsequent stone vaulting after 1288.[44] But at Tewkesbury, in spite of the remodelling of the upper part of the choir in the 14th century, there remains above the eastern crossing arch the line of the former vault, which, as in the transept, was presumably a barrel (Pl. IVb). Here it is interesting to observe that the vault has left a scar in the masonry. It must therefore have been keyed

into the wall in contrast to the transept vaults which were merely built up against the wall above the crossing arches. The technique of bonding the webbing of the vault into the wall has already been illustrated in the West Country School of Romanesque architecture in the north transept chapel of Ewenny priory. It might also be suggested that the same method was employed in the north transept at Pershore, for had that vault simply abutted the wall above the crossing arch, it is unlikely that the projecting webbing would have remained to this day. If this assumption is correct then at Pershore as well as Tewkesbury both methods of vault-to-wall construction were used in a single building. In this connection, it is pertinent to note that at Lilleshall Abbey (Salop) in the second half of the 12th century, the same duality of constructional method is found within single rib-vaulted bays in the transept chapels and slype.[45] Comparison with the nave and nave aisle vault marks at Pershore is also important for the Tewkesbury choir vault. At Pershore it has been demonstrated that the vault webbing confined fire to the roof. Fire damage within the gable on the east face of the Tewkesbury crossing tower and its absence below the vault line suggests that the vault webbing, like that at Pershore, prevented the spread of fire.

The reconstruction of a barrel vault over the Tewkesbury choir raises certain questions regarding abutment. One might expect to find quadrant vaults over the tribunes, but the exterior east walls of the transepts above the tribune arches show no sign of ever having been abutted by a vault. Indeed, the fact that almost every stone of the south transept east wall is fire damaged precludes the former existence of a vault. Other than the high vault, the only evidence for vaulting in the eastern arm is at aisle level, in the second bay from the west on the north. There to either side of the window, beneath the 14th-century wall rib, the line of the former Romanesque vault is apparent. From the trajectory of this line a segmental groin vault must be reconstructed like those in the choir aisles of Gloucester Cathedral, where the slim half-shaft responds and the large columnar piers of the main arcade are akin to those at Tewkesbury. It may be conjectured that the lack of tribune vaulting might jeopardize the stability of a high masonry vault. Against this, however, is the fact that the piercing of the east wall of the transept with four major arches, leading respectively to the choir aisle, gallery, and upper and lower chapels, is directly analogous to the arcaded arrangement of the choir. Therefore if the barrel was stable in the transept so would it have been in the choir. Furthermore, given a webbing of just a single row of stones like Ewenny and Pershore, the great mass of the choir arcade, a full six feet thick, would easily have absorbed the thrust of the vault.

The form of the high vault in the apse of the Tewkesbury choir is a matter for pure conjecture. There may have been a three-sided cloister vault, a semi-dome fudged onto the supporting structure as at Loudun, a three-part rib-vault as in the south transept chapel at Tewkesbury or the apse at Kilpeck (Herefordshire)[46] or even a four-part rib-vault, a form which may have been used in the apse of the Romanesque choir at Gloucester.[47]

Immediately above the triforium on both the north and south sides of the nave at Tewkesbury there is a similar horizontal break in masonry. As in the transept, it marks the change from Romanesque ashlar to rough 14th-century stonework. Given the reconstruction of a transept barrel vault, the same form can be suggested for the nave, which would, after all, find perfect reflection in the great western arch of the facade.

Although one may be tempted to read the present 14th-century clerestorey windows as enlargements of Romanesque precursors, this is in fact impossible. There is a lack of correspondence between the placement of the present windows and the north exterior blind arcade.[48] This leads to the suggestion that the alignment of the clerestorey windows in the nave at Tewkesbury is 14th-century and this is confirmed by two specific details. The sixth clerestorey window occupies the space of two former Romanesque blind arches. If the original arches are reconstructed, the column between them must therefore occupy the middle of the window and concomitantly the middle of the Romanesque bay.[49] A Romanesque clerestorey window in this bay is therefore not possible. And in the westernmost bay of the nave the clerestorey opening is placed well to the west of the Romanesque main arcade arch and yet

is central to the 14th-century vault.[50] The placement of the window is therefore 14th-century and as the external arcade is undisturbed immediately to the east of this window, that is the area central to the Romanesque main arcade arch, the existence of a Romanesque clerestorey in this bay is impossible, and most unlikely in the rest of the nave.[51]

If the master mason was somewhat daring in not constructing tribune abutment for the choir high vault, the evidence in the nave aisles suggests that admirable caution prevailed. The arches leading from the nave aisles to the transept arms are of a quadrant design, which if continued down the length of the aisles would have formed the perfect abutment for a main span barrel vault. Then, in bays six, seven and eight of the south aisle, which retain their original Romanesque wall arches, there is a horizontal break in the stonework immediately above the wall arch, once again a change from Romanesque ashlar to 14th-century masonry. The break occurs two to three courses above the cut back tops of the Romanesque half-shaft respond capitals which now carry 14th-century wall arches and vault ribs. Originally these responds would have received the quadrant arches of a half barrel vault, exactly like those of the arches leading from the nave aisles into the transepts. It is also next to these arches that the height differential between the springing of the quadrant arch and the reconstructed (?) webbing of the vault is seen. Given the same arrangement of arch and vault webbing down the length of the aisle, this would explain the continuation of the Romanesque masonry above the height of the respond capitals as observed in bays six, seven, and eight of the south aisle.

At Pershore, the former existence of a Romanesque nave high vault has been determined with reference to the fire damage above the western crossing arch (Pl. IXc). The fragmentary state of the nave does not provide further clues as to the form of the vault, but because of the analogy of the huge columnar piers with the Tewkesbury nave, and the existence of a fragment of Romanesque blind arcading at the east end of the north nave wall like that at Tewkesbury (Pl. IXB), it may be suggested that the nave of Pershore was also barrel-vaulted.

One further detail of the Tewkesbury internal elevation calls for examination. Immediately to the west of the western responds of the nave arcades, the wall is thickened slightly as if in preparation for towers over the aisle west bays. That towers were indeed intended is confirmed by the existence of the beginning of a cross wall behind the south nave triforium, the placement of which corresponds to the thickening of the wall below. The tower plan was, however, soon abandoned. On the south side, even though the wall west of the west respond continues up at the increased size, the half-shaft, which was presumably intended to support a transverse arch of the high barrel and to articulate the west bay between the towers, was terminated at the base of the triforium. On the north side, the half-shaft stops at the same point and is accompanied to the west by a thinning of the wall which is also evident to the east of the shaft down to the abacus of the west respond capital of the main arcade. One consequence of this reduction of wall thickness to the east of the shaft is that the westernmost triforium openings are set further to the west on the north than on the south where the western triforium arch springs from the continuation of the thicker wall.

With the abandonment of the twin-tower plan, the present design was adopted with turrets above the spandrels of the great facade arch. The turrets bear a remarkable kinship to those on the angles of the crossing tower of Sainte-Marie-des-Dames, Saintes.[52] This comparison is all the more interesting in view of the parallel between the Tewkesbury high barrel vault and upper external blind arcade combination and examples in western France. Then there is the frequent occurrence of aisles with quadrant vaults buttressing high barrel vaults in the same region of France, for example Sainte-Eutrope, Saintes,[53] and now Clapham's parallel between the tall columnar piers of the Tewkesbury and St-Savin-sur-Gartempe naves takes on a new importance with the reconstruction of a high barrel in the English abbey.[54]

There remains to be discussed the great west arch of Tewkesbury which must ultimately derive from Charlemagne's Palace Chapel at Aachen.[55] In this connection, reference to the Bishop's Chapel at Hereford is of prime importance.[56] The chapel, constructed by Bishop Robert de Losinga, 1079-95,

was, according to William of Malmesbury, modelled on Aachen.[57] Although the copy may be rather free there can be no doubt as to the close kingship of certain details. These include the great west arch flanked by stair vices, the very feature repeated in the Tewkesbury facade. In view of this parallel and similarity between the Tewkesbury choir piers and those in the upper storey of Hereford chapel, it is especially interesting to see that the upper storey of the chapel has quadrant vaulted aisles buttressing a barrel over the main span in the east and west bays.

Tewkesbury and Pershore were not alone in the West Country in having Romanesque vaulted main spans as had already been seen at Ewenny. At Chepstow there are distinct marks of the original groin vaults in the nave.[58] Scott's suggested reconstruction of groins over the choir of Hereford cathedral would happily explain the nook-shafted pilasters between each bay as supports for transverse arches.[59] But what of Romanesque Gloucester?

Given the retention of so much of the Romanesque fabric from the abbey church of St. Peter at Gloucester commenced by Abbot Serlo in 1089, it would seem a simple task to reconstruct the form of his building. Indeed, certain elements are quite clear. That the three-bay choir terminated in a three-sided apse like Tewkesbury is proven by the discovery of the former pier bases beneath the present reredos.[60] Then, on the present easternmost piers, the springing of the former Romanesque arches of the canted bays is quite distinct. The choir aisles retain their original groin vaults, the north-east and south-east radiating chapels are as built, with the exception of refenestration, and the crypt remains intact.[61] The choir gallery stands as built, except, of course, for the insertion of the great east window, and the rebuilding of two responds and transverse arches of the quadrant vault on the south side in the 14th century. The use of quadrant vaults over the gallery has long been taken to indicate that the main span of the choir was vaulted, or at least intended for a vault.[62] The form of this hypothetical vault, and the design of the upper part of the Romanesque building have not, however, been determined. Did it have a clerestorey like the nave of the abbey, where, it will be argued, a rib vault was probably used over the main span?[63] Was it like Tewkesbury and Pershore with a triforium, no clerestorey and a high barrel vault? Perhaps it had just had a barrel vault over the two-storey elevation of main arcade and

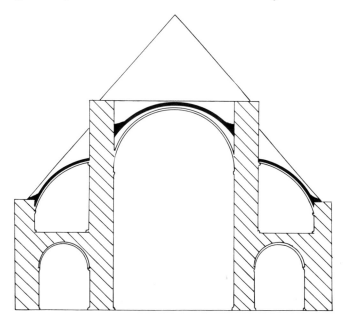

Fig. 3: Gloucester Cathedral: hypothetical cross-section of barrel vaulted Romanesque choir.

gallery? Or, finally, it may have been like Hereford and Worcester in having a clerestorey and wooden roof. A parallel with Worcester has been suggested by Richard Gem, who observes that Gloucester 'certainly took Worcester as its starting point in the east arm (witness the extension crypt, the ambulatory plan, the columnar piers,...the interest in awkward pentagonal elements in the plan'.[64] Of these points of kinship there can be no doubt, but Gem also assumes a 'full three-storey elevation above the crypt' at Gloucester as at Worcester.[65] The weight of evidence is, however, against such a reconstruction. One of the crucial details is the fragment of one and a half bays of Romanesque blind arcading to the west of the westernmost clerestorey window on the north side of the choir (Pl. IXD). Is this arcade to be connected with a clerestorey? I think not, for the arches are much smaller than any Romanesque arcade which forms part of a clerestorey scheme, as is seen by comparison with the near-contemporary clerestoreys at Norwich and Ely.[66] Instead, the obvious parallel is with the nearby and closely related Tewkesbury abbey where, as we have seen, the east walls of both transepts and the north wall of the nave preserve the upper external blind arcade (Pl. VIE). It was suggested that these arcades at Tewkesbury and the analogous fragmentary example at Pershore (Pl. IXB) were used in conjunction with a high barrel vault, and it therefore seems logical to reconstruct a barrel vault over the choir at Gloucester springing from above the gallery. Figure 3 shows the hypothetical barrel-vaulted cross section. The trajectory of the vault is shown as segmental, like the crypt and aisle vaults at Gloucester, the crypt vault at St Nicholas' priory, Exeter, and the high barrels at Tewkesbury and Pershore, which is the result of calculating the diameter of the vault from the wall centres rather than the inner face of each wall. It should be noted that because of the similarity between the choir and transept elevations at Gloucester, high barrels could also logically be reconstructed in the transepts.

Indirect support for the theory of barrel vaulting the choir and transepts at Gloucester is supplied by the placement of the former doorways to passages in the north-west stair vice of the north transept.[67] In

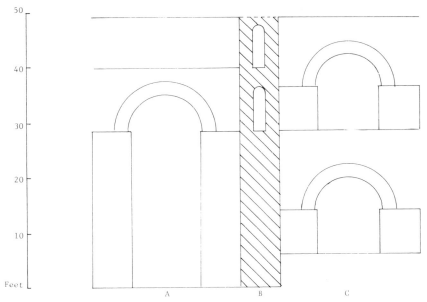

Fig. 4: Gloucester Cathedral: diagram of:
A: Romanesque nave arcade and triforium.
B: N. transept N.W. stair-vice with lower arch to E. formerly connecting across N. wall
to transept and choir gallery.
C: Choir main arcade and gallery.

the schematic drawing, (Fig. 4), the central section, B, represents the stair vice; to the left, A, is the nave arcade and triforium; and to the right, C, the choir arcade and gallery. The lower opening from the stair vice faces east and is at the exact level of the choir and transept galleries with which it would have connected through a passage across the north transept terminal wall. The upper opening, also facing east, is at the height of the nave triforium, well below the top of the choir and transept gallery arches. It can therefore have nothing to do with the choir elevation, and because it never connected with the nave, it must simply have given access to a passage across the north transept terminal wall as at Tewkesbury, where the passage does not communicate with, but is at the same level as, the nave triforium.[63] Furthermore, when the relative height of levels in west country buildings of the Romanesque period are compared, it will be noticed that the distance between the two passages at Gloucester, C in Fig. 5, is within inches of Pershore, A, and Tewkesbury, B, the very buildings to have supplied direct analogues for the barrel-vaulted reconstruction over the Gloucester choir and transepts, and yet is totally different from Hereford, D, or Worcester, E, which were wood-roofed three-storeyed structures with upper openings giving access to the clerestorey passage. In addition to being paralleled with Tewkesbury, Pershore, Hereford Bishop's Chapel, Ewenny and St John's Chapel in the Tower of London, the high barrel vault at Gloucester must be seen against a French background. For Tewkesbury, continental analogues for certain details have been found in the region from the Loire Valley to the south-west, with Sainte-Croix at Loudun being particularly close to the east arm of Tewkesbury. It

FIG. 5: A: Pershore, S. transept S.W. stair vice: lower passage to E. to gallery at 272″ above floor level; upper passage to E. to triforium 138″ above passage to gallery.
B: Tewkesbury, N. transept N.E. stair vice: lower passage to E. to gallery at 296″ above floor level; upper passage to E. triforium 123″ above passage to gallery.
C: Gloucester, N. transept N.W. stair vice: lower passage to E. to gallery at 342″ above floor level; upper passage to E. 127″ above passage to gallery.
D: Hereford, S. transept S.E. stair vice: lower passage to N. to triforium/gallery at 302″ above floor level; upper clerestorey passage to N. 192″ above triforium/gallery passage.
E: Worcester, S. transept N.W. stair vice: lower passage to E. to gallery at 349″ above floor level; upper passage to E. to clerestorey 166″ above passage to gallery.

is in the south-west of France that one finds a source for the Gloucester elevation in the great pilgrimage church of Saint-Sernin, Toulouse, which has the two-storey scheme comprising main arcade and gallery, with quadrant vaults over the galleries to abut the thrust of the high vault just as at Gloucester.[69]

One detail preserved on the easternmost Romanesque pier of the north choir gallery must now be explained in relation to the original elevation. On the choir side of this pier there remains a single Romanesque attached shaft which is placed just to the east of the centre of the pier. Half-shafts and nook-shafts are used in a very logical fashion in Romanesque Gloucester to support individual arched orders. In the choir aisles one finds the half-shaft respond for the transverse arch of the vault and to the left and right the nook-shafts for the wall arches. An analogous system is used in the two ambulatory and transept chapels. Then the north nave aisle responds have a central half-shaft for the transverse arch, to the left and right there are nook-shafts for the diagonal ribs of the vault and finally the nook-shafts for the wall arches. In the choir gallery the inner order of each arch has its own separately articulated shaft, as does the transverse arch of the quadrant vault. In short, there is a single shaft for each arched order, with the exceptions, of course, of those springing from within the core of the massive main arcade and gallery piers, the inner order of the former crossing arches and the arches from the transepts to the nave aisles which were carried on paired shafts. The shaft on the choir side of the north-east gallery pier should therefore be read in conjunction with the structure and articulation of the high vault. Its placement to the east of centre precludes its use as a support for a transverse arch or rib. Rather, it must be connected with a quadripartite rib vault in the apse, a ribbed version of the apsidal groin vaults in the north-east and south-east ambulatory chapels. The combination of a ribbed apse vault and a barrel may be paralleled in the south transept chapel at Tewkesbury and the chancel at Kilpeck (Herefordshire), which was given to St Peter's, Gloucester, in 1134.[70]

The arrangement in the nave at Gloucester is quite different from the choir and transepts, for instead of the main arcade and gallery of similar height, there is a taller main arcade, a triforium and a clerestorey with wall passage. The north aisle preserves its Romanesque rib vault, the one on the south being rebuilt after the collapse in 1318.[71] The present Romanesque scheme was not, however, intended from the first. Examination of the responds of the arches from the nave aisles to the transepts demonstrates the designer's indecision. In the south aisle the south respond has one half-shaft going up to a scalloped capital at the level of the respond capitals in the remainder of the aisle. But above the capital a shaft continues to another scalloped capital, and is paired immediately to the left with another half-shaft and capital at the height of the apex of the former Romanesque aisle windows. The north respond has paired half-shafts; that to the right continuing uninterrupted to the webbing of the vault, while on the left the shaft is punctuated by a scalloped capital at the level of the main arcade capitals before continuing to the vault. The same situations is seen on the south respond of the north aisle arch to the north transept, while on the north respond the right shaft runs straight to a scalloped capital just beneath the vault, and the left shaft terminates at the same level but is interrupted at the height of the remainder of the aisle respond capitals with a scalloped capital. Above the aisle vaults, no evidence for the continuation of the shafts is found on the south, but in the roof space behind the north triforium the right shaft of the south respond is still extant although embedded in later masonry (Pl. VIID).[72] It continues to a cushion capital level with the apex of the rear enclosing arch of each triforium bay. The intention must therefore have been to vault the aisles with quadrants springing from above the aisle windows and rising to immediately above the triforium rear enclosing arches, in fact at exactly the same height as the quadrant vaults in the choir gallery. This scheme was, however, soon abandoned and the arrangement as preserved in the north aisle constructed.

The present nave high vault was erected by monks before 1242. What did it replace? The evidence points in favour of quadripartite rib vaults over single bays. Above each main arcade pier at the triforium string course stand the present vault shafts. To the left and right of the shafts and continuing up to the ribs, there is considerable 13th-century infill before reaching the Romanesque ashlar. Had

the *c.* 1242 vault shafts simply been introduced onto plain Romanesque walling, then there would be no need for the expanse of new masonry to either side. On the other hand, if Romanesque vault shafts had to be removed before the 13th-century work could be commenced, then the infill would be explained. One may therefore propose the reconstruction of grouped shafts similar to those over the minor piers in the choir of Durham Cathedral where one detects exactly the same setback at the stringcourse above the main arcade as at Gloucester.[73] One difference between the two schemes must, however, be suggested. In the north nave aisle, the responds have a five-part composition; a central half-shaft for the transverse arch, two nook shafts for the diagonal ribs, and two nook-shafts for the wall arches. An analogous system should be imagined for the high vault.

The reconstruction of Romanesque high vaults at Gloucester, Tewkesbury and Pershore brings a new perspective to the early vaulting experiments in post-conquest England. While Tewkesbury has no bearing on the development of the high vaults at Durham after 1093, the possible relationship between Gloucester and Durham should provide an interesting field for future research.

Postscript

Since the completion of this article, J. Philip McAleer's paper on 'The Romanesque Transept and Choir Elevations of Tewkesbury and Pershore' has appeared in *The Art Bulletin*, LXIV (1982), 549-63. Professor McAleer arrived independently at the conclusion that Tewkesbury and Pershore had high barrel vaults. His remarks on certain details at Tewkesbury call for some comment. The Romanesque masonry above the south crossing arch is not "refaced along a horizontal course" (p. 557) but is original up to the 14th-century vault, with the exception of patching to the left of centre of the fire-damaged arc that defines the trajectory of the original barrel vault.

The marks of the vault on the north wall of the second bay of the north choir aisle suggest to McAleer 'the curve of a groin or transverse barrel' (p. 558). The latter would be impossible because the transverse arches of the aisles spring from the same level as the vault and the arches leading to the transepts. A groin vault is therefore the only possibility.

McAleer notes that 'the evidence relating to a vault over the former choir gallery is even more slender' (p. 558). Indeed, I believe it is non-existent. I observed above that the fire damage around the south gallery arch precludes there having been a quadrant vault. As for 'the downward sloping cutting curved in a line parallel to the voussoirs after passing the apex of the (north gallery) arch' (p. 558); this can hardly be equated with a masonry quadrant vault, for the cutting is only two to three inches in thickness. Furthermore, immediately above and below the curve of the cutting the stones are fire damaged, thus precluding the possibility of the vault webbing abutting the wall at this point.

McAleer's reconstruction of the choir, which he painstakingly spells out in 'The Romanesque Choir of Tewkesbury Abbey and the Problem of the "Colossal Order"', *The Art Bulletin*, LXV (1983), 535 – 558, is not supported by the evidence on the responds on the eastern crossing piers. In particular, the springing of his main arcade arch is denied by the existence of the partly curved Romanesque stone two courses above the present 14th-century capital of the south arcade west respond. This stone in fact supports the Benson/Clapham reconstruction of giant columns.

ACKNOWLEDGEMENTS

*I should like to thank many friends and colleagues with whom I have discussed the Romanesque fabric of Gloucester and Tewkesbury. I am particularly indebted to Eric Fernie for introducing me to the question of vaulting in the two structures and for drawing my attention to several details at Tewkesbury which might otherwise have been overlooked. Richard Halsey, Richard Morris and Christopher Wilson have accompanied me on several visits to the buildings and have contributed greatly to my understanding of the architecture. In North America, Jean Bony, William Clark and J. Philip McAleer have been stimulating in discussion of the two structures. At Gloucester, Canon David Welander has guided me over all parts of the building. His astute observations and

searching questions have been of great help in elucidating the problems in the building. At Tewkesbury, M. Ernest Leach and Mr. L.N.A. Thompson have cheerfully facilitated my access to all parts of the structure.

My last visit to the buildings discussed in the text was made possible in part by a grant from the Inter-University Centre for European Studies, Montreal.

REFERENCES

1. For Gloucester, see R. Willis, *Archaeol. J.*, XXVII *(1860)*, 335−342; H. J. L. J. Masse, *The Cathedral Church of Gloucester*, (London 1898); J. Bilson, 'The Beginnings of Gothic Architecture', *R.I.B.A. Journal*, 3rd series, VI (1899), 294−5, 305; VCH *Gloucestershire*, II (1907), 53; W. H. Knowles, 'The Development of Architecture in Gloucestershire to the close of the twelfth century', *Trans. BGAS*, L (1928), 68−74; Sir A. W. Clapham, *English Romanesque Architecture: After the Conquest*, (Oxford 1934), 32−3, 37, 52, 53, 54, 55, 56, 59, 64, 65n, 100, 119, 135n; J. Bony, 'Gloucester et l'origine des voutes d'hemicycle gothiques', *Bull. mon.*, XCVIII (1939), 329−331; D. T. Rice, *English Art 871−1100*, (Oxford 1952). 74, 75; T. S. R. Boase, *English Art 1100−1216*, (Oxford 1953), 91−3; G. Webb, *Architecture in Britain: The Middle Ages*, (Harmondsworth 1956), 26, 27, 28, 30-1, 32, 33, 35, 38, 48; P. Kidson, P. Murray, P. Thomson, *A History of English Architecture*, (Harmondsworth 1965), 35, 54, 55−8; D. Verey, B/E *Gloucestershire: The Vale and The Forest of Dean*, (Harmondsworth 1980), 17, 198−210; David Verey and David Welander, *Gloucester Cathedral*, (Gloucester 1979). For Tewkesbury, see J. L. Petit, *The Abbey Church of Tewkesbury*, (Cheltenham 1848); T. Blashill, 'The Architectural History of Tewkesbury Abbey', *Associated Architectural Reports and Papers*, XIV (1877−8), 97−104; A. Hartshorne, 'Tewkesbury Abbey Church', *Archaeol. J.*, XLVII (1890), 290−301; H. J. L. J. Masse, *The Abbey Church of Tewkesbury*, (London 1901); W. G. Bannister, *Trans. BGAS*, XLVIII (1926), 10−16; W. H. Knowles (1928), 74−77; Sir A. W. Clapham (1934), 34, 47, 52, 53n, 60, 63, 100; Bony (1937), 'Deux élévations...', and Bony (1937), 'A propos...' 503−4; E. G. Benson, 'What was the original apse of Tewkesbury like?', *Trans. BGAS*, LXVII (1946−8), 399−404; Clapham (1952), 10−15; G. Webb (1956), 27, 28, 32−3, 49, 50; P. Kidson (1965), 54, 55−8, 62; VCH *Gloucestershire*, VIII (1968) 154−161; D. Verey (1980), 357-65.

I use the label "West Country School" in connection with Gloucester and Tewkesbury and related buildings, rather than the south-west Midlands School, because of the inclusion of Exeter Cathedral in the group.

2. The canted bays in the 13th-century choir at Pershore Abbey may be a reflection of the original Romanesque arrangement; see R. A. Stalley and M. Thurlby, 'A Note on the Architecture of Pershore Abbey', *JBAA*, 3S, XXXVII (1974), 113−118.

It has been suggested that the Romanesque choir of Exeter Cathedral terminated in a five-sided apse because of the discovery of foundations of that form (H. E. Bishop and E. K. Prideaux, *The Building of the Cathedral Church of St. Peter in Exeter*, (Exeter 1922), 25−7, Fig. 2). The design would therefore have derived from Anglo-Saxon prototypes like Deerhurst (Gloucestershire) and conformed to the polygonal planning elements in the West Country School of Romanesque architecture. However, it is possible that the five-sided foundation was topped by a three-sided arcaded apse just as at Gloucester, where the apsidal main arcade is built over the five-sided crypt.

3. In the West Country School, compare Malvern Priory, Hereford Cathedral, Pershore Abbey, Exeter Cathedral (?), Evesham Abbey, Leominster Priory, Malmesbury Abbey and Sherborne Abbey. It is possible that this feature is derived from Anglo-Saxon prototypes like the western crossing piers at Great Paxton (Hunts), H. M. and J. Taylor, *Anglo-Saxon Architecture*, (Cambridge 1965), Fig. 236.

4. In the West Country School compare Pershore Abbey.

5. Compare Pershore nave. Clapham (1934), 51−2, suggests that Evesham nave probably had tall columnar piers and would therefore have been the prototype of the group. A fragmentary capital reused in St James' Chapel at Exeter Cathedral, and now preserved in the east cloister walk, originally topped a huge columnar pier of the Tewkesbury and Gloucester type. The capital must have come from the main arcade of the choir which was demolished in the 1270s to make way for the present structure. The present Exeter choir and nave main arcade and triforium proportions correspond to those of the Romanesque nave at Gloucester. It is therefore possible that the 13th-century scheme at Exeter repeats the original Romanesque proportions which concomitantly may have used large columnar piers like Gloucester.

6. For the remodelling of the Gloucester choir and transepts, see John Harvey, *The Perpendicular Style 1330−1485*, (London 1978), 75−96; for the 14th-century work at Tewkesbury, see in particular R. K. Morris, 'Tewkesbury Abbey, The Despenser Mausoleum', *Trans. BGAS*, XCIII (1974), 142−55; J. Bony, *The English Decorated Style: Gothic Architecture Transformed 1250−1350*; (Ithaca 1979), 37−8, 51−2.

7. Bony (1937), 'Deux élévations...', A propos...'. the term "aisle arcade" is used with reference to the arches facing the aisle vault to avoid possible misinterpretation of "main arcade", which in the Tewkesbury choir with the use of the giant order more properly refers to the gallery arches.

8. N, Pevsner, B/E *Worcestershire*, (Harmondsworth 1968), 14. Both Petit, *Tewkesbury* (1848), 22, and Hartshorne, 'Tewkesbury' (1890), 294, suggest the possibility of a barrel vault over the nave but with a Romanesque clerestory. Therefore if their reconstructed vault was applied to the eastern arm a four-storey elevation would result.

9. Clapham (1934), 55, 56n.

10. *Hist. et Cart.*, 29.

11. W. Dugdale, *Monasticon Anglicanum*, II (London 1819), 53.

12. Ibid.

13. Ibid.

14. For literature see above, note 6.

15. For the plan of St. Werburg's Chester, see *The Builder*, LI (4 March 1893), between 172 and 173. For Winchester see Clapham (1934), Fig. 21.

16. Clapham (1952), 10–15.

17. Ibid. 14.

18. Ibid.

19. Benson (1946–8), 402.

20. Clapham (1952), 10–11; Benson (1946–8), 404.

21. Benson (1946–8), 494.

22. Clapham (1952), 12–13.

23. I should like to thank Professor J. Philip McAleer for drawing my attention to this point.

24. Blashill (1877–8), 102.

25. But see now McAleer (1983), especially 551–554.

26. On the east side of the third pier of the north arcade, the north and south sides of the piers in the ambulatory, and the east side of the third pier of the south arcade, the inner arches spring in part from the 11th-century corbel, in part from the Decorated main arcade capital; see Clapham (1949), Pl. VI.

27. N. Drinkwater, 'Hereford Cathedral: The Bishop's Chapel of St Katherine and St Mary Magdalene', *Archaeol. J.*, CXI (1945), 129–137.

28. I should like to thank Richard Morris for pointing out this detail. The documentation relating to the Decorated remodelling of Tewkesbury has been analyzed by Morris (1974), 142–55. He convincingly associates the work in the eastern arm with Edward II's favourite, Hugh le Despenser the younger. Construction must have commenced after 1317 when Hugh inherited the manor of Tewkesbury. In July 1321, Edward II sent him and his father into exile, from which they returned at the end of the year. At a parliament in May 1322, Despenser received back the lands taken by the coalition of the Marcher Lords in 1321, and considerably more. His downfall came when he was captured with the king at Neath by Roger Mortimer in November 1326, after which he was hung, drawn and quartered in the same month. Relating this to the remodelling of the church, Morris suggests 'that the scheme was conceived and the plans drawn up before the minor setback of 1321. Perhaps even one season's building campaign took place before that date. But the major part of the work executed in his lifetime must have taken place at the period of his greatest wealth, between regaining his estates in mid-1322 and his downfall in 1326', Morris (1974), 146. I concur with Morris' view that the remodelling of the eastern arm as a whole must have been financed by the younger Hugh le Despenser. Whether one can attribute the change in plan from the first phase to the present scheme to Despenser's period of exile is a moot point, but given just four years between his return from exile and his downfall, the decision to go ahead with the reconstruction of the choir superstructure must have been taken early on in the second campaign.

29. J. Bilson, in Clapham (1934), 52–3n; Bony (1937), 'Deux élévations...', 'A propos...'; Benson, (1946–8), 403; Clapham (1952), 11.

30. Bannister (1926), 10–16, especially 13.

31. Clerestorey windows above piers do occur in the context of the West Country School in the north nave arcade of Ewenny Priory (Glamorganshire), where the design seems to be conditioned by the desire to make the bottom splay of the windows as deep as possible while keeping the height of the nave roof level with that of the choir. Had the present windows been placed above the arcade arches then the nave roof would have been higher than the choir; conversely with clerestorey windows above the arcade arches and a consistent roof height, the bottom splay of the windows would not be so steep.

32. J. Britton, *Cathedral Antiquities of Great Britain*, III (London 1836), Pl. XI.

33. The inside of the south transept wall above the vault has been refaced leaving no sign of the opening.

34. *CA*, XC (1927), 261–70, in which Aubert gives a date in the second quarter of the 12th century for Souillac. That it is later than Tewkesbury is of no concern for the parallel and is not intended to be indicative of direct influence but rather to show typological similarity.

35. See, for example, Geay (Charente-Maritime), R. Crozet, *L'Art Roman en Saintonge,* (Paris 1971), Pl. XXVB; Talmont (C-M) *CA*, CXIV (1956), 193 and 187 for the interior of the choir; Rioux (C-M) *CA*, CXIV (1956), 129; Retaud (Charente-Inferieure) *CA*, CXIV (1956), 134–5; St-Maurice (Vienne) *CA*, CIX (1951), 325; Chalivoy-Milon (Cher) *CA*, XCIV (1931), Pl. opposite 460; Nourray (Loire-et-Cher), F. Lesueur, *Les Eglises de Loire-et-Cher,* (Paris 1969), 272–3, Pl. XXIX.

36. R. Crozet, 'Eglises romanes a deambulatoire entre Loire et Gironde', *Bull. mon.*, XCV (1936), 61–73. The church was begun after 1062 and belonged to Tournus, an interesting connection in view of the large columnar piers in both places: see Bony (1959), 42–43; Kidson (1965), 52.

37. Annales Monasterii de Theokesberia, 52, quoted in 0. Lehmann-Brockhaus, *Lateinische Schriftquellen zur Kunst in England, Wales und Schottland vom Jahre 901 bis zum Jahre 1307*, vol. II, (Munchen 1956), 560, no. 4357.

38. For Pershore see Sir A. W. Clapham in VCH *Worcestershire*, IV (1924), 159; Stalley and Thurlby (1974), 113–118, with further bibliography. The 1102 date frequently referred to in connection with the Romanesque fabric seems to have originated through the incorrect transcription of the 1002 reference to the reopening of the church following the repairs after the fire of about the year 1000, given in W. Dugdale, *Monasticum Anglicanum*, II, (London 1819), 410. The Romanesque structure can therefore be dated only by style.

39. Sir. N. Pevsner, B/E *Worcestershire*, (Harmondsworth 1968), 14, 179; M. Thurlby, 'A note on the former barrel vault in the choir of St John the Baptist at Halesowen and its place in English Romanesque Architecture', *Transactions of the Worcestershire Archaeological Society*, forthcoming.

40. Bony (1937), 'A propos...'

41. I should like to thank Christopher Wilson for drawing my attention to this detail.

42. Clapham (1924), 160. An engraving in R. Styles, *The History and Antiquities of the Abbey Church of Pershore*, (London 1838), opposite 21 shows the remains of the north transept vault before the heightening of the roof.

43. For Ewenny see C.A.R. Radford, *Ewenny Priory*, (H.M.S.O. 1976).

44. Stalley and Thurlby (1974), 113–118.

45. For Lilleshall see S. E. Rigold, *Lilleshall Abbey*, (H.M.S.O. 1969).

46. The Kilpeck apse vault is illustrated in G. R. Lewis, *Kilpeck*, (London 1852), Pl. 23.

47. See below.

48. This is discussed by P. Kidson.

49. I should like to thank J. Philip McAleer for drawing my attention to this point.

50. *Vetusta Monumenta*, V, (London 1835), Pl. XXXIX.

51. The westernmost clerestorey window on the south side of the nave is likewise set to the west of the Romanesque main arcade arch.

52. F. Eygun, *Saintonge roman*, (Zodiaque 1970), Pl. 22.

53. Ibid., Pl. 11, pp. 37–85.

54. This comparison was made by A. W. Clapham (1934), 52, 53, but he did not follow through the implications of the parallel.

55. F. Kreusch, 'Kirche, Atrium und Porticus der Aachener Pfalz', in W. Braunfels (ed.) *Karl der Grosse*, III, (Dusseldorf 1965), 463–533; L. Hugot, 'Die Pfalz Karls des Grossen in Aachen', ibid., 534–72.

56. Drinkwater (1954), 129–137; Bony (1959), 36–43.

57. Although this connection has been played down by modern writers, is it not more than coincidence that one of the closest parallels in plan for the Hereford Chapel is the oratory at Germigny-des-Pres (Loiret), built between 799 and 806 by Theodulf of Orleans, a member of Charlemagne's court circle, and which was related to Aachen by a late 10th-century writer, R. Krautheimer, 'Introduction to an Iconography of Medieval Architecture', *Journal of the Warburg and Courtauld Institutes*, V (1942), 2; W. Eugene Kleinbauer, 'Charlemagne'a Palace Chapel at Aachen and Its Copies', *Gesta*, IV (1965), 3, 7n. 19–21; J. Hubert, 'Germigny-des-Pres', *CA*, XCIII (1930), 534–568.

58. C. Lynam, 'Notes on the nave of Chepstow Parish Church', *Archaeol. J.*, LXII (1905), 271–278.

59. *Archaeol. J.*, XXXIV (1877), 323–348, Pl. opposite 328. The similarity between the nook-shafted pilasters at Hereford and those in the four western bays of the nave at Lessay (Manche), L. Mussat, *Normandie Romane: La Basse Normandie*, Zodiaque, 2nd ed. (1975) Pls. 81–3 may suggest that the Hereford choir was ribbed rather than groined.

60. Masse (1898), 51.

61. For a plan of the crypt showing the Romanesque alterations to the original scheme, added, I believe, before completion of the superstructure, see Masse (1898), 71.

62. Clapham (1934), 55, 56n.

63. See below. J. Bony, "Diagonality and Centrality in Early Rib-Vaulted Architectures', *Gesta*, XV/1 and 2 (1976), 24n 8.

64. R. D. H. Gem, 'Bishop Wulfstan II and the Romanesque Cathedral Church of Worcester', *BAA CT*, 1 1975 (1978), 34.

65. Ibid.

66. J. Ruprich-Robert, *L'architecture normande aux XI^e et XII^e siecles en Normandie et en Angleterre*, (Paris 1884), Norwich, Pl. XCII; Ely, Pl. LX.

67. Masse (1898), 22, observes that "Fosbroke, writing at the end of the last century noted that there was an inscription on the outside wall (of the south transept) making mention of one William Pipard, who was sheriff of the county about sixty years after Serlo's time." A remodelling *c.* 1160 may account for the advanced nature of some of the detailing of the south transept facade, at which time additional openings from the S.W. stair vice were cut through the original fabric.

68. See the longitudinal section of Tewkesbury in *Vetusta Monumenta*, V (1835), Pl. 39.

69. For St-Sernin, see T. Lyman, 'Raymond Gairard and Romanesque Building Campaigns at St. Sernin, Toulouse,' *Journal of the Society of Architectural Historians*, XXXVII (1978), 71–79.

70. *Hist. et Cart.*, 16.

71. Ibid., 44.

72. My thanks to Stephen Gardner for pointing out this feature.

73. J. Bilson, 'Durham Cathedral: The Chronology of its Vaults', *Archaeol. J.*, LXXXIX (1922), 125n 2.

Abbot Serlo's Church at Gloucester (1089 – 1100): Its Place in Romanesque Architecture

By Christopher Wilson

The study of Romanesque architecture in England will always be constrained by the discouraging fact that most of the great churches built in the thirty years following the Conquest have been destroyed. Ignorance of the lost buildings inevitably inhibits assessment of the importance of the survivors for the development of Romanesque as a whole, so it is not altogether surprising that the historiography of the subject should have retained to a large extent the monographic and 'archaeological' bias of Willis's pioneering studies. The present study grew out of the realisation that the chances of identifying the sources and influence of Gloucester were relatively favourable because this was among the very first major Romanesque churches in its region and also one of the few English examples of its particular building type. Since Gloucester has never been made the subject of a monograph,[1] this paper must be partly monographic in approach, but in order to give precedence to setting the building in its 11th-century context the discussion takes as its starting point the reconstruction studies reproduced in Figs 1 – 3. The structural evidence on which the reconstruction is based is set out in Appendix I. Appendix II fixes the limit of Serlo's work at the east end of the nave and argues that the elevations of the nave built in the early 12th century follow in their main lines the original scheme formulated when work began in 1089.[2]

FIG. 1. Axonometric reconstruction of Romanesque church from south-east (crossing tower turrets omitted).

THE SOURCES OF THE PLAN AND ELEVATIONS

The general format of its east end immediately marks out Serlo's church as one of the most ambitious built in post-Conquest England. Its combination of ambulatory, radiating chapels and crypt had been used three times in Normandy during the early 11th century, at Rouen Cathedral and at the abbeys of Saint-Wandrille and Mont-St-Michel.[3] The great prestige of these churches is probably sufficient explanation for the adoption of the same scheme in four English churches begun in the twenty-three years between the Conquest and the start of work at Gloucester: St Augustine's Abbey at Canterbury (begun c. 1073), Winchester Cathedral (begun in 1079), Bury St Edmunds Abbey (begun in 1081) and Worcester Cathedral (begun in 1084). When the mid 11th-century church at Gloucester was burned in 1088, Worcester was the most recent and imposing church in the vicinity and hence the most obvious model for the new building.[4] Yet comparison with Worcester highlights what must be regarded as Gloucester's greatest peculiarity. Whereas Worcester and all other first-class Norman and Anglo-Norman churches with choir galleries all have nave galleries, Gloucester has galleries in the choir but only relatively low triforia in the nave (Fig. 2, Pl. X). The triforia were actually built at some time in the early 12th century, but since the best precedent for their elevation occurs in the nave of Serlo's former monastery, Mont-St-Michel,[5] there is a good chance that Serlo was responsible for the inclusion of this feature in the original designs and that the latter had remained 'on file' until the nave could be proceeded with. The contrasting nave and choir elevations might simply reflect Serlo's aesthetic or associational preferences: a memento of his days at Mont-St-Michel coupled with an admiration for the

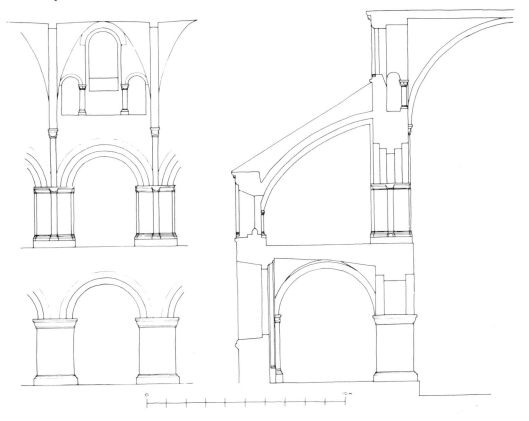

FIG. 2. Reconstructed choir interior elevation.　　　FIG. 3. Reconstructed section through north side of choir.

spacious chapel-ringed galleries of the church built by his friend and diocesan, Wulfstan. Alternatively, and even more simply, the omission of nave galleries might have been intended to help expedite the completion of the church. Perhaps one should not attempt to disentangle the pragmatic and aesthetic/associational factors behind Gloucester's unmatched elevations: the important point is surely that this conflation of what had evidently been thought of hitherto as distinct architectural types seems to have originated with the patron rather than the designer. It is inherently improbable that a designer would on his own initiative abandon nave galleries such as had always been deemed the proper accompaniment to the liturgically more important altar-containing galleries of choirs.[6]

The inclusion of galleries in the choir and their omission from the nave can be seen as the major premise underlying the design of the main elevations, for it departed from the long-established convention in Norman great church architecture that the elevations of eastern and western arms be closely matched.[7] It even precluded the more subtle equilibrium achieved in the earlier Anglo-Norman churches with crypts, ambulatories and galleries. At Worcester and St Augustine's the choirs differed from the naves in having narrow bays and columnar rather than compound supports,[8] and their overall height had to be less in order to accommodate crypts; yet despite all these differences, continuity between the two limbs was preserved by keeping their wall heads and clearstorey and gallery floors at the same levels.[9] At Winchester the choir and nave were similarly related except that the floors of their galleries were not at the same level, but even this diminution of continuity was compensated for in the supports of the lateral choir arcades, alternately columnar piers of the kind used in the hemicycle and compound piers like those in the nave.[10] The Winchester choir arcades foreshadow the Gloucester master's use of piers to play down the differences between choir and nave, though the imbalance he had to contend with was far greater than at Winchester, Worcester or St Augustine's.[11] The difficulty of the problem facing him will be appreciated when it is realised that elimination of the nave galleries from the three earlier churches would have left the naves and choirs sharing almost nothing other than the heights of their clearstoreys. Such a disparity was evidently unacceptable to the Gloucester master, and he set about avoiding it by means which, like the concept of restricting galleries to the choir, had no antecedents in Norman or Anglo-Norman architecture.

In essence his method was to unify the two elevations by including in the nave features normally found in choirs and *vice versa*. Thus the nave takes from the repertory of choir design its continuous sequence of cylindrical piers, and the choir abandons the narrow bays of the St Augustine's, Winchester and Worcester choirs in favour of the wide spacing of supports usual in naves. The wide bays continue even in the apse, where five or seven divisions had hitherto been normal. The straight sides of the apse can be set down to the impracticality of raising a semicircular wall over only three arches, and the extreme stockiness of the piers compared to earlier columnar piers in Normandy and England[12] can be seen as reflecting both the unprecedented width of the bays they define in the choir and their role as substitutes for the compound supports of earlier naves and choir galleries.[13] The drum-like character of the choir gallery piers is slightly offset by half-shafts applied at the cardinal points. These may have been thought of partly as tokens of continuity with the compound piers usually to be found in this position and partly as extensions to the responds of the high vault and gallery vaults. The contribution of these shafts to the overall effect of the interior was quite small and did not significantly detract from the basic conception that all supports be columnar, except those of the central tower.

Concern to establish visual continuity between the eastern and western arms is also evident from the systematic relation of the main horizontals in the two elevations. The floor of the choir gallery is level with the tops of the nave piers, as is the sill of the nave triforium with the tops of the choir gallery piers, and the sill of the nave clearstorey with the extrados of the choir gallery arches.[14] Thus almost all the main features of the elevations and the plan can be regarded as stemming from the designer's determination to achieve coherence despite the patron's decision to dispense with a feature which had helped maintain overall unity in all earlier Norman and Anglo-Norman churches of this class.

The previous sentence includes the word 'almost' because the theory that the design of Gloucester was conceived as the solution to a unique aesthetic problem is not entirely satisfactory. It takes no account of the chapel recently erected at Hereford for Bishop Robert of Lorraine (1079 – 1095). As Jean Bony demonstrated, this building (Fig. 4) was designed by someone familiar with the Romanesque of Lorraine, a region heavily influenced by Burgundy, where cylindrical piers were common.[15] Bony believed that Robert imported his own architect from Lorraine, but it is also conceivable that the patron was to an unusual extent his own designer, for Robert was a distinguished mathematician and astronomer, and, according to William of Malmesbury, 'omnium liberalium artium peritissimus'.[16] A possible hint at Robert's involvement in drawing up the designs for Serlo's church may be the fact that he rather than Wulfstan laid the first stone in June 1089. Certainly, the influence of the Hereford chapel and its sources explains several things about Gloucester which cannot be attributed wholly to the designer's imaginative response to his 'brief'. Firstly, the preference for cylindrical over compound piers, the latter readily usable in the wide bays of the choir as well as in the nave. Secondly, the tallness of the nave piers, which are merely magnifications of those in the main upper level of the Bishop's Chapel; unified elevations could perfectly well have been achieved by adding the height saved from the omission of nave galleries to the clearstorey[17] rather than to the main arcades. Thirdly, and most fundamentally, Hereford forges a link between Gloucester and Tournus, the outstanding surviving monument of the First Romanesque in Burgundy and the only earlier church anywhere with nave arcades on similarly elongated and bulky cylindrical piers. The connection is reinforced by the fact that the Tournus and Gloucester arcades both adjoin two-storey structures which roughly equal them in height and incorporate two tiers of squat cylinders with almost the same diameter as the nave piers.[18] Gloucester is not built in the First Romanesque technique of coursed rubble, but this does not invalidate the connection, for even at Hereford, whose First Romanesque credentials seem unassailable, the masonry technique was basically Anglo-Norman.[19]

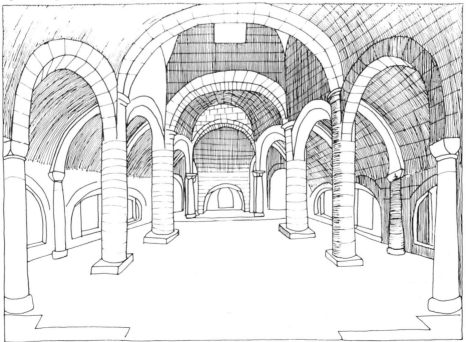

FIG. 4. The Bishop's Chapel at Hereford, upper chapel looking east (after W. Stukeley, Oxford, Bodleian Library, MS top. gen. d. 13).

The plan of the ambulatory at Gloucester (Fig. 5) is unparalleled in any 11th-century English or Norman church. Its alternately triangular and rectangular compartments have suggested to more than one scholar the Palatine Chapel at Aachen,[20] and in view of the proximity of the Hereford Chapel, which is known to have been conceived as an imitation of Aachen, the possibility of such a link cannot be discounted. Admittedly, Aachen's polygonal plan is not reproduced at Hereford, but it must have been known to Bishop Robert or his designer.[21] Another possible source is the chevet of Ste-Croix at Loudun in Poitou (c. 1062), a priory founded from Tournus and perhaps known to the Hereford master.[22] Loudun parallels closely not only the plan of the Gloucester chevet but even its drum piers with their plain annular capitals. Yet a third possible influence is Mont-St-Michel, already cited as a likely source for the nave triforium, where the choir Serlo knew was unique in Normandy in having a polygonal ambulatory, albeit with only one chapel.[23] There seems no obvious way of adjudicating between these different possibilities, and indeed there is no reason why they need be seen as mutually exclusive alternatives. Obviously, architect and client must have discussed the design, and the plan of the east end could perfectly well reflect both Serlo's remembrance of Mont-St-Michel and the architect's familiarity with polygonal ambulatories.

Aachen, Loudun and Mont-St-Michel parallel only the general conception of the Gloucester ambulatory; the detail of the plan is so irregular and so odd that it would be unrealistic to embark on a search for sources. The lack of accurate survey drawings precludes a thorough analysis of the setting out, but it is possible to explain the main peculiarity of the ambulatory, that is, its progressive narrowing from west to east. The seven-sided plan of the outer wall is generated from three sides of a regular octagon,[24] and one therefore expects the three-sided apse to conform to the same scheme. It is in fact roughly half-hexagonal and hence appreciably deeper than if it had been based on an octagon.[25] Why the half-hexagonal plan was chosen is unclear. Could it have beeen an afterthought inspired by the even deeper three-sided apses of the Worcester transept chapels?[26] Or was it due to a belated realisation that in an apse planned as three sides of an octagon the distance from the mid point of the chord to the eastern piers would be far less than to the western piers? Possibly, though no such concern is evident in the apses of the radiating chapels.

The radiating chapels have no counterparts at Aachen, and Mont-St-Michel had only a single axial

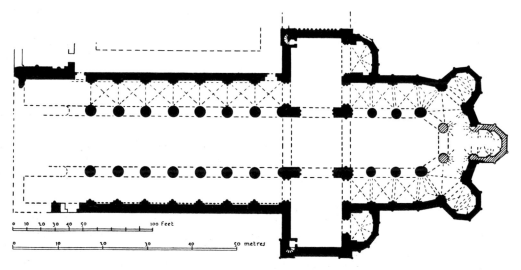

FIG. 5. Plan of Romanesque church from A. W. Clapham, *English Romanesque Architecture after the Conquest* (Oxford 1934), Fig. 10.

chapel. The only parallel for the three-sided apses of the Gloucester chapels seems to be at Worcester, where the termination of the transept chapels was probably repeated in the lost axial chapel.[27] The source of the strange asymmetrically polygonal chapels opening eastwards from the transepts need surely be sought no further than Gloucester itself. They are basically variants of the radiating chapels, and the way in which their inner walls are made to abut the choir wall at right angles instead of turning back towards the transepts exemplifies the Gloucester designer's penchant for simplifications which are bold to the point of crudity, a taste which will be found to permeate the detailed handling of the elevations.

To speak of detailing might appear odd in relation to a building where conventional niceties are so seldom observed. The drum piers of the choir (Fig. 2) are set apart from all earlier Norman and Anglo-Norman columnar arcade piers by their squat proportions;[28] and the closest parallel for the omission of rectangular elements from their capitals and bases is in the piers of the upper chapel at Hereford, where, however, there are still shallow square bases. William Stukeley's drawing of Hereford does not include enough detail to enable one to say whether the annular capitals had the same bulging torus as Gloucester's or whether they were of the simple stepped profile used at Tournus. Loudun has annular capitals with chamfered abaci like those at Gloucester but a deep pail-like main section in place of the Gloucester tori. A third near-parallel, in this case independent of Hereford, is the pair of piers under the north and south transept galleries at Winchester. The capitals here look like 'stretched' versions of the Gloucester tori, but though the piers as a whole come closer than any other Anglo-Norman arcade piers to Gloucester's squatness and elimination of rectangular elements, they still retain very shallow plinths and abaci.[29]

The piers of the apse have been referred to so far as if they were simple cylinders like all those further west. The chord piers are in fact of composite plan: a rectangle between two semicircles of the same diameter as its longer sides, the whole aligned on an east-west axis. The two easternmost piers were apparently of the same plan but less elongated, and their long axes were set tangentially to a semicircle struck from the mid-point of the chord (Pl. XIc).[30] These strange ovoid piers were necessitated by the use of wide archivolts in the arches of the main arcades and galleries. On the chord piers, the arches of the adjoining bays meet at 145° and hence the surface area on top of the capital has to be greater than that of the two eastern piers which receive arches set at 125°. It is curious that the inclusion of triple archivolts should have taken precedence over regularity in pier design, but the anomaly can be referred to the fairly widespread Norman and Anglo-Norman tendency to give archivolts more complex sections than their supports.[31]

Gloucester also followed the Anglo-Norman 'mainstream' in its inclusion of the other major concomitant of the thick wall, the clearstorey consisting of two masonry skins either side of a continuous passage. The elevation of the clearstorey probably had the stepped tripartite arrangement pioneered at Winchester and soon to become the norm in England. At Winchester the side openings have half-shafts that balance the freestanding shafts between the openings, whereas the reconstruction (Fig. 2) shows plain jambs, a detail not substantiated by existing remains but which accords with Gloucester's general 'primitivism'. A parsimonious use of half-shafts is certainly characteristic of the extant fabric at Gloucester. Even on the gallery piers, the one part of the design where they are important, the aim seems to have been to limit their impact; their segmental section minimizes their plasticity and the containment of their capitals within the circumference of the main capital looks like a deliberate playing down of their visual autonomy. These shafts and those on the outer walls of the gallery (Pl. XIA) have semicircular plinths, a form all but unknown in Norman and Anglo-Norman architecture but common in the Burgundian First Romanesque, whence it was transmitted via Hereford to Gloucester.[32] The wall-shafts of the upper chapel at Hereford (Fig. 4) virtually prove the anteriority of Hereford relative to Gloucester for they follow First Romanesque practice in being edge-bedded monoliths, whereas at Gloucester the same design is translated into the regular Norman technique of coursed ashlar. Shafts with semicircular plinths only occur at Gloucester on 'first-floor'

level, where they had occurred at Hereford; in the main ambulatory the plinths of the vault responds are of the usual rectangular form. [33]

The First Romanesque severity of Hereford was emulated at Gloucester to the extent of eliding string courses, abaci and even imposts and capitals. But whereas at Hereford all the arches which lack imposts or capitals are of rectangular section, the Gloucester master applied this device to thick roll mouldings and used it very prominently, both externally on the clearstorey and gallery, and internally round the ambulatory and chapel windows and the entrances to the chapels (Pl. XI B). Like the capitals of the piers, this seems to be a case of the Gloucester master's imitating an unusual Norman or Anglo-Norman detail on the strength of its compatibility with Hereford. Continuous roll-moulded arches are extremely rare in both Normandy and England but they do appear, unobtrusively by comparison with Gloucester, in two buildings dependent on St-Etienne at Caen: St-Nicolas at Caen (exterior of the crossing tower) and Cérisy-la-Forêt (rear arches of the clearstorey). Neither St-Nicholas nor Cérisy parallels the anomalous Gloucester trait of including bases, and no Romanesque building in Normandy or England presages the almost pneumatic aspect of the quarter-roll arches framing the ambulatory windows. [34] This particular effect was evidently a personal speciality of the designer's as it differentiates the torus mouldings of the main arcade capitals from their possible sources at Loudun and Winchester.

The final quirk exhibited by the arches round the windows and chapel entrances is their segmental curvature. Once again, there are analogies at Hereford, in the western portal and the wall arches of the upper chapel. The ultimate source may have been some mid 11th-century Burgundian building like Chapaize, whose crossing arches are of markedly depressed curvature. [35] In all probability, segmental arches began as a by-product of the First Romanesque preoccupation with vaulting, for such curves arose readily in groin vaults whose semi-circular transverse arches are deeper than their supports. In the lower chapel at Hereford and in the crypt and main aisle level at Gloucester the vault cells display this common characteristic, but whereas most Romanesque architects seem to have regarded the segmental curvatures of groin vaults as 'accidentals' with no aesthetic implications, the Gloucester master elevate them into a *leitmotiv* of his design. His use of unconventional curvatures will be considered again in the following two sections.

THE SOURCES OF THE CRYPT

The crypt (Fig. 6) is a much less original work than the choir it supports. It is of a type whose genealogy extends back at least as far as the crypt of Clermont-Ferrand Cathedral (consecrated in 946) and which had become firmly established in northern France and southern England by the 1080s. [36] The Gloucester master must have had information about some or all of the four earlier English ambulatoried crypts, for practically every element of his design can be paralleled there. The one major exception, the small number of piers in the apse arcade, is a function of the main choir design. The most obvious borrowing is from Worcester: the doubling of columns in the central space relative to the rectangular piers of the main arcade, so that the bays of the central space are alternately open and closed to the aisles. This idea is also applied in the ambulatory, but in the aisles each main arcade pier incorporates only a single respond. The ambulatory and aisles at Winchester show the same disparity. St Augustine's or Bury St Edmunds may have been the source for the planning of the central space, with its three aisles and columns planted according to a grid, although this arrangement was extremely common in Romanesque crypts throughout Europe. A puzzling feature at Gloucester is the lowness of the presbytery floor in relation to that of the aisles and ambulatory. Faced with such a severe limit on height, less unpredictable designers might have been content to copy Worcester's subdivision of the central space into four aisles covered by vaults of small span and elevation. However, the Gloucester master opted for three broad aisles and covered them with vaults of a daringly shallow profile whose geometrical characteristics will be discussed in the next section. The ambulatory and aisles are

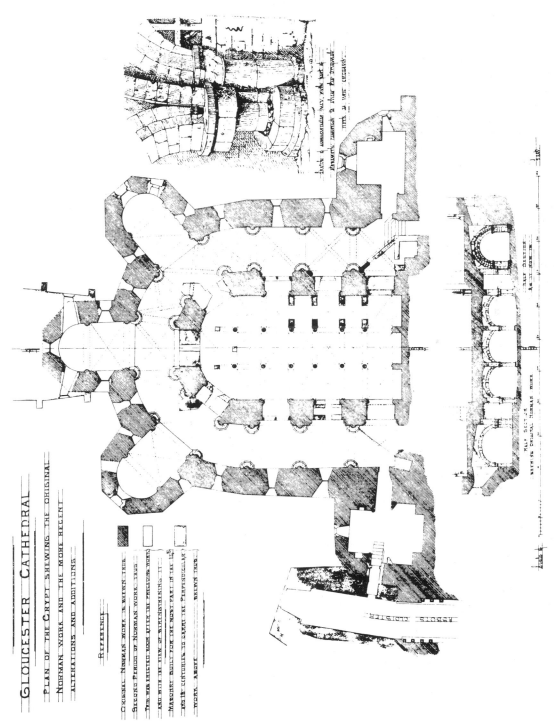

FIG. 6. Plan of crypt by F. S. Waller from *Transactions of the Bristol and Gloucestershire Archaeological Society*, 1 (1876).

traversed by segmental arches for which there are several English precedents, including the central room of the Winchester crypt.[37] However, segmental arches were an obvious and very widely employed means of overcoming the problems of restricted height inherent in the design of crypts. The Gloucester master's use of these arches outside the crypt, in the choir and transepts, is better bracketed with the west door of the Hereford chapel, whose segmental head can confidently be ascribed to the exercise of free choice.[38]

The question of First Romanesque influences transmitted via Hereford arises again with regard to the outer wall of the crypt. The continuous curvature of the interior faces of the ambulatory wall and the apses of the radiating chapels contrasts so oddly with their faceted external treatment as to suggest that the latter, along with the polygonal plan of the main apse, might be due to a change of plan. Some confirmation that the outer crypt wall was actually built curved and then reclad externally is provided by the outer splays of the windows, which change angle near the points where the new masonry might be thought to start (Fig. 6). Nevertheless, the possibility cannot be discounted that the outer wall of the Gloucester crypt is all of a piece. The ambulatory wall at Paray-le-Monial (c. 1110–1120) is also polygonal externally and curved within, and Paray may well owe this feature to some lost 11th-century Burgundian church which could also have influenced Gloucester via Hereford.[39] The double-splay windows of the Gloucester crypt recall those in the Hereford Chapel, and their discontinuance in the upper storeys suggests that Burgundian First Romanesque influence was being exerted particularly powerfully upon what must have been the first part of Serlo's church to be erected.[40]

THE VAULTS

In his elevations and plan the Gloucester master was exploring avenues of enquiry which were largely new, but in his use of vaulting he can be seen participating in one of the great collective enterprises of Romanesque architecture. Norman and Anglo-Norman achievements in this field are easily under-estimated. For, although it is clear that naves and transepts were almost never vaulted,[41] (even if it is unclear why,) the choirs, which most often received vaults, are the very parts of 11th-century churches where original fabric has most frequently been lost through later remodelling or rebuilding. It is probably safe to assume that apses were vaulted as regularly in Normandy and England as elsewhere, but the only extant high vault over rectangular choir bays which predates the start of work at Gloucester is that at St-Nicolas in Caen. The survival of this vault in a grandiose parish church built for the monks of the Conqueror's nearby foundation of St-Etienne, and to all appearances designed by the architect of the abbey church, provides strong grounds for thinking that the choir at St-Etienne itself was groin vaulted.[42] The only other high vaults known to have existed in Norman and Anglo-Norman choirs, those at Mont-St-Michel and St Albans, were probably also groin vaults.[43] Like St-Etienne, St Albans provides a precedent for Gloucester's combination of a high groin vault with a clearstorey wall passage.[44] Of course high vaults were not invariably used over the choirs of major Norman and Anglo-Norman churches: the rectangular bays of the choir at Bernay (begun c. 1008–17) were timber-roofed, as were those of three out of the four ambulatoried Anglo-Norman choirs pre-dating Gloucester, namely Winchester, Bury St Edmunds and Worcester.[45] Nevertheless, the high choir vault at Gloucester belonged to a tradition that had become well established even if not universal. The products of this tradition have fallen victim not only to later medieval rebuilding but also to technical failure, the latter accounting for the demise of Gloucester's high vault.[46]

Although the Norman tradition would have equipped the Gloucester master to design the completely vaulted choir reconstructed here, it was undoubtedly the influence of the First Romanesque transmitted via Hereford which clinched the matter. By the 1080s vaults were a far more central feature of First Romanesque than of Norman Romanesque, and in its use of vaulting over every part the Hereford chapel typified the former tradition. In fact the Gloucester choir is, at least in terms of vaulting, simply an enlarged version of the central bay of the Chapel; the groin-vaulted central vessel

and aisles corresponding to the Chapel's central 'shaft'[47] and lower aisles, and the quadrant-vaulted galleries to the aisles of the upper Chapel (Fig. 4). The quadrants in both buildings[48] are actually much smaller segments of circles than quarters, and in this and in their non-tangential springings they recall the gallery-level vaults in the rotunda of St-Bénigne at Dijon (1001 – 16) and in the narthex at Tournus. The only known Norman precedent for a groin-vaulted and galleried choir, St-Etienne at Caen, also had quadrants over the galleries,[49] but these were true or nearly true quarter-circles and hence less close than Hereford to Gloucester. Although it was clearly Hereford which provided the immediate inspiration, awareness of St-Etienne or other Norman prototypes would have provided the necessary encouragement to use the Hereford scheme on a far larger scale. The parallel cases of Caen and Hereford confirm that the Gloucester quadrants were intended to perform the buttressing function that such vaults normally do in French Romanesque churches. Admittedly, the Durham choir combined a high vault with galleries containing only semicircular transverse arches of very doubtful value as abutments, but the openings of the galleries are proportionately far smaller than at Caen, Hereford and Gloucester and were presumably seen as posing a correspondingly smaller threat to the stability of the main walls.[50]

The predominant form of vault at Gloucester, as at Hereford, is the groin vault. It is used in the aisles, ambulatory and central area of the crypt, in the aisles, ambulatory and chapels of the choir, in the transept chapels and, according to the reconstruction proposed here, in the central vessel of the choir. The south-west Midlands had already seen groin vaulting of a very high order of aesthetic and technical accomplishment in the crypt at Worcester, but, as Bilson pointed out long ago, the Gloucester groin vaults appear to mark a new departure.[51] In the Worcester crypt and virtually all earlier Norman and Anglo-Norman buildings, curvilinear groins occur whenever the adjacent sides of a vaulting compartment are not equal. This disturbing detail, the product of the intersection of two half-cylinders of unequal radius, is avoided at Gloucester, where the groins rise in a straight line from springing to crown. Straight-groined vaults of rectangular plan are in fact common in the First Romanesque and in the various national and regional traditions that grew out of and succeeded it, so the Gloucester vaults may be yet another non-Norman element transmitted via Hereford. Bishop Robert's chapel had only domical groin vaults of square plan,[52] but this does not disprove the connection, since acquaintance with his Hereford colleague would have given the Gloucester master the means of learning about other First Romanesque vault types.

In other contexts besides rectangular bays the incorporation of groin vaulting posed aesthetic and geometrical problems, and in the pursuit of solutions the Gloucester master did not hesitate to break what most of his contemporaries in England or Normandy would have regarded as rules. The lowness of the central room of the crypt prompted him to use extremely depressed transverse arches of a profile unparalleled in Norman or Anglo-Norman architecture. Correct analysis of this profile is hampered by rough execution and by distortion due to differential settlement, but it is clear that most of the transverse arches aligned north-south have haunches of much shallower curvature and therefore approximate to the apexes of very obtusely angled triangles. The transition from the haunches to the vertical is effected by blocks, many of which have soffits whose curvature is so slight that it makes them look more like cantilevers than conventional springers. Quasi-triangular arches with flattened haunches, though admittedly of less shallow profile and without the canted springer blocks, occur regularly in First Romanesque architecture from the late 10th century onwards, so the transverse arches that run north-south in the Gloucester crypt should probably be seen as a further debt to this tradition in the field of vault design.[53] On the assumption that it was intended to give all the springer blocks the curved soffits that only some of them have, the complete profile of the north-south arches can be categorised as five-centred; and even this extraordinary form finds a First Romanesque parallel in the cloister vault added to the baptistery at Lomello in the early 11th century.[54] The east-west transverse arches are mostly steeper versions of the same profile,[55] but the lunettes against the north and south walls of the central room come very close to the semi-elliptical curvature which occurs quite

often in 11th-century Norman and Anglo-Norman vaults of rectangular plan. Semi-elliptical lunettes have the merit of facilitating straight groins and eliminating the conoidal or 'ploughshared' lateral cells normally generated by the use of stilted semi-circular lunettes in this position, as in the crypt at Worcester, for example.[56] In parts of the Winchester crypt the use of semi-elliptical lunettes in rectangular groin vaults resulted in straight groins, but in other parts of the same building, and in the high vaults over the choir of St-Nicolas at Caen, twisting groins persisted. The obvious inference to be drawn from these two buildings is that some Norman and Anglo-Norman designers saw twisted groins as a lesser evil than ploughsharing, which they successfully eliminated. Some support for this interpretation is provided by the survival of semi-elliptical lunettes from the earliest known high-level rib vaults, those formerly over the choir of Durham Cathedral.[57]

The Gloucester master seems to have gone out of his way to avoid conventional stilted arches and lunettes. In the narrow rectangular bays of the radiating chapels (Pl. XID), the lateral lunettes had to be stilted in order to rise as high as the transverse arches, but the curvature of their upper parts is a more acutely pitched version of the profile used for the transverse arches aligned north-south in the central room of the crypt. Once again a First Romanesque derivation is possible, since the rotunda and crypt of St-Bénigne at Dijon made extensive use of this profile for both arches and lunettes.[58] However, it also appears in the narrow bays of the crypt ambulatory at Winchester, in a form nearer Gloucester than Dijon to the extent that it is stilted and occurs only in lunettes (Pl. XIE). Like the resemblance between the columnar piers at Gloucester and those in the transepts at Winchester, this correspondence is made difficult to evaluate by the destruction of the eastern terminations of virtually all earlier Norman and Anglo-Norman churches. Narrow bays such as tend to occur in ambulatories may have been given lunettes of this profile quite regularly, and direct influence on Gloucester from Winchester in respect of the design of lunettes is in any case unlikely considering the very different character of the arches of compound profile used in the two crypts.[59] A feature of the radiating chapels not paralleled at Winchester is the head of the blind window immediately under the lunette on the south-west side of the southern chapel. This is a close approximation to an obtusely pointed arch,[60] but the rounded top of the arch on the opposite side of the same bay shows it to be primarily a symptom of crude execution.

Over and above their geometrical peculiarities, the groin vaults at Gloucester are remarkable for the extent to which they displace other vault types. In fact Gloucester seems to be the only 11th-century church whose lesser apses at 'ground-floor' level all contain groin vaults rather than traditional semidomes. Just one earlier Romanesque apsidal groin vault has survived, that in the south transept chapel of St-Nicholas at Caen (c. 1080) (Fig. 7).[61] The other four apses and St-Nicolas are covered by

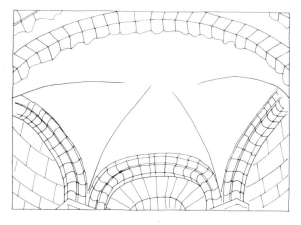

FIG. 7. St-Nicolas, Caen, vault of south transept chapel.

semidomes, as are all other Romanesque chevets in Normandy,[62] so in the context of the late 11th-century architecture of the duchy the south transept chapel vault appears as a mere flash in the pan. It is not surprising that this experiment was followed up in the far more innovatory and electic milieu of post-Conquest England. At Caen and in the radiating chapels at Gloucester the groins consist of four separate arcs, as in trapezoidal ambulatory bays,[63] and their western cells resemble the longitudinal cells of ordinary rectangular groin vaults. The six-part vaults over the Gloucester transept chapels may be the outcome of internal evolution, like the strange plan of these chapels, but it is possible that they were influenced by the lost vaults in the unique five-sided radiating chapels at Worcester Cathedral, which can hardly be reconstructed as anything other than five-cell groin vaults.[64] What appear to be the only earlier examples of five-part groin vaults are in the ambulatory of the crypt at Winchester, and probably these were repeated in the main ambulatory above.[65] But Worcester remains preferable as a source for the Gloucester transept chapel vaults, on account of its nearness and its use of the rare motif of polygonal chapels. Since the destroyed axial chapel at Worcester appears to have had the same three-sided termination as all the radiating chapels at Gloucester,[66] the immediate source of the apse vaults in the latter may also be Worcester.

A precondition for the full assimilation of an apse vault to rectangular groin vaults was that the apexes of the apse windows be set level with the crown of the arch at the entrance to the apse; only thus could the ridge of each converging cell be horizontal or nearly so. The Gloucester master's eschewal of stilted curves led him to set the springings of each apse vault at the same level as those of its windows, well above the springings of the transverse arches in the rectangular parts of the chapel (Pl. XID). The outcome is that the apse vault has the shallow segmental profile to which he was so partial. The same characteristic is still more prominent in each transept chapel where the omission of a transverse arch dividing the rectangular bay from the apse allows the whole vault to be treated as a single unit almost as shallow in profile as the apse vaults in the radiating chapels (Pl. XIB). As if to emphasise the point, each entrance arch is given a segmental curvature concentric with that of the adjoining vault cell and of a width greater even than that of the chapel itself. This virtuoso vaulting was clearly a special effort, for the apse vaults in the crypt and gallery are simple tunnel vaults unceremoniously butted up against the apse walls.

In view of the exceptionally enterprising character of the surviving groin vaults at Gloucester, it is worth speculating on the form and significance of the lost vault over the main apse of the choir. The almost exact similarity in plan of the main apse and the radiating chapel apses, as well as the probability that the straight-sided bays of the choir were covered by rectangular groin vaults of similar proportions to those in the west bays of the radiating chapels, suggest that the major and minor apse vaults were also closely akin in their design. Yet the parallel is unlikely to have been exact. The small scale of the radiating chapels precluded the introduction into their apses of shafts comparable to those in the rectangular bays, with the result that the apse vaults spring directly from the wall surface, as they do in the south transept chapel at St-Nicolas in Caen.[67] In the main body of the choir, however, the two destroyed piers of the apse gallery must surely have matched all those further west in having a single shaft continued upwards to receive a transverse arch. So the unmodified extension into the main apse of the system used in the rest of the choir would have resulted in halved transverse arches converging on the apex of the full transverse arch at the eastern limit of the adjacent rectangular bay. In other words, the main apse was covered by a rib vault. This theory cannot be tested by reference to earlier ambulatoried choirs in Normandy and England since none is well enough preserved to show whether it fulfilled the basic precondition of the solution proposed here for Gloucester, namely conformity between the apsidal and rectangular parts of the choir in respect of levels and bay divisions. There is a good chance that the Winchester hemicycle resembled Gloucester in having bay-defining vault shafts,[68] but here and at all other Norman and English ambulatoried choirs the galleries of the turning bays could have been lowered to accommodate a semidome above a clearstorey. The hemicycle of Norwich Cathedral, begun seven years after Gloucester, exemplifies this method to a limited extent

(see below). Another way of including a semidome[69] would have been to omit the clearstorey from the main apse, but there seem to be no examples of this among ambulatoried churches whose regular bay design incorporates a clearstorey, and it is in any case improbable that any designer or patron would willingly have allowed the most sacred part of his church to be the darkest.[70]

The only late 11th-century Norman church to have retained its high choir vault, St-Nicolas at Caen, is of negative interest as a parallel for the main apse vault at Gloucester since it shows how in a choir without an ambulatory the upper range of windows in the apse could be set much lower than the clearstorey of the aisled bays, low enough to allow the retention of the time-hallowed semidome. Admittedly, the base of the semidome is partly cut away by the heads of the upper windows, but these do not rise high enough to necessitate any adjustment to the form of the vault. Cérisy-la-Forêt comes closer to Gloucester in having an apse with three storeys rather than two, but here again the absence of an ambulatory allowed the designer to duck the problem which confronted the Gloucester master and to make the upper apse windows low relative to the springing of the apse vault.[71] Yet Cérisy is better than St-Nicolas as a parallel for Gloucester in that the shafts defining the bays of the side walls continue into the apse, where they can only have served as responds to ribs.[72] Instead of the Gloucester type of multicellular vault, the Cérisy apse vault was a semidome with surface ribs, very like the early 12th-century example at St-Martin-de-Boscherville near Rouen (Pl. XIF). The absence of any shafts under the ribs at Boscherville was no doubt due to the influence of St-Nicolas, the model for the rest of the choir. Although Cérisy is imperfect as a parallel for Gloucester on account of the traditional solid geometry of the apse vault, it is nevertheless a valuably early illustration of how vaults with ribs were virtually unavoidable in any church whose other vaults were groin vaults or conventional semidomes and whose main apse was divided by shafts into bays comparable with those in the rest of the choir. The only exact late 11th-century parallel for Cérisy's apse vault appears to be the extant ribbed semidome in S. Abbondio at Como.[73] The presence of groin vaults over the rectangular bays of the choir at Como and the subsequent use in Lombardy of true rib vaults may perhaps be interpreted as evidence that rib vaults evolved there in circumstances almost exactly parallel to those already postulated for the Normanno-English series. The lack of detailed stylistic and technical correspondences between the two series would seem to vouch for their independence, but the notoriously poor dating evidence for the Lombard vaults precludes certainty in the matter.

A much better parallel for Gloucester than either Cérisy or Como is the ambulatoried and clearstoreyed choir of Norwich Cathedral (begun 1096). Norwich is closely akin stylistically to Cérisy[74] and almost certainly later, but it can fairly be regarded as earlier typologically, for the shafts in the Cérisy apse are merely decorative versions of what are at Norwich part and parcel of the elevational system used throughout the church. Similarly, the ribs of the Cérisy semidome were surface embellishments, whereas those in the Norwich vault must have defined the limits of five cells converging behind the apex of the triumphal arch and lit by windows only a little less high than those in the adjoining unvaulted bays of the choir.[75] Like Cérisy, Norwich has only groin vaults and semidomes over its aisles and lesser apses. Gloucester and Norwich are the only late 11th-century English churches which preserve substantial remains of ambulatoried choirs other than in crypts, and the fact that Norwich shows absolutely no sign of indebtedness to Gloucester must suggest that rib-vaulted hemicycles were already well established by c. 1090. Assuming that the main apses of 11th-century great churches were as regularly vaulted in Normandy and England as they were in the rest of Europe, any of the ambulatoried choirs built in these lands between the 1020s and the 1080s may have had hemicycles covered by multicellular vaults, either groined or ribbed.

Apsidal rib vaults of the kind postulated for the Gloucester choir still survive in two late 11th-century English buildings. Christchurch Priory preserves no fewer than three such vaults in the parts of the church which were built during the 1090s for William II's chief minister, Ralph 'Flambard'.[76] Two of the vaults are in small and otherwise tunnel-vaulted crypts below the outer bays of the transepts, and a third covers the south transept chapel at ground-floor level (Pl. XIIA). All are identical

in technique and virtually identical in design. A detail which hints at a lack of experience in building rib vaults is the absence of a key-stone,[77] and indeed it is clear that all the vaults of rectangular plan in the aisles and transepts at Christchurch were groin vaults. The south transept chapel at ground-floor level in Tewkesbury Abbey has essentially the same kind of vault, also without a key-stone (Pl. XIIB). Its square-sectioned ribs have been crudely chamfered in the 13th or 14th century, but enough of the original tooling survives to vouch for a late 11th-century date.[78] Tewkesbury is so heavily dependent on Gloucester in its plan and elevation that some indebtedness in respect of vaulting is almost to be expected. In fact the most surprising feature of the Tewkesbury vault, the absence of shafts below the radial ribs,[79] gives the whole the look of a cross between the vault proposed here for the main apse at Gloucester and those still existing in the radiating chapels there. At Tewkesbury, as at Gloucester and all the other buildings discussed in this and the two preceding paragraphs, the regular ground-floor vaults were still groin vaults. Tewkesbury's debts to Gloucester other than its vaulting will be discussed in the next section.

Rib vaulting which results from the concern to make main apses uniform with the rectangular bays of a groin-vaulted choir is a phenomenon that appears not to have attracted the attention of historians of Romanesque architecture. If the interpretations advanced here are valid, the conclusion must be that fully developed rib vaults appeared some time before the wholly rib-vaulted choir of Durham was begun in 1093. We now have no means of knowing how soon this development got under way, but there is something to be said for seeing the Gloucester master's concern to straighten out the curvilinear groins in rectangular vaults as an attempt to endow groin vaults with one of the main characteristics of rib vaults. This is of course an exact inversion of Bilson's and Bony's conclusion that straight-groined vaults were a necessary conceptual preliminary to the creation of the first rib vaults.[80] Moreover, multicellular apsidal groin vaults of the Caen/Gloucester type may have originated as derivatives of rib vaults rather than precursors, as Bony argued.[81] After all, the designing of choirs whose main apses and rectangular bays were consistent in their elevations and vaulting ranks as a problem altogether weightier and more likely to stimulate invention than that of ensuring a uniform level for the windows and vault ridges in subordinate chapels. An obvious objection to this theory is that the earliest rib-vaulted and groin-vaulted apses differ in plan, the former with cells converging on the mid-point of the chord, the latter with a radiating arrangement. The use of both plans at Gloucester may indicate that they were thought of as interchangeable variants of the same type rather than as two distinct types with distinct applications. On the other hand, the similar positioning of the related apses within Cérisy and St-Nicolas provides grounds for thinking that Gloucester was following an established pattern in its use of rib vaults with chord-centred cells over the main apse and radiating groin vaults over the lesser apses.[82] Of course the survival rate for 11th-century apses is very low and the Cérisy and St-Nicolas examples may not adequately represent the full range of current practice. A totally different pattern could be reconstructed on the basis of the chord-centred rib vaults in the minor apses at Christchurch and the twin-centred groin vaults in the apses of the Winchester crypt, the latter construable as reflections of multicellular radiating vaults over the hemicycle and the axial chapel. One might expect the radiating type to be used in apses whose depth is more than half their span, but the extant or recoverable examples show no such correlation. In the rather shallow apses of the ambulatory chapels at Gloucester, chord-centred vaults would have been easier to accommodate than the rather cramped radiating vaults actually built there. The chord-centred cells of Gloucester's main apse could be explained partly by the near-impossibility of fitting more than single vault shafts onto the gallery piers at the chord,[83] but no such reasoning will account for the absence of analogous shafts from the western limits of the apses at Cérisy and Norwich, where there is ample space for them. Multicellular versions of the radiating type were used in all the known examples of large-scale early 12th-century English and Norman apsidal rib-vaults, namely those in the choir at Peterborough (begun in 1118) and the chapter houses of Jumièges (before 1127) and Durham (completed c. 1133–41).[84] Apse vaults of the Gothic period are almost invariably of this type.[85]

The theory advanced above that groin-vaulted apses originated as a back-formation from rib-vaulted apses may help explain the extreme rarity of the former. While Normandy reverted to semidomes, some architects in England favoured the new vault types even to the extent of using the most innovatory of them in relatively unimportant places. It is possible that to the Gloucester master his main apse vault was less important as a novel concept in its own right than as a means of breaking with the tradition of contrasting elevations in apses, choirs and naves. Be that as it may, there is a good case for thinking that fully developed rib vaulting made its first appearance in the apse of some 11th-century ambulatoried great church, not necessarily Gloucester, where it was recognised as the basis for a new approach to vault design either by the architect of the Durham choir or by some near-contemporary whose work has been less fortunate. Such a theory also offers an explanation for the numerous ribbed semidomes in the apses of 12th-century French churches and perhaps also for their 11th-century North Italian precursors.[86] To envisage the origin of rib vaulting as a process whereby a form originally proper to apses was progressively extended westwards, firstly to choirs and eventually to naves, is itself only an extension of the generally accepted view that earlier and simpler types of vault had at first been confined to the most sacred parts of churches and only gradually came to cover whole interiors. The loss of so many of the greatest churches built in England in the quarter century following the Conquest prevents one from saying whether the vaults in the choirs at Gloucester and Durham represent new departures or whether they are merely the earliest evidence of a trend initiated elsewhere.

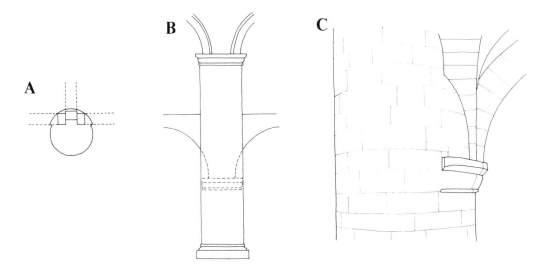

FIG. 8. Tewkesbury Abbey, choir arcade. A: Reconstructed plan of arcade springing level, B: elevation of pier to choir C: Lateral view of springing. A and B are not to scale.

THE INFLUENCE OF GLOUCESTER IN THE SOUTH-WEST MIDLANDS

It has long been recognised that Gloucester and Tewkesbury are more closely related than any other two Romanesque churches in the south-west Midlands. Obvious points of resemblance between them are the plans of their choirs and transepts and the elevations of their naves, and in the preceding section of this paper the analogies have been extended to the realm of vault design. A comprehensive definition of the relationship is hindered by the disappearance of even more of Tewkesbury's choir than of

Gloucester's. Discussion has centred around the upper parts of the elevations, where the evidence is at its most fragmentary. Most scholars have favoured the so-called giant order, a series of cylindrical piers supporting arcades at two levels, the lower arcade occupying a plane further from the central axis of the choir than the upper arcade. According to this theory, Tewkesbury was the prototype of designs like the choir at Jedburgh, the eastern bays of the Romsey nave and the main elevations at St Frideswide's, Oxford. What appears to be an echo of this system is found on the east, north and south walls of the transept at Tewkesbury, where deep pilasters rather than columns receive upper and lower arcades in two planes.[87]

The case for tall columnar piers in the choir can be regarded as proven,[88] but some comments on the form of the main (lower) arcades are necessary in view of the conflicting interpretations advanced in the literature. The original capitals occur, as one would expect, at the same level as those of the surviving vault responds on the aisle walls. Quite unexpectedly, however, the capitals extend round only about one-third of the circumference of the piers, with which their upper edge is not quite concentric (Fig. 8a). Above the capitals, the original surface of the piers does not reach round to the springings of the 14th-century aisle vault but ends in curved lines connecting the upper edge of the 11th-century capitals to the base of the 14th-century capitals from which the main arcades now spring. Between these lines and the springings of the Gothic aisle vaults there are in some cases very rough masonry inserts and in others smaller radially jointed stones dressed back to conform to the cylindrical surface of the pier. In the axial bay these stones have been partly recut to form a vertical moulding at the springing of the 14th-century arcades, but what remains of their vertical eastward-facing surface retains Romanesque tooling. These and their less well preserved counterparts further west can only be the lowest voussoirs of the Romanesque arcade, and the curved lines on every pier must represent their junctions with the curving surface of the drum. As Figs. 8a, b and c show, such a curved junction would be generated by the springers of an arcade whose span exceeded the intercolumniation and whose lowest voussoirs were mostly embedded within the piers. What there is now no way of discovering, since the 14th-century capitals curtail the curved junctions of piers and arcades, is how thick the latter were.[89] In Fig. 8a, b and c it has been assumed that the front edges of the arcades as seen from the central vessel were aligned with the front edges of the capitals and so did not quite coincide with the shortest distance between neighbouring piers. The end result, and presumably also the purpose of this strange arrangement, was to play down the visual impact of the arcades when seen from the central vessel and thus to enhance the similarity of the choir piers to the simple cylindrical supports in the nave. This concern that the main choir and nave elevations should be as similar as possible, despite the presence of a gallery in the former and the absence of one in the latter, provides a sequel to the designing process at Gloucester which is so exact as to suggest that the Tewkesbury master had understood the thinking of his Gloucester colleague and was applying it even more rigorously here.[90] Presumably the monks of Tewkesbury gave their sanction to the Gloucester-derived conjunction of galleried choir and ungalleried nave, but if the foregoing interpretation is correct, credit for the innovations of the choir elevation must go to the designer rather than the patron.

The imaginative leap represented by the Tewkesbury choir elevation was less prodigious than comparison with only Gloucester would suggest. The Bishop's Chapel at Hereford, the single most important source of inspiration for the detailed handling of Gloucester, also exerted a powerful influence upon Tewkesbury. As Jean Bony observed, the piers of the upper chapel form a link between the piers in the narthex at Tournus and Tewkesbury's giant order.[91] Hereford's abrupt junctions between the lower arcades and the drum piers are just as at Tournus,[92] and also anticipate the way in which the greater part of Tewkesbury's lower arcade springs directly from the curved surface of the piers. Over and above details, the resemblance of Hereford and Tewkesbury resides in the use of tall columnar piers with annular capitals to carry arcades at two levels, the lower arcade being far thinner than the piers. Tewkesbury's debt to Hereford extends right to the west end whose giant niche is an enlarged and elongated version of Hereford's Aachen-derived west entrance (Pl. I).[93]

The direct influence of Gloucester can be seen in the double ranges of drum piers in the nave of Shrewsbury Abbey (c. 1095–1100),[94] in the single ranges at Great Malvern (c. 1095–1100) and even in the cathedral at Hereford (begun c. 1107–15), where the choir galleries have half-drum responds and the nave has low drum piers under a triforium clearly modelled on that in the Gloucester nave.[95] The high piers in the naves at Pershore and Evesham should probably be counted as following Tewkesbury. The continuously roll-moulded arch is the only part of Gloucester's legacy which can be classed as decorative. It was to enjoy a great vogue in the south-west and Wales throughout the 12th century, reaching its peak in the last three decades at Worcester, Wells, Glastonbury, St David's and Llanthony.

Drum piers and continuous mouldings apart, Gloucester's most enduring contribution to the region's architecture was its use of vaulting over main spans, but since this was emulated at Tewkesbury, probably in all four arms, Gloucester cannot be regarded as the immediate source of all the relatively many high vaults in the south-west Midlands.[96] The type of vault raised over the eastern arm at Tewkesbury is unknown since all that remains is the line of its junction with the east face of the crossing tower. There are no grounds for supposing that it was a tunnel vault, even though there is good evidence that the transepts originally had this kind of covering.[97] The status of the sanctuary as the liturgically and symbolically most important part of the church means that its vault as well as its elevations could well have been more complex and impressive than those the transepts, for unaisled 11th- and early 12th-century transepts are, almost without exception, plainer and less rigorously articulated than the choirs they adjoin. A choir vault on the Gloucester model would allow the existing south transept chapel vaults to be seen as part of a coherent scheme rather than as an isolated novelty.[98] A groin-vaulted choir implies a clearstorey[99] and this in turn enables the apparently purposeless passages above the transept galleries to be assigned the role of links between the passages of a Winchester-type clearstorey in the eastern arm and the spiral access stairs in the outer eastern angles of the transepts. An analogous arrangement is in the surviving transept at Hereford Cathedral, where a passage runs along most of the east wall to connect the choir gallery with the stairs at the outer western angle.[100] The passages above Tewkesbury's nave arcades are obviously not explicable as functions of the choir clearstorey. They and the tunnel vault which sprang directly over them are features without precedent in the nave of any Norman or English great church, and it is very likely that they represent a change from a relatively conventional clearstoreyed scheme to a version of the transept design. Certainly, the proportions of the nave elevations are sufficiently different from those of the eastern parts to allow one to postulate a pause in building and a revision of the original scheme: the piers are much more closely spaced than in the choir, there is more plain wall over the arcades and the paired openings of the passages have become taller than in the transept. The nave of Durham Cathedral parallels not only the extension of vaulting into a vessel originally intended to be wooden-roofed but also the adoption of features originally conceived as expressions of the lesser status of the transept relative to the choir.[101] Tewkesbury in its final form became the model for Pershore, where both transept and nave were tunnel-vaulted and without clearstoreys.[102]

CONCLUSION

Simply through having survived, Serlo's work at Gloucester possesses great significance. The choir is not only the oldest ambulatoried choir still standing in Normandy or England but the earliest great church choir of any kind on this side of the Channel. Its isolation inevitably rules out any definitive assessment of its place in Romanesque architecture, but the study of elements for which analogies exist elsewhere has shown that Gloucester was an extremely individualistic building, even by the standards of the era which produced the west front of Lincoln and the eastern parts of Durham and Tewkesbury. Much, though by no means all that is not Norman about Gloucester is due to the influence of the First Romanesque manner employed at the Bishop's Chapel in Hereford. The fact that this little building

could exert so profound an influence on the great churches at Gloucester and Tewkesbury highlights the sparseness of the architectural landscape of the south-west Midlands in the late 11th century. If the region had supported a longer established and more productive tradition of Romanesque architecture it is very doubtful whether the appearance of such an 'exotic' would have had anything like the same effect. That the frontier character of this milieu was the source of its creative vigour is also illustrated by the Gloucester master's purposeful exploitation of apsidal groin vaults, a form invented in Normandy but totally ignored there. If Gloucester has been overshadowed in the minds of architectural historians by its still more original and imposing neighbour at Tewkesbury, this merely testifies to the importance of the earlier building, for Tewkesbury is inconceivable without Gloucester, even allowing for its parallel and independent borrowings from Hereford. In the long run, the Gloucester-Tewkesbury concept of unifying interiors through reducing numbers and kinds of elements proved to be less enduring than the systematically articulated designs stemming from St-Etienne at Caen, a tradition whose dominance was eventually reinforced by its more obvious capacity to accommodate the rib vaulting which Gloucester may well have pioneered.

APPENDIX I. THE STRUCTURAL EVIDENCE FOR THE DESTROYED PARTS OF SERLO'S WORK

The remodelling of the choir and transepts c. 1330–73 involved the destruction of Romanesque fabric by four distinct processes. (1) Demolition of the main apse, together with the axial chapels and those parts of the upper and lower ambulatories directly to the east of the apse, in order to make room for a two-bay extension of the central vessel. (2) The 'decapitation' of the central vessel above the galleries to make way for new clearstoreys and high vaults. (3) The insertion of new windows, usually but not invariably where there had been windows in the Romanesque church. (4) The removal of ashlar from the main elevations and its replacement by Perpendicular tracery and vault shafts, a process which, incidentally, could not have been carried out successfully unless the corework of the Romanesque structure had been unusually well built. The remodelling was concerned primarily with the interior and was undertaken in three separate phases, each confined to a separate arm of the church. To these circumstances is due the survival of a modicum of Romanesque masonry above gallery level, enough to allow a partial reconstruction of the clearstorey. Another peculiarity of the remodelling which is fortunate from the point of view of recreating the appearance of Serlo's work is the extensive reuse of salvaged Romanesque elements.

THE CRYPT

The 14th-century builders hardly touched the crypt except to add masses of masonry to support the high altar screen and the new piers flanking it. The much more extensive reinforcements added in the early 12th century were successfully disentangled from the original work by the cathedral architect F. S. Waller in 1876.[103] What has not been mentioned before in print is the differential nature of the settlement which led to the 12th-century strengthening. On the south side, the arcade wall has sunk about 40 cm more than on the north, a variation sufficient to have brought about the failure of the high choir vault. The whole outer south wall leans outwards, a fact best appreciated in the choir gallery, where the tracery inserted into the Romanesque window apertures is perpendicular in the ordinary sense.

THE 'GROUND-FLOOR' PLAN OF THE EASTERN ARM

The general plan of the destroyed axial chapel, outer ambulatory walls and eastern apse piers can be extrapolated from that of the crypt. Confirmation that the detailing of the lost parts was uniform with the rest is provided by fragments reused in the 14th-century work.[104] Bilson and Clapham reconstructed the eastern apse piers as cylinders matching those in the lateral choir arcades,[105] but a detailed plan made immediately after the removal of the early 19th-century reredos in 1872 shows the footings of the piers as irregular ovoids (Pl. XIc). Recently, Canon Welander noticed that some Romanesque ashlars with curved faces cut to the same radius as the lateral arcade piers had been reused on the inside of the Perpendicular raising of the south gallery wall. These can only be parts of the eastern apse piers. Taken together with the 1872 plan, they allow a reconstruction of each lost pier as two half-cylinders linked by a straight section, a more compact version of the very elongated piers at the chord.

THE ELEVATIONS OF THE CHOIR ARCADE AND GALLERY

The original appearance of the main arcade can be recovered simply by supplying the pier segments and the parts of the arch orders cut away in the course of the 14th-century refacing of the main elevations (Figs. 2, 3). Whether the division between the two storeys was marked with a string course cannot now be known. The gallery arches have lost an arch order like the four which remain, and the segment cut from the piers must have included a shaft matching the three survivors. On the

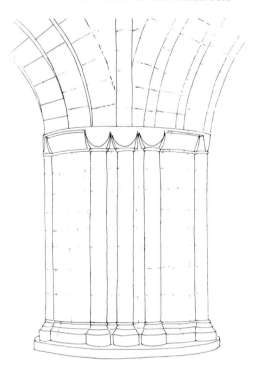

Fig: 9. Reconstruction of south face of gallery pier at north-west angle of apse.

northern chord pier a shaft appears through a gap in the Perpendicular refacing, so it is clear in principle that there were shafts towards the central vessel, even though, as will become apparent, the chord piers were a special case. The other shafts on each gallery pier either receive the innermost order of the arches or are extended upwards to meet the soffits of the quadrant transverse arches of the gallery vault. The shafts facing the main vessel must have performed some function, and it need hardly be doubted that they resembled the shafts towards the gallery in being prolonged upwards to receive the transverse arches of the high vault. It is even possible that the other three shafts on each pier were conceived primarily as decorative echoes of that facing the main vessel. This would at least offer an explanation for the uncharacteristic fastidiousness shown in the introduction of shafts to receive the quadrant arches in the gallery, a feature not paralleled in the galleries of the otherwise far more elaborately articulated nave of St-Etienne at Caen.

 The shaft exposed on the south face of the northern chord pier can never have continued above capital level, for it would have been obstructed by the outer order of the gallery arch in the northern canted bay of the apse. Since its coursing ranges with that of the rest of the pier, it must be *in situ*. The most obvious explanation is that it was placed here to offset the abnormal bulk of the pier. Symmetry towards the main vessel would be achieved if another shaft were included at the same distance from the western shaft as that which separates the eastern shaft from its neighbour still exposed on the south face (Fig. 9). Between the two 'decorative' shafts there is room for a third, continued up to the vault. The gallery sides of the chord piers also have more than the usual complement of shafts, although here the reason is the paired transverse arches bounding each triangular bay of the gallery ambulatory (Pl. XIIc).

THE CLEARSTOREY

The original wall head of the transepts and eastern arm is fixed by evidence on the north side of the stair turret at the south-east angle of the south transept (Pl. XIID). The 14th-century parapet above the east clearstorey partly blocks a small door (about 1.2m high) which originally gave access onto the leads of the roof. The wall head must have been within a few centimetres of the sill of this door, which is 20.19m above the level of the south transept floor (hereafter referred to as the datum). That the door is at the upper limit of the 11th-century work is confirmed by the use of finer tooling above this level inside the stair turret. Externally, the change to the early 12th-century work begins a little lower down, at the base of the

decorative arcading. Below the door to the leads is a buttress representing the residue of the thick Romanesque clearstorey wall. It retains a length of string course whose profile and level (17.67 m above datum) are matched exactly on the only other fragment of the original clearstorey, in the angle of the presbytery and the north transept (Pl. XIIE). Here the string course defines the lower limit of a decorative blind arcade 1.18 m high which ran northwards along the east side of the transept and eastwards along the north choir clearstorey. The string course above the arcade is about 1.30 m below the sill of the door to the south transept leads, but the proximity of the wall head is affirmed by the rounded overhanging base of the cylindrical north-east turret of the Romanesque crossing tower. Unrefaced parts of the north-west turret remain in the main nave roof space.

Comparison with Tewkesbury might suggest that the arcading on the clearstorey extended round the whole of the eastern parts except the transept facades and that the string course at its base marked the junction of the gallery roofs with the walls of the main vessels. However, there is good evidence that the external elevation of the clearstorey extended well below the base of the arcading and that the latter was interrupted by windows lighting each bay. Nothing survives of these windows *in situ*, but some parts of the nook-shafts which almost certainly come from their external jambs were reused in the east clearstorey of the south transept and the south clearstorey of the choir. Some of the nook-shaft bases match closely those on the surviving fragment of the clearstorey arcading, and the diameter of their shafts is also close (16 cm). The original roofs of the choir and transept galleries have left no traces, but the level at which they met the clearstorey walls can be established on the basis of the weathering for the pre-1100 nave aisle roof, surviving on the west face of the north transept (Pl. XIIF). Evidence that the roofs of the nave aisles were originally to have matched in height and pitch the choir and transept gallery roofs is the very close correspondence between the heights of the wall heads supporting those roofs and the exact correspondence between the springing levels of the choir quadrant vaults and the quadrant arches at the east ends of the nave aisles. The buttress in the angle with the north transept ends about 30 cm below the sill of the door to the south transept leads, and if one allows for a corbel table as deep as that preserved on the north radiating chapel of the choir, the correspondence would be exact. Thus the choir and transept clearstorey (and the original design for the nave clearstorey) must have been close to 3.25 m high, high enough to include windows of reasonable proportions. The continuously moulded and chevron-decorated arcading reused on the famous 'bridges' that maintain gallery-level circulation east of the radiating chapels must have been part of the 12th-century rebuilding after the failure of the original vault, for the width of each arch is the same as that of the *in situ* fragment of the original 11th-century arcading. The daintily scalloped jamb shaft capitals reused on the south choir clearstorey are further evidence for the extent of the later Romanesque rebuilding of the eastern arm. It is most unlikely that so much of the original design would have been followed in the early 12th century if it had made no provision for windows. The arcading must have been broken up into short runs by the windows, whose width is of course unknown. The clearstorey window heads are shown in figure 2 as if they sprang at the same level as the heads of the external blind arcading. This interpretation is based on the exact correspondence in level between the tops of the jambs in the arcading and the string course on the north nave clearstorey (Pl. XIIF) which must have marked the springing points of the windows before their remodelling in the 15th century. This string course is already provided for on the easternmost clearstorey buttress that probably marks the western limit of Serlo's work at this level. The motif of blind arcading was not used on the nave. The string course under the arcading on the choir occurred half way up the jambs of the windows. Assuming that there were no buttresses, as at Tewkesbury, it is likely that there were six arcading units between each window.

All that survives of the clearstorey passages are their entrances from the stair turrets at the eastern angles of the transepts. These ascended behind the haunches of the adjacent gallery arches, and therefore nothing survives of the passages at their normal height. Obviously their floor cannot have been set below the top of the gallery quadrants,[106] and if one assumes that it just cleared these vaults, the amount of plain walling left above the gallery openings would exactly equal that existing over the main arcades.

The only elements to have survived from the internal structure of the clearstorey are three freestanding colonnettes reused as responds to heavy quadrant arches added under the transept gallery vaults in the early 12th century (Pl. XIA). Their awkward relation to the arches they carry, as well as their detailing and finish, prove that they are salvaged 11th-century pieces. The greater part of each shaft is a monolith 28 cm in diameter, the southern one being the highest at 98 cm. Probably the monoliths accounted for the whole shaft originally, in which case the supplementary pieces will have come from other shafts. The reuse of these colonnettes in the early 12th century vouches for their provenance from the clearstorey, the part of the building most vulnerable to settlement, rather than from any lower parts such as the passages leading from the transept vices to the galleries. The monoliths are in themselves evidence that the clearstorey was modelled on Winchester, for in the Winchester transepts the clearstorey shafts are nearly all similarly proportioned monoliths (about three and a half diameters) while the shafts carrying the paired arches in the galleries are coursed. The Gloucester colonnettes cannot easily be seen as evidence for the Tewkesbury type of triforium, since the transept triforia there, the earliest and hence the closest to Gloucester in date, have shafts which are not only far squatter than those at Gloucester (about one and a half diameters) but are also coursed. The later triforia in the nave and crossing tower at Tewkesbury have taller shafts made of more courses.[107]

THE HIGH VAULT OF THE CHOIR

The demolition of the crossing arches in the 14th century has removed the most obvious means of ascertaining the springing level and curvature of the high vault. Fortunately, in 1908 a voussoir of the outer order of the east crossing arch was

discovered two or three inches (5 – 7.5 cm) behind the face of the north-east crossing pier. Since the cathedral architect of the time, F. W. Waller, considered the voussoir to be close to the springing,[108] it would appear that the crossing arches sprang either at the level of the extrados of the gallery arches (still visible between the uprights of the Perpendicular blind tracery) or that the bases of the vault shaft capitals were at this level. The latter seems the more likely, as the paired Romanesque shafts on the north and south crossing piers survive to this same level. The recessing of the springing of the outer parts of the crossing arch behind the face of the pier was no doubt due to the inner order's being deeper than the shaft receiving it, as in the transverse arches of the choir aisle and gallery vaults. The absence of capitals below the outer order is matched on the arcade and gallery responds integral with the east crossing piers.[109] It seems reasonable to assume that the springings of the transverse arches of the high vault ranged with those of the crossing arches. Their span would be the same as that of the inner order of the east and west crossing arches.

Fig: 10. Diagrammatic reconstruction of Romanesque wall passages in south transept.

THE TRANSEPTS

The east elevations of the transepts were remarkable for the way in which the entrances to the eastern chapels were emphasised at the expense of the openings into the choir aisles and galleries. Although the main sections of the 'ground-floor' chapels are not much wider than the aisles (5.51 m as against 4.94 m), their entrances attain a width of about 7.30 m, some 2.96 wider than the arches to the aisles[110] and 0.34 m wider than the north and south crossing arches. These entrance arches are further distinguished from the other arches by heavy continuous roll mouldings. The gallery-level chapels had unmoulded arches of the same width as the inner order of the 'ground-floor' chapel arches. In the south transept all the arches except that into the choir aisle have been reinforced by the insertion of much narrower arches. The settlement of the south side of the choir was accompanied by an outward movement of the entire east wall. This is now effectively disguised by the Gothic remodelling, but one can still see how the 14th-century builders had to cut away some upper parts of the south-west crossing pier in order to install upright vault shafts and tracery. The south-west angle turret is also badly out of plumb.

The terminal walls and west walls have been more drastically remodelled than the east walls, where at least the major openings were retained. The insertion of large windows in the terminal facades has removed not only the original windows but also the passages which linked the galleries and clearstoreys of the eastern parts to the vices at the outer western angles of the transepts. How these passages were treated in elevation cannot be known now, but their levels are preserved by the openings into the vices at all four outer angles. The arrangement of these passages is shown in Fig. 10. On the parts of the west angle turret which jut into the north transept there are 12th-century string courses at each inward contraction.[111] The presence of string courses high up on the turret proves that in the early 12th century there was no tunnel vault comparable to those in the transepts at Tewkesbury and Pershore. It also indicates a substantial remodelling of Serlo's work, as do the large numbers of chevron-decorated voussoirs and jamb stones reused in the 14th-century work, particularly on the end gables and around the windows of the south transept. This remodelling could have been occasioned either by the failure of original vaults or by the burning of a wooden covering in the serious fire of 1122.[112] It may be assumed that the transepts acquired rib vaults by the time that those in the nave were under construction. The west walls of the outer bays were recessed considerably in relation to the arches of the inner bays, as is clear from the extensive original ashlar at the back of the Perpendicular blind tracery. For the quadrant arches formerly between the transepts and the nave aisles see Appendix II.

APPENDIX II THE WESTERN LIMIT OF SERLO'S WORK

In many Norman and Anglo-Norman monastic churches a major pause occurred in the works as soon as enough of the fabric had been completed to enable the monks to use the presbytery and liturgical choir. At Gloucester the eastern arm and transepts could not have been put into service before the building of the stair turrets at the outer west angles which give access to the clearstoreys and galleries. Equally, the stair turrets could not have been built independently of the west walls of the transepts. The choir stalls stand, as they have always stood, under the crossing tower, and it is the adjoining part of the nave, the easternmost bay, which preserves evidence for a protracted cessation of work, followed by a radical revision of the design. The successive phases will be described as they survive on the north side of the nave because the evidence is clearer there on account of the survival of the 12th-century vault.

PHASE 1

As first built some time shortly before 1100, the arch between the north aisle and the north transept was a quadrant springing from paired shafts on the outer aisle wall and meeting the crossing pier above a matching pair of shafts. The quadrant itself has gone, but the plain cushion capitals from which it sprang remain against the north wall (Pl. XIIIB). On the crossing pier paired shafts disappear through the vault cell (Pl. XIIIA), but in the roof space above the vault the western shaft reappears, in company with the dosseret which in the nave aisle separated it from the east respond of the north nave arcade (Pl. XIIIC). The scalloped capital of the western shaft is very close to the underside of the present aisle roof, and it is obvious that a quadrant, even of the shallowest curvature, could never have fitted in between capital and roof. The higher roof indicated by the weathering on the west wall of the transept (Pl. XIIIF) would have accommodated the quadrant, but with virtually no room to spare. Compatibility with the quadrant vaults over the choir galleries was clearly intended, as their springing points were exactly level. However, the apex of the nave quadrant, as preserved by the capital against the crossing pier, is about 25 cm higher than in the choir galleries. This variation, taken together with the lack of room for vault cells under the aisle roof as originally planned, can be seen as a clear indication that there was to have been no vaulting over the nave aisles. There is nothing to show whether the original designs provided for a series of quadrant diaphragm arches between the aisle bays (such as may have existed in the nave at Tewkesbury), because all the responds to the west of the easternmost aisle bay belong to the early 12th-century (Phase 2). Diaphragm arches or not, the aisle roofs would have been visible from below.

The quarter-shaft between the responds of the quadrant and the north-window of the east bay originally continued round the aisle window, like the continuous roll mouldings round the choir aisle and ambulatory windows. The half-cylindrical east responds of the nave arcades probably represent a revision of the original design made before 1100, as the analogous west responds in the choir arcade and gallery are rectangular with paired shafts. There is no reason to suppose that the freestanding arcade piers had ever been planned as anything other than cylinders. The greater diameter of the nave piers compared to the choir piers is presumably a function of their greater height. The only other pre-1100 revision to the designs of 1089 is embodied in the buttress at the east end of the north clearstorey. As was shown in Appendix I, the clearstorey of the choir and the east side of the transepts had neither buttresses nor any other kind of vertical bay division. The undecorated base of the east buttress indicates that it was built in anticipation of a roof fitting under the weathering on the west wall of the transept.

Except for the east responds of the arcades, no part of the main nave elevations was built before 1100. The floor of the nave clearstorey passages are about 1.25 m below those in the choir, and it seems likely that the decision to make them lower was taken at the same time as the decision to reduce the pitch of the aisle roofs. Adjustments to the design of the triforium could have been made at this point, but if so they are likely to have been minimal, given the plentiful plain walling over its only English antecedent at St Albans and over the arcade and gallery in the choir at Gloucester.

PHASE 2

The main change wrought in Phase 2 was the introduction of rib vaulting into the aisles as part of a design entailing the use of rib vaults throughout the nave. The western shafts of the two pairs under the quadrant arch were commandeered as responds for the easternmost transverse arch, and for this purpose capitals were inserted into the shafts at the level of the main arcade capital. On each capital one voussoir of the transverse arch remains in place. Above these are traces of voussoirs roughly dressed back when the transverse arch was removed in the 14th century. When the transverse arch was in position it would presumably have carried a wall obscuring the 11th-century western capitals and the western half of the quadrant. The eastern capitals and the part of the quadrant over them would remain visible from the transept. Responds also had to be improvised for the diagonal ribs of the vault. In the north-east corner of the east bay a respond for the diagonal rib was improvised by inserting a capital into the quarter-roll moulding originally intended to frame the north window (Pl. XIIIB left). The new vault responds (Pl. XIIID left) receive wall ribs as well as diagonal ribs and transverse arches, and therefore project farther into the aisle than their makeshift counterparts at the north-east corner. At the south-east corner (Pl. XIIIA) the diagonal rib rests mostly on the west respond of the arcade but partly on an impost inserted into the Phase 1 masonry at the same time as the transverse arch capital. No attempt was made to match the abacus and necking of the impost to those of the capital of the east arcade respond. The rear orders of the arcade arches were kept rather shallow so as to leave room for the aisle vault springers, whence it follows that the arcade belong wholly to phase 2.

PHASE 3

During the remodelling of the north transept in 1368–73 the easternmost transverse arch of the Phase 2 rib vault was demolished along with the adjoining vault cell. It was rebuilt at a higher level so that it should not obstruct the openwork tracery applied to the west elevation of the transept.

PHASE 4

In the 15th century the easternmost aisle window was replaced by a larger one (Pl. XIIId). At the same time the Phase 2 wall rib gave way to another, lacking a respond on its east side, as its predecessor must have done. The wall face was brought forward so as to obscure the jambs beside the window frame-cum-diagonal rib respond. The north cell of the vault was rebuilt higher and with a ridge rib.

ACKNOWLEDGEMENTS

I would like to record my great indebtedness to Canon David Welander, who facilitated in every possible way my examination of the Romanesque fabric. I am also most grateful to Dr Maylis Baylé, who gave me the photograph on which Fig. 7 is based.

REFERENCES

(SHORTENED TITLES USED)
(See also LIST OF ABBREVIATIONS AND SHORTENED TITLES, iv above.)

BILSON (1899)–J. Bilson 'The Beginning of Gothic Architecture', *RIBA Journal*, VI (1899), 259–319.
BONY (1939)–J. Bony 'Gloucester et l'origine des voûtes d'hémicycles gothiques', *Bull.mon.*, XCVIII (1939), 329–31.

1. Gloucester is almost the only major late 11th-century English church not to have been accorded an important publication by either Robert Willis or John Bilson. From Willis we have only a summary of an address delivered to the Archaeological Institute at Gloucester in 1860; *Archaeol.J.*, XVII (1860), 335–42. Bilson was working on a very detailed study of Gloucester during the 1920s, but for some reason he never brought it to completion. The use of a draft of this article, which was intended to be published in the Archaeological Journal, was acknowledged by the Dean of Gloucester, Henry Gee, in an address of 1921; *Trans. BGAS*, XLIII (1921), 37–56. Nevertheless, it is clear from Bilson's notebooks (R.I.B.A. Drawings Collections, Bi J/1.2.92, 95) and from drawings intended as illustrations to this article (R.I.B.A. Drawings Collection, box X/15, folder 26) that he was still collecting material in 1926. J. C. A. Thompson, *The Norman Architecture of Gloucester Cathedral, formerly the Abbey of St Peter*, Ph.D. thesis, Johns Hopkins University, 1977 (University Microfilms International, Ann Arbor, 1977) may be mentioned as the most recently published work devoted wholly to Romanesque Gloucester. The present article began as a medieval research seminar paper given at the Courtauld Institute of Art in 1970.
2. This date and the rest of the chronology of the Romanesque church derive from the history of the abbey written at Gloucester in the late 14th century; *Hist. et Cart.*, 8–19.
3. The crypts at Rouen and St-Wandrille extended under the whole eastern arm, like the Anglo-Norman examples, although unlike the latter, they were without an arcade between ambulatory and central section; G. Lanfry, *La cathédrale dans la cité romaine et la Normandie ducale* (Rouen 1956), 20–36; M. Aubert, 'Les fouilles de Saint-Wandrille', *Bull.mon.*, XCVII (1938), 301–3. The view of Mont-St-Michel in the *Très Riches Heures* of the Duc de Berry shows that the ambulatory of the Romanesque choir opened into a single axial chapel, although no trace of this was found during the investigation of the crypt in the 1960s; J. Vallery-Radot, 'Le Mont-Saint-Michel. Travaux et découvertes II. Eléments romans récemment découverts dans le choeur de l'église', *CA*, CXXIV (1966), 433–46.
4. The eastern arm of Evesham Abbey built by Abbot Walter of Cérisy (1077–86) had no ambulatory until the early 13th century; D. C. Cox, *The Chronicle of Evesham Abbey* (Evesham 1964), 19, 38. Clearance of the site in the early 19th century revealed remains of a crypt whose central room was divided by two rows of six columns described at the time as Norman; *Vetusta Monumenta*, V (1835), 5, Pl. LXVII. How much more of the eastern arm was 11th-century is unclear. The lack of correspondence between the spacing of the main arcades and the columns in the central room suggests that the former were the result of remodelling an unaisled crypt and choir much simpler than the eastern arm of Wulfstan's

5. The nave of Mont-St-Michel was begun about a decade before Serlo's appointment to Gloucester, which took place in 1072. A triforium somewhat similar to that at Mont-St-Michel is at St Albans Abbey, but this differs from the Mont-St-Michel and Gloucester examples in fronting a continuous wall passage, in occupying a greater proportion of the elevation and in being confined to the eastern parts of the church. The Gloucester triforium differs from all 11th-century Norman triforia, including that at Mont-St-Michel, in not opening straight onto the aisle roof space; Bony (1937) 'Deux élévations...', 285 and n. Bony's statement that a continuous wall passage runs the length of the triforia at Gloucester is incorrect, but his classification of the Mont-St-Michel triforia as typologically more primitive is convincing. All the same the suggestion that the Gloucester nave triforium is a late 11th-century design executed in the early 12th century receives support from the fact that the only possible sources are late 11th-century. Gloucester's discontinuous lengths of passage in each bay probably reflect the need for solid masonry behind the springers of the high nave vault.

6. S. Stefano in Verona (second half of the 10th century) combines an ungalleried basilican nave with an apse surrounded by a primitive ambulatory and gallery, the latter apparently intended to house altars; P. Verzone, *L'architettura religiosa dell'alto medio evo nell'Italia settentrionale* (Milan 1942), 137–45. S. Stefano seems to have been an important influence on St-Bénigne at Dijon, and if, as is possible, the similarity included the restriction of galleries to the eastern parts, this could reasonably be added to the list of Gloucester's borrowings via Hereford from early 11th-century Burgundian architecture. But opinion remains divided as to whether the nave of St-Bénigne should be reconstructed with galleries. In favour, is W. Schlink, *Saint-Bénigne in Dijon. Untersuchungen zur Abeteikirche Wilhelms von Volpiano (962–1031)* (Berlin 1978), 85–92. Against, is C. Malone, 'Les fouilles de Saint-Bénigne de Dijon (1976–1978) et le problème de l'église de l'an mil', *Bull. mon*, CXXXVIII (1980), 253–84.

7. Mont-St-Michel seems to be the only major pre-Conquest Norman church where there are grounds for thinking that the nave and choir elevations may have been fundamentally dissimilar. The view in the *Très Riches Heures* of the Duc de Berry shows the choir wall head well above that of the nave, but it is still possible that the choir elevations were shorter than the nave elevations, owing to the presence of an exceptionally high crypt, a feature hardly explicable except by reference to some north Italian source like S. Stefano, Verona. Hence the unmatched elevations at Gloucester might reflect north Italian influence transmitted via Mont-St-Michel, rather than through Hereford, as suggested in n. 6. All the rest of the evidence from early and mid 11th-century great churches (i.e. Bernay Jumièges, Bayeux Cathedral, St-Etienne at Caen) suggests fairly closely matched choir and nave elevations. It seems likely that this important but generally overlooked aspect of Norman Romanesque reflects influence from the 'pilgrimage churches' of the Loire Valley, a type which I consider to have existed by the early 11th century, *pace* C. Lelong, 'Le transept de Saint-Martin de Tours', *Bull. mon.*, CXXXI (1973), 297–307.

8. Although no remains of columnar piers have survived at either St Augustine's or Worcester, the choir bays are so narrow that the use of compound piers would have resulted in intercolumniations hardly greater than the breadth of the piers; Gem (1978), 27. The columnar piers in the choir of Christ Church, Canterbury were probably inspired by St Augustine's, like the oblong plan of the aisle bays and indeed the basic conception of the relic-filled ambulatoried choir. The use of columnar piers throughout ambulatoried choirs may have originated as a device for unifying hemicycles and straight-sided choir bays. Earlier and fully preserved examples are the choirs of Ste-Croix at Loudun (begun in 1062) and St-Benoît-sur-Loire (*c.* 1067–80), but the occurrence of the form at Stavelot (*c.* 1021–40) probably points to its use in northern France at an earlier date. On this hypothesis, Loudun and St-Benoît are merely the oldest surviving examples of a type current by *c.* 1000. Wide diffusion of the type by the 1080s and 1090s is suggested by its use at Bury St Edmunds (see n. 11), where it was combined with wide lateral bays, and at Tynemouth Priory, where columnar nave piers reflect the form of the supports in the destroyed hemicycle arcade.

9. Continuity of gallery and clearstorey floor levels at Worcester is established beyond doubt by the remains of the Romanesque choir elevation surviving beside the eastern crossing piers and by the perpetuation of the nave levels in the late 12th-century western bays. At St Augustine's continuity may be inferred from the unusual tallness of the nave arcade, explicable as the aggregate of the choir arcades and the distance between the choir and nave floors. Continuity of wall head levels appears to have been the norm in major Norman and Anglo-Norman churches (but see n. 7). The ruins of the St Augustine's nave include the outer walls of ample galleries, and the existance of galleries in the eastern arm is proved by the remains of vices between the choir aisles and the transept chapels. Further light will no doubt be shed on the St Augustine's choir when the excavations of the 1970s are published in a Society for Medieval Archaeology Monograph by David Sherlock and Humphrey Wood. During these excavations a very large piece of the south choir wall was found where it had fallen during the post-Dissolution demolition. It has been suggested that the galleries in the nave at Worcester had two separate openings per bay (Gem (1978), 32), an arrangement without exact parallel in the nave of any Norman or Anglo-Norman church, though approximating to the Mont-St-Michel nave triforium and to the Cérisy-la-Forêt choir gallery.

10. At Winchester the height of the main choir arcades matched that of the transept and nave arcades, and the clearstorey continued at the same level throughout. As a result, the floor of the choir gallery was set higher than that of the transept and nave galleries by a distance equal to that separating the choir floor from the transept and nave floors. These relationships are evident from the inner bays of the east transept walls and the remains of the west choir bay, both

rebuilt after the collapse of the original crossing tower in 1107. The evidence for the Romanesque choir piers is presented in R. Gem, 'The Romanesque Cathedral of Winchester: Patron and Design in the Eleventh Century', *Medieval Art and Architecture at Winchester Cathedral, BAA CT* (1983), 6, where the alternation is explained as a feature introduced into the design at the behest of Bishop Walkelin, the intention being to surpass the Confessor's Westminster. However, the two-bay arcades at opposite ends of the central transept vessel confirm the aesthetic significance assigned here to the variations in pier plans at Winchester, for they are part of a carefully modulated transition between the highly contrasted elevations of the hemicycle and the nave. The full east-west sequence of arcades facing the main axis is: hemicycle with all piers columnar and narrow bays; lateral choir arcades with alternately columnar and compound piers and narrow bays; north and south transept arcades with wide bays and alternately columnar and compound piers; nave with wide bays and all piers compound. The columnar piers in the north and south transept arcades probably preserve the form of the columnar piers in the choir, except that the latter, judging from the fragment in Bishop Gardiner's chantry, lacked attached shafts facing the aisles. The compound piers in the choir certainly had shafts facing the aisles and probably had them towards the main vessels also. The curiously short lengths of shaft above the capitals of the columnar transept piers may well echo wall shafts over the columnar choir piers, in which case the choir would have incorporated vertical accents comparable to those in the rest of the church.

11. Bury St Edmunds has not been mentioned because the nave, transepts and western choir bay belong to a revised scheme begun some time after 1095; R. Gilyard-Beer, 'The eastern arm of the Abbey Church of Bury St Edmunds', *Proceedings of the Suffolk Institute of Archaeology and Natural History*, XXXI (1967–69), 256–62. Nevertheless, it is likely that the nave elevations were always intended to be very similar to the lateral choir elevations begun in 1081, as these incorporated wide bays and galleries. Probably the only major difference between the two elevations would have been the higher floor level in the choir, necessitated by the inclusion of a crypt. The remains of pier bases in the crypt indicate that the whole arcade, not only that of the hemicycle, rested on cylindrical piers; hence it is fairly safe to assume that the arcade of the choir above also had cylindrical piers.

12. The piers of the axial arcades in the Westminster dormitory and the Winchester crypt are as squat as the Gloucester choir piers, but their relatively obscure placing and small size and the fact that they are not part of a main arcade limit the significance of the resemblance.

13. Much earlier 11th-century examples of the use of columnar piers in both arcades and galleries are St-Bénigne, Dijon (rotunda, hemicycle, east side of transept) and St-Rémi at Rheims (west side of north transept). The narthex at Tournus has two tiers of piers closer to Gloucester's in their proportions than the relatively slim Dijon and Rheims piers, but less close in not being visible simultaneously.

14. The sill of the nave clearstorey passage was probably first intended to be at the same level as the equivalent feature in the choir; see above.

15. Bony (1959), 36–43, Bony's thesis rests on convincing parallels between 11th-century Lorrain and Burgundian buildings, but also on the assumptions that Robert's toponymic is genuine and that it denotes Lorraine rather than any other region of Lotharingia. The equation of Lotharingia with modern Lorraine is accepted by Frank Barlow, who notes that William of Malmesbury, apparently the only independent source who calls Robert 'Lotharingus', can sometimes make mistakes about people's origins; *The Life of King Edward who rests at Westminster*, ed. F. Barlow (London 1962), XLVII and n. I am most grateful to Dr Diana Greenway for drawing my attention to this reference and for telling me of the paucity of evidence for Robert's background. Another of Bony's assumptions was that Robert began the chapel fairly soon after his elevation to the see in 1079. This seems likely in view of the exotic character of the building; if it had been started later the chances of its being more conventionally Anglo-Norman would have increased.

16. William of Malmesbury, *De Gestis Pontificum Anglorum*, ed. N. E. S. A. Hamilton, Rolls Series, LII (1870), 300.

17. This method was used at Hereford Cathedral in the early 12th century.

18. The tall piers of S. Abbondio must somehow be related to the Tournus piers, though they are much less bulky. Closer to Tournus both geographically and in their proportions were the ashlar-built columnar piers of the demolished early 11th-century nave of St-Germain, Auxerre; J. Vallery-Radot, 'Saint-Germain d'Auxerre. L'église haute', *CA*, CXVI (1958), 30–5. For the diameters of the Gloucester piers see n. 90.

19. Bony (1959), 37 n. 3. The main borrowing from First Romanesque technique was the use of edge-bedded monoliths in the upper chapel.

20. P. Kidson, 'La cattedrale di Gloucester' in *Tesori d'arte cristiana*, II (Bologna 1966), 376; J. Bilson, R.I.B.A. Drawings Collection, Bi J/1.2.92, 93. Of course the plan of Gloucester can be compared to other polygonal or partly polygonal Carolingian buildings, notably St Mary's church at Centula and the choir of Thérouanne Cathedral, as well as to most of the many derivatives of Aachen.

21. It is not impossible that Hereford and Gloucester were designed by the same man, although the omission of edge-bedded monoliths from the choir galleries at Gloucester suggests a distancing from First Romanesque sources. For the use of tufa in both buildings see n. 48.

22. R. Crozet, 'Eglises romanes a déambulatoire entre Loire et Gironde', *Bull. mon.*, XCV (1936), 45–81 (65). The similarity between Gloucester and Loudun was first pointed out by P. Kidson in *Archaeol. J.*, CXII (1965), 221–2.

23. J. Vallery-Radot, article cited in n. 3.

24. The entrance arches to the north and south radiating chapels are set at 135° to the longitudinal axis.

25. The layout of the apse arcade in the crypt is even stranger than in the choir. It appears that the centres of the inner faces of the piers mark the angles of a half hexagon, although the centres of the outer faces are not related in this way. The arcades are laid out like those of the main apse above, i.e. with angles of 145° and 125°.

26. The three-sided apses of the crypt chapels underneath the transept chapels are shown in a plan by Harold Brakspear (*The Builder*, LXIII (July-December 1892), 107) and have been incorporated in the crypt plan by Gem (1978), Fig. 1. See also the following note.

27. It seems likely that the purpose of the curious pentagonal plan of the north-east and south-east radiating chapels was to accommodate almost exactly orientated altars; whence it follows that the axial chapel would not have had an angle on the main axis. If it had a three-sided apse like the south transept chapel, the other radiating chapels would become explicable as versions of the same plan adjusted to fit the tangent of the ambulatory wall. A further element in the design of these chapels is their almost exact correspondence in plan to the five-sided bays in the analogous positions in the Winchester crypt; clearly the Worcester designer must have had access to a plan of Winchester and have been sympathetic to Winchester's emphasis of correct orientation.

28. The main piers in the crypt at Bury St Edmunds (begun 1081) were squat cylinders, perhaps inspired by those in the same position at St-Benoît-sur-Loire. See also nn. 11, 12.

29. The overhanging slab-like abaci appear to be unique, though something similar in principle can be seen in Notre-Dame at Jumièges, on the arches between the transepts and the aisles and galleries of the nave. The capital of the southern columnar pier at Winchester, the earlier, approaches the pail-like Loudun form.

30. The evidence for the eastern apse piers is presented in full on above.

31. The two most important extant examples of this tendency are St-Etienne at Caen and Durham Cathedral.

32. Major early to mid 11th-century Burgundian examples of the motif are in the nave aisles and cloister at Tournus and the crypt of Auxerre Cathedral. The very rare non-Burgundian examples include the bases of the north tower piers at St-Hilaire at Poitiers and those of the columnar piers in the transepts of Winchester Cathedral.

33. Round plinths do occur at ambulatory level, on the external shaft-buttresses.

34. There is a continuous roll moulding with bases on a window of the tower built at Jarrow after the reintroduction of the Benedictine Rule by Alwin in 1074, and possibly before the monastery became a cell of Durham in 1083. Since Aldwin was previously prior of Winchcombe and had travelled to Jarrow with two monks of Evesham it is possible that the detailing of the tower was derived from some south-west Midlands Romanesque church, perhaps the rebuilding of Evesham begun by Abbot Walter of Cérisy in 1077. The roll-moulded tower windows at Sompting and Langford are no doubt approximately contemporary with Jarrow and similarly dependent on Romanesque sources; hence all three are parallels for Gloucester rather than antecedents. For Sompting and Langford see R. Gem, 'L'architecture pré-romane et romane en Angleterre. Problèmes d'origine et de chronologie', *Bull.mon.*, CXLII (1984), 255.

35. First Romanesque designers, especially in northern Italy, showed a marked predilection for arches of depressed profile, and not only in crypts. Large-scale examples of segmental arches are at Capo di Ponte, Civate and Lomello.

36. The diagnostic feature of the type is the ambulatory corresponding to that of the choir above. Arcades linking the ambulatory and the central space occur at Auxerre Cathedral (*c.* 1030), though not at Rouen and St-Wandrille. The French and specifically Norman derivation of the English examples has been stressed, correctly in my view, in R. Gem, 'The Significance of the 11th-century Rebuilding of Christ Church and St Augustine's, Canterbury, in the Development of Romanesque', *Medieval Art and Architecture at Canterbury before 1220, BAA CT* (1982), 15–16.

37. Other 11th-century English examples of crypts with segmental arches are at Westminster Abbey (dormitory under-croft), Canterbury Cathedral (west wall of Lanfranc's crypt) and Christchurch Priory (crypts below outer bays of transepts).

38. The form of the door head did not reflect the curvature of the vault over the lower chapel, for Stukeley's drawing shows the wall arches and transverse arches as semicircular, and the remaining north wall confirms this.

39. Cluny III, the source of most things at Paray, had an ambulatory wall curved inside as well as out. A possible local source for Paray's polygonal exterior finish is the hexagonal chapel of the outer crypt at Flavigny as rebuilt in the late 10th century, though this is also polygonal inside. Encouragement to postulate a First Romanesque origin for the plan of the outer ambulatory wall at Paray is provided by the 'corbel table' inside the main apse, which must be derived from St-Hymetière or some other building closely related to Tournus.

40. Double splay windows were of course common in England before the Conquest. It has been suggested by Peter Kidson (*Archaeol.J.*, CXXII (1965), 221) that the design of the main apse might have been determined by masonry surviving from an apse like that at Deerhurst, but this seems unlikely given that all other major church building projects in post-Conquest England involved a clean sweep of existing work and that the new buildings were vastly more ambitious than any conceived by English masons before 1066. The other peculiarity noted by Kidson, the lowness of the central room relative to the ambulatory, is repeated in the main choir above and is therefore much more likely to be a feature desired by the creators of the Romanesque church than a pre-Conquest inheritance. The tentative suggestion was made by A. P. Baggs at the 1980 BAA conference at Gloucester (reported in E. C. Fernie, *The Architecture of the Anglo-Saxons* (London 1983), 160) that the non-concentric arrangement of archivolts on the ambulatory side of the main arcade could indicate a difference of date, the outer archivolts being cladding of an older aisleless choir. This discrepancy is of little consequence, however, for the arch forms used throughout the crypt are very varied and very unusual.

41. The nave of Chepstow Priory (founded before 1071) had high groin vaults and may date from the 11th century, though this is not certain. The mid 11th-century tunnel-vaulted transepts at Mont-St-Michel appear to have had no sequel in Normandy. For the transept vaults at Tewkesbury see n. 97. For the suggestion that St-Etienne at Caen was intended to have a high nave vault before the building of the present clearstorey see n. 49. Tunnel vaults over unclearstoreyed main vessels have recently been proposed, unconvincingly in my estimation, for the choir at Chichester (M. Andrew, 'Chichester Cathedral: the Problem of the Romanesque Choir Vault', *JBAA*, CXXXV (1982), 11–22), the nave of St-Pierre at Jumièges, the choirs of Bernay, Mont-St-Michel, Notre-Dame at Jumièges and St-Vigor at Bayeaux (U. Bangert, A. Czuchra, W. Dilthey, B. Laule, M. Mannewitz, H. Wischermann, *Die romanische Kirchenbaukunst der Normandie – ein entwicklungsgeschichtliche Versuch* (Freiburg-im-Breisgau 1982).

42. For the evidence of a high choir vault at St-Etienne see n. 49.

43. The existence of vaulting in the transepts at Mont-St-Michel is sufficient proof that the choir was also vaulted. That the choir was groin vaulted is suggested by the only view of the abbey taken before the building of the present early 15th-century choir, that in the *Très Riches Heures* of the Duc de Berry. The distance between the clearstorey windows and the wall head was not nearly enough to accommodate a tunnel vault, unless the windows rose above its springing, an arrangement for which there are no 11th-century Norman parallels. There are three pieces of evidence that the high choir vault at St Albans which failed in 1257 was a groin vault. First, the remains of wall passages continuing those of the transept clearstoreys and so presumably also combined with clearstorey windows. Second, the provision of additional responds on the east side of the crossing matching those which receive the groins of the extant aisle vaults. Third, the remains of pilaster buttresses in the choir aisle roof spaces. These show that the main vessel of the choir had four bays as against five in the aisle, a variation hardly explicable except in terms of the common Roman and Romanesque preference for groin vaults of square or approximately square plan.

44. High vaulting and clearstorey passages were combined in the apse of Norwich Cathedral and no doubt in other great churches whose main spans were otherwise timber roofed.

45. It is clear from the undisturbed ashlar facing of the east side of the crossing tower at Winchester that there was no high vault over the rectangular bays of the choir. It is fairly safe to assume that there was no vault before the tower fell in 1107, for the post-collapse work seems to have been conceived as straightforward reinstatement. The same kind of evidence proves the absence of choir vaults at Christchurch and Norwich. The evidence for a timber roof over the Worcester choir is the record of its burning in 1113; William of Malmesbury, *De Gestis Pontificum Anglorum*, ed. N. E. S. A. Hamilton, Rolls Series, LII (1870), 288–9. The Bury St Edmunds choir had an open timber roof in 1198, presumably the carved roof mentioned shortly after the completion of the east arm in 1094; *The Chronicle of Jocelin of Brakelond*, ed. H. E. Butler (London 1949), 107, 115; *Hermanni Archidiaconi Liber de Miraculis Sancti Edmundi* printed in *Memorials of St Edmunds Abbey*, ed. T. Arnold, Rolls Series, XCVI. I (1890), 84–5.

46. For the failure of the Gloucester high choir vault in the early 12th-century see above. Documented instances of the failure of Romanesque high vaults are at Durham in 1235 and St Albans in 1257.

47. Since the Hereford chapel was conceived to a large extent as a longitudinal building (Bony, (1959), 38) its high central space, even more than that at Aachen, is analogous to a clearstoreyed central vessel rather than to a lantern tower over a crossing. However, Bony refers to the central bay as a 'lantern' and asserts that it was covered by a cloister vault (ibid., 37–8), a type of vault often used over the crossings of First Romanesque churches. In the Stukeley drawing the vault is not fully visible, but the fact that its springings are shown extending below the window sills argues in favour of a groin vault. The crossed dotted lines in Stukeley's plan of the upper chapel confirm this interpretation. Admittedly, the groin vaults of the lower chapel are not indicated in any way on the plan but, as the interior view shows, they were markedly domical with only faint groins near the springings.

48. As can be seen from the roof space, the gallery vaults at Gloucester are built of tufa, and judging from the quantities of tufa in the post-demolition blocking of the north windows at Hereford, the vaults there were built of this material.

49. For the remains of the quadrant vaults in the choir galleries and the evidence that the choir was covered by a high vault see G. Bouet, 'Analyse architecturale de l'abbaye de Saint-Etienne de Caen. 1ᵉʳ partie, période romane', *Bull.mon.*, XXXI (1865), 434–5. The suggestion that the choir galleries were groin vaulted (R. Liess, *Der frühromanische Kirchenbau des 11 Jahrhunderts in der Normandie* (Munich 1967), 186) takes no account of the nature of Bouet's discoveries over the gallery vaults of the Gothic choir and appears to be based on Bouet's observation of traces of wall arches on the outer walls of the nave galleries, features which could not have co-existed with the quadrant vaults there now. The original intention must have been to build groin vaults (cf. the nave galleries at Notre-Dame, Jumièges), though these would have had lateral cells ramping up from the outer wall to the gallery arcades. The evidence that quadrant vaults were originally to have been confined to the choir galleries confirms that they were thought of as abutments, their normal role in 11th-century French churches. Except in the eastern bay of the nave, the quadrants were certainly built together with the galleries, as witness the exact correspondence between the responds of their transverse arches and those on the back of the gallery piers. so the nave gallery quadrants are either survivals from a short-lived 11th-century plan for a high nave vault, as John Bilson thought (*The Builder*, CV (July-December 1913), 579), or an extreme instance of the Norman tendency to include in naves the elements ancillary to a high vault but not the high vault itself. The evidence that the high choir vault was a groin vault is the parallel with St-Nicholas and, as at St Albans, the presence of a clearstorey wall passage, suggesting that there were also clearstorey windows. A groin

vault is favoured in E. G. Carlsson, *The Abbey Church of Saint-Etienne at Caen in the eleventh and early twelfth centuries*, Ph.D. thesis, Yale University, 1968 (University Microfilms International, Ann Arbor, 1974), 246.

50. The gallery walls are 1.73 m thick at Gloucester and 1.83 m thick at Durham. The Norwich Cathedral hemicycle resembled the Durham choir in its combination of high rib vault and semicircular transverse arches spanning the gallery, and here too the gallery openings were relatively small, in this case because of the narrowness of the hemicycle bays.

51. Bilson (1899), 294−5.

52. Stukeley's rendering of the Hereford vaults as domical receives confirmation from the extant north wall where there is a great distance between the lower chapel rear arches and the upper chapel floor level. The vaults in the crypt of St Maria im Kapitol in Cologne and those in the nave aisles of S. Ambrogio in Milan are only the most important of many such vaults in mid 11th-century Rhenish and Lombard architecture.

53. Examples of arches with this curvature are in the crypt at Agliate and the east part of the crypt at Aosta Cathedral, both of *c.* 1000. Judging from the very careful early 18th-century drawings by Plancher, the transverse arches of the vaults over the tomb of St-Bénigne at Dijon was of this kind; A. Martindale, 'The Romanesque church of St-Bénigne at Dijon and MS 591 in the Bibliothèque Municipale', *JBAA*, 3rd ser., XXV (1962), Pl. II.

54. P. Verzone, *op. cit.*, 109.

55. Because of their varied spans the east-west transverse arches are even more varied in curvature than the north-south arches. Most incorporate semicircles or segments, but the presence of the canted springer blocks makes them resemble the straight-haunched north-south arches. Only the westernmost and easternmost of the east-west arches are simple semicircles, the easternmost rising higher than the rest so as to create an elevated platform for the high altar.

56. R. Willis, 'The Crypt and Chapter House of Worcester Cathedral', *Transactions of the R.I.B.A.*, 1st ser., XIII (1862−3), Pl. 1.

57. J. Bilson, 'Durham Cathedral: the chronology of its vaults', *Archaeol.J.*, LXXIX (1922), Pl. V. Following Durham, virtually all 12th- and 13th-century English high vaults had continuously curved rather than stilted lunettes.

58. For the St-Bénigne arches and lunettes see Martindale, *op. cit.*, Pls. 11, 12 and Malone, *op. cit.*, Fig. 14. Earlier examples of this profile are in the late 10th-century crypt of S. Secondo at Asti (P. Verzone, *op. cit.*, Pl. XLXI) and later examples are the arcades at Almenno S. Bartolomeo and the baptistery at Arsago Seprio. There are minor examples of the form in Burgundian High Romanesque, e.g. the openings in the belfry stage of the north-west tower at Paray-le-Monial.

59. Whereas the Gloucester master uses a quasi-triangular profile for abnormally narrow or wide arches, the Winchester designer favours a curvature approximating to a halved convex-sided rectangle both for the wide 'wall arch' on the east side of the axial ambulatory bay and for the narrow arch at the east end of the central arcade in the crypt of the axial chapel. These compound profiles are used only in parts of buildings where the regular arch form is semicircular. In the crypt ambulatory at Gloucester and the central room at Winchester, where semicircular arches are in a small minority, segmental arches predominate.

60. These blind windows are wrongly referred to as wall arches in Bilson (1899), 294. Their status as rear arches is clearest in the choir aisles, where they frame the window openings and are separated by areas of blank wall from the vault and its responds. Nevertheless, these arches seem to have been interpreted as wall ribs by late 12th-century masons in the region, notably the designer of the western nave bays at Worcester.

61. There seem to be no apsidal groin vaults between the Caen example and those in the early 6th-century oratory of St-Oyand at Grenoble, which are obvious derivatives of Roman 'pumpkin' vaults; R. Girard, 'La crypte et l'église Saint-Laurent de Grenoble', *CA*, CXXX (1972), 243−63. For the non-apsidal multicellular groin vaults of the Winchester crypt see n. 65.

62. Only the Jumièges chapter house had a true apsidal rib vault, as distinct from a semidome with surface ribs. There are only a handful of French examples of apsidal groin vaults later than St-Nicolas at Caen, and none of them is in a major church.

63. Four-arc groin vaults are used in the trapezoidal ambulatory bays at St Maria im Kapitol, Cologne, (*c.* 1040). Their use in the Winchester and Gloucester crypt ambulatories and the choir ambulatory at Norwich suggests strongly that they had occurred in earlier Norman ambulatories and crypts.

64. The alternative to the five-cell reconstruction is a roughly rectangular vault over the inner part of each chapel and a triangular compartment over the remainder, the two divided by a transverse arch. This reconstruction is unlikely as it would emphasise the irregularity of the plan and also the radial axis rather than the roughly east-west axis implicit in the placing of the altar against the 'east' wall. It would also result in an improbably narrow groin vault over the inner bay. A radial arrangement of vault cells in the surviving south crypt chapel is clear from the provision of transverse-arch-bearing shafts at every angle; cf. Gem (1978), Fig. 1.

65. The connection between the Gloucester transept chapel vaults and the five-cell Winchester vaults was made in Bony (1939). As Bony indicated, the Winchester vaults are in the nature of expedients, devised to resolve problems posed by a unique plan. On the Worcester designer's response to the Winchester plan see n. 27.

66. See nn. 26, 27.

67. No doubt the lack of shafts in the St-Nicolas apse reflects continuity with ordinary rectangular groin vaults. In the Gloucester chapels the half-cylindrical uprights between the windows look at first sight like vault shafts but are in fact contiguous rear arches whose limits are not marked in any way – one of many instances of the Gloucester master's predilection for elided forms. See also n. 79.

68. See n. 10. Worcester is the only ambulatoried Anglo-Norman choir in which masonry survives to the full height of the elevation, but as this consists of little more than narrow strips sandwiched between later phases of work, there is no evidence for the form of the bay divisions. A mid 11th-century ambulatoried choir which presented the right conditions for an apse vault like that proposed here for Gloucester survives at Nogent-le-Rotrou; C. Métail, *Saint-Denis de Nogent-le-Rotrou 1031–1789* (Vannes 1895), 19. The apse here continues almost without alteration the elevation of the straight bays, including their heavy wall shafts. Unfortunately, everything above the triforium has been demolished. Another near-parallel is in the crypt or lower church of Ste-Eutrope at Saintes (c. 1081–95), where a unique combination of hall church format, restricted height and ambulatory plan resulted in an apse bounded by an arcade of maximum height, over which it was clearly impossible to build an ordinary semidome. Nevertheless, the apse vault fails to qualify as a true rib vault since it lacks any equivalent to the transverse arches between the adjoining rectangular bays. The narrow rib-like strips of masonry which meet near the crown of the apse vault are really the residue of a notional semidome left by the cells converging from the hemicycle.

69. That is, a semidome whose crown was at the same level as the heads of the lateral choir walls.

70. The case of St-Hilaire at Poitiers cannot be used to argue the contrary. Admittedly there are clearstoreys in the nave and none in the choir, but the variation here represents the outcome of successive revisions to the design. The choir must be roughly contemporary with the phase in which the central vessel of the basilican nave was converted into a kind of hall-church. Likewise, Vignory's 'hall-choir' belongs to a different phase from its clearstoreyed nave. The 'pilgrimage churches' are the most important illustration of the contrary concern that the hemicycle should be the best lit part of the interior.

71. The springing level of the apse vault is established by the partly surviving triumphal arch. As at St-Nicolas, Caen, this level coincided with the string under the clearstorey of the straight bays and with the springings of the apse clearstorey openings, the latter preserved only in the two western bays. The lowness of the two upper storeys of the apse relative to those of the straight bays is only understandable as an adjustment made in order to incorporate a semidome whose crown is level with the main wall heads and the crossing arches.

72. The shafts could not have carried an arcade enclosing the top pier of windows (as at Cardona or S. Michele at Pavia) because there are no shafts to receive the western springers of such an arcade.

73. Opinion has long been divided between those who favour a date for the apse shortly before the 1095 consecration and those who prefer one closer to the series of major grants extending from 1015 to 1063. For the present discussion, the important point is that S. Abbondio or its sources may predate Gloucester.

74. Apart from architectural correspondences such as the shafts in the main apses, the capital sculpture exhibits at least one remarkably close parallel; G. Zarnecki, '1066 and architectural sculpture', *Proceedings of the British Academy*, LII (1966), 96, Pl. XIV.

75. At Norwich, as at Cérisy, the former existence of a ribbed vault can be deduced from the presence of shafts between the bays of the apse and from the lowness of the sills of the apse clearstorey relative to those of the clearstorey in the rest of the presbytery. The springing of the apse vault must have been at the same level as the springings of the crossing arches and the (restored) triumphal arch of the apse. Whether or not the apse clearstorey was as high as in the rectangular bays, its windows rose so far above the springing level of the vault as to make it virtually certain that the vault consisted entirely of converging cells with ridges sloping down to the apexes of the window arches, as in the 14th-century vault now covering the Cérisy apse or in Brunelleschi's 'umbrella' vaults at S. Lorenzo and S. Croce in Florence. Even if the apse vault consisted of a ribbed semidome penetrated by cells with horizontal ridges, the residue of a semidome would have been very small. The only English Romanesque apse vault known to me which has both penetrations and ribs is that in the chancel at Kilpeck.

76. The eastern parts of Christchurch have usually been dated to the early 12th century, apparently on the strength of their rich detailing and the assumption that all English rib vaults postdate those in the choir at Durham. However, the *Historia Fundationis* in the Christchurch cartulary compiled in 1312 (printed in W. Dugdale, *Monasticon Anglicanum*, VI, Pt. I (1830), 303) makes clear that Ralph built a substantial part of the church before his elevation to the see of Durham in 1099. The date at which he became Dean of Christchurch is unknown, but he held the post by 1093–4; *Regesta Regum Anglo-Normannorum 1066–1154*, ed. H. W. C. Davis, I (Oxford 1913), 93. Ralph's character as reflected in the sobriquet 'Flambard', coupled with his overweening ambition, mean that neither the richness of the building nor the stylistically advanced character of the ornament is a serious obstacle to a date in the 1090s. Stylistic evidence in favour of this dating includes: the double-splay form of some of the transept windows, the similarity of some capitals to the Canterbury crypt capitals (now generally admitted to be of the late 11th century), and the presence of capitals by the sculptor of one of the south transept capitals in the choir of Checkendon church, Oxfordshire, a building whose herringbone masonry makes unlikely a date much after c. 1100. The crypts under the Christchurch transepts, which must have been built at a very early stage, have apsidal rib vaults practically identical to the one in the south transept chapel. Unfortunately, the apse of the crypt beneath the choir has been destroyed.

77. The lack of a key-stone at least vouches for the independence of these vaults from the Durham rib vaults and their derivatives at Winchester, Peterborough, Selby and elsewhere. It suggests continuity with late 11th-century French ribbed domical vaults, such as those in the north-west tower of Bayeux Cathedral, the crossing of Ste-Croix, Quimperlé and the north tower of St-Hilaire, Poitiers. The ribs in these vaults, as in the Lombard series and those added to the Gloucester crypt in the early 12th century, comprise one complete arch abutted by two half arches.

78. Nothing in the masonry of the chapel suggests that the existing vault is secondary. Rebuilding is in any case unlikely because of the presence of the original vault at gallery level, a simple semidome. A positive indication of early date is the jointing of some courses of the ribs, despite their being too narrow to need more than one stone per course. The presence of the joints is perhaps best explained as a survival of the technique used for transverse arches. That the Tewkesbury designer favoured unusually thin transverse arches is evident from the surviving vault responds in the choir aisles. The ribs added to the Gloucester crypt vaults in the early 12th-century imitate both the jointing and the breadth normal in transverse arches.

79. The nearest approximation to this arrangement in early 12th-century English architecture is the pair of apses at the east end of Romsey Abbey, where the ribs have no other visual support than extensions of the abaci of the nook shafts flanking the central window. The ribs in the apse of the Jumièges chapter house were not carried on shafts, but there is not enough evidence to show whether they died into the wall like the Tewkesbury ribs.

80. Bilson (1899), 293–4, Bony (1939), 329.

81. Ibid.

82. Since Cérisy and St-Nicolas are the two Norman churches most closely modelled on St-Etienne at Caen, it is possible that their most ambitious apse vaults reflect one or more of the lost apses of the Conqueror's church.

83. See above, 63 and Fig. 9.

84. The Peterborough apse vault was replaced by a wooden ceiling in the 15th century and the vault responds became mere wall shafts. The outer shafts are still original to the springing level of the highest windows and must therefore have carried wall ribs. The original masonry of the central shafts and dosserets ends a little below the sills of the highest windows, where originally a capital received the radiating ribs. The westernmost radial ribs must have sprung from the shafts on the back of the triumphal arch. The ridges of the cells would have been level, unlike those of the Norwich hemicycle vault but like those of the rectangular rib vaults surviving in the aisles at Peterborough. The Jumièges apse vault is reconstructed in G. Lanfry, 'La salle capitulaire de l'abbaye de Jumièges, *Bull.mon.*, XCIII (1934), 323–40. Curiously, Lanfry's plan (ibid., 331) shows the intersection of the radiating ribs linked to the transverse arch of the adjoining bay by a short ridge rib, whereas the text (ibid., 330) describes a conventional radiating arrangement. For the Durham chapter house vault see Bilson (1899), 317–18 and Bilson's article cited in n. 57, 158–59.

85. The exceptions occur in parish or minor monastic churches.

86. The widespread 12th-century French tendency to use rib vaults only in main vessels and groin vaults in aisles might also be connected to the first appearance of ribs in main apses, though it can perhaps be more readily explained as a consequence of the earliest Norman rib vaults having been introduced into churches whose aisles were already groin vaulted.

87. The ancestry of the Tewkesbury transept elevations goes back to Antiquity, but its adoption here may to some extent reflect awareness of the transept clearstorey at Worcester as reconstructed in Gem (1978), Fig. 4.

88. Tall columnar piers forming part of a giant order are reconstructed in A. W. Clapham (1952). The inconsistencies in Clapham's reconstruction are exhaustively discussed in McAleer (1983), 535–58, where the elevation is reconstructed as two tiers of drum piers without any form of vertical linking. The correctness of this solution may be doubted on several counts. (1) It entails seeing the giant order arrangement in the transepts as an isolated phenomenon rather than as a reflection of the choir elevation; and the reappearance of this kind of design in the south transept at Romsey, in company with a columnar giant order in the nave, has to be dismissed as a coincidence. (2) It takes no account of the earlier giant order in the Bishop's Chapel at Hereford. (3) The columnar gallery piers have to be reconstructed without bases, in accordance with the remains of the gallery piers and floor visible from the choir aisle roof spaces. Omission of bases would be anomalous if the gallery piers were self-contained supports (as McAleer proposes) but entirely logical if they were part of a giant order like that at the east end of the nave at Romsey. (4) The sheer surfaces of the east crossing arch jambs run without interruption into the semicircular west responds of the choir arcade, an arrangement paralleled only at the east ends of the Tewkesbury and Pershore naves, where there are of course tall cylindrical piers. Elsewhere in English Romanesque architecture the fronts of piers and arcades are not exactly aligned, and gallery piers are not centred with perfect accuracy above arcade piers.

89. My interpretation of the structural evidence for shallow arcade arches was formulated independently of the similar account published in McAleer (1983), 548, Fig. 31B. However, McAleer, for reasons not stated, assumes that these arches were not complete arcades in themselves but merely part of deep multi-order arcades which have otherwise disappeared. I cannot see the force of his assertion that arcade capitals must necessarily have continued at least half way around the circumference of the piers. Admittedly, this is the case in the later and fully preserved giant order elevations, but given the 12th-century English predilection for deep and complex arcade profiles it would not be surprising if the imitators of Tewkesbury were unwilling to reduce the main arcades to a third or less of their normal depth.

McAleer's reconstruction with multi-order arcades (ibid., Fig. 42) seems to me to have only the status of a theoretical possibility, for it is not based on surviving structural evidence or on analogies with other Romanesque churches, and its clumsy, over-complex appearance is wholly at odds with the marked predilection for 'clean lines' exhibited in all the surviving parts of Romanesque Tewkesbury.

90. Tewkesbury achieves greater consistency than Gloucester in its use of regular cylinders throughout the choir, in place of Gloucester's shafted gallery piers and apse piers of ovoid plan; and the diameter of nave and choir piers was closer than at Gloucester (1.83 m and 1.92 m as against 1.88 m and 2.10 m). The choir gallery arcades at Tewkesbury were no doubt less bulky than at Gloucester and hence more readily fitted onto piers of circular plan.

91. Bony (1959), 42–43.

92. This feature can also be seen in the west walls of the transept at St-Hymetière, a derivative of Tournus. In fact St-Hymetière is the better parallel for Hereford in that the giant order forms part of a main elevation.

93. It is difficult to agree with Bony (1959), 43, that Tewkesbury had a series of Hereford-inspired quadrant vaults running the whole length of the church. There are no signs of such vaults on the east walls of the transepts or in the nave aisles. Quadrant arches in these positions cannot be ruled out in view of the quadrant form of the arches between the nave aisles and transepts.

94. Shrewsbury may have been begun in 1083 and was certainly in building by 1086. Orderic Vitalis, whose father was involved in the foundation, says that the founder, Roger of Montgomery, became a monk here three days before his death (27 July 1094) and was buried 'inter duas altares'; *The Ecclesiastical History of Orderic Vitalis*, ed. M. Chibnall, III (Oxford 1972), 148–9. Probably this means that Roger was buried in the eastern arm between the high altar and the matutinal altar, an appropriate place for a founder. It is unlikely that much of the still-surviving nave had been built by 1094. The compound east responds of the main arcades, the only supports in the nave not cylindrical or half-cylindrical, were no doubt built along with the eastern parts, which have been demolished. Clearly the nave was built to a revised design, and the fact that the change occurs just to the west of the liturgical choir – the most usual place – must suggest a significant pause in building. Shrewsbury is probably the source of the only later elevation with two tiers of drum piers, the choir of St John, Chester.

95. Views taken before the fall of the west tower in 1786 show that each bay of the nave arcade was surmounted by two arches each enclosing two smaller arches. The triforium occupied a greater proportion of the elevation that at Gloucester, and there were no wall shafts.

96. The choir of Malmesbury Abbey has vault shafts resting on a plinth formed by recessing the triforium relative to the arcades, a device used also at Durham and in the nave at Gloucester. Execution of high vaults is vouched for by parts of a diagonal rib remaining in position next to the north-east crossing pier. There is no vault shaft plinth in the transept, so the vault there was probably an afterthought. At Chepstow Priory the nave bears clear traces of the high vault removed together with the vault shafts in the early 18th century. For the vaults of Pershore Abbey see n. 102. For the groin vault planned and probably executed in the choir of Hereford Cathedral see G. M. Hills, 'The Architectural History of Hereford Cathedral', *JBAA*, XXVII (1871), 506; G. G. Scott, 'Hereford Cathedral', *Archaeol.J.*, XXXIV (1877), 327, Fig. opposite p. 328; RCHM (England), *Inventory of the Historical Monuments in Hereford*, I (London 1931), 94a.

97. Evidence for high tunnel vaults in all four arms at Tewkesbury and in the transepts at Pershore is adduced in McAleer (1982), 555–7, 559–60. By far the most obvious trace of high vaulting at Tewkesbury is the curving line on the east face of the crossing, between the arch and the present 14th-century choir vault. Below this line is carefully though unusually coursed ashlar, above it small stones patching the scar left by the removal of the original vault. The springing level is unfortunately concealed by the springers of the 14th-century choir vault, but if, as McAleer supposed, the Romanesque vault was a tunnel springing immediately above a triforium like that in the nave, it would have been segmental and of the same pitch as the Pershore transept vaults, i.e. a height approximately one-third of the span. This and the unusual height of the vault relative to the crossing arch cannot be seen as evidence for a tunnel over the choir, as the springing level of the choir vault would, whatever its form, match those of the transept tunnels. If, however, the Tewkesbury vault was a groin vault, its transverse arches would have extended down between the clearstorey openings and would probably have died into the wall, like the outer orders of the east and west crossing arches and the radial ribs in the south chapel. Transverse arches are in any case likely as they must have occurred in the transept vaults above the shafts separating the bays.

98. The tunnel vault at the west end of the south transept chapel is an equivalent to those at the west end of the choir aisles and so has no implications for the form of the main choir vault. A clearstorey would have been needed in the choir more than in the other parts of the church, as there was no light source comparable to the lantern over the crossing, the windows in the north, west and south walls of the transept or the west wall windows and very tall aisle windows in the nave. Mont-St-Michel is a precedent for the combination of tunnel vaulted transepts with a clearstoreyed choir, and if, as is argued in n. 43, the choir was also groin-vaulted, the parallel would be closer still. The Gloucester transepts were certainly not tunnel vaulted, at least by the early 12th century (see above, 72).

99. It seems likely that the external arcading below the lateral wall heads of the transepts and nave was also used on the choir. The small scale of the arcading is not an argument against its having contained clearstorey windows. The partly preserved openings into the transept roof spaces prove the practicability of fitting windows into the arcading units. The nave clearstorey of Selby Abbey parallels the extreme external lowness of the hypothetical clearstorey of the Tewkesbury choir.

100. Chester Cathedral preserves a similar 'feeder' passage in the north transept, and at Pershore a short passage of this kind connects the gallery-level chapel of the south transept to a south wall passage and south-west angle stair.

101. The Durham nave derives the corbelling of the high vault from the west walls of the transept and the absence of intermediate transverse arches from the east wall, where the vaults spring from paired shafts first built as wall shafts echoing the triple vault shafts of the much wider choir bays.

102. The earliest reference to the Pershore transept vaults is W. R. Lethaby, 'Vaulted Norman Churches in England', *The Builder*, CV (July-December 1913), 337 – 8. In a letter written in response to Lethaby's article (ibid., 397), John Bilson said he had examined the remains in both transepts seven years earlier and had concluded that they were of groin vaults. The correctness of Lethaby's reading is evident from the absence of signs of clearstorey windows in the largely original exterior masonry of the south transept and the perfectly consistent horizontal break inside the transept between original ashlar facing and rubble inserted after the removal of the tunnel. There appear to be no references in print to the remains at the east end of the nave of what can hardly be anything other than the lowest courses of a vault springing at the same level as the transept vaults. The Romanesque ashlar in the spandrels of the west crossing arch suggests that the vault was an afterthought.

103. F. S. Waller, 'The crypt of Gloucester Cathedral', *Trans. BGAS*, I (1876), 147 – 52.

104. In the north gallery the respond of a 14th-century internal flying buttress incorporates capitals from the vault shafts of the main ambulatory, and the angles of the 14th-century piers inserted in the crypt to carry the new presbytery piers have quarter-roll mouldings from the ambulatory windows.

105. The plan in A. W. Clapham, *English Romanesque Architecture after the Conquest*, (Oxford 1934), 33, appears to be based on Bilson's plan in the R.I.B.A. Drawings Collection, box X/15, folder 26.

106. The nave gallery quadrants of St-Etienne at Caen abut the main walls below the level of the clearstorey passage.

107. In his unpublished article on Romanesque Gloucester, Bilson concluded that the choirs here and at Tewkesbury had four-storey elevations anticipating French Early Gothic designs; Gee, article cited in n. 1, 54.

108. F. S. Waller, 'Gloucester Cathedral Tower', *Trans. BGAS*, XXXIV (1911), 175 – 94A (194); J. Bilson, notebook 107 (R.I.B.A. Drawings Collection, Bi J/1.2.95), 7, 25, 34.

109. The responds to the east crossing arch have been modified in the 14th century, but the west crossing arch preserves the original forms, including the curious rounded corners of the broad dosseret under the outer order.

110. These dimensions are taken from the north transept.

111. The equivalent string-courses in the south transept are 14th-century.

112. The effects of the fires of 1102, 1120 and 1122 have never been explored fully, but it seems clear that the most important of these was the last. In the present context, the most relevant of these fires is potentially that of 1102, said by Florence of Worcester to have burned the church and city of Gloucester. A serious fire so soon after the 1100 consecration would help explain the apparently long delay before the resumption of work on the nave, but corroborative reports of the fire are lacking, and the extent of the damage is in any case unknown.

The Gloucester Candlestick

By Alan Borg

The Gloucester candlestick (Pl. XIVA) is an extremely well-known object, today housed in the Victoria and Albert Museum. It has been published a large number of times, appearing in most general studies of Romanesque art; however, there have been only two detailed studies. In 1958 it was the subject of a monograph by Charles Oman, then Keeper of Metalwork in the Museum;[1] at the same time it was studied by Anabell Thornton for an M.A. thesis at the Courtauld Institute, and the main conclusions of her work appeared in the Journal of this Association (under her married name of Anabell Harris) in 1964.[2] Although Oman must have been writing his monograph when Thornton was doing her research, they do not appear to have communicated since neither mentions the other in their texts (although Harris does of course refer to Oman in her published text, stating that she was unaware of his research at the time). Despite this lack of communication, they reached broadly similar conclusions, which, like independently executed scientific experiments, thereby acquired added veracity. At any rate, a quarter of a century later their main conclusions still seem valid, and where they differ from each other is essentially a matter of fine tuning. Consequently, the purpose of this paper is to ask some questions about the Gloucester candlestick which have not been posed sufficiently in the past, rather than to revise conclusions which are already generally accepted.

Before posing these questions it is necessary to give a brief description of the candlestick, and to summarise, equally briefly, the opinions of previous researchers. The object is some 51 cm tall (excluding the pricket) and was cast by the lost wax process in three sections: the foot with the lowest node, the stem with the middle node, and the greasepan with the uppermost node.[3] The three sections are held together by an iron rod which also forms the pricket, and which appears to be old and possibly original. Analysis, by Dr Brownsword of Lancaster Polytechnic, has shown that the candlestick is not made of bell metal, as previously stated, since it contains virtually no tin, but is an alloy of copper, zinc, silver, and a very little iron. The percentage of silver is extremely high, almost 25% in the base, but since the whole was then gilded the silver is only visible on the underside of the base and in places on the stem where the gilding has rubbed off.[4]

There are three inscriptions on the candlestick. A spiral scroll on the stem bears the words ABBATIS PETRI GREGIS ET DEVOTIO MITIS/ME DEDIT ECCLESIE SCI PETRI GLOECESTRE which may be safely translated as 'The devotion of Abbot Peter and his gentle flock gave me to the church of St Peter at Gloucester.' The slightly odd Latin word order is probably the result of a desire to produce a rhyme. Around the greasepan are the words LVCIS ON(VS) VIRTVTIS OPVS DOCTRINA REFULGENS/PREDICAT VT VICIO NON TENEBRETVR HOMO. While the general meaning of this is clear enough, its precise translation is more difficult. Oman goes for 'The debt of light is the practice of virtue. The glorious teaching of the Gospel preaches that man be not benighted by vice.' Harris' version is 'This upholder of light is the work of virtue. With its brightly shining instruction, it preaches that mankind be not overcome by the darkness of vice.' Both of these are acceptable, but a third more literal version may be proposed: 'The burden of light is the work of virtue. Shining doctrine teaches that man be not shadowed by vice.'[5] The third inscription, inside the greasepan, is again straightforward HOC CENOMANNENSIS RES ECCLESIE POCIENSIS/THOMAS DITAVIT CVM SOL ANNVM RENOVAVIT which may be rendered as 'Thomas of Poché gave this to the church of Le Mans when the sun renewed the year' – i.e. at the new year, although which new year is not specified.

These inscriptions give us some basic information about the candlestick, of the sort which is so often lacking for medieval objects. Firstly, they provide a relatively secure date bracket. There was only one Abbot Peter of Gloucester, who was formerly prior of the monastery; he succeeded Serlo, who died in 1104, and held office, probably from 1107, until his own death in 1113.[6] Thus the candlestick must date from this period, barring the unlikely (but never considered) possibility that Peter took an existing

candlestick and had his inscription engraved upon it. The inscription on the greasepan reveals that it was then given to Le Mans, at a date which Oman judged, on epigraphical grounds, to be the 13th century. Although the lettering is rather crude, and therefore perhaps not to be relied on too heavily for purposes of dating, there is nothing about either the style of the capitals, which lack the swelled curves typical of the 13th-century, nor the letter forms themselves which need be later than the mid 12th century.[7] The reasons for and circumstances of the gift to Le Mans are perhaps something that would repay further study.

The subsequent history of the candlestick need not concern the present enquiry. By a roundabout route, detailed in the previous studies, it arrived in its present home in 1861.

We have, therefore, that rare thing, an apparently securely dated medieval object. More than this, there is a general agreement as to its origin. Both Oman and Harris, working independently, came to the conclusion that it was English, a view which had already established the upper hand in the general literature. The only serious contender was Germany, partly on account of the well-known German tradition of metalwork and specifically because the most closely comparable objects were the pair of candlesticks made for Bernward of Hildesheim shortly after the year 1000. Bernward's candlesticks will be considered later, but here all that need be said is that both Oman and Harris based their attribution of the Gloucester candlestick to England on stylistic comparisons with illuminated manuscripts, the former finding parallels for the style in post-Conquest Durham books, while the latter produced comparisons with Canterbury (and specifically St Augustine's) manuscripts. Ignoring the detail of precise location, it may be accepted that the decoration of the candlestick fits securely into the late 11th/early 12th-century Anglo-Norman Romanesque style. In fact, where precisely it was made seems of comparatively little significance. It was probably neither Canterbury nor Durham, but we can have no doubt that the person who designed it was intimately familiar with the styles then current for embellishing the books that found their way into major cathedral and monastic libraries. In this context it may be noted that Abbot Peter gave a large number of books to the monastery at Gloucester which, together with his construction of a wall of stone around the precinct, is one of the two facts about his tenure of office deemed worthy of note in the cartulary.[8] However it may be doubted whether an artist of the calibre of the maker of the candlestick would need to resort to illuminations for his ideas; he may just as well have worked from a pattern book of his own or from a memorised repertoire of decoration. Whatever the case, the candlestick could as well have been made in Gloucester itself as anywhere else.

Given broad agreement about the date and provenance of the candlestick, we may turn to some of the more general issues which it raises. Two particular questions will be considered: firstly, why is it a candlestick at all, and secondly why does it look the way it does?

In asking the first of these questions – why is it a candlestick at all? – I am not implying that the traditional identification of the object as a support for a candle is incorrect. It is undoubtedly a candlestick, but it is not always realised that, at the date concerned, this fact alone makes it remarkable. There are very few earlier surviving candlesticks with Christian connotations, and the most important of these will be considered below. Still more significantly, the size of the object, only 51 cm tall, makes it virtually certain that it was intended to stand on something, for it is surely too small to have stood on the ground. What it stood on was almost certainly an altar, and this makes it more remarkable still.[9]

In order to explain this we must make a slight diversion into the history of the usage of lamps and candles in Christian worship.[10] For about the first 1000 years of the Christian era candles were never, or almost never, placed on altars. The slight qualification is necessary because there is some evidence for the early and unorthodox use of altar candles in the African church, and what may be altar candles are depicted on a floor mosaic from Tabarka.[11] There appears to be no evidence for the use of altar candles in the early Latin church, and indeed to begin with there was strong opposition to the use of lights at all in Christian ceremonies. On the one hand lights were associated with the worship of the Temple, and on the other they bore connotations of pagan ritual. This early opposition was soon

overcome, not least because a good many Christian services took place during the hours of darkness, and lights were required for their primary practical purpose of providing illumination. Once admitted, however, lights very quickly acquired (or rather recovered) their symbolic role of defining and, quite literally, highlighting places of particular sanctity within the church. In Britain by the time of Bede it is clear that lamps or candles were widely used in churches, and that this reflected established Continental practice.[12] Wooden beams or 'trees' were set up across the sanctuary, and candles placed upon them, while great circles of lamps or *coronae* were hung above the altar. A number of these are preserved, such as the 11th-century example at Hildesheim, or that given to Aachen by Barbarossa in 1164.[13] Documentary evidence shows that fittings of this general type were in use from at least the 6th century, nowhere more splendidly than in Justinian's Hagia Sophia.[14]

What one does not find is candles or any other type of lamp placed upon the altar itself. The reason for this would seem to be that the altar, as the Lord's table, was a place of sacrifice and too holy to be decorated in any way. It received those effects which were a direct part of the sacrifice itself, such as the cup, the paten, and the linen cloth. There were no candles, no cross, and if the Gospels were laid upon the altar during the Mass this was only because the Book was regarded as representing the presence of the Lord himself. Some free-standing candlesticks were however in use, even if not on the altar. These included the seven-branched type, but this represented a separate strand of development which will be referred to again briefly below.[15] There are also some examples of single free-standing candlesticks in Early Christian art, often in association with tombs. What is perhaps the earliest example of such candlesticks in western medieval art occurs on one of the choir screen panels given by patriarch Sigvald (?762 – ?786) to Cividale.[16] Here they flank a large cross, which is apparently not on an altar. Candlesticks alongside or in front of altars can be found in Carolingian art, and there are several examples depicted in the Stuttgart Psalter;[17] in most instances only a single candlestick is shown, and this sometimes probably represents the Paschal candle (which is certainly shown in the Exultet rolls).[18]

All this is reasonably clear. What is not clear is how and why the position changed. The early medieval altar was normally cubic, or nearly so, and certainly small. However, by the 9th century the altar was growing in size, and assuming a more clearly oblong shape. It has been suggested that the reason for this change may lie in the new practice of placing relics directly on the altar, instead of inside or underneath it, for such practice inevitably required the enlargement of the altar itself. But in fact we do not really know the reason, and either development might have caused the other. The first clear evidence for the placement of relics on the altar occurs in the so-called Pastoral Homily of Leo IV, an apparently late compilation which must have been in existence by the year 958 for it was quoted by Ratherius of Verona, who died in that year. This states that 'nothing should be placed upon the altar, except caskets and relics, or perhaps the Four Gospels and the Pyx with the body of the Lord'.

This is not the place to become distracted by the complex and controversial topic of altars and relics, but it may simply be noted that the growth in the size of the altar does seem to be related in some way to the general movement of and emphasis on relics at this period, which led among other things to the installation of relics behind, at right angles to, and on the altar. One consequence of this was the decline in importance of the ciborium, which was the early Christian device for honouring the altar and also for lighting it from above. However, as we shall see, even this change was not clear-cut.

There was also a long tradition of honouring the relics of saints with lights, which initially were placed around shrines but not upon them. This practice is of course continued in the lighting of candles before the relics or images of saints in Catholic churches today. It seems that in the 10th and 11th centuries this practice too developed to include the placing of candles on shrines themselves. An illustration of the *Psychomachia* in Lyons shows candles placed on what appears to be a shrine, although Braun saw this as an early illustration of candles on an altar.[20]

All this suggests that the idea of placing candles on the altar may be connected with the developing practice of putting relics on the altar itself. However, even if this is correct, it is equally apparent that from much the same period (i.e. around the year 1000) there began to be a direct association between

the use of lights and the Sacrament itself. Indeed, the earliest illustration of altar candlesticks may be the ivory panel from a book cover, now in Frankfurt, which is commonly known as the Celebration of the Mass, and which is dated by Lasko to the period 990 – 1000.[21] However it is not entirely clear whether these candlesticks are intended to be represented as on or behind the altar, for although the former interpretation is the more obvious, their position suggests that they are adjacent to, but separate from the rear corners of the altar. Far more straightforward are two illustrations from the *Codex Vyshradensis*, which is the coronation book of the first Bohemian king, Vratislav I, dating from 1085. One of these shows an altar bearing two candlesticks, but retaining the ciborium from which a corona is suspended.[22] Perhaps the best known early illustration of altar candles occurs in the lower church of S Clemente in Rome, where one of the frescos shows the Saint before an altar with two candles placed upon it.[23] One point worth noting is that the altar shown is not prepared for the Mass, and where, in other scenes in the cycle, the Saint is shown celebrating Mass there are no candles on the altar. This might be seen as supporting the idea that altar candles may be related to relics, but it might equally well derive from the fact that pictorial tradition reflected earlier liturigical practices.

Thus, while the precise reasons for the introduction of candles on the altar remain unclear, it does seem that this development took place only gradually in the course of the 11th century. It would also seem that one of the major influences behind the change was the monastery of Cluny. The earliest documents which refer to the use of candles on altars are Cluniac, starting with the Consuetudinary of Fleury.[24] This gives a very specialised usage: on the vigils of Christmas, Easter, and Pentecost lights were placed before every altar before Compline, to burn through the night, while before Matins the Sacrist lit candles on the altar (*super altare*) of St Benedict. It was no doubt the Cluniac liking for candles in general (not specifically altar candles) that led St Bernard to condemn them in his famous letter to William of St Thierry, and no candles at all were permitted in Cistercian churches. Instead lamps were used very sparingly.[25]

Returning to the Gloucester candlestick, there is enough evidence to show that, provided it is an altar candlestick, it is a very early and rare example of the type. It is in fact considerably earlier than the first known written reference to candles on altars in England; this occurs in a list of gifts made by Henry of Blois (d. 1171) to Winchester cathedral, which includes 'a silver Tabernaculum with four silver columns, which is customarily placed on the altar with a candle on Christmas Day'.[26] Moreover, the Gloucester candlestick is apparently the second oldest surviving example, preceded only by the pair made for Bernward of Hildesheim (Pl. XIVB). It is true that the classic study of Romanesque candlesticks by von Falke and Meyer lists a further nine examples from the 11th century, but none of them is dated and most look to be 12th-century.[27] Also none of these is English, with the possible exception of the von Hirsch candlestick base, which is cruder than Gloucester and in my view later.[28]

At this point reference may be made to the Kremsmunster candlesticks, which have been left out of previous discussions of the Gloucester example. These are problematic and rather curious examples of the three-noded variety, which have been associated with the Tassilo chalice (also at Kremsmunster) and dated to the late 8th century, although von Falke and Meyer (followed by Lasko) put them into the 11th century. The inventory of Abbot Sigmar (1013 – 40) does refer to two *candelabra auro et argento parata* which might represent the existing pair. Significantly, Dr Pankraz Stollenmayer has put forward the theory that the shafts of the two candlesticks originally formed part of Tassilo's sceptre, which was later converted into candlesticks.[29] If this is correct it again emphasises the special nature of candlesticks at this period. It would certainly seem that the Kremsmunster pair are no earlier than the 11th century, and a 12th century date, if they are a conversion, is equally possible.

Hildesheim and Kremsmunster provide pairs of candlesticks, but nonetheless it is perhaps wise to question the assumption, made by Oman, that the Gloucester example is one of a pair, the second of which is lost. It is possible, one might say probable, that it is, but a number of documents refer only to single candlesticks and since there is no evidence that abbot Peter gave a pair it is safest to assume that there was always only one. There is indeed an English illustration of a single altar candlestick, which

dates, in my opinion, from the first quarter of the 12th century. This is on an ivory box in the Victoria and Albert Museum, and dated by Beckwith to the early 11th century. In a recent study by T. A. Heslop, the scene is identified as part of the liturgical rites for Easter, and he too suggests a 12th-century date.[30] The box shows a draped, and still more or less cubic altar, on which a single candlestick is clearly depicted (Pl. XVc).

We may now turn to the second of the two questions posed above; namely, why does the Gloucester candlestick look the way it does? At this point it is necessary to turn again to the Hildesheim candlesticks, which may be presumed to date from some one hundred years before the Gloucester example and are the earliest altar candlesticks in existence, if the Kremsmunster pair can be excluded.

The presumption that the Hildesheim candlesticks were made for an altar is based upon their size, which, at some 43 cms tall, is rather smaller than Gloucester. They were made for the famous bishop Bernward, in whose tomb they were discovered on the day of the translation of his relics in 1194. This appears to be the only recorded example of a bishop (or anyone else) being buried with candlesticks, and is further evidence of the exceptional nature of such objects at this date. They are made of electrum with an extremely high silver content (a fact which appears to be recorded in their enigmatic inscriptions) and were cast by the lost wax process.[31]

The immediately striking thing about the Hildesheim pair and Gloucester is the similarity of their forms (Pl. XIV). Oman ignored the problems which this poses by not mentioning Hildesheim at all in his monograph; Harris accepted the similarity, but argued that the relationship was only of a general nature, and that as soon as one got down to analysing detail they were quite different. However, this is not seeing the wood for the trees, for the visual kinship is remarkable, the more so since they are one hundred years apart in date, were made in different parts of Europe, and are probably the only purpose-built objects of this type to have survived from this period. Even more curious is that a fairly large number of other candlesticks survive from a slightly later period, and most of these look generically similar to the Gloucester/Hildesheim type. The von Hirsch base has already been mentioned, but anyone who turns the pages of von Falke and Meyer will find plenty of other comparable examples. For the most part these are rather simpler versions, but the relationship between them all cannot be escaped. It is therefore worth asking why it is they do all conform to a pattern (more or less) and why particularly the Gloucester and Hildesheim examples look so similar when they are widely separated in time and space. Excluding the possibility that our dating and provenance of them may be wrong (and, for once in medieval art history, such an exclusion is justified) then similarities can only be explained in two ways, either or both of which might be correct. On the one hand we can invent a Weitzmannesque prototype candlestick, which provided the ultimate model for future candlesticks and which (like all good prototypes) is lost, or we can argue that the idea of what a candlestick represented was common to western Christendom, and consequently anyone making a candlestick would have gone about it in much the same way. Whichever solution we choose must be set against the fact that specifically altar candlesticks seem to have been totally unknown before c. 1000.

In order to come to some decision about this let us examine the common ground. Both the Hildesheim and Gloucester candlesticks are of the same basic type, with a tall three-noded shaft. The bases have three feet, in the form of claws at Hildesheim, and at Gloucester and elsewhere dragons. At Gloucester the dragons' wings provide the triangular borders of the base, and their tails are looped back over the shoulders of little crouching men. At Hildesheim there are also three dragons, but entirely on the base proper, facing the shaft, and each has a figure riding on its back. The spaces between the dragons are filled with twining tendrils. Gloucester is more complex here, having additional dragons in conflict with human figures, and this theme is continued on the lowest node, which shows a man riding a dragon and a winged centaur. The lowest node at Hildesheim has a foliage pattern, and the stem above has a foliage growth in which two figures clamber upwards. The lower stem at Gloucester is more warlike, having an ape-man fighting a dragon amidst foliage. The central nodes differ, with the Symbols of the Evangelists at Gloucester and another, more complex foliage pattern at Hildesheim.

The upper shaft at Gloucester continues the theme of the lower though in a subtly different form, while at Hildesheim there is a repetition of the foliage growth, without clambering figures but with the addition of birds. The upper node at Hildesheim has three human masks, while at Gloucester there is a return to the theme of dragon conflict and mythological monsters. In both cases the grease pans are supported by creatures, which are clearly dragons at Gloucester, less clearly identifiable at Hildesheim but sufficiently dragon-like.

As this brief summary makes clear, the Romanesque work is far more complex than the Ottonian, but this is only what one would expect. Reducing the candlesticks to their simplest decorative elements, both have men riding on dragons on the base, both have figures enmeshed in foliage on the stems, and both have dragons supporting the grease pans. In addition, Gloucester has a more warlike aspect, stressing conflict, and also adds the Symbols of the Evangelists on the central node.

In approaching the component motifs of Gloucester and Hildesheim we come up against one of the basic tenets of medieval art history, which is that while mythical or fantastic creatures may be agreed to have held generalised meaning, they were primarily decorative and are not susceptible to detailed iconographic explanation. Art historians who attempt to impute specific meaning to these fantasies are usually regarded in much the same way as orthodox physicists regard para-psychologists. Support for the generally accepted view is drawn from the previously mentioned letter of St Bernard to William of St Thierry, in which he seems to condemn the monstrous fantasies of Romanesque sculpture as without purpose or profit. However, this is not necessarily the same thing as saying that the images were without meaning, indeed one can easily interpret Bernard's words as implying the opposite, since he specifically remarks that there was a temptation to 'read in the marbles' rather than in books.[32] From what we know of 12th-century monastic reading it was a laborious business involving not merely an absorbtion of the words on the page, but a meditation on them to extract every last ounce of significance from them.[33] Was this the kind of reading cloister monks were tempted to indulge in when confronted by fantastically carved capitals? Bernard was a practical puritan and seldom condemned evil in the abstract. In other words, Bernard's distaste for the fantasies of Romanesque sculptors does not prove that such things were meaningless – rather the reverse, it shows that people did seek meaning in the marvellous, even if this was something that *he* could not accept as useful. In the light of this I believe we must take seriously the possibility that an iconographic interpretation of candlesticks was something that was sufficiently widespread to allow an analysis to be made of the closely comparable examples from Gloucester and Hildesheim. The general theme of this iconography is set out in the inscription on the Gloucester grease pan: 'The burden of light is the work of virtue; shining doctrine preaches that man be not shadowed by vice.' The overall meaning is clear: the candlestick supports the light which is Christ, the base shows a confusion of evil, in the form of monsters and dragons. In some later candlesticks the combat of Virtues and Vices is here represented, conveying the same message still more clearly. The shaft and top of the candlestick denote a ladder of tribulation for the gradual ascent towards God. At Gloucester the light is reached through the medium of the Gospels represented by the Evangelists' symbols on the central knop. Within this general framework some details have obvious connotations, such as dragons as manifestations of evil. Perhaps more contentiously one can suggest in the case of Gloucester a reason for the differences between the clambering figure on the stem below the knop and that above. On the lower shaft a human form bearing a beast's head drives a sword into the throat of a small winged dragon (Pl. XVA). On the upper part, above the level of the teaching and life of Christ as represented by the Evangelists' symbols, another figure attempts to ascend to the light by climbing through the tangled scrollwork (Pl. XVB). Here there is neither the vilification implicit in the animal's head nor the violence implied by the sword. In case this seems very far fetched, it is worth mentioning an illustration exhibited in the recent exhibition of English Romanesque Art.[34] It accompanies that part of the text of Boethius's *Consolation of Philosophy* in which Philosophy herself says that people who abandon goodness are little better than animals. The adjacent picture shows the transformed companions of Odysseus. They have human lower parts, but their heads, arms and torsos

are animal. If this is how a 12th-century artists indicated a person behaving like an animal it lends credence to the interpretation, offered above, of the shaft of the candlestick.

Such an exegesis is arguably of the kind dismissed by Bernard and practiced by monks who 'read in the marble'. However it leaves many details of the form of the object unexplained. If these have meaning I am unable to define what it is. But this does not mean that it is not there, or at least was not there for one or two or many contemporary observers. There are a very large number of things that we in the 20th century will never know about the workings of the medieval mind.

The fact that the Hildesheim and Gloucester candlesticks are generally susceptible of similar allegorical interpretations helps to explain why the forms used were felt to be appropriate. But there are other explanations for the kinship. In the first place it is clear that some of the elements belong to an ancient common stock of forms and motifs which were considered appropriate for candlesticks. Thus, the tripod base is commonly found on Roman candelabra, and it has also been shown that the seven-branched candlestick of the Hasmonean kings had three feet[35] (despite the well-known depiction of a bi-podic version on the arch of Titus). Moreover, these feet were in the form of animals' claws, as are the feet of many of the Roman candlesticks excavated from Pompeii. Some Pompeian examples show complete animals, of dragon-like nature, on the base. Candlesticks with noded shafts were also known in the ancient world, and a number of the early medieval depictions referred to above are of this type. There is some evidence that pronounced bulbous nodes became more common in the 11th century; a comparison of the candlestick shown in the illustration to Psalm 58 in the Utrecht Psalter and in its copy, Harley 603, reveals a much larger central node in the later drawing.

The evidence does seem to suggest that the general type of candlestick, with a tripod animal-related base and a noded shaft, was sufficiently part of the western tradition for it not to be surprising that both Gloucester and Hildesheim should have this form. It does not suggest, at least to this writer, that the received knowledge of candlestick design was sufficient to explain why the really quite detailed iconographic parallels between the two – namely, men riding on dragons on the base, figures in foliage on the shaft, and dragons supporting and biting the cups. Are we then back to the theory of a lost proto-type?

One possible explanation for these similarities may lie, if not in an actual prototype, at least in the transmission of the basic form and the attendant allegorical ideas. But through what channel can we imagine this occurring? There are a number of possibilities, one of which is a written description. For example, Theophilus, (in his treatise on Divers Arts written *c.* 1120), explains not only how a censer is made, but gives a quite detailed account of iconographies for such an object.[36] Although there is no comparable description of a candlestick in his work or, so far as is known, in any other, it does not mean that one did not once exist. The other reasonably straightforward possibility is that the maker of the Gloucester candlestick had seen an earlier example of the Hildesheim type, which was arguably also German. The importance of Ottonian metalwork as a source for European Romanesque is reasonably well established. Several of the objects in precious materials made in Northern Spain in the second half of the 11th century find their closest parallels in Hildesheim itself. And on another, the shrine of St Aemilianus at Cogolla, there is a carving of two of the craftsmen engaged in making it. Their names are Engoloram and Redolfo, both rather more German than Spanish.[37] For England, lacking as it does major surviving objects from the later 11th century, the evidence is largely documentary, but that perhaps makes it all the more striking. There is for example the cast metal screen at Beverley which is referred to as '*Opus Teutonicum*'. It is not clear whether it was the craftsmen themselves who were German or whether they were Englishmen carrying out a type of work which was normally associated with German production. Even if it is the latter which is the correct explanation it suggests both an awareness of artistic developments in Germany and quite possibly training in them. Then again, the two wealthiest metalworkers in England in the decades after the Conquest were called Otto and Theoderic, clearly both Germanic rather than English or Norman names. Both of these men are shown with considerable land holdings in Domesday Book, and both were practising craftsmen.[38]

Otto, indeed, made the cast bronze tomb for William the Conqueror at St Etienne, Caen. There is in addition some stylistic evidence, perhaps the clearest example of which is the Chichester reliefs. The links of these stone panels with, for example, the bronzes cast for Bernward of Hildesheim have long since been established.[39] Finally, it is worth bearing in mind that the west of England, in particular, was an area open to 'German' connections, since bishops of Hereford, Exeter, Wells and Sherborne/ Ramsbury in the second half of the 11th century all seem to have come from that part of Europe.[40]

Thus, if we require a context within which the general form and several of the more specific aspects of the iconography of the Gloucester Candlestick can have reached England it is not hard to provide one. We cannot know at this distance whether Gloucester was always exceptional in its adherence to and development of this particular range of ideas. All I want to do here is to suggest that, given the known facts about candlesticks in general, and Gloucester and Hildesheim in particular, what might be termed the 'evolution of appropriate form and meaning' solution explains the relationships as well, and perhaps better, than a specific lost prototype.

In Francis Tschan's long study of the life and works of Bernward of Hildesheim a detailed symbolic interpretation of those candlesticks is given.[41] It is of the sort which makes the average medievalist reach for a gun (or at least a halberd). However, before condemning it out of hand, we should perhaps note that it is based upon the observations of the pastor of St Magdalen's church in Hildesheim, who for many years was *custos* of the candlesticks. It seems to me that he had as good a chance as any one of understanding the meaning of these objects, and he was perhaps better placed than many of us for whom knowledge of the Middle Ages remains based entirely upon known facts and existing documents.

ACKNOWLEDGEMENTS

The paper presented here is substantially as given at the Conference. However, I would like to express my thanks to the Hon. editor, Mr T. A. Heslop, for some additional material which I have included, particularly towards the end of the text.

REFERENCES

1. C. C. Oman, *The Gloucester Candlestick*, Victoria and Albert Museum Monographs, No. 11 (London 1958).
2. A. Harris, 'A Romanesque Candlestick in London', *JBAA*, 3rd series XXVII (1964), 32 – 52.
3. A good description of the candlestick is given by Neil Stratford in the catalogue, *English Romanesque Art 1066 – 1200* (Arts Council 1984), 249. I am grateful to Mr Stratford for giving me access to his work before publication.
4. The results of Dr Brownsword's analyses will appear in the *JBAA*, CXXXVII (1984).
5. For the most recent commentary on this inscription see a letter from Colin Sydenham, 'Translating the Gloucester Candlestick', *Burlington Magazine*, CXXVI (1984), 504.
6. For the evidence concerning the dates of Peter's abbacy see the references cited in D. Knowles, C. N. L. Brooke and Vera London, *Heads of Religious Houses: England and Wales, 940 – 1216* (Cambridge 1972), 52. They give 1107 for Peter's election which would limit the commissioning of the candlestick to a six year period.
7. Stratford, *loc. cit.*, suggests 'late 12th century?' and T. A. Heslop, personal communication 10th Jan. 1985, considers even the mid-12th century 'a possibility'.
8. *Hist. et Cart.*, 13 – 14.
9. Stratford, *loc. cit.*, suggests that the candlestick was intended to stand near the altar. There is no proof, but its small size suggests to me that it was intended to stand on the altar.
10. The best general study is D. R. Dendy, *The use of lights in Christian worship*, Alcuin Club Collections, No. 41 (London 1959).
11. The mosaic is so restored that it provides only uncertain evidence. See P. Gauckler, 'Mosaiques tombales d'une chapelle de martyrs a Thabraca', *Fondation Piot, Monuments et Memoires*. XIII (1906) 175-227 and Pl. XVIII.
12. Dendy, *op. cit.*, 9.
13. P. Lasko, *Ars Sacra: 800 – 1200* (Harmondsworth 1972), *178 – 9, 216.*
14. *Dendy, op. cit.*, 8.

15. H. Strauss, 'The history of the form of the Seven Branched Candlestick of the Hasmonean Kings', *Journal of the Warburg and Courtauld Institutes*, 22 (1959), 6 – 16.

16. C. Cecchelli, *I monumenti del Friuli dal secolo IV al XI*, I (Rome 1943), 34 ff and Pl. XVIII.

17. E. T. DeWald, *The Stuttgart Psalter* (Princeton 1930), e.g. folios 108 and 130v.

18. See M. Avery, *The Exultet Rolls of South Italy*, II Plates (Princeton 1936), e.g. XLVI and CXXXVIII.

19. Dendy, *op. cit.*. 18.

20. J. Braun, *Der Christliche Altar* (Munich 1924), II, 173 and Pl. 150.

21. Lasko, *op. cit.*, 108 and Pl. 105.

22. Prague, University Library Ms. XIV A 13 (facsimile edition, Prague 1970) and, more accessibly, O. Pacht, F. Wormald, and C. R. Dodwell, *The St Albans Psalter* (London 1960), Pl. 117c.

23. J. Wilpert, *Die Romischen Mosaiken und Malereien der Kirchlichen Bauten vom IV bis XIII Jahrhundert* (Freiburg 1917), 533, and illustrated in C. R. Dodwell, *Painting in Europe: 800 – 1200* (Harmondsworth 1971), Pls. 152 – 154.

24. B. Albers, *Consuetudines Cluniacenses*, V (Monte Cassino 1905), 138.

25. The most accessible translation is still G. G. Coulton, *Life in the Middle Ages* (Cambridge 1930), IV, 72 – 6.

26. Dendy, *op. cit.*, 50.

27. O. von Falke and E. Meyer, *Romische Leuchter und Gefässe Giessgefässe der Gotik, Bronzegeräte des Mittelalters*, I (1935).'

28. Currently on loan to the British Museum. See the sale catalogue, *The Robert von Hirsch Collection*, II (Sotheby's 1978) No. 210, 12 – 13.

29. P. Stollenmayer, *Tassilo-Leuchter, Tassilo-Zepter* (Kremsmunster 1959).

30. T. A. Heslop, 'A walrus ivory pyx and the *Visitatio Sepulchri*', *Journal of the Warburg and Courtauld Institutes*, 44 (1981), 157 – 60.

31. R. Wesenberg, *Bernwardische Plastik* (Berlin 1955).

32. This is the literal translation of Bernard's 'ut magis legere libeat in marmoribus quam in codicibus'.

33. On monastic reading see M. B. Parkes, 'The influence of the concepts of *Ordinatio* and *Compilatio* on the development of the book', *Medieval Learning and Literature: essays presented to R. W. Hunt*, eds J. J. G. Alexander and M. T. Gibson (Oxford 1976), 115 ff. See also e.g. *The ecclesiastical history of Orderic Vitalis*, ed. and trans. M. Chibnall, IV (Oxford 1973), 320 – 1, where he states that monks 'seek out secrets by reading sacred law, and while meditating on these they gladly preserve silence'.

34. *English Romanesque Art 1066 – 1200* (Arts Council 1984), 102.

35. Strauss, *op. cit.*

36. *Theophilus, the Various Arts*, ed. and trans. C. R. Dodwell (1961), 111 – 2, 113 – 7.

37. Lasko, *op. cit.*, 148 – 51 discusses the influence of Ottonian art on that of Spain.

38. C. R. Dodwell, *Anglo-Saxon Art: a new perspective*, (Manchester 1982), 65 and 78 n. 261, 262.

39. G. Zarnecki, 'The Chichester Reliefs', *Archaeol. J.*, CX (1953), 118 – 9.

40. F. Barlow, *Edward the Confessor* (London 1970), 191 and n. 4.

41. Francis J. Tschan, *St Bernward of Hildesheim*, II (Indiana 1951), 136 – 8.

Early Gothic Architecture at Tewkesbury Abbey

By Richard K. Morris

In the annals of recent architectural history, the Romanesque and Decorated fabric of Tewkesbury Abbey have commanded attention, to the virtual exclusion from consideration of some interesting modifications made in the early Gothic period. The evidence for these changes is best observed in the north transept and in the former chapels adjoining it to the east and north-east (see Plan and Fig. 1). At first inspection, their fabric suggests nothing more than amplification of the chapels in this area, but it will be shown that thorough consideration of the context implies the likelihood of important modifications to the elevation and plan of the whole east end of the church during the 13th century.

Since the late 19th century at least, these chapels have been generally assigned to St James, directly east of the transept, and to St Nicholas, which lies to its north.[1] However, as there is no certainty to which saints they were dedicated originally, in this paper they will be referred to as the 'east chapel' and the 'north chapel' respectively (Fig. 1 D & C). The north one is evidently the chancel of a larger chapel, which originally included a nave built against the north wall of the transept and which was rib-vaulted in four narrow bays (Pl. XVIA & Fig. 1 C). The original entrance to the chapel was through the broad early 13th-century archway still surviving in the north wall of the transept, now blocked internally except for a small door (Fig. 1 C, w). The nave communicated with the chancel through an elegant archway subdivided by a double arch in the form of a 'Y', now partly walled-in and partly glazed (Pl. XVIA & Fig. 1 C, y). It is not certain when the nave was demolished, but shortly after the dissolution of the monastery is likely. The exposed west wall of the chancel, as it appeared in the early 19th century, may be seen in plate XVII.

In the early 14th century, large archways were pierced through both the south and north walls of the east chapel (Fig. 1 E, z), to link it respectively to the north choir aisle and to the chancel of the north chapel. Up to this time, the main entrance (and probably the only access) to the east chapel had been through the original Romanesque arch from the north transept (Pl. XVIC & Fig. 1 D, x). As the new archways are exactly the same in detail as the arcades into the radiating chapels off the ambulatory, they must belong with the general remodelling of the east end undertaken from c. 1320.[2] The vault of the north chapel was presumably reconstructed in this period as well, as the moulding profiles indicate that the diagonal and transverse ribs are 13th-century, whereas the ridge ribs, bosses and corbels are 14th-century additions. It may be that the lost vaults in the east chapel were also modified in this way, for the surviving springers have the remains of early Gothic diagonal and transverse ribs, whilst the corbels over the north and south arches are early 14th-century (Pl. XVIC). Presumably it was at this date that the ogee reticulated windows replaced the original east windows of both chapels (Pl. XVID & Fig. 1 E, v), and that similar two-light traceries were introduced into the north window openings of the chancel of the north chapel (Fig. 1 E, u). Some structural work was also required, with the building of a large buttress between the two north windows, and some renewal of the plinth mouldings suggesting work on the foundations in this area. Apparently the older fabric of the north wall had begun to lean outwards, which provides the likely explanation for the reconstruction of the vault. The larger buttress supporting the east wall between the two chapels (Pl. XVID) and the flying buttress at the north-east angle probably belong to this period as well.

A clue to the date is provided by the heraldry of the vault bosses in the north chapel, which include the arms both of De Clare and Despencer, and must allude to the union of Hugh le Despencer the younger, the first Despencer lord of the manor, with Eleanor de Clare, the eldest of the De Clare heiresses. They came into possession of the manor not earlier than 1317, and Hugh was executed in 1326, so the work should belong between those years. If the ogee reticulated tracery is to be considered as an integral part of the work, then a date nearer 1326 would be more satisfactory in the context of the Decorated style in this area.

This remodelling changed the earlier medieval character of this area from a series of compartments to the more unified north/south space we see today, the more so since the demolition of the nave of the north chapel. After the Dissolution, it came to be regarded and used as one room – in actuality as the grammar school for almost three centuries, and in legend to be designated 'the chapter house' by the 19th century.[3] Its state early in that century may be deduced from the Plan, which shows the arches from the east chapel to the north transept and to the choir aisle walled-up. At the time of its restoration, *The Tewkesbury Register* (27 September, 1879) could describe how 'but little daylight struggled in, and the moles and bats held indisputable possession of this dreary chamber'. Just over a century later, the chancel of the north chapel is now fitted out as the choir vestry and song school, screened off from the east chapel, which is now the abbey shop.

This resumé of the later use of this area serves to emphasise how distant we are from its early medieval disposition. In fact, it is not known with certainty to which saints these chapels were dedicated, and there must have been at least three altars. Such evidence as exists is derived from the monastic Annals, which state that a chapel of St Nicholas was built anew from the old in 1237, and that altars of St James and St Nicholas were dedicated in the following year.[4] As the chapels under consideration contain the only fabric surviving which might fit this period, writers have linked them with these dedications, but this can be no more than speculation.

The hypothesis works best if one places both altars in the east chapel, an arrangement which is implied by the fact that it has two east windows (Pl. XVID). Then the sense of the statements in the Annals would be fulfilled, in that what was being undertaken apparently was the demolition of an older north transept chapel, which originally had two chapels one above the other as the surviving arches show (Pl. XVIC), and its replacement by a larger single-storey chapel to accommodate both altars side by side at ground level. As will be shown below, the older chapel may not have been the original Romanesque one, but a chapel rebuilt on its site in the later 12th century, probably still preserving its two-storey form. This means that the north chapel should not be assigned to St Nicholas, as it has been since the 19th century at least, and it is in need of a different designation. It has been plausibly suggested that it was an Elder Lady Chapel, which was supplemented or replaced in the 14th century by the new one erected at the east end of the church, an arrangement found also at St Augustine's, Bristol (now the Cathedral).[5]

On stylistic grounds, the north chapel should belong to the early years of the 13th century and is unlikely to be later than the 1220s. Although it incorporates features employed also in the east ends of Worcester Cathedral and Pershore Abbey in the 1220s and 1230s, such as detached shafts of Purbeck marble or lias, these occur at Tewkesbury in combination with other elements which imply an earlier date.[6] Most obvious is the undercut chevron ornament carved between two of the roll mouldings in the outer order of the chancel arch, a motif used in a variety of imaginative ways in the 'West Country School' of the late 12th century, and here carved with such delicacy as to suggest that it represents the swan-song of this tradition (Pl. XVIB).[7] The impression of an early 13th-century date finds corroboration in the style of the stiff-leaf capitals, which have a general resemblance to crocket capitals with tight knots of foliage at the tips (e.g. Pl. XVIB), in contrast to the more luxuriant use of stiff-leaf in the capitals at Pershore and Worcester. In some instances, there is no stiff-leaf and the overall form is nearer to broad-leaf capitals more prevalent in the 12th century.

In sum, an approximate date for the north chapel should be *c.* 1210 – 20. It is therefore unlikely to be the chapel of St Eustachius built in 1246, as some writers have maintained, and so Massé's suggestion of a dedication to the Virgin Mary is still a possibility.[8]

The north chapel provides a *terminus post quem* for the building of the enlarged east chapel, as is shown by an examination of the south wall of the north chapel, which originally separated the two chapels (Fig. 1 D). There are clear signs on its south face, above the inserted 14th-century arch, of two hoodmoulds for windows, which would correspond exactly with the 13th-century window frames still extant in the north wall of the north chapel (Fig. 1 E, u). This is confirmed by the chamfered stones still

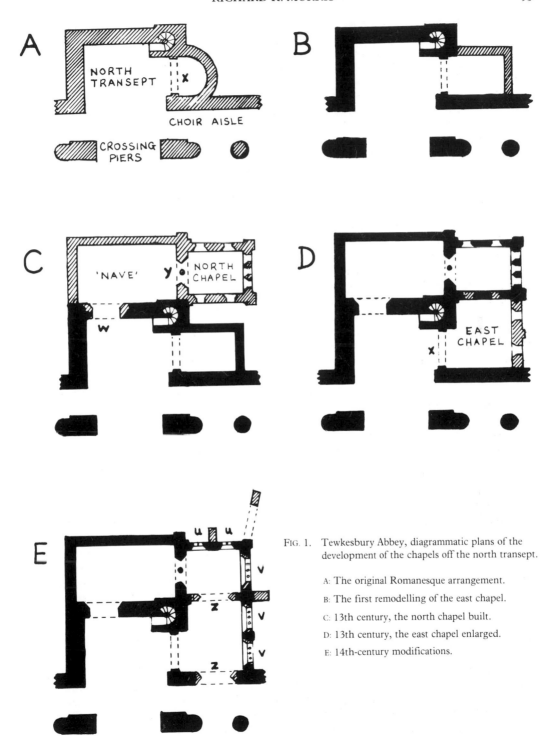

FIG. 1. Tewkesbury Abbey, diagrammatic plans of the
development of the chapels off the north transept.

A: The original Romanesque arrangement.

B: The first remodelling of the east chapel.

C: 13th century, the north chapel built.

D: 13th century, the east chapel enlarged.

E: 14th-century modifications.

visible below the westernmost of these hoodmoulds, which are evidently part of the exterior mouldings of the window frame, as may still be observed in the north wall's windows; the latter have chamfer mouldings to the outside only, with shafted mouldings to the interior. Furthermore, a projecting vertical strip of masonry surviving to a height of about ten feet in the north-west corner of the east chapel, and belonging with the south wall of the north chapel, would appear to be an external buttress for the latter chapel. All of which points to the fact that at one stage the chancel of the north chapel was freestanding on its south side (Fig. 1 C), and therefore that it must pre-date the final enlargement of the east chapel, which made the two chapels contiguous and caused the windows referred to above to become redundant (Fig. 1 D).

Within the east chapel, the vault corbels provide evidence which suggests that it had been remodelled or rebuilt[9] at least once before the enlargement in the 13th century to its present size. Stylistically, the earlier remodelling would fit best in the late 12th century, and may possibly have been a result of the fire of 1178. The corbels supporting the stumps of the former vault, two of which are visible in plate XVIc, are similar in overall form but are decorated differently – some with delicate trumpet scallops and others with stiff-leaf foliage. In the lower Severn valley area, the scallop capital was popular in the decades *c.* 1160 – 1200 in the milieu of the 'West Country School', with Worcester Cathedral as an important centre.[10] Although there are some late examples after 1200,[11] it is very hard to conceive of the form still being employed at Tewkesbury after *c.* 1220, which is the *terminus post quem* implied by the evidence from the north chapel. On the other hand, the stiff-leaf foliage of the other corbels looks more developed and probably later than that employed in the north chapel, and therefore might well fit the work indicated in the Annals for 1237 – 8.

As it is very difficult on stylistic grounds to accommodate the carving of these two types of ornament within the same campaign, one must assume that the trumpet scallop corbels in the east chapel are later 12th-century, subsequently re-used. They are almost certainly not in their original 12th-century positions, for in the south-west corner of the chapel, which potentially would be the area least disturbed by the 13th-century enlargement (Pl. XVIc), one finds a new stiff-leaf corbel. Given that the 12th-century chapel was narrower than its replacement (Fig. 1 B & D), it seems reasonable to assume that it preserved the two-storey arrangement of its Romanesque predecessor. In addition, one may deduce that one of the reasons for moving the corbels in the 13th century was the need for a higher vault in the new single-storey structure, rising well into the space of the former gallery chapel (Pl. XVIc). In conclusion, the identification of the present east chapel with the chapel of SS James and Nicholas, rebuilt in 1237, seems plausible on the limited evidence available.

The main purpose of this detailed examination of the east chapel has been to identify the approximate date of demolition of the Romanesque two-storey chapel which formerly stood on the site. This in turn provides one of the few clues as to when the gallery and gallery chapels of the eastern part of the Romanesque church were suppressed or fell into disuse, presumably to be replaced by additional chapels on the ground floor.[12] The move to ground-floor chapels for liturgical reasons was one of the most fundamental changes affecting English great churches in the 13th century, of which the complete rebuilding of the east ends of Worcester Cathedral (after 1224) and Pershore Abbey (*c.* 1220 – 30) provide typical and pertinent local examples.[13] At Tewkesbury, we can now see that this phase would seem to have been reached by 1237 at the latest, for the line of the vault of the rebuilt east chapel clearly cuts right into the space of the former gallery chapel. Of course, this need not be taken to mean that all the gallery chapels in the east end at Tewkesbury had been suppressed by this time. The equivalent chapel in the south transept still survives today, and was evidently kept in use of some sort throughout the Middle Ages; an unusual circumstance probably to be explained by its proximity to the stair to the monks' dormitory.

Nonetheless, one additional piece of evidence implies that the gallery of the east end must have fallen into disuse as an internal circulation space well before the end of the 13th century. This is the insertion of a geometrical bar tracery window into the gallery opening in the east wall of each of the transept

arms, directly above the arch leading into each choir aisle (Pl. XVII). As the design of the window in the south transept consists of a large curved-sided triangle containing three cusped oculi, a date in the 1260s or 1270s is indicated, by analogy with similar features in the north transept of Hereford Cathedral and the nave of Lichfield Cathedral. This period would also fit the equivalent design in the north transept, a circular window containing seven cusped oculi (Pl. XVII). This provides a *terminus ante quem* for conjectural modifications to the Romanesque east end, and they may well have occurred considerably earlier, for the two windows could represent the end of a long and fairly piecemeal process: namely the improvement of the transept arms to bring them into general conformity with an east end already updated. Much as a little later new traceries were added into the pair of large window openings in the end wall of each transept, probably in the 1290s (Pl. XVIA).

One can only speculate as to what the modifications were to the east end, along the lines indicated by the evidence from the transept arms. Firstly, as the apertures of the gallery to the transept had been glazed, it is virtually certain that the same sort of treatment must have been accorded the gallery openings round the presbytery. Secondly, the underlying reason for this modification was that the gallery chapels, probably three of them on analogy with Gloucester, had been demolished and rebuilt at ground floor level. It may be that some of the references in the Annals to chapels being built and altars dedicated in the 1240s, including that of St Eustachius in 1246, refer to the gradual progress of this work. Certainly, the medieval dedications of most of the present eastern radiating chapels are not known, which leaves scope for this hypothesis. Against it may be raised the objection that the Annals record a dedication for the church of Tewkesbury with its 'major' altar in honour of the Virgin Mary in 1239, potentially in the middle of these conjectural works. However, at least one authority has suggested that this may allude to a new Lady Chapel, which could be the north chapel, rather than to the church as a whole.[14] Furthermore, perhaps too much emphasis should not be placed on this date, as there is a suspicion that the bishop of Worcester was catching up on business of this kind that was long overdue; for in that year he also dedicated such other major churches as Gloucester, Winchcombe, Pershore and Great Malvern.

In terms of the Romanesque superstructure of the east end, remarkably little of it may have been replaced in these alterations. It would have necessitated the removal of any roof covering from the gallery to illuminate the new windows, and from the evidence remaining on the exterior of the east walls of the transept arms, this would seem to have been only a lean-to timber roof, not a stone quadrant vault as at Gloucester. Quite possibly stone transverse arches were employed at intervals in the Romanesque work, and these might have been preserved or adapted as the equivalent of flying buttresses. For some time now, it has been thought that the Romanesque church was barrel-vaulted, without a clerestory, and this hypothesis has been expounded in a recent article by Philip McAleer.[15] The lack of clerestory windows would be particularly archaic for a great church by the early Gothic period, and would accentuate the need to add glazing somewhere – in this case, in the existing apertures of the gallery. Since the appearance of McAleer's article, an opportunity has been afforded to make a close inspection of the east face of the wall directly above the east crossing arch, from scaffolding erected in 1984 for the redecoration of the present vault.[16] The details of the masonry of this wall not only tend to confirm the former existence of a stone vault of semi-circular section, presumably a barrel vault, integral with the Romanesque masonry, but it also shows no clear sign of the existence of any other vault except for the present 14th-century one. Thus, one assumes that the barrel vault was retained in the 13th-century remodelling, and not replaced by a Gothic rib vault as one might anticipate.

Another adaptation would concern the floor of the former gallery, sitting directly on top of the ambulatory and choir aisle vaults, which would need to be covered over with a roof of low pitch. A possible solution could have been a low gabled roof over each bay, with a transverse ridge so that water drained away in the valley between each of the chapels. Probably the new glazing in the former gallery openings would have been impeded at least a little by such roofs, and altogether this remodelling must

have appeared piecemeal and far from satisfactory. It is thus no surprise that the east end was almost totally rebuilt in the following century, and in the process virtually all traces of this interesting 13th-century conversion were lost. *University of Warwick*

ACKNOWLEDGEMENTS

The author has benefited greatly from discussion of points in this paper with Richard Halsey, Philip McAleer, Ted Potter, and especially Roger Stalley.

REFERENCES

(See also LIST OF ABBREVIATIONS AND SHORTENED TITLES, iv above.)

1. An exception is H. Massé, *The Abbey Church of Tewkesbury* (Bell Guide, 1921), 56 sqq. and plan.
2. R. K. Morris, 'Tewkesbury Abbey: the Despenser Mausoleum', *Trans. BGAS*, XCIII (1974), 142 – 55.
3. The tradition that it was ever a chapter house seems improbable, given that the conventual buildings were on the south side of the church; but Roger Stalley has pointed out to the author that the most obvious parallels for the 'Y' arch into the chancel of the north chapel are with chapter houses and their vestibules.
4. Luard, H. R. (ed.), *Annales Monastici*, I (Rolls Series, 1864), 41 – 180. The relevant entries are – 1237: 'De veteri nova fabricata est capella Sancti Nicholai in ecclesia Theokesberiae, per fratrem Herveium de Siptone tunc priorem...'; 1238: 'Dedicata sunt altaria sanctorum Jacobi et Nicholai...'.
5. Massé, *op. cit.*, 56 – 7.
6. See R. Stalley and M. Thurlby, 'A Note on the Architecture of Pershore Abbey', *JBAA*, XXXVIII (1974), 117, where the authors note the possibility that the eastern part of the new work at Pershore may have been under way before 1223.
7. A very late example of a chevron-type ornament occurs in the transept of St Patrick's Cathedral, Dublin, a design of *c.* 1220 – 30 with strong links with the western parts of England (Roger Stalley, personal communication to the author).
8. See note 5.
9. For clarity, Fig. 1 B shows a rebuilding, but a partial remodelling is as likely; no evidence exists for the precise form.
10. C. Wilson, 'Sources of the late Twelfth-Century Work at Worcester Cathedral', in *Medieval Art and Architecture at Worcester Cathedral, BAA CT*, I (1978), 82 – 4.
11. E.g. at Boyle Abbey, Roscommon, in Ireland, *c.* 1215 – 20 (Roger Stalley, personal communication to the author).
12. McAleer (1983), 551, n. 35, also briefly alludes to this possibility.
13. See for example A. Klukas, 'The *Liber Ruber* and the Rebuilding of the East End at Wells', in *Medieval Art and Architecture at Wells and Glastonbury, BAA CT*, IV (1981), 30 – 5.
14. Massé, *op. cit.*, 56 – 8.
15. McAleer (1982), 555 sqq.
16. This matter is considered in more detail in Richard Halsey's paper.

Ballflower Work in Gloucester and its Vicinity

By Richard K. Morris

Gloucester Cathedral boasts one nationally important example of Decorated architecture, namely the south aisle of the nave with its ornate ballflower work. Ever since Rickman,[1] ballflower has rightly been regarded as peculiar to the Decorated style just as dogtooth is to Early English. Its validity as a stylistic criterion, however, depends on distinguishing it from globular ornaments used in other periods, such as the 'stud' moulding found in Yorkshire in the later 12th and early 13th centuries (e.g. at Old Malton). True ballflower simulates the appearance of three leaves (or very rarely four leaves) opening up to reveal a small ball, like a marble, in the centre of the ornament (Pl. XIXc). Occasionally, for reasons of speed or cost, the ornament remains unadorned as a plain single ball, though usually this occurs in conjunction with true ballflower (e.g. Pershore tower, Salisbury spire).

Visually its purpose is not just to impress through ostentation, but to break up the lines of the architecture and to dematerialize the fabric so that when used on great towers like Hereford, Lichfield and Salisbury, their shimmering forms would conjure up images of a celestial city. Whether it is a representational carving is unlikely ever to be proven, but analogies with foliate decoration, such as a stylized rosebud,[2] or with bells as on animal collars, are probably not far off the mark. The ornament is specifically English in usage, though it occurred occasionally in northern France in the 13th century, notably in the upper stages of the facade of Notre-Dame, Paris (c. 1250–60), where the masons developed foliage crockets into true ballflower. Even if the prototype is French, no convincing connexion has ever been demonstrated, though the possibility should be entertained of a link through the Kentish school of masons at court.[3]

In England, the application of ballflower intertwined with foliage tendrils or alternating with fleurons is more characteristic of the South and East (e.g. St Albans Lady Chapel),[4] where there is perhaps also a preference for smaller, daintier ballflower, in contrast to the larger, unadulterated usage typical in the West.[5] However, this distinction is in part one of chronology, for no examples of the more decorative usage can be dated with certainty earlier than the main western works to be discussed in this article. It therefore appears to be a slightly later phase as well, at which stage occasional instances also appear in the West (e.g. Exeter Cathedral rood screen, 1317–25[6]). Another factor pertinent to its distribution is the local availability of good carving stone, for in such areas there developed an expectation amongst patrons and a tradition amongst masons that architecture should be lavishly decorated. Thus, a dense band of examples, mainly parish churches, follows the oolitic limestone belt diagonally from Gloucestershire through Oxfordshire and Northamptonshire, Leicestershire and Rutland, to southern Lincolnshire. Not that sandstone necessarily proved a deterrent, as shown by the virtuosity of the ballflower in Herefordshire, and one must assume that an urge existed there in the Decorated period to vie with the creations of the limestone belt, as much as it had in the time of Brakspear's 'West Country School' of c. 1200.[7]

The counties of Herefordshire and Gloucestershire are well-known for the extrovert use of ballflower in their churches. It has even been assumed that it originated there,[8] but in fact the ornament seems to have arrived from Wells, where its appearance in the cathedral chapter house provides the first datable example in this country (late 1290s–1306).[9] Despite the bias in the antiquarian literature towards examples in counties further east on the limestone belt, especially Oxfordshire and Northamptonshire, no detailed study of them exists to contradict the point of view that the churches of the lower Severn valley area constitute the most coherent early group of works characterised by ballflower. It should be realised that there is no intrinsic development within ballflower ornament to supply a scheme for dating, apart from the general guidelines given above, and it became evident very early in the author's research that the mouldings that contain the ornament, and all the other

circumstances of context, are of the utmost importance. Enough evidence exists, however, to suggest that before *c.* 1320 ballflower ornament was becoming popular in several centres in different parts of the country, and therefore that the more western examples to be considered here are but a part of the complete story.[10]

GLOUCESTER SOUTH AISLE

The significance of the nave south aisle at Gloucester is that it is the best documented of the works of the lower Severn valley group, and provides the chronological starting point for evaluating their development. The *Historia et Cartularium* states simply that the aisle 'was constructed' in the time of Abbot Thokey in 1318,[11] which is generally taken to mean that work commenced then and was complete at the latest by Thokey's death in 1329. A calculation of work-speeds shows that the whole job could have been carried out in one year (see Conclusion), but this is unlikely. Another possible interpretation is that the aisle was finished in 1318, the work having been in progress for several years before. However, the stylistic connexions to be examined below, particularly with Hereford, Tewkesbury and Badgeworth, indicate that the earlier date is less likely, and this tends to be corroborated by an appeal to the bishop of Worcester in 1318 to appropriate the church of South Cerney to the abbey for reasons that included 'the fabric of the church threatened by ruin'.[12]

An examination of the stonework suggests that the impending disaster was the collapse of the nave south aisle, as its outer wall was leaning dangerously outwards in the centre bays. This is evident from the massive freestanding buttresses that spring from new abutments built beyond the old foundations (Pl. XVIII), and on the inside, by the insertion of narrower new stones about halfway up the wall, at a level a little higher than the window sills, where one might anticipate horizontal cracks to develop when the leaning action was arrested by external shoring. The cause of the problem may well have been irregular foundations relating to the underlying remains of the Roman city wall and ditch, which lie diagonally under the nave from north-east to south-west, the wall running across the south aisle between the fourth and fifth bays from the east. The patching mentioned above is particularly evident in the responds of these bays. The problem was lessened in the bays further east by the lateral buttressing effect of the south transept, and further west too it is noticeable that the Norman respond between the sixth and seventh bays is still vertical, suggesting perhaps that there already was a porch abutting the aisle on the site of the present 15th-century one. Thus, though the south aisle appears to have been remodelled to create an ostentatious display of power and wealth on the public side of the abbey church, the decoration may equally have been used deliberately to mask the underlying structural necessity of the work.

Stylistically, the aisle shows obvious links with the ballflower-encrusted towers of Hereford Cathedral, of which one (if not both) appears to have been completed before 1319, just as the work at Gloucester was starting. The date hinges on a papal bull of that year, in answer to the Cathedral authorities' petition for funds to help avert the collapse of a tower on which much money had recently been expended.[13] This is generally taken to be the present crossing tower, but it might refer to the west tower that finally collapsed in 1786, and which was in a similar style. In turn, the sources for the ballflower works at Hereford, the towers and also various tomb recesses, are found in the South West, particularly at Wells Cathedral, whence an important mason seems to have moved to Hereford towards 1310.[14] The similarities of detail include not just the extensive use of ballflowers in parallel rows of hollow mouldings, as in the windows of Wells chapter house: but also extend to the mouldings themselves, to the subcusped cinquefoils of the tracery in the upper stage of the tower, and to the buttresses set diagonally (Pl. XIXA). It will be seen that some stylistic reminiscences of the South West continue to appear in the work at Gloucester and in its vicinity, which may well indicate that this Wells-trained mason had moved the centre of his operations there by *c.* 1320.

The profusion of ballflower and the virtuosity of its use is the most obvious way in which the south aisle exhibits its Hereford pedigree. A particular characteristic is the application of ballflowers to

GLOUCESTER : NAVE SOUTH AISLE

Fig. 1

window tracery, to be seen also in this area at Badgeworth, Leominster and Ledbury (see further below). Even the ballflower itself can be said to be of a general Hereford type, carved in a straightforward way (Pl. XIXc), as opposed to certain alternative treatments discernible elsewhere, such as at St Augustine's, Bristol, where the leaves of each ballflower are given a definite twist. There are seven ballflower windows (Pl. XVIII), of which the easternmost one was carefully modified in about 1400.[15] The sheer quantity of ornament in each original window may be judged by Bond's correct observation that a horizontal line drawn just above the springing of the arch cuts through no less than thirty-two rows of ballflowers, 'sixteen within and sixteen without' (Pl. XIXd).[16] The buttresses in between the windows have their main lines softened by ballflowers as at Hereford, and also recall the Cathedral tower in being similarly adorned with a horizontal band of ballflowers, and in having large tabernacles set diagonally at window sill level (cf. Pls. XVIII & XIXA). Internally, even the vaults of the eastern bays have ballflower ornament, but it was phased out in the fourth bay from the east, probably reflecting a growing disenchantment with its cost and labour, particularly in a location where it is virtually invisible. Overall, the exterior distribution of the ballflowers is more restrained than the 'horror vacui' effect at Hereford, but this is probably to be explained largely by the fact that an earlier structure was being remodelled. Thus, most of the Norman wall masonry was retained, and also the exceptional thickness of the wall resulted in window splays too deep to be entirely concealed by rows of ornament.

In the windows, each vertical row of ballflowers alternates with a roll moulding, treated as a shaft (Pl. XIXd and Fig. 1 A, B). The junction between the roll and the hollow moulding containing the ballflowers is almost invariably delineated by a fillet, and the whole formation is taken directly from the windows of Hereford tower as, for example, a comparison between their mullion profiles demonstrates (Fig. 1 A, D).[17] In the arches of the window frames wave mouldings are employed instead, which is related to the use of large wave mouldings in the lantern cage of masonry inside Hereford tower and to their appearance in other Herefordshire churches from about 1320 (Fig. 1 E, F).[18] It is interesting, however, that their particular use at Gloucester in combination with a hollow moulding and canted fillets constitutes a very early and rare occurrence of this complete formation in the West, and suggests the possibility of a connexion with work from the 1320s in East Anglia (e.g. Prior Crauden's Chapel at Ely, in building 1324 – 5),[19] a theme also observed in the mouldings of the near contemporary Decorated work at Worcester Cathedral.[20] Had a mason from the East of England arrived in the lower Severn valley in this decade? The possibility should not be overlooked.

The other mouldings employed in the aisle are typical of the Decorated style in this area and, though too common to prove a specific connexion, Hereford provides parallels as close as any. The profile of the window capitals (as those of the south transept gallery chapel, Fig. 2 B) is of the same design as the string-courses between the stages of Hereford tower, and of the earlier string-course around the interior of Wells chapter house: all are decorated with ballflower.[21] Surprisingly, the bases are simpler than those employed in the north-east transept at Hereford and Wells chapter house, but it should be noted that they have in common the use of typical part-octagonal sub-bases (Pl. XIXd). Thus, Harvey's statement that the bases are the source for the part-hexagonal sub-bases in the early Perpendicular work in the south transept is unfounded: the latter mark the advent of an influence completely new to the lower Severn valley.[22]

The aisle windows are distinctive for their 'butterfly' tracery pattern, the head divided into six equal parts around a central point treated like an 'eye' (Pl. XIXd). Within it, three cusped mouchettes alternate with cusped triangles, the tall centre light impaling the design where the third triangle should be. The form stems ultimately from the Rayonnant idea of dividing a large roundel into six parts, as could be seen before 1280 in the clerestory window design in the wider bay of the choir of Old St Paul's Cathedral,[23] and by the 1290s in works as far apart as Lincoln Cathedral cloister and Exeter Cathedral Lady Chapel. Within this general spread of Rayonnant ideas, the most precise prototype for Gloucester is to be found in the tracery of the fourth bay from the east in Merton College Chapel,

Oxford (1290–4), as Willis pointed out long ago.[24] There the roundel is omitted, and the design expands to fill the whole head of the window. However, one should not forget that similar tendencies had been at work in the South West, as shown by the three radiating almond or petal shapes (the equivalent of the mouchettes at Gloucester) in the eastern lateral windows of the Bishop's Palace Chapel at Wells (1280s); and a five-petal design in the choir aisles at Exeter stresses the centre point as a small aperture, rather like Gloucester.

There is evidence that the butterfly pattern was already in use in the Gloucester area before 1318. The chancel east window at nearby Badgeworth, which can be shown to antedate the severe Victorian restoration of this part of the church,[25] was probably in place at the dedication of the high altar recorded in 1315:[26] the tracery is essentially as at Gloucester, but without ballflower. Bigland's 18th-century view of the now demolished church of St Michael at the Cross in Gloucester shows that there once existed in the south chapel two similar windows, again without ballflower.[27] No firm evidence exists to date them, but if the window with uncusped intersecting tracery shown alongside them actually belongs with them, then a date before 1318 is very likely: this tracery is common in Herefordshire around 1300 (e.g. Much Marcle), and with cusping added continues into the early 14th century (e.g. Ledbury, south aisle). One other local example of the butterfly pattern exists in the chancel east window at Hartpury, a possession of Gloucester Abbey five miles north of the city across the Severn. In this case, however, it is most likely to have been a derivative of the 1318 work at the Abbey because its mullion profile and mouldings to the interior are from the same templates as those for the south aisle windows (Fig. 1 A), and at the centre of the tracery is a single ballflower set in the characteristic 'eye'.

Just how close the links between the works at Hereford and Gloucester are in this period is revealed by an analysis of the tracery in the ballflower-studded windows of the nave south aisle at Leominster Priory. In the head of each window is a butterfly pattern identical to the heads of the Gloucester south aisle windows, even to the detail of the 'eye', except that the pattern is contained in a large roundel. On the other hand, each pair of lights below has a delicately subcusped cinquefoil in the head, a direct borrowing from the tracery in the upper stage of the Hereford crossing tower, and the aisle is undoubtedly by masons from the cathedral workshop. But the combination of forms in the tracery suggests a designer familiar with the ballflower works at both Hereford and Gloucester – the master of the Hereford tower, who may be one and the same person as the master at Gloucester. There is no date recorded for the Leominster aisle, but given its incorporation of features specifically from the Gloucester aisle tracery, a date around 1320 is most likely.[28]

OTHER BALLFLOWER WORK AT GLOUCESTER

Ballflower ornament is employed more discretely at Gloucester in the remodelling of three of the chapels in the old Norman east end, and in a surviving fragment associated with the lost monastic dormitory. Stylistic evidence suggests that all these works should be regarded as a continuation of the south aisle work, and that none of them antedates 1318. It will be shown that they all accord well with the decade c. 1320–30, so that ballflower work continued to be executed at the Abbey right up to the advent of the proto-Perpendicular style in the main body of the south transept, when all the architectural detail changed so dramatically (after 1329, probably 1331 sqq.). If there ever was a 'ballflower master', he ceased then to design for Gloucester, though presumably the local masons who had worked to his patterns now turned their hands to the new style rather than emigrating elsewhere as a team.

The eastern chapels to be considered here are the north-east gallery chapel, and the gallery and crypt chapels which are respectively above and below St Andrew's Chapel off the south transept (see plan). Unlike Worcester Cathedral, for example, the Norman eastern chapels were retained in use in the Gothic period, and the fabric of individual chapels was updated from time to time, as witnessed by the fine 13th-century double piscina in the north transept gallery chapel. Thus, the various ballflower fittings are likely to be intermittent rather than simultaneous works. A precise date for the south crypt chapel is elusive, for the remodelling is limited to a single-light window with cusping but no tracery,

and a chamfered rerearch decorated with one row of ballflowers. The north-east gallery chapel received a two-light window with a new exterior frame incorporating ballflowers (Pl. XIXB). On the interior, a pair of foliate image brackets flank the window, though the colonnettes of the Norman window frame were retained internally. The tracery is very reminiscent of the south aisle in its bold plastic forms, with the customary arch removed from each of its lights so that the trefoil-cusping is emphasized, and with the cinquefoil in the head unframed to match. In addition, the tracery is completely decorated with ballflowers inside and out, and the horizontal bands at the springers of the exterior framing arch echo those around the buttresses of the south aisle (cf. Pls. XIXD and XIXB). If the interior brackets were executed at the same time as the window, their mannered foliage would incline one to a date a little later than the commencement of the aisle in 1318, and the angular profile of the mullion also fits better with the development of this workshop during the 1320s (Fig. 2 F).

By comparison, the refitting of the south transept gallery chapel is altogether more splendid. The centrepiece is a two-light ogee reticulated window which is thickly encrusted with ballflowers, complemented internally by an elaborate rerearch with openwork cusping, and by several canopies and brackets for images (Pl. XXB). An unusual feature is the treatment of the arch of each of the window lights as a canopy terminating in a finial, a sculptural embellishment of the tracery probably derived from knowledge of work in the Thames valley (e.g. the east windows of Merton College, Oxford, and St Albans Lady Chapel). Several factors suggest that the remodelling of this chapel belongs to the 1320s, probably c. 1325 – 30, and is the last of the ballflower works to be carried out in the abbey church. Most significant is the employment of the ogee arch, which had been conspicuously absent in all the previous works, except for a discrete appearance in the south aisle in the canopies over the images on the buttresses. There is no evidence that ogee reticulated tracery was in regular use in the lower Severn valley area before the 1320s,[29] and this accords stylistically with the tendency towards a nodding ogee design in the ballflower canopies of the internal window splay (Pl. XXB); and also with the small size of the ballflower in the tracery, as found in later works in the this style in Herefordshire (e.g. Ledbury, St Katharine's Chapel). The rare form of the cusping of the rerearch of the window, with two cusps rather than three between each foil, is repeated in the so-called 'Forthampton' ballflower tomb adjoining the sacristy at Tewkesbury Abbey, which is likely to be the monument to Abbot Kempsey (d. 1328), and thus provides another parallel for dating (cf. Pls XXB and XXIB).

Two other features in the chapel call for comment: the image brackets with their sideshafts and canopies, and the tracery of the smaller south-east window. The image brackets, one of which is visible in plate XXB and the other of which directly adjoins the north side of the main window, are by a superior hand, with exquisite foliage tendrils carved in shallow relief up the sideshafts. It cannot be taken for granted that they belong with the other work in the chapel, but the fact that they include ballflower in the miniature vaults of the canopies and in one of the foliage tendril patterns makes it reasonably likely. The carver may have come from Bristol, for the springer of the northern bracket is decorated with a style of foliage reminiscent of the arum lily, of which the only other examples known to the author in this area are at St Augustine's, Bristol, in isolated capitals in the Berkeley Chapel and in the south choir aisle: works which are unlikely to antedate c. 1310 in execution, and which could be up to a decade or so later. Running up the inside edge of each sideshaft is a narrow band of what may best be described as single-lobed leaves, a little bit like crockets, and they too recall the decoration of certain fittings at St Augustine's and at Exeter Cathedral.[30] This implied connexion with Bristol corroborates the observations of earlier authorities that there is Bristol influence present in the remodelling of the main vessel of the south transept, as exemplified in such features as the elaborately cusped entrance to the south choir aisle.[31] There is a possibility, then, that the work in the chapel overlaps with that in the transept, which was not commenced until the time of Abbot Wigmore (1329 – 37) and is generally accepted to have been started in 1331.[32] In this context, the prominent depiction of a king's head on the southern image bracket may specifically refer to the burial of King Edward II at Gloucester, which would place the work after 1327.

Fig. 2

The smaller south-east window (Pl. XXв) may also provide a clue to dating, in that its reticulated tracery includes the key proto-Perpendicular detail of the extension of the vertical lines of the tracery (here flanking the reticulation unit) to intersect the arch of the frame. Much has been made of the fact that this detail is absent from the reticulated tracery of the lateral windows of the south transept but is present in the great south window, implying that it arrived at Gloucester about 1335.[33] Extending this argument to the gallery chapel produces rather a late date for the ballflower work, and it is tempting to assign the tracery of its south-east window to a subsequent general refenestration of all the smaller gallery windows, which could have taken place at any time in the later 1330s or 1340s. On the other hand, the mouldings of its interior frame are different from the other windows of this type, and in the jamb adjoining the ballflower window they are cut from the same stones that are carved with ballflower. Whatever the exact date one would wish to assign to this chapel within the decade c. 1325 – 35, its late date in relation to the other ballflower works and its closeness in time to the proto-Perpendicular remodelling seem certain.

Another indication of the date of the south transept chapel is provided by the mouldings (Fig. 2 A – E), which are in obvious contrast to those of the south-east chapel in the gallery (Fig. 2 G). The latter seem to fit best with the style of the proto-Perpendicular remodelling in the mid-1330s, when a Kentish influence is discernible in such works as Edward II's tomb and the south window of the south transept.[34] In the main window of the south-east chapel, the delicate ogee lines of the tracery seem to recall Kentish work as much as the distinctive profile of the mullions;[35] and the part-hexagonal form – here used in the brackets of the reredos – is a key motif of the Perpendicular style at Gloucester. As the work in the south transept gallery chapel is most likely to precede this style, a date no later than the early 1330s is the logical conclusion. The ballflower mouldings show expected affiliations with those in the nave south aisle, particularly in the capitals of the window frame (Fig. 2 B), which are from the same template as the sill string-course of the aisle. However, they also reveal a further stylistic development in a fondness for angular and polygonal forms. In the south aisle, this interest was mainly evident in the profile of the rib (Fig. 1 C), which was probably the last moulding to be designed in this work,[36] whereas in the transept chapel the form is obvious in the part-octagonal shaft of the window frame and in the sideshafts of the image brackets, and is probably also reflected in the sharp forms of the mullion (Fig. 2 D, E, C, A, respectively). The tendency has already been noted for the mullion of the north-east gallery chapel (Fig. 2 F), and it is one of the features of the north chapel at Badgeworth, where a date in the mid-1320s seems most likely.

However, before turning away from Gloucester, the fragmentary remains of a window frame associated with the lost dormitory block must be examined, because it has been considered by some to incorporate the earliest ballflower work at the monastery. It adjoins the north-east corner of the chapter house externally, seems to be in situ, and therefore should pertain to the monastic dormitory, which was directly to the north of the chapter house. The only ballflower is on the capital of the interior window frame, for there is no sign that it ever existed on the tracery. St John Hope considered that the use of the ornament confirmed this window as belonging with the rebuilding of the dormitory which appears to have taken place between 1303 and 1313,[37] but modern research suggests that this is rather too early for ballflower work. In fact, the mouldings indicate that the true date is likely to be in the decade c. 1320 – 30, which means that it must represent a later modification to the dormitory range, perhaps for a private chamber, or that the date usually accepted for the dormitory rebuilding is suspect.[38] The closest parallel for the window frame lies in the nave south aisle, the profile of the jamb being the same size and design as the outer moulding formation of the aisle window frame (Fig. 1 B, J); their capitals are also identical (as Fig. 2 B). The jamb of the tracery, however, indicates that the exterior profile of the window mullions was a double chamfer (Fig. 1 H), a design not found elsewhere at Gloucester in conjunction with ballflower work, and not proven to be in use in the lower Severn valley area until about 1330 (e.g. the curvilinear tracery in the north transept of Cheltenham parish church, Fig. 1 G). Taking into consideration the slightly earlier dating applied to the stepped chamfer

type of mullion, a closely related design of which some local examples are also shown in Figure 1 G, a date in the 1320s is possible, but not earlier.[39]

BADGEWORTH AND TEWKESBURY

In the vicinity of Gloucester, there are a number of churches that incorporate ballflower work in a style derivative of, or related to, the south aisle workshop. These include Bishops Cleeve, Brockworth, Cheltenham, Newent, Teddington and Withington, but by far the most ostentatious examples are the north chapel at Badgeworth and the work centred on the sacristy at Tewkesbury.

Badgeworth is only five miles east of Gloucester though historically its allegiance lies more with Tewkesbury, for in the period during which the north chapel was built, the manor was almost certainly in the possession of the lord of the manor of Tewkesbury. Most authorities attribute the chapel to the munificence of Gilbert de Clare III (d. 1314), and assume therefore that it was complete by the time of the dedication recorded at the church in 1315.[40] However, only the high altar is mentioned, and it is virtually certain that it is the chancel east window that is the architectural testimony to this event, as argued above. If the chapel is connected with the patronage of the lord of the manor, then it will be shown that the final years of Hugh le Despencer the younger from 1322 to 1326 accord better with the stylistic evidence.[41] This applies not only to the architecture, to be examined in detail below, but also to the surviving medieval glass in the heads of the north windows.

The chapel has four windows in the Decorated style and a prominent north door, all ornamented inside and out with rows of ballflowers (Pl. XXA). The east window is 15th-century, and such anomalies as the poor assembly of the ashlar masonry suggest the possibility that the chapel was widened and rebuilt at that date, re-using earlier materials, but without detriment to most of the 14th-century features, except perhaps for partial recutting of some of the ballflowers.[42] It is the sheer profusion of the ballflower that provides the most obvious link with Gloucester, but of more consequence is the preponderance of polygonal terminations to moulding formations, combined with hollow mouldings (Fig. 3 A, D). The parallel with features in the gallery chapels at Gloucester is evident (Fig. 2 D, E, F), and contrasts with the shafted forms of the window mouldings in the south aisle at Gloucester; only the rib profile, which may be the last feature of the south aisle to have been designed, moves closer to the Badgeworth style (Fig. 1 C). In the south transept gallery chapel at Gloucester the spiky profile of the window mullions may also be related to the fluted shafts of the window frames at Badgeworth (cf. Figs 2 A and 3 C), and the little sprig-like finials in the window tracery and canopies to similarly primitive finials over the hoodmould of the north windows at Badgeworth (cf. Pls. XXB and XXA). Thus, the style of the north chapel coincides best with works at Gloucester later than 1318, and particularly with the refitting of the south transept gallery chapel, which we have seen may date well into the 1320s.

Some reminiscences of late 13th-century architectural features from Wells and the South West are also discernible at Badgeworth, a fact which fits in with the hypothesis that Wells was the original source for ballflower in the Hereford and Gloucester area. The design of the two-light windows with a sex-cusped curved-sided triangle in the head (Pl. XXA) repeats exactly the openwork tracery in the vestibule of the Wells chapter house,[43] and though this pattern is by no means confined to Wells, the identification is made more specific by the rare use of a round-arched door, which recurs at Wells in the Bishop's Chapel. The profile of the rerearches of these doors is also similar (Fig. 3 E), though without ballflowers at Wells. One might contend that such a tracery pattern would be outmoded by the 1320s, but it has been shown that the tracery employed at Gloucester in the same period is also of late 13th-century origin, and conservatism in tracery design is obviously a characteristic of the lower Severn valley. The most elaborate of the moulding formations at Badgeworth occurs in the exterior frames of the windows and door, and incorporates a distinctive design – a deep hollow flanked by apposed fillets and keel mouldings (Fig. 3 B¹) – for which the most convincing parallel lies in the dado mouldings of

BADGEWORTH : NORTH CHAPEL

Fig. 3

the Lady Chapel at Exeter Cathedral, c. 1280–90[44] (Fig. 3 H, without ballflower). The relationship is intriguing, as nothing very similar is found elsewhere in the lower Severn valley, though it is possible that the intermediary may be Tewkesbury Abbey, where parallels exist with other aspects of the window frame design and where links with Exeter have been noted previously.[45]

The closest affiliations for the Badgeworth style lie in the general remodelling of the east end at Tewkesbury, c. 1320–40, especially the early work on the ambulatory chapels, for during the 1320s it had replaced Gloucester as the main centre for Decorated work in the area. The mouldings are particularly revealing. The capitals of the ambulatory piers at Tewkesbury and of the arcade between the chapel and the nave at Badgeworth make use of keel mouldings and roll and fillet mouldings (Fig. 3 K), whereas the standard Decorated capital in the area is predominantly scroll-moulded. The main moulding formation of the door and window frames at Badgeworth finds a close parallel in part of the design employed for the entrance arches to all the ambulatory chapels at Tewkesbury – a roll and fillet moulding flanked by a semi-circular hollow with fillets (Fig. 3 B[2] & L). Other details, such as the hollow chamfer moulding framing the west window of the chapel, and the use of chamfer mouldings on different planes for the arcade arches, are also particular to Tewkesbury.[46] Moreover, the Badgeworth tracery pattern is repeated exactly in the sacristy at Tewkesbury, and the style of carved heads and tablet flower ornament on the exterior of the chapel recalls the decoration of the parapet string-course above the choir clerestory at the abbey (though the latter is unlikely to predate the 1330s). Taken together, these detailed similarities imply a close exchange of masons between the two works.

This impression is reinforced by the parallels with work executed under Despencer patronage at Caerphilly Castle in the same decade. From the architectural context and from its style, it would appear that it was the rebuilding of the great hall that involved the documented presence of the Kentish mason, Master Thomas de la Bataile, at Caerphilly in 1326.[47] Stylistically, it is particularly the use of fluted shafts in the window frames that points to a craftsman trained in the Kentish school of masons at court (Pl. XXIA), for these were a feature of St Stephen's Chapel at Westminster, and also had appeared around 1300 in the ambit of the king's works in north Wales, in the upper parts of the east end of Chester Cathedral. De la Bataile had worked in the royal service in London, and Master John de la Bataile, probably his father, had been undermaster at the royal foundation of Vale Royal Abbey near Chester.[48]

The fluted shafts at Caerphilly also provide the most specific connexion with Badgeworth (Pl. XXc and Fig. 3 C). This is echoed in other more general parallels of style which, taken together, imply that masons working under Thomas de la Bataile worked also at Badgeworth. Both buildings make use of ballflower ornament; of a very slight ogee in their arches (door and piscina at Badgeworth, windows at Caerphilly, Pls. XXB and XXIA); and of a semi-circular hollow moulding flanked by fillets to contain the ballflower (Fig. 3 D, E, F). Some of these features, such as fluted shafts and delicate ogees, emanate ultimately from the Kentish court style, and the presence in Gloucestershire of a master of De la Bataile's background might also explain the appearance of mullions and ribs with polygonal terminations at Badgeworth and Gloucester, for the South East provides early examples of this type (cf. Fig. 3 A and J). Curiously, however, this particular design is not found at Caerphilly, where the mullion profile looks local (Fig. 3 G), though again there is a hint of an interchange of ideas with the South East. The appearance of keel and roll and fillet mouldings in the capitals at Badgeworth and Tewkesbury (Fig. 3 K) could also be indicative of Kentish influence.[49]

In addition, one can detect at Caerphilly a strain of influence from Wells in the ballflower and delicate ogees, which occur in the chapter house (the ogees almost certainly from a Kentish source), and in the hollow moulding flanked by fillets as found in the west door of the Bishop's Chapel. This influence was also observed at Badgeworth, but the one difference between it and Caerphilly, which may be significant, lies in the window tracery. Both have windows of two lights, cinque-cusped, with a form of curved-sided triangle in the head (Pl. XXB, and just visible in Pl. XXIA), but at Caerphilly the base of the triangle is omitted to create a 'fish-scale' pattern. Like the Badgeworth tracery, this pattern

is also potentially of Wells origin, but it appears there in a later phase of the Decorated work, namely in the Lady Chapel. This observation provides the only stylistic pointer to the relative dates of Badgeworth and Caerphilly, and implies that the former is earlier. As Despenser patronage in the period 1322–6 is another likely link between them, this would place Badgeworth in the period c. 1322–5, and it should be regarded as a work of probably no more than one building season. One of the leading masons engaged there had a familiarity with Wells, and the presence of a court mason in the area is also evident – perhaps De la Bataile, working for the Despencers at Tewkesbury.[50] By 1326 at the latest, we may surmise that De la Bataile had been ordered to Caerphilly to supervise the rebuilding of the great hall, and took with hime one or more of the masons from Badgeworth to serve in a senior capacity under him.

The ballflower work at Tewkesbury occurs mainly in the early stages of the remodelling of the east end, dating from the 1320s, and apart from the ornate sacristy, it is restricted to fittings. Though the Despencer family must surely be the patrons of the main work of the presbytery, the work in the ambulatory and chapels where the abbots are buried may well have been mainly the responsibility of the monastery and of certain wealthy ecclesiastics, notably Abbot Kempsey, the likely benefactor of the sacristy. Elsewhere, the author has demonstrated the similarities with the Gloucester south aisle, especially in the mouldings of the sacristy.[51] Other parallels exist with the south transept gallery chapel, such as the unusual type of sub-cusping (Pl. XXIB), and also the way in which shields hang by heavy bands from hooks on the *ex situ* remains of a screen or fitting of some kind (Pl. XXID); this feature occurs in one of the image brackets in the gallery chapel (Pl. XXB). It is interesting that Bristol influence was cited for these image brackets, and that the type of ballflower carved on the above fitting has the twisted leaves encountered in the aisles of St Augustine's , Bristol – surely the sign of a Bristol carver on the move.

Recently, a series of pieces have come to light, found loose in the abbey, from a tomb recess or screen or other kind of fitting incorporating sideshafts (Pl. XXIC). Their carvings include grotesque heads reminiscent of some of the sculpture of the 'Forthampton' recess, though of finer quality, but their real relevance here is that they constitute a rare instance in this area of the combination of ballflower ornament with foliage tendrils. As this tends to be a feature encountered more in Southern and Eastern examples, it is tempting to assign this development to the presence of someone like De la Bataile. However, this pattern has already been noted in the south transept gallery chapel at Gloucester, in one of the image housings attributed to the Bristol carver, who seems to have worked also at Tewkesbury, so this must be considered as an alternative source. The analogy with Gloucester suggests a date in the late 1320s or later. A locally carved tomb recess at nearby Bredon employs the same motif, and its architectural context suggests a date around 1330:[52] the probability is that it is a derivative of the Tewkesbury work.

CONCLUSION

The general homogeneity of all these works in the lower Severn valley is obvious. Their conservatism in tracery patterns and vault patterns is compensated by excessive ornament and cusping, and throughout there runs a strong tinge of influence from the South West. Nonetheless, there is a considerable variety of specific detail, which implies the appearance of craftsmen from different backgrounds during the twenty or more years that ballflower was fashionable in the area. A Kentish hand is evident at Tewkesbury, Badgeworth and Caerphilly, and apparently influenced work at Gloucester by the mid-1320s. A Bristol hand appears in the south transept gallery chapel at Gloucester, and also in certain fittings at Tewkesbury. An older Wells hand is especially obvious at Badgeworth. All of this tends to undermine the idea that these works are the product of one itinerant team of masons, all moving on together from one job to another, and carving in a consistent style of which ballflower was the particular trademark.

Nonetheless, there is enough continuity of detail for it to be credible that the same master was responsible for the works at the main centres – Hereford, Gloucester and Tewkesbury. He left Wells at about the time when the chapter house was completed, perhaps in company with one or two other masons, and was engaged at Hereford Cathedral, his work culminating in the design of the two towers with ballflower ornament. In 1318, he was called to Gloucester to reconstruct the ailing south aisle, and though he employed a local pattern for the tracery, he treated it in a distinctive manner found also at Leominster, suggesting that he provided at least the design for the priory windows as well. Particularly important amongst the features that link Gloucester to the Hereford towers is the design of the shafted window frames, though in the south aisle they are given bases, capitals, and more elaborately detailed rerearches (Pl. XIXD). One need not look to an outside influence to explain this increased sophistication, for any combination of several material factors could be the cause – the availability of greater funds, the more prominent position of the work, and the better carving qualities of limestone as against sandstone.[53]

The connexion with Tewkesbury is also evident through the use of shafted moulding formations backed up by other parallels of decorative detail. The known dates for the remodelling of the east end suggest that this master would have shifted his attentions to Tewkesbury by the early 1320s. However, the main work surviving today – the sacristy and the 'Forthampton' recess – would hardly have occupied him for long, and it is during this decade that the number of works attributable to him with any degree of certainty begins to diminish. It is a reasonable assumption that he continued to be involved at Gloucester in additional small works, such as the south transept gallery chapel, but even here extraneous influences have been noted. The north chapel at Badgeworth has too many differences from the ballflower work in the main churches to be assigned securely to him, though he might be the source of the rather outdated features from Wells found there. At Tewkesbury, the mouldings employed at the resumption of the work on the east end in the 1330s are closely related to those of the 1320s,[54] but devoid of ballflower so that it is not easy to determine whether the same master was still in charge. In fact, if he had been engaged in an important capacity in the work at Wells chapter house in the 1290s, it is a reasonable expectation that his active working life would be coming to a close towards 1330. An alternative hypothesis for the later stages of his career would be that he left Gloucester early in the 1320s for Salisbury, and thus that the later ballflower works at Gloucester and Tewkesbury are by another local hand, working alongside masons from Bristol and the Kentish court school. However, the difficult problem of the precise relationship of the Salisbury tower design to work in the lower Severn valley – and also to the west towers of Lichfield – lies outside the scope of this paper.[55]

A particular aspect of ballflower work which has always intrigued ecclesiologists is the amount of extra time taken by the carving of the ornament. Doubts may arise as to whether, for example, it would be possible to finish the Gloucester south aisle in the years 1318 – 29 traditionally assigned to it. In the 1960s, Mr Arthur Jones, who was then the foreman-mason at Hereford Cathedral, told the author that he took about three hours to carve a ballflower from a block roughed-out ready for it on the stonework, which works out at three or four ballflowers per working day. This figure excludes all other stages of preparation, from quarrying the stone to cutting the mouldings in which the ballflowers are located. Admittedly, this estimate is for the large ballflowers of Hereford tower (around 4 ins diameter) and for carving in sandstone, and therefore one should make allowance at Gloucester for smaller ballflowers (around 2½ ins diameter) and for the use of limestone that was probably more amenable to carving. So for Gloucester one might allow a figure of at least five ballflowers per mason per working day.

Bond observed that each of the south aisle windows contained about 1,400 ballflowers. On the assumption that there were seven such windows originally and allowing for the other ballflowers decorating the buttresses and ribs, this gives a total of around 11,000 ballflowers. This in turn produces the daunting figure of 2,200 extra workdays to carve the ornament alone. Calculations on a similar basis for Badgeworth north chapel produce 320 extra workdays, and for the two Hereford towers together a horrifying estimate of around 10,000 extra workdays (on the basis there of three ballflowers per day).

These figures are suspiciously high, as they imply that it would take longer to carve the decoration than it would to carve the actual window tracery.[56] If, for the sake of argument, the other work involved in the south aisle, particularly the cutting of all the necessary mouldings and ashlar, and the construction, took roughly twice as long as the carving of the ballflower, a very approximate figure of 6,600 workdays is obtained for the total working time of the masons. That would have kept one mason occupied for almost the whole of his career!

However, taking a slightly earlier local parallel, the rebuilding of the nave aisles of Hereford Cathedral, the surviving compotus roll for 1290 – 1 indicates about ten to twelve masons preparing stones in the lodge in winter, and the number rising to between forty and fifty for the main building season:[57] an average, theoretically, of thirty masons per week throughout the year. Applying such a labour force to Gloucester, the whole of the south aisle could have been finished in one working year if the campaign was very well planned and co-ordinated. For Badgeworth, three masons might suffice to do the north chapel in the same time.

Not that it is likely that the Gloucester aisle was completed so rapidly. There were structural problems that must have slowed the work, and it is doubtful that the team of masons was as large as that mustered at Hereford in 1290 – 1. Nonetheless, clearly a period of three or four building seasons at the most is likely to have been sufficient, even for a very moderately sized workshop of seven or eight masons. So slowness of production is less of a hindrance than might be imagined in ballflower works, but one may surmise that its extra cost was a critical factor. It is surely significant that the quantity of ballflower diminishes in the western parts of the Badgeworth chapel, that it was never completed on the ribs of the Gloucester aisle, and that it was omitted altogether in the later stages of the remodelling of Tewkesbury. No major institution – Wells, Hereford, Gloucester, Lichfield – invited masons back for a second indulgence in an ostentatious ballflower work, and by the early 1330s, the taste for it had died until its revival in the 19th century. *University of Warwick*

ACKNOWLEDGEMENTS

I am indebted particularly to the following for facilitating my access to the relevant works over the years – at Gloucester, Canon David Welander, and Mr Bernard Ashwell, Architect to the Dean and Chapter, who first drew my attention to the dormitory fragment; at Tewkesbury, the former vicar, Canon C. G. R. Pouncey, and the head vergers, Mr E. Leach in the 1960s and Mr Ray Mulcuck more recently; and at Hereford, to the vergers, especially the late Mr W. Gittens.

REFERENCES

SHORTENED TITLES USED
(See also LIST OF ABBREVIATIONS AND SHORTENED TITLES, iv above.)

BIGLAND II (1792) – R. Bigland, *Historical Monumental and Genealogical Collections relative to the county of Gloucester*, II (1792).
CAPES – W. W. Capes, *The Charters and Records of Hereford Cathedral* (1908).
ERSKINE, Part 2 (1983) – A. M. Erskine, 'The Accounts of the Fabric of Exeter Cathedral, 1279 – 1353', Part 2, *Devon and Cornwall Record Society*, N.S. 24 (1983).
HARVEY (1961) – J. H. Harvey, 'The Origin of the Perpendicular Style', in *Studies in Building History in recognition of the work of B. H. St.J. O'Neil* ed. E. M. Jope, (1961), 135 – 165.
HARVEY (1974) – J. H. Harvey, *The Cathedrals of England and Wales* (rev. ed., 1974).
MORRIS (1972) – R. K. Morris, *Decorated Architecture in Herefordshire: Sources, Workshops and Influence* (unpublished doctoral thesis, University of London, 1972).
MORRIS (1973) – R. K. Morris, 'The Local Influence of Hereford Cathedral in the Decorated Period', *Trans. Woolhope Nat. Fld. Club*, XLI (1973), Part I, 48 – 67.
MORRIS (1974) – R. K. Morris, 'Tewkesbury Abbey: the Despenser Mausoleum', *Trans. BGAS*, XCIII (1974), 142 – 155.

MORRIS (1977) – R. K. Morris, 'Pembridge and mature Decorated Architecture in Herefordshire', *Trans. Woolhope Nat. Fld. Club*, XLII (1977), Part II, 129 – 153.

MORRIS (1978) – R. K. Morris, 'The development of later Gothic mouldings in England, *c.* 1250 – 1400, Part I', *Archit. Hist.*, 21 (1978), 18 – 57.

MORRIS (1979) – R. K. Morris, 'The Development of later Gothic mouldings in England, *c.* 1250 – 1400, Part II', *Archit. Hist.*, 22 (1979), 1 – 48.

VINER – Rev. E. Viner, 'Badgeworth and its Church', *Trans. BGAS*, XIII (1888 – 9), 63 sqq.

1. T. Rickman, *An Attempt to Discriminate the Styles of Architecture in England* (1817 and many later editions).
2. A late medieval parallel that survives in painting is the rose-petal decoration on the vault of the Lady Chapel at Ely Cathedral, a reference presumably to the cult of the Virgin Mary.
3. Kentish influence is strong in the earliest datable example of ballflower, Wells chapter house. See further Morris (1972), 117 – 21; and, passim, J. H. Harvey in *Wells Cathedral, A History*, ed. L. S. Colchester (1982), 73 and 89.
4. Provisional lists compiled by the author in the 1960s are as follows. (a) Ballflower combined with tendrils: – Berkshire – Ardington; Buckinghamshire – Milton Keynes; Cambridgeshire – Fowlmere, Lolworth, Over; Devon – Exeter Cathedral rood screen; Hertfordshire – St Albans Abbey Lady Chapel; Lincolnshire – Greatford; London – St Stephen's Chapel at Westminster (some apparently original stonework adjoining the door to the undercroft vestry, an important royal example though almost certainly not *in situ*); Northamptonshire – Barnack, Everdon, Rushden; Oxfordshire – Broughton, Dorchester Abbey, Oxford St Mary-the-Virgin; Staffordshire – Lichfield Cathedral exterior recesses (but doubtful if genuine); Warwickshire – Brailes, Chesterton; Wiltshire – Enford, Salisbury Cathedral (Simon of Ghent's tomb); Worcestershire – Bredon; Yorkshire – Croft.

 (b) Ballflower alternating with fleurons: – Bedfordshire – Bedford (St Paul, font); Buckinghamshire – Chalfont St Giles, Wendover; Cambridgeshire – Lolworth, Over; Essex – Waltham Abbey; Hertfordshire – St Albans Abbey (nave); Huntingdonshire – Abbotsleigh; Lincolnshire – Boston, Brant Broughton, Grantham, Irnham, Northorpe, Rippingale; Norfolk – Helhoughton, Rougham; Northamptonshire – Higham Ferrers (churchyard cross), Kings Sutton, Kislingbury, Rushden, Wellingborough, Yelvertoft; Oxfordshire – Adderbury, Bampton, Great Rollright; Rutland – Langham, Uppingham, Whitwell; Warwickshire – Brailes; Yorkshire – Beverley Minster (Percy tomb).
5. There are virtually no instances of Decorated ballflower in the North, but its use on the west door of York Minster, *c.* 1310, constitutes an important early example: see J. H. Harvey in *A History of York Minster* (1977), ed. G. Aymer and R. Cant, Ch. IV, 156 – 7.
6. Erskine, Part 2 (1983), XXX.
7. H. Brakspear, 'A West Country School of Masons', *Archaeologia*, LXXI (1931), 1 sqq.
8. E.g. G. Marshall, *The Cathedral Church of Hereford* (1951), 102.
9. L. S. Colchester and J. H. Harvey, 'Wells Cathedral', *Archaeol. J.*, 131 (1974), 205.
10. Important and potentially early examples outside the lower Severn valley area include the crossing tower of Lincoln Cathedral (before 1311); the spire of St Mary-the-Virgin, Oxford (perhaps before 1320); the west towers of Lichfield Cathedral (probably complete at the latest by 1321, when work on the new Lady Chapel was under way); and the tower and spire of St Mary Redcliffe, Bristol (at some date after 1294). For Oxford, see T. G. Jackson, *The Church of St Mary the Virgin, Oxford* (1897), 78 sqq.; and for Lichfield, Harvey (1974), 215 – 6.
11. *Hist. et Cart.*, I, 44.
12. VCH, *Gloucestershire*, II (1907), 57.
13. The bull of Pope John XXII is reprinted in Capes, 184 – 186. The towers are not mentioned specifically, but the wording 'superedificare fecistis opere sumptuoso', in the context of the known works of the Decorated period at Hereford, makes it virtually certain that the reference is to the towers; the 'opere sumptuoso' presumably refers to the rich ballflower ornament.
14. For further details on the date and style of the Hereford towers, see Morris (1972), 105 sqq.; and for the tombs, R. K. Morris, 'The Remodelling of the Hereford Aisles', *JBAA*, XXXVIII (1974), 32 sqq.
15. Externally, the head of the easternmost window has been heightened and given a four-centred arch, but retaining ballflower decoration for the frame (Pl. XVIII). For the arch of the frame, voussoirs of the original two-centred arch seem to have been modified and re-used, for their profile is the same as the other windows except for the omission of the outer hollow moulding (Fig. 1 F). To accommodate the higher arch, the ballflower jambs of the frame had to be extended, which seems to have been effected by adding in stones of the same design from the disused frame of the interior. The same apparent care to blend older work with the new is shown in the tracery, in which the use of a transom in combination with the ogee lines in the head of each pair of lights harks back to the adjoining south transept windows of the early 1330s (Pl. XVIII). However, the likely date of the modifications is *c.* 1400, as the type of stepped mullion profile is very similar to that employed in the north, south and west walks of the cloister, executed in the time of Abbot Froucester (1381 – 1412), and the rather shapeless cusped figure in the head of the window recalls the tracery of these

walks. This date accords well with the style of the effigies of the so-called 'Brydges' tomb beneath the window, and presumably the provision of new tracery and glass was part of their memorial.

16. F. Bond, *Gothic Architecture in England* (1906), 83.
17. For comparative drawings of the Hereford window frames, see Morris (1972), Fig. 20.
18. See Morris (1977), 131–4.
19. N. Coldstream, 'Ely Cathedral: the Fourteenth-Century Work', *BAA CT*, II (1979), 29.
20. For more context on this 'second variety' of the wave mouldings, see Morris (1978), 23 sqq.; for Worcester, see R. K. Morris, 'Worcester Nave: From Decorated to Perpendicular', *BAA CT*, I (1978), e.g. 123. The only other local example known to the author of ballflowers carved on a wave moulding is in the undated arches of the west door and window at Wotton-under-Edge church, Gloucestershire (assuming they are original). With regard to the wave and three-quarter hollow formation, the next occurrences in the West after Gloucester are not until near 1340 and later (e.g. Worcester Cathedral nave, south aisle; Ottery St. Mary, chancel; St Augustine's, Bristol, Lady Chapel reredos). One possibility needing further investigation is that the link with eastern England in the 1320s may lie through the Oxford area, which shows an inclination towards what is the likely forerunner of this wave formation, namely three-quarter hollow mouldings alternating with fillets and roll mouldings (e.g. Merton College Chapel, 1290–4).
21. For comparative drawings of all these examples, see Morris (1972), Figs. 18 and 19.
22. J. H. Harvey, *The Perpendicular Style* (1978), 78; for part-hexagonal sub-bases, see Morris (1979), 29.
23. All Souls College, Oxford, Codrington Library, Wren Drawings, Vol. II, No. 7; reproduced, for example, in J. Bony, *The English Decorated Style* (1979), pl. 28.
24. Reported in *Archaeol. J.*, XVII (1860), 336.
25. See a pen drawing of the church from the north-east in an unpaginated sketchbook of architectural drawings by Henry Wilson, c. 1850, in the Gloucestershire Record Office (D. 1232). In the restoration of 1869, the walls of the chancel are said to have been rebuilt: see Viner, 66. The east window was also renewed, and it seems that at this stage the 'eye' in the centre point of the head was introduced, for it is not shown in the drawing.
26. Cited in Viner, 66.
27. Bigland, II (1792), 176–7. As general views of other buildings in Bigland show ballflower where it exists (e.g. Badgeworth north chapel, Gloucester south aisle), one may assume that its omission in the view of St Michael's is accurate. These windows were lost in the rebuilding of the church in 1851: see John Clarke, *The Architectural History of Gloucester* (n.d., c. 1855), 54.
28. For further detail on Leominster, see Morris (1973), 54–7.
29. See Morris (1977), 138–9.
30. E.g. the banded ornament of the finials on the door from the south choir aisle to the Berkeley Chapel anteroom at Bristol, and on the piscina in the Chapel of St John the Evangelist at Exeter. Also at Bristol, on the arch of the door between the anteroom and the Berkeley Chapel, the way in which two bands of organic ornament, one large (ferns) and one small (poppy heads), are carved alongside each other, seems related.
31. E.g. N. Pevsner, 'Bristol, Troyes and Gloucester', *Archit. Review*, CXIII (Feb. 1953), 28, though the author would not agree with Pevsner that the Bristol master is the predominant influence in the south transept work.
32. Harvey (1961), 135–6.
33. Ibid., 136.
34. For the dating of the vestibule, see R. K. Morris, 'The Architectural History of Wells Cathedral: a review article', *Trans. Anc.Mon.Soc.*, 28 (1984), 194–207. Sex-cusped curved-sided triangles are also employed at Wells in a three-light window design in the bishop's chapel.
35. See Morris (1979), 18.
36. In fact, if the Bell's Guide is correct and the new buttresses show evidence of tipping after erection, replacing the vault was an afterthought.
37. See Rev. W. Bazeley (ed.), *Records of Gloucester Cathedral*, III (1897), 105.
38. The data comes from Hart's edition of *Hist. et Cart.*, I, 41, but as he points out in the Introduction, x–xi, his edition derives from two manuscript versions, of which he regarded that at Queen's College, Oxford, as the more reliable. However, Bigland, II (1792), 87, states that the alternative version, British Museum Cottonian Ms. Domitian VIII, attributes the dormitory to the time of Abbot Wigmore, i.e. 1329–37.
39. For the context, see Morris (1979), 8–11.
40. See Viner, 63 sqq.
41. For Despencer, see Morris (1974), 143 sqq.; and Sir Robt. Atkyns, *The Ancient and Present State of Glostershire* (1712), 238–9.
42. The sharp, studded shape of some of the balls is not paralleled in the early 14th century. Other inconsistencies appear to be inherent in the original work, such as the sparser distribution of the ballflowers in the more western windows, which is paralleled by cases like the omission of ballflowers from some of the ribs in the Gloucester south aisle. The suggestion that the fluting on some of the window frame shafts is the result of recutting in the 15th century seems to be an unnecessary explanation, given the existence of other local examples in the Decorated period, as in the monastic refectory at Worcester (c. 1330).

43. For the dating of the vestibule, see R. K. Morris, 'The Architectural History of Wells Cathedral: a review article', *Trans.Anc.Mon.Soc.*, forthcoming. Sex-cusped curved-sided triangles are also employed at Wells in a three-light window design in the bishop's chapel.
44. Erskine, Part 2 (1983), XXVI–XXVII.
45. Especially two-bay diagonal vault patterns: see H. Bock, 'The Exeter Rood Screen', *Archit. Review*, CXXX (1961), 313–7.
46. See further Morris (1973), 57–9.
47. Cited in A. J. Taylor, 'Building at Caerphilly in 1326', *Board of Celtic Studies Bull.*, XIV, 4 (1952), 299–300.
48. For fluted mouldings, see Morris (1978), 50; for Chester, see V. Jansen, 'Dying Mouldings...', *JBAA*, CXXXV (1982), especially Pl. XXIVA.
49. For all these south-eastern features, see Morris (1979), 10, 12, 33.
50. See further, Morris (1974), 151 sqq.
51. Ibid., 147–150 and Fig. 3.
52. Morris (1972), 181–4.
53. A possible connexion that needs further investigation is with Decorated work in Oxford (e.g. the tabernacle work at the base of the spire of St Mary-the-Virgin).
54. Morris (1974), 149.
55. For some recent thoughts on this matter, see Morris (1973), 65, n. 4, and Harvey (1974), 215–6.
56. Mr Arthur Jones suggested that it would take a mason most of a building season to carve all the mouldings of an average size traceried cathedral window (say one hundred and twenty-five working days); whereas the author's calculations for carving just the ornament of one of the Gloucester south aisle windows produce the figure of two hundred and eighty working days.
57. Capes, 163–5.

The East Window of Gloucester Cathedral

By Jill Kerr

In 1921, Rushforth commenced his address to a joint meeting of the Royal Archaeological Institute and the Bristol and Gloucester Archaeological Society by stating that: 'It might have been thought that the subject of the East Window of Gloucester Cathedral had been exhausted by Charles Winston's important paper of 1863 and Drayton's valuable notes of 1916.[1] So far as the history and heraldry of the window is concerned, this is probably true. But renewed study of the glass in preparation for (this) meeting convinced me that there was still something to be said about the general design of the window, and about the selection and identification of the persons represented in it'.[2]

Sixty years later, having read the results of Rushforth's renewed study, it might be thought that the subject of the east window was indeed well and truly exhausted, until preparation for another meeting provoked a detailed scrutiny of the glass which led to the conviction that there was still something further to be said about the design and subject matter. This paper attempts an examination of the overall design and iconography, questions several assumptions that have been made about both, considers the question of restorations and intrusions and proposes a redating and new assessment of the aesthetic function of the window and its relationship to other surviving glass in the region.[3]

From a glass historian's point of view, the window is an extraordinarily deceptive structure with several unique and fascinating features. Resolution of the questions the east window poses is inevitably hampered by the complete lack of documentary evidence concerning either its commission or installation and the fact that nothing is known of the designers or glaziers. The whole architectural structure built to contain the glass was itself totally unprecedented. Even today it would be a monumental undertaking for any workshop; 72 feet high and 38 feet wide, it is the second largest extant window in Britain – yielding pre-eminence only to the great east window of York Minster (1405). When it was deglazed for re-leading in the 1860s, it was estimated that the area of glass amounted to 2000 square feet and weighed, with the lead, 35 hundredweight (Pl. XXII).[4] It is difficult to imagine the original impact of what Rushforth and Winston rightly recognised as a 'landmark in the history of glass painting...the first example as well as one of the grandest, of a window filled with tiers of full-length figures which are so characteristic of the fifteenth century'.[5] Physically the glaziers' response to the challenge of this wholly new Perpendicular style stone structure demonstrates an entirely assured confidence with only one curious indication of apprehension.

Winston observed that the appearance of the external glazing in the tracery and the heads of the lights did not correspond to the interior effect. His diagram (Fig. 1) demonstrates this clearly; the left column represents the exterior extent of the glazed area, which shows the fine detailing of the cusps in the tracery and heads of the lights to be unglazed on the inside of the window, while on the exterior the glazing is squared to run continually behind the details of the stonework. The glass obscured by the stonework is clear and rebated directly into the masonry. Apart from the (later) east window of Exeter Cathedral, this phenomenon has not been observed elsewhere and it would be interesting to know of any other examples. In both cases there is no technical reason for this feature apart from the convenience of not having to glaze into such relatively complex openings.[6]

The shadow cast by the Lady Chapel now greatly impairs the full impact of the entire window, but nevertheless the observer is immediately struck by the considerable areas of white glass (Pl. XXII). At the 1860s restoration those panels *in situ* at the base and apex levels were filled with clear glass, from which Winston deduced that these area were originally all filled with reticulated glazing with small centralised decorative bosses at the lower level.[7] The central area below the window comprises blind tracery, and was obviously never intended to be glazed, the figure of St Clement and the two wavy stars at the apex are 15th-century intrusions.[8] The colour range is indeed remarkable – predominantly white

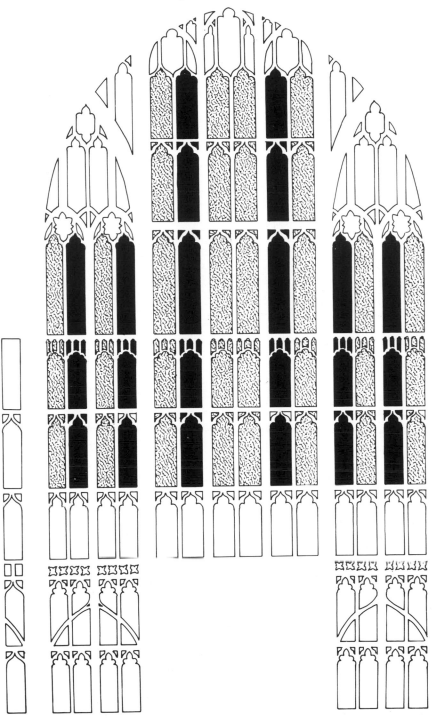

FIG. 1. The colour background alternation and the overall arrangement of the window showing the extent of the exterior glazing in the left column. Black = Blue backgrounds.

with extensive use of black, grey and brown paint and yellow stain – a limited repertoire more usually associated with 15th-century glazing. There are rare extensions of the palette to murrey, green and pot metal yellow for decorative clasps, attributes and base grounds. The backgrounds are arranged in an alternation of blue and a remarkable quantity of very fine streaky ruby and are mostly quite plain, again an unusual feature. The exceptions are the six blue lights on either side of the emphatic central double red panels; these particular blue backgrounds are completely painted with a very precise and beautiful rinceaux design (Fig. 1 shows the background alternation, the blue area defined in black). The concentration of paint on the white glass against the rich density of the pot metal grounds is quite deliberately engineered to create an optical illusion, by which the background recedes into a subordinate plane against which the figures are thrown into the foreground. As there is no evidence to the contrary, the veracity of the present colour proportions cannot but be accepted as original.

All those who have written on the glass – Winston in 1863,[9] Gambier Parry in 1883,[10] Dancey in 1911,[11] Drayton in 1916[12] and Rushforth in 1922[13] – have subscribed to the view that the reason for this lack of dazzling colours was merely to maximise the light level and minimise the cost. In the light of recent research into documentary evidence for contemporary costs of raw materials, red and blue glass were incontrovertably the most expensive colours and they are used here in almost profligate profusion.[14] Apart from the sheer volume of glass needed to glaze this huge area, the quantity and quality of the blue and striated ruby glasses indicate that this was by no means an inexpensive production. The overall effect does indeed maximise the light level, but there is another reason for the extraordinary restraint of the designer in his choice of colour that has hitherto been completely overlooked.

Apart from the evidence of the colour choice, close examination of the painting techniques reveals that the effect of the entire window is quite deliberately directed to achieve the visual impression of sculpted figures in niches. The depth and perspective of the architecture painting is carefully designed and articulated with the use of extensive monochrome contour washes to define the third dimension. The niches are three-quarters angled to reveal simple vaulting heavily painted with shadow to create depth, the ribs and decorative bosses being picked out of matt wash. The side shafts are developed in segments with elaborate blind window designs in reserve, punctuated by capitals and surmounted by finials. The canopies themselves are painted with consummate skill, the high relief of the crockets boldly defined with wash and line reinforcement and the low relief of the elaborate decorative devices precisely manipulated with delicate fine lines and picking out of contour half-tones. The alterations in plane and the prominent decorative details were originally emphasised in yellow stain – a dimension of the design which has unfortunately been almost completely removed during an over zealous exterior cleaning. The arrangement of the figures in the niches against the colour backgrounds emphasises the sculptural effect; the feet are firmly and formally placed on the pedestals and the postures plausibly deployed to enhance the sculpture-in-niche effect by the incursion of parts of the figures and attributes in front of the side shafts.

The overwhelming achievement of the sculptural impression is undoubtedly in the painting of the faces and draperies. These are defined with great deliberation and skill by very bold, direct line-painting and by modelling washes with the highlights rubbed out. Examination of the exterior from the roof of the Lady Chapel reveals traces of extensive backpainting on all the white glass especially the faces and drapery. It is unfortunate that previous cleaning of the exterior has largely reduced this effect, but on the best preserved figures there is no doubt that the force of this exterior emphasis of the interior paint imbued the figures with great power and depth. Decorative detail does not detract from the monumental arrangement of the drapery which has minimal but intricate borders, originally stained yellow, to enhance the movement of the folds. The face painting is superb. Once the observer has gazed in to these strikingly cadaverous physiognomies with the lugubrious deep set eyes and formalised hair and beards, their powerful dignity is never forgotten. The imposing scale of these monumental figures with their bold paint lines and strong contour washes are entirely legible from the

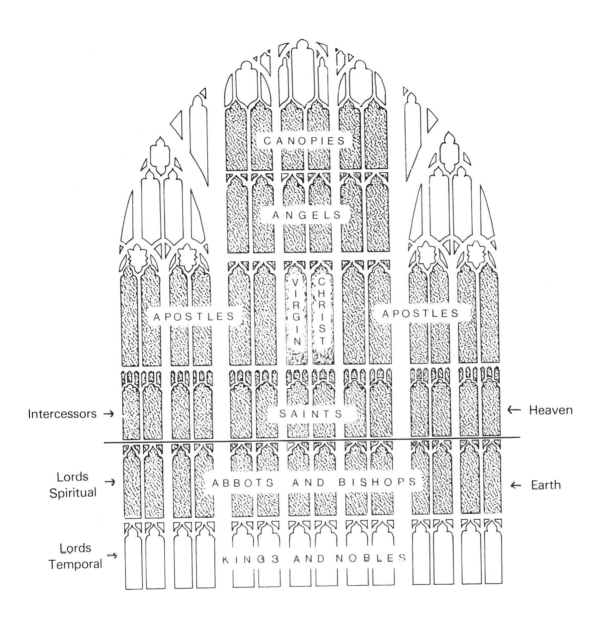

FIG. 2. The Iconography of the east window.

ground and there is no doubt that the painter has taken the distanced viewpoint of his audience into account in the simplification of the painting techniques.

The sculptural effect is also dependent on the designer's deployment of scale and plausible detail in the canopies. Over fifty percent of the painted area of the east window is devoted entirely to architecture and this aspect of the design has never attracted the analytical attention of historians of architecture or sculpture. The glass painter/designer has derived the inspiration for both figures and canopies from three dimensional models and it would be interesting to investigate comparative material in stone for possible sources. The canopies increase in height at each level while decreasing in detail and they also exhibit another interesting and (in glass at least) unique feature. The designer has contrived the panel divisions at each stage so that the apex of the canopies at the lower level becomes the pedestal of the figure above it (Pl. XXIIIA). Unconventionally, this arrangement ignores the horizontal transom cut off point of the physical three dimensional architectural structure by emphasising the verticality of the glass designer's own two dimensional architectures. The stonework of the tracery becomes a subordinate supportive network for the fictive stonework of the glass itself. The glass designer is demonstrably as neoteric as the mason in devising novel forms; it is extremely unusual to encounter a design for glazing at this time where the architecture in the glass does not conform to the framing of the stonework.

The overall effect of this entirely innovative design is that of a conventional 14th-century Decorated horizontal band window made perpendicular by removal of the intermediary grisaille and by stacking the coloured figure strips on top of each other in tiers. The proportions of the figures in relation to their canopy/bases and the emphasis on verticality directs the eye upward rather than arresting the visual movement at any one level. The reason for this is not simply aesthetic; the iconography itself is hieratic (Fig. 2).

The lowest range is the least interesting visually and contains a row of shields of arms in cusped quatrefoils above decorative roundels and set in diamond plain quarry glazing within a narrow foliate border. The shields represent kings and nobles – the Lords Temporal. The tier above originally contained the standing figures of fourteen mitred bishops and tonsured abbots alternating to face each other. They have no nimbs and represent the Lords Spiritual. Above them was a row of fourteen standing saints, originally paired facing each other. The next level contained the twelve apostles standing looking towards the central crowned figures of the Virgin and Christ. Above them were six angels carrying palms, arranged in pairs facing each other, and, at the apex over their heads, six canopies.

Since Winston, it has been accepted that the window design is derived directly from painted triptychs, with the canting of the sides of the window forming the wings. The canted sides do not however have any particular relevance to the glazing programme but are entirely the result of the disposition of the crypt foundations on which they are built.[15] The subject matter of the east window is invariably described as 'The Coronation of the Virgin'. A different interpretation is proposed here. The figures of Christ and the Virgin – bearing in mind the distance and the height from the viewer – do not command attention in a visually compelling way. There are no distinctions whatsoever made between the two central figures and the six apostles on each side of them in terms of scale, height of canopy, proportion, background, decorative detail, colour or gesture. Even allowing for the fact that the lower half of the figure of Christ is lost and has unfortunately been replaced with the lower half of a standing figure – the seated posture of the Virgin, and presumably originally that of Christ, is not clearly distinguished from the saints around them (Pls. XXIVc, D and XXII). Furthermore, both figures are already crowned. The right hand of Christ is raised in benediction and the Virgin's hands are crossed on her breast. It is indeed, with the six disciples turned towards the centre on each side and the two central figures inclined threequarters towards each other, the only example of the depiction of any relationship between figures in this window, but there is no cross mullion iconography. This is the Virgin and Christ together in Majesty, and the subject matter of the whole east window depicts a

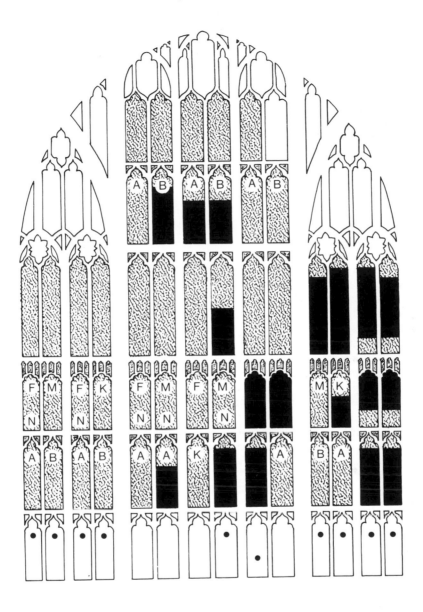

Fig. 3. The extent of lost areas and the extant arrangement.
Black = lost glass. Apex level A/B = Alternation of cartoon.
Base level A/B = alternation of abbot and bishop figures.
F = Female. M = Male. K = King. N = Nimbed.
● lowest level = original shield of arms.

specific, formalised hierarchy – the derivation of authority from heaven to earth – a perfectly acceptable Benedictine doctrine entirely appropriate for such a context.[15a] The Lords Temporal, Lords Spiritual, Intercessors, the Twelve Chosen, the Mother of Christ and the Son of God, the Angels as God's Intermediaries and Heaven itself are all depicted here in what is effectively a gigantic didactic glass reredos entirely visible from the monks' choir and the nave.

In order to examine the iconography in greater detail, it is expedient to consider the state of preservation of the surviving figures (Fig. 3 illustrates a much simplified plan of the panels containing composites or intruded figures in black). As stated earlier, this window is deceptive, and this is certainly the case with regard to the disparity between the overall impression of completeness from a distance and the loss or interpolation of figures evident from closer observation. As Gambier Parry so eloquently described it 'in general effect, it is magnificent, but in detail it is a wreck'.[16] Charles Winston stated that he personally supervised the 1860s restoration and succeeded in prevailing upon the Dean and Chapter to preserve the historical veracity of the glass by undertaking a straightforward re-leading, 'The archaeological inquirer has, therefore precisely the same means of investigation now as he would have had before the recent repairs.'[17] Would that similar restraint had been exercised in the only major restoration since the 1860s which was undertaken by Mr Wallace Beck of Cheltenham at the end of the Second World War.[18] It seems highly unlikely that the state of the leading of the 1860s restoration, so carefully supervised by Winston in the workshops of his colleague Henry Hughes, was so bad that it necessitated a complete replacement accompanied by a very extensive alteration to the glass itself. Unfortunately there are no photographs or accounts by Beck either of the condition in which he found the glass or recording what he did, but comparison between the excellent photographs taken by Sydney Pitcher before the war and the present state of the glass reveal that he was an exponent of the type of 'tidying up' restoration Winston castigated so fluently in his account of the glass.[19] To Beck we owe the increased legibility of the window with the removal of many interpolated 15th-century fragments and pieces of unrecorded inscription which may well have originally belonged at the base of the unidentified figures. He also made up missing areas of figures from carefully chosen 15th-century fragments which read as areas of drapery from a distance. However, quite apart from the loss of the fragments of inscription, his restoration has unfortunately deprived us of the rare opportunity to study a major monument which was the subject of a sensitive and historically sympathetic restoration supervised by the pre-eminent glass historian of the 19th century in Britain.

It has not been possible to establish precisely when the alterations and omissions preserved by Winston and Hughes' re-leading occurred; none of the documentary sources or prints and drawings shed any light on the matter. There is but one mention in the Chapter Act Book for 1798 recording that, 'a quantity of painted glass has been stolen from the East Window of the Cathedral. Ordered, that a reward of fifty guineas be offered for the discovery and conviction of offenders'.[20] History does not relate whether the reward was ever claimed, but it might explain why the right side of the window is much less complete, and why so many figures at the lowest level are composites or inserts. It is, nevertheless, a most remarkable survival considering how vulnerable the window is to access from the Lady Chapel roof.

To commence at the top of the window; the apex canopies representing Heaven are intact. At the next level there is an intrusion of a 15th-century figure of the Virgin and Child in the second centre light from the left, and the two angels to the right of her have had the lower halves of their drapery interfered with. The original arrangement of the angels was a rhythmic alternation of two cartoons. Repeat cartoons are very much a corollary of Perpendicular architecture and the repetition of figure designs from the same cartoons in this window is noticeable (Fig. 3).

The tier below contains the Apostles, the Virgin and Christ. Eight of the Apostles are identifiable by their attributes, two are not and two are missing. Reading from left to right, the first and third figures carry books and have no other identifying attributes. The second is James the Less (a club), and the fourth St Andrew (saltire cross). Although the integrity of the original lead lines is now lost, the white

glass was originally cut into large shapes that followed the folds of the drapery, outlines of heads and hands etc., and the leads would have appeared an integral part of the structure of the figure. These figures of St James the Less and St Andrew are particularly fine examples of the Gloucester glaziers' techniques and style (Pls. XXVIc, D). Much of the backpainting is preserved on St Andrew's drapery, and that of St James still retains its rich yellow stained hem and border designs. In accordance with iconographic convention the apostles are represented nimbed and with bare feet, but there is a radical departure from this tradition in the fifth figure, St Thomas (a spear) (Pl. XXIIIc). He has no nimbus and his feet are covered with geometrically patterned slippers. This figure is the most complete in this register and is one of the finest in the entire window, retaining much of the paint and yellow stain and with very few intrusive mending leads. Winston recorded this figure on the south and not the north side, and so the present location is the result of a more recent rearrangement,[21] perhaps recovering its original position on the basis of the south facing direction of the figure turned towards the central figures of Christ and the Virgin. The canopy above is also worthy of note as a particularly well preserved survival of the interior painted details as well as the back paint and yellow stain. The sixth figure is St Peter (keys and a church) (Pl. XXIIIB), also well preserved, and set against the blue background with the formalised foliate rinceaux.

The next figure is the seated figure of the Virgin, crowned and nimbed with her hands crossed on her breast, facing three-quarters right in Majesty with the adjacent figure of Christ (Pls. XXIVc, D). He turns three-quarters left towards her, his right hand raised in benediction, his left hand now lost. He is crowned and cross nimbed but does not show the wounds or the stigmata; his torso is fully clothed. The lower half of the figure is missing and has been skillfully replaced with drapery from a standing figure on a composite pedestal. The drapery appears to course through from a distance, but detailed examination reveals a different border design. The red background to the upper half of the figure is the only one to be patterned with a geometric diaper design picked out of a matt wash and this does not appear in the lower panel. The apostle adjacent to Christ is St Paul (sword and book), who is also set against a blue foliate rinceaux background identical to that of his companion figure of St Peter. The face is lost completely and replaced with white glass, otherwise this figure is very well preserved with very rich yellow stain for decorative details and, unusually, for the hair and beard. On his right is the figure of St John Evangelist (eagle and palm) who is represented bearded. This figure was recorded by Winston on the north side,[22] but has been rearranged to the present position because the figure is turned towards the central figures of Christ and the Virgin.

The next four figures are composite intruded kings which will be discussed below. However, the distinctive bare feet on pedestals with some remnants of the lower portion of the robes remain at the base of the first and second composites from the right as the only surviving fragments of two missing apostle figures. Two further fragments have escaped to the level below and will be discussed in that context.

The row below originally contained fourteen standing figures of saints of which only five are now identifiable from their attributes. The present arrangement from left to right is as follows. St Dorothea of Cappadocia or St Cecilia (crown of red roses and a book) is nimbed and has yellow stained hair. Winston[23] and Rushforth[24] both identify her as St Cecilia, but perhaps her more usual attribute of a musical instrument might be more appropriate to a monastic choir. St George (in armour, with a red cross and a spear) is the next figure (Pl. XXVIB); he is un-nimbed and placed beside an unidentifiable female virgin saint, whose attribute has been lost as a result of the numerous replacements to her drapery. Rushforth suggested 'Agatha or Agnes are likely names' for this figure, but since there is no means of affirming his suggestion and he cites no evidence, these must remain speculative.[25] There are no discernible traces of an attribute appropriate to either of these saints (the lamb or the severed breasts) in any other part of the window. The next figure was identified as St Canute by Winston and St Edmund by Rushforth.[26] It is an un-nimbed figure of a king holding a sceptre which Rushforth mistook for an arrow. There is a figure of a crowned male holding three arrows inserted in the lowest

register which is probably a St Edmund, even though this too is un-nimbed.

In the central register is St Margaret (spearing a dragon at her feet) whose face has been lost and replaced with plain glass (Pl. XXIIIA). Next is St Laurence (vested as a deacon with a gridiron), one of the best preserved figures in this register, set against the distinctive rinceau background (Pl. XXIIIA). Continuing the alternation of male and female saints is a crowned, un-nimbed female saint (sword and book) identified by Rushforth as St Catherine.[27] Next to her is a nimbed male saint with bare feet and a short fringed tunic. On the basis of his appearance, and in the absence of a definitive attribute, both Winston[28] and Rushforth[29] identify this figure as St John Baptist. The next six figures are either composites or very incomplete. Two of them, the second and the fourth from the right contain identifiable parts of apostle figures from the level above: the club of St Simon is in the lower half of the left figure, and the head of St James the Great wearing a pilgrim's hat with a head of Christ badge on it is in the right composite. The fourth figure from the right also contains the remains of a figure of a nimbed male saint whose head is original, but the paint has completely perished on the interior surface. Traces of exterior backpainting confirm that this was a bearded male figure. The head and torso of the adjacent figure, to the right of the ghost-head saint, appears to be *in situ* and contains the un-nimbed figure of a king holding a sceptre. As there is no allowance at the base of this register for any identifying inscriptions, further attempts to identify the original iconographic programme of this level must remain speculative.

The lowest level of figures also presents problems of identification. Here, there is the space available for identifying inscriptions, and it is possible that some of the fragments of lettering retained in this window until the last restoration may have come from the bases of these figures. There were originally fourteen figures, mainly comprising alternating Abbots and Bishops. As Gloucester was not granted the mitre until the 1380s, these figures have always been assumed to be Abbots of Gloucester and Bishops of Worcester. Rushforth was able to find names for all of them, but in the absence of any documentary or other evidence these suggestions cannot be confirmed.[30]

The condition of this level is extremely poor with extensive paint loss and many mending leads. The first figure from the left is a tonsured abbot carrying a crozier. The paint on his head has scuffed off completely leaving only a shadow of the original fired area. The mitred bishop next to him has a better preserved face, but the drapery paint has perished, although the cope retains the original cut lines of the white glass. (His alb contains a splendid 15th-century insert of red and blue jewelled poker work.) The alternation of abbot and bishop continues for the next four lights (Pl. XXIIID), which appear to be repeat cartoons of the first two, although the pair in the central area no longer retain their original heads, and the interference with the background makes it impossible to determine the original shape and thus to ascertain whether a mitre or a tonsure was intended. The sixth from the left can, however, be interpreted as an abbot from the shape of the head, tonsured without a mitre, although the remainder of the figure is completely composite.

The next three figures are kings. The central one, seventh from the left, appears to be *in situ*; his posture and scale are consistent with the other figures in this register and his drapery is almost complete. The two outer kings are larger in scale and, although the lower halves of each are now very composite, the glazier had originally to insert them into the lower area of the canopy design in order to fit them in. The left of the two figures is St Edmund carrying three arrows, his companion faces frontal and carries an upright sceptre.

The faceless frontal figure next to the scepted king retains a lower half clad only in plain white drapery with no indication of any form of vestment. Rushforth has convincingly suggested that this figure may represent one of the abbesses of Osric's first foundation at Gloucester.[31] Next to her the alternation of bishop and abbot resumes with two very incomplete figures, and the last two figures are completely composite.

The problem of the intruded kings is interesting. The only identifiable figure is St Edmund with his arrows and there are no records to assist with determining when they first made their appearance in the

east window. There are altogether the remains of at least ten crowned male figures in this window and several more dispersed throughout the Lady Chapel. Some of them undoubtedly came from the much pruned fragments of a later Tree of Jesse now in the Lady Chapel;[32] the lower parts of the fourth from the right, and the heads of the second and third intruded kings from the right in the apostles register are from the Jesse. There are also, in return, many fragments of drapery and pieces of architecture from the east window in the Lady Chapel composite panels, but unfortunately nothing significant enough to explain the lost iconography. None of the figures of kings in either context is now complete and so it is difficult to estimate their original scale, size or identification. Rushforth[33] and Winston[34] both subscribed to the opinion that they came from the choir clerestory, which would imply a stunning series of no less than forty figures, and suggested that they represented either the kings of England or the ancestors of Christ. Unfortunately no record survives to inform us of their original context. The scale of the more complete figures might be appropriate to a clerestory, but it is also possible that at least two of them (perhaps including the figure on the right of the faceless abbot and the incomplete remains of the sceptred figure with the gloved, gesturing hand in the same level) belong in the central red place of honour in the lower level of the east window, and represented Osric and Edward II who are both buried here in the choir of the Benedictine Abbey.[34a]

The lowest level, containing the heraldry, perhaps poses the most interesting questions of all. These have been argued in great detail elsewhere by experts infinitely more competent to analyse such a specialised subject than the present writer.[35] What follows can be only a brief summary of the heraldic evidence, as no account of the east window could possibly be complete without its inclusion. There were originally fourteen shields of arms of which ten only are extant (Fig. 3). They are, from left to right, the first to the fourth, the eighth on the upper level in the central register, the ninth on the lower level in the same and the eleventh to the fourteenth on the right of the window. The original shields are set in cusped quatrefoils against superbly painted rinceau backgrounds and are all exactly the same dimensions. Below these were decorative geometric and foliate roundels similar in design to those embellishing the canopies above. The original shields on the left and right of the window represent, reading from left to right: Richard FitzAlan, Earl of Arundel (d. 1376), Thomas, Baron Berkeley (d. 1361), Thomas Beauchamp, Earl of Warwick (d. 1369), William Bohun, Earl of Northampton (d. 1360), Laurence Hastings, Earl of Pembroke (d. 1348), Richard, Lord Talbot (d. 1356), Sir Maurice Berkeley (d. 1347) and Thomas, Lord Bradeston (d. 1360). The central assembly contains only two of the original series: Edward the Black Prince and Henry of Lancaster. The rest of the shields are either earlier or later in date and come from elsewhere in the building.

It should be emphasised that there is absolutely no evidence that the positions and relationship of the shields are original. We have seen much interference at all levels in this window, and there is no reason to suppose that this, the most accessible level of all, has not been rearranged at some stage in its long history of re-leading and restoration; quite apart from what may have occurred in earlier times. Unfortunately there are no antiquarian records to confirm the arrangement of the heraldry and supply the missing four shields. It is on evidence of the heraldry alone that this whole great east window has long been accepted as a vertical war memorial to those who served at the battle of Crecy. Indeed, all but two of those whose shields survive were at Crecy, and these two were most certainly present at the siege of Calais.[36] So the common factor for all these representations – apart from local connections which are somewhat tenuous in several cases – is not specifically associated with Crecy but with the French Campaign. However, it must be said that the Crecy Roll is a veritable Who's Who for the period; it was de rigueur to be recorded as present in some capacity, and so the omission of Lancaster and Pembroke might be said to effectively discount the commemoration of Crecy as the paramount reason for the commission.[37] Apart from participation in the French Campaign, all those whose shields survive in the window were also participants in the Scottish Campaign.[38]

Drayton argued, unfortunately on the basis of the position of the shields, that the donor of the window was Thomas, Lord Bradeston, whose arms are on the extreme right of the window in the so-

called 'donor position'.[39] They are also the only arms surviving displayed against a coloured background; a significant distinction indeed, and it would be interesting to know of any other examples of such a differentiation. Leaving aside the possibility that the shields, which are the same dimensions, are therefore interchangeable and could have been moved, and accepting that Bradeston's arms were indeed intended to receive this distinction, Drayton's argument still presents some difficulties.

Bradeston's arms are placed next to those of Maurice Berkeley who differenced his arms from those of Thomas, Baron Berkeley, on the immediate left in the window, by using a chevron ermine. Lord Berkeley was Bradeston's feudal overlord, and Maurice was his half-brother. The historical peerages[40] and the *Dictionary of National Biography* confuse him with Maurice, *son* of Thomas, which would have meant his receiving a knighthood at an embarrassingly early age. Drayton did not know of this feudal link between the two men and claimed that the placement (without questioning its veracity) of a mere knight – Sir Maurice – before a peer of the realm – Bradeston – was something 'not even the Abbot of Gloucester would dare to do'.[41] The explanation for this, according to Drayton, is that Bradeston donated the entire window in memory of his bosom friend Sir Maurice, who died of wounds received at the siege of Calais in 1347.[42] Drayton's account, written in 1916, is much coloured by references to the French campaigns of the First World War. The relationship between Maurice Berkeley and Thomas Bradeston escalates from comrades in arms to bosom friends in three pages. Leaving aside the problems a mere knight would have to face in paying for such an expensive commission, Drayton overlooked two important points. In fact Bradeston became Lord Bradeston by Barony Writ only between 1347 and 1360,[43] and Maurice is described in the *Inquisitions Post Mortem* as having been *invalided* home from Calais.[44]

Four questions remain: why Crecy rather than Calais, or even the Scottish Campaign for the common factor of the heraldry represented? Why should this be specifically the donation of Bradeston in memory of Sir Maurice Berkeley even assuming that one man could afford the gesture? What is an expensive glazing programme donated by one secular lord doing in such a prominent position in an abbey church and with such an extraordinary choice of subject matter? How does the heraldry affect the dating of the glass? The total absence of documentary evidence places both questions and the proposed answers in the realm of speculation. However, there is no reason to doubt that the display of heraldry is coeval with the rest of the window; the whole window would have been glazed as soon as the tracery was completed to receive it. The practical possibilities of leaving such a large area unglazed before the scaffolding was struck surely precludes the suggestion of glazing much later than the actual completion of the construction of the stonework. In view of the general historical associations between the personages commemorated in the heraldry, it is invidious to select specific commemoration of one event or individual as the sole reason for the display. It is more plausible to suggest that the expense of glazing such a large area would have been defrayed by a royal or more than one donor.

Stylistic comparisons with contemporary glass in the west country do not greatly assist with a more precise dating. The extraordinarily distinctive painting style of the east window, which undoubtedly involved a very large workshop to execute such a massive design, is evidently highly developed. Such a prominent and avant-garde commission would hardly have been placed in the hands of an untried group of glaziers. The patrons and architect must have been able to see extant examples of the glaziers' achievements elsewhere in the area (Pl. XXIVB). We unfortunately know little or nothing of the glass lost from the cathedrals of Hereford and Worcester, which may have been crucially important, and the dating of the other major monuments of contemporary glazing surviving in the locality is far from established. There are heads and decorative details surviving among the fragments at both Bristol (Pls. XXIIIE, XXIVA, XXVA) and Wells Cathedrals that exhibit a strong similarity to those produced by the Gloucester glaziers, particularly the choir clerestory figures (Pl. XXVF) and tracery light heads of the Lady Chapel at Wells dated by Woodforde to *c.* 1330.[45] The Bristol heads are less well known[46] but they too possess many of the distinctive characteristics of the Gloucester glaziers' painting style.

However, it is in the Tewkesbury Abbey glazing of the 1340s that the most convincing parallels with

the Gloucester east window can be seen (Pls. XXVIA, XXVB, C, E, G). Comparison with Tewkesbury serves to emphasise the deliberate sculptural effect achieved by the Gloucester glaziers, with their carefully limited repertoire of colours, and heavy use of contour washes. Even though the context, idiom, conception, scale, palette and proportions of the figures are different, it is in the painting of the draperies, the hair and faces and the repertoire of decorative motifs that the similarity is perceptible. There is the same extensive use of contour washes for drapery and faces, the same concentration on formalised clumping for the hair and beards, the same gaunt physiognomies, and the same use of decorative borders and devices. There is also a distinct similarity in the proportional relationships between the heads and necks (Pls. XXVE and XXVIC), and, although the gestures of the Gloucester figures are more statuesque and restrained, there is a definite affinity in the articulation of the elongated figures and expressive hand gestures (Pls. XXVC, D). The proximity is so consistently striking that attribution to the same workshop, the Tewkesbury glass being an earlier manifestation of the Gloucester glazing, is not beyond the bounds of possibility.

Comparison between the armour worn by the figure of St George at Gloucester (Pl. XXVIB) and the military figures at Tewkesbury (Pl. XXVIA) is of great assistance in establishing the dating of both glazing programmes. Expert opinion on the armour advises that the plate aventails in the Tewkesbury glass have to be c. 1344, whereas the cutaway front to the coat armour of the Gloucester figure places the latter firmly in the 1350s.[47] The dating evidence of the Tewkesbury armour confirms the accepted dating on stylistic and heraldic grounds.

Even though we are confronted with the probability of a minimal gap, of perhaps ten years at the most, between Gloucester and Tewkesbury, and twenty years or so between Gloucester and Bristol and Wells, the impression that Gloucester belongs to another era is tangible. Although the repertoire of decorative detail, the drapery and face painting and the architectures are remarkably similar in all four churches, the Gloucester glaziers deliberately subordinate the impact of the ornamentation to achieve the monumental effect demanded by both the context and the iconography. The masterful way the designers and glaziers combine their skills with that of the architect and masons is a formidable achievement responding to both the unprecedented design of the stone, and the innovative arrangement of the glazing programme. A date between 1350 and 1360 is consistent with the evidence for the completion of the structure,[48] the stylistic and technical advances on earlier manifestations of the same workshop and the date of the armour, and is not inconsistent with the heraldic evidence.

Finally, Winston said of this glass: 'it must be admitted that the general design through the size and simplicity of its parts, is calculated to produce a good effect at a distance and that the execution of the painting, rough and imperfect though it is, is well adapted to the nature of glass. But here our admiration should stop. Like all medieval works in painted glass, the presentation is open to the gravest criticism. The figures are ill drawn, ungraceful and insipid, the shadowing is artificially employed, and all the figures and canopies seem to be equally on the same plane'.[49] Winston underestimated and mistook both the achievement and the virtuosity of the Gloucester glaziers, and misunderstood the intentions of the designer in creating what is effectively a monumental hieratic reredos in glass. Were this achievement executed in any other medium it would be regarded as one of the major achievements of mid 14th-century English painting and it is to be hoped that this paper will stimulate further study of the east window's stylistic and innovative significance.

ACKNOWLEDGEMENTS

This paper could not have been written without the most generous assistance of the Dean and Chapter of Gloucester Cathedral, especially David Welander, Canon Librarian, who made access to the glass possible both physically and intellectually. I am also grateful to my colleague Dr Peter Newton, Dr Christopher Wilson, Dr Charles Kightly, Mr James Thorn who drew the diagrams and Miss Linda Dennison. The advice and help afforded by the Cathedral Glazier, Mr Edward Payne has been invaluable, and I am also much obliged to the glaziers Mr Dennis King and Mr Alfred Fisher. Finally I would like to thank the editors for their exemplary patience and skill.

REFERENCES

SHORTENED TITLES USED
(See also LIST OF ABBREVIATIONS AND SHORTENED TITLES, iv above.)

WINSTON (1863) – C. Winston, 'The Great East Window of Gloucester Cathedral', *Archaeol.J.*, XX (1863), 239–53, 319–30 (reprinted in C. Winston, *Memoirs Illustrative of the Art of Glass Painting* (London 1865), 285 ff.)
DRAYTON (1916) – T. D. Grimke–Drayton, 'Notes on the Heraldry of the East Window of Gloucester Cathedral', *Trans. BGAS*, XXXVIII (1916).
RUSHFORTH (1922) – G. McN. Rushforth, 'The Great East Window of Gloucester Cathedral', *Trans. BGAS*, XLIV (1922), 293.
GAMBIER PARRY (1883–4) – T. Gambier Parry, 'Ancient Glass Paintings in the Cathedral', *Records of Gloucester Cathedral*, II (1883–4), 67–75.

1. Winston (1863), 284 ff; Drayton (1916).
2. Rushforth (1922), 293.
3. The West Country glass of this period is currently being studied for a doctoral thesis by Mrs S. Bown of Westfield College. In lieu of any published account of the West Country school of glass painting, definition of the precise chronology and stylistic relationships must await the results of Mrs Brown's research. Miss L. Dennison of Westfield College is currently working on a doctoral thesis on late 14th-century manuscript painting with special reference to the Bohun manuscripts. Detailed stylistic analysis is not the purpose of this paper which involves only a brief consideration of style to assist with an attempt to establish comparable chronological material.
4. Winston (1863), 241 n. 4, 327 n. 3.
5. Rushforth (1922), 293; Winston (1863), 240.
6. I am grateful to the Master Glaziers Mr Dennis King, Mr Edward Payne and Mr Alfred Fisher for discussing this point with me.
7. Winston (1863), 243, 245.
8. The Cathedral glazier, Mr Edward Payne informs me in a letter dated December 22nd 1982 that he considers the stars to be part of the original glazing and intended to enhance the 'heavenly level' of the iconographic programme.
9. Winston (1863).
10. Gambier Parry (1883–4).
11. C. H. Dancey, 'Ancient Painted Glass in Gloucester Cathedral', *Trans. BGAS*, XXXIV (1911).
12. Drayton (1916).
13. Rushforth (1922).
14. The most recent tabulations of glazing accounts for this period have unfortunately not been published. They are Dr B. De Clare's transcripts of the Winchester glazing accounts and Dr R. Marks' analysis of the St Stephen's Chapel, Westminster accounts.
15. See above.
15a. For references to the source material see D. Knowles, *The Monastic Order in England* (Cambridge 1966), especially chapters I, II, XXII and XXXII.
16. Gambier Parry (1883), 70.
17. Winston (1863), 328.
18. I am grateful to the present Cathedral Glazier, Mr Edward Payne for this information divulged in a letter to me dated December 22nd 1982. He informs me that his own notes on the condition of the glass record his opinion that Beck refired and repainted some of the medieval glass and also used some form of acid on the exterior. This might explain the unusual appearance of some of the faces (such as the St Edmund in the lowest tier) and also the loss of yellow stain and backpainting on the exterior.

19. Winston (1863), 327-9. This is well worth reading for the enlightened views he expresses on restoration techniques and is especially notable for the remarkable disquisition on 'transparent man' in footnote 5 on page 329.
20. Quoted in Gambier Parry (1883), 72 – 3.
21. Winston (1863), 250 no. 20.
22. Winston (1863), 250 no. 15.
23. Winston (1863), 251 no. 25.
24. Rushforth (1922), 299.
25. Rushforth (1922), 299.
26. Winston (1863), 251 no. 28; Rushforth (1922), 299. The head of the sceptre has been replaced by a piece of white glass but there is only one shaft and the outline of the missing head of the attribute is similar to other foliate finial sceptre heads in the window.
27. Rushforth (1922), 299.
28. Winston (1863), 252 no. 32.
29. Rushforth (1922), 299.
30. Rushforth (1922), 300 – 302.
31. Rushforth (1922), 302.
32. For a detailed discussion of the Lady Chapel glazing see G. McN. Rushforth, 'The Glass of the East Window of the Lady Chapel in Gloucester Cathedral', *Trans. BGAS*, XLIII (1921), 191 – 218.
33. Rushforth (1922), 303 – 4.
34. Winston (1863), 247.
34a. Canon Welander has argued convincingly that this association between the Royal burials and the glass is indicative of Royal patronage for the east window.
35. All the writers listed in notes 9 to 14 discuss the heraldry.
36. Lancaster was not at Crecy but joined the King at the seige of Calais; G. Wrottesley, 'Crecy and Calais from the Public Records' *Collections for a History of Staffordshire* edited by the *William Salt Archaeological Society*, XVIII (1897). Listed in Walter de Wetwang, Treasurer of the Household Muster Roll in the Public Record Office and collated with Duchesne, Knighton, Walsingham and Froissart's contemporary accounts. Pembroke was not recorded at Crecy but also appears with Lancaster in the Calais accounts and records. I am particularly grateful to Dr Kightly for his assistance with the historical accounts and chronology.
37. Ibid., Wetwang's Household Accounts are the major source.
38. *Dictionary of National Biography*, individual entries citing documentary sources.
39. Drayton (1916).
40. G. E. Cokayne, *The Complete Peerage* (1910 – 59).
41. Drayton (1916).
42. Drayton (1916).
43. *Complete Peerage*, II, 273; writ of 34 Edward III.
44. *Inquisitions Post Mortem*, 21 Edward III. *Complete Peerage*, Ibid. 196.
45. C. Woodforde, *Stained Glass in Somerset 1250 – 1830* (London, 1946), ch. 1;
46. Photographs are available in the *Corpus Vitrearum Medii Aevi* Archive at the National Monuments Record which also contains the Pitcher photographs and extensive comparative material in the region. A detailed study of the Gloucester workshop is being conducted by the *CVMA* Archivist, Mrs S. Brown.
47. I am grateful to the Master of the Armouries at H.M. the Tower of London, Mr V. Norman for his opinion and expertise.
48. See above 000. Also G. McN. Rushforth 'The Glass in the Quire Clerestory of Tewkesbury Abbey', *Trans. BGAS*, XLVI (1924), 289 – 330.
49. Winston (1865), 329.

Bishop Benson and his restoration of Gloucester Cathedral, 1735 – 1752

By T. H. Cocke

Martin Benson (Pl. XXVIIIA) was consecrated to the see of Gloucester in January 1734/5 and held it until his death in 1752, refusing translation to a better endowed bishopric.[1] As Bishop he instigated a series of repairs and improvements in the Cathedral which constituted one of the most considerable and intelligent restorations of the 18th century.

Benson was not only a 'vigilant and active Prelate' but also an attractive personality; 'wherever he went he carried Cheerfulness and Improvement along with him.'[2] His closest friends were the other pre-eminent figures of the early Georgian episcopate: the philosophers, Bishop Butler and Bishop Berkeley, and the witty Bishop Rundle. His brother-in-law was Archbishop Secker, a Dissenter by birth who rose to the highest ranks of the Church. Alexander Pope linked them together in a verse:

'Ev'n in a Bishop I can spy Desert;
Secker is decent, Rundle has a Heart,
Manners with candour are to Benson giv'n,
To Berkeley ev'ry virtue under Heav'n.'[3]

Benson's family connections must have helped to make him sympathetic to medieval architecture and aware of the importance of church restoration. He was descended through his paternal grandmother from Samuel Fell, Dean of Christ Church, Oxford (1584 – 1649) who, with his son John, Dean and then Bishop of Oxford (1625 – 1686), gradually completed the great college planned by Cardinal Wolsey, remaining faithful to the late Perpendicular of the original and indeed crowning their achievement by commissioning the Gothic Tom Tower from Christopher Wren.[4] Benson was also a cousin of the eccentric antiquary Browne Willis (1682 – 1760), who spent much of his life and fortune on building and restoring churches.[5] Willis idolized Benson as his 'Saint Martin' and persuaded him to accept the living of Bletchley of which Willis was patron and whose church he proceeded to repair and beautify. Benson was equally involved with Willis's restoration of the small church at Bow Brickhill and his building of a new church, dedicated to St Martin, at Fenny Stratford on the Great North Road, to replace an earlier, ruined church.

Bishop Benson had therefore good family precedent for concerning himself with the restoration of Gloucester Cathedral. There had been repairs to the building after the Civil War: those necessary to the glass alone were estimated in September 1660 at £362.[6] In the first decades of the 18th century, however, attention was directed towards the furnishings of the choir and of the 'sermon place' at the east end of the nave. Possibly work in this latter place, in front of the medieval choir screen, revealed structural weaknesses which made its rebuilding necessary. In any event Benson commissioned from no less an architect than William Kent a new screen which was erected in 1741 (Pl. XXVII).

The medieval choir screens had consisted of a pulpitum closing off the choir, substantial enough to support an organ, and a rood screen, long since vanished, one bay to the west.[7] The new screen replaced the western wall of the pulpitum. Like its predecessor it supported an organ loft. The space below remained unobstructed by cross walls; two blind niches were added on the far wall to either side of the entrance to the choir (Pl. XXVIIID). Kent's design for the screen was typical of the way he created a contemporary Gothic by expressing classical forms of architecture in conventionalized, loosely medieval details.[9] He was not concerned with archaeological accuracy. Thin shafts carried three wide ogee arches covered with wavy crockets. The parapet above was adorned across the front with decorative panels, probably painted, and crowned by a bizarre cresting of pineapples and pinnacles.

Kent carried out other work in the Cathedral for Benson, as well as making alterations for him in the Bishop's Palace.[10] He is said to have designed the stucco facing with which Benson clothed the mutilated medieval reredos of the Lady Chapel (Pl. XXVIIID) and, much more ambitiously, to have planned to flute the massive Romanesque piers of the nave and to have been deterred only by fears that tampering with their ashlar facing might disturb their rubble core.[11] Neither Bishop nor architect was being frivolous. The nave of Gloucester Cathedral presented two major faults to Augustan eyes; first the abrupt change from Romanesque to Perpendicular towards the west end, thanks to the rebuilding of c. 1421–37 by Abbot Morwent, and, second, the piers' vast girth which was considered 'much too large in proportion to their height'.[12] Even in the Romantic era some visitors continued to condemn the piers as 'heavy and inelegant' while others began to admire 'their appropriate grandeur'.[13] On the Continent, the technique of contemporary architects such as the Asam brothers, when faced in 1732–3 with the similar problem of modernizing the Romanesque church of St Emmeran in Regensburg, was to conceal the medieval structures with painting and with gilded plaster and woodwork.[14] The Georgian transformation of Gloucester nave proposed by Benson and Kent would by contrast have been as solid as the Perpendicular remodelling begun by Morwent four centuries before.

William Kent was an unexpected choice as architect to a church restoration, for which contemporary patrons usually turned to local builders or surveyors. He had carried out little ecclesiastical work, except for some monuments. Benson would however have known the alterations recently made by Kent in two great historic buildings; his Gothic refashioning of the east range of Clock Court in Hampton Court in 1732 and, even more relevant, his monumental screens erected at the south end of Westminster Hall in 1738/9 to enclose the Courts of Chancery and the King's Bench. Benson had a further link with Kent through one of Kent's major patrons, Frederick, Prince of Wales, to whom Benson had been appointed a chaplain in 1726. Benson had a good knowledge of classical and contemporary architecture. He bequeathed to Gloucester Cathedral Library a distinguished collection of Italian and French architectural books and prints, mostly collected when he was 'bear-leading' young peers on the Grand Tour but, in at least one case, given to him by Lord Burlington.[15]

Bishop Benson was responsible for other, less decorative schemes of restoration in the Cathedral, executed without Kent's guidance. The paving of the nave was renewed, an expensive and, to the 18th century, most necessary work. The pinnacled parapet on the exterior of the Lady Chapel was replaced by more conventional openwork battlements (Pl. XXVIIIB). The Bishop even managed to turn the failings of members of the Chapter to the benefit of the fabric. The fines which he levied on the canons when they failed to fulfil their due terms of residence were spent on repairs. In 1740 two canons' slackness contributed £36 for 'new paving and beautifying the entrance into the choir'; in 1742 the fines went towards the new floor of the nave, in 1743 towards 'painting the Choir and repairing pinnacles'.[16]

Few of the Bishop's contributions to the Cathedral survive today. The screen was replaced by another, more purely Gothic design in 1820, the plasterwork on the Lady Chapel reredos removed in 1819 to the neighbouring church of Minsterworth and there lost and the Lady Chapel pinnacles were rebuilt in the 1890s. The Bishop's palace was swept away by Ewan Christian in 1861. Even the fine monument erected to Benson by his friends in the south transept has been banished into invisibility high up in the south choir gallery. Only the modest tablet Benson himself ordered to be set up by his executors survives on the west wall of the nave north aisle to bear witness to a munificent patron of the Cathedral and to the unjustly ignored contribution of his generation to church restoration.

REFERENCES

1. Benson possessed only a modest patrimony but, through the influence of the Talbot family, had obtained a series of valuable preferments, of which he resigned all except his Durham prebend on becoming Bishop: see M. E. Benson, 'Memoir of Dr M Benson, Bishop of Gloucester 1735–52', *Records of Buckinghamshire*, IV (1869), 204.

2. B. Porteus and G. Stinton (eds) 'A Review of the Life and Character of Archbishop Secker' in *The Works of T. Secker LLD, late Lord Archbishop of Canterbury* (3rd edition, Dublin 1775), vol. I, xxi-xxii.

3. *Epilogue to the Satires*, Dialogue II, lines 70–3.

4. A good summary of their work can be found in W. D. Caroe, '*Tom Tower*', *Christ Church, Oxford* (Oxford 1923), 4–9.

5. The fullest modern account of Willis is J. G. Jenkins, *The Dragon of Whaddon* (High Wycombe 1953).

6. Dean and Chapter records, on deposit at Gloucester Record Office, D936/*24.

7. W. H. St J. Hope, 'Quire Screens in English Churches', *Archaeologia*, LXVIII (1917), 96–7.

8. See the view in J. Storer, *A Graphic and Historical Description of the Cathedrals of Great Britain* (London 1816), vol. II, Gloucester, Pl. 8.

9. J. Summerson, *Architecture in Britain 1530–1830* (5th edition, London 1970), 396–7.

10. Plans and elevations of the old palace are illustrated in W. H. St J. Hope, 'Notes on the Benedictine Abbey of St Peter at Gloucester', *Archaeol.J.*, LIV (1897), Pl. III opp. 110. The contributions of Benson and Kent appear to have been a Palladian frontispiece to the hall and internal alterations in the principal apartments.

11. H. J. L. Masse, *The Cathedral Church of Gloucester* (London 1899), 35–6.

12. Ibid., 35.

13. T. Bonnor, *Copper Plate Perspective Itinerary* (Gloucester 1799), 13.

14. A. Laing, 'Central and Eastern Europe', *Baroque and Rococo Architecture and Decoration*, ed. A. Blunt (London 1978), 228.

15. John Harris kindly told me of Lord Burlington's gift.

16. G. H. Fendick, 'A Good Bishop and His Friends', *23rd Report of the Friends of Gloucester Cathedral* (1959), 10.

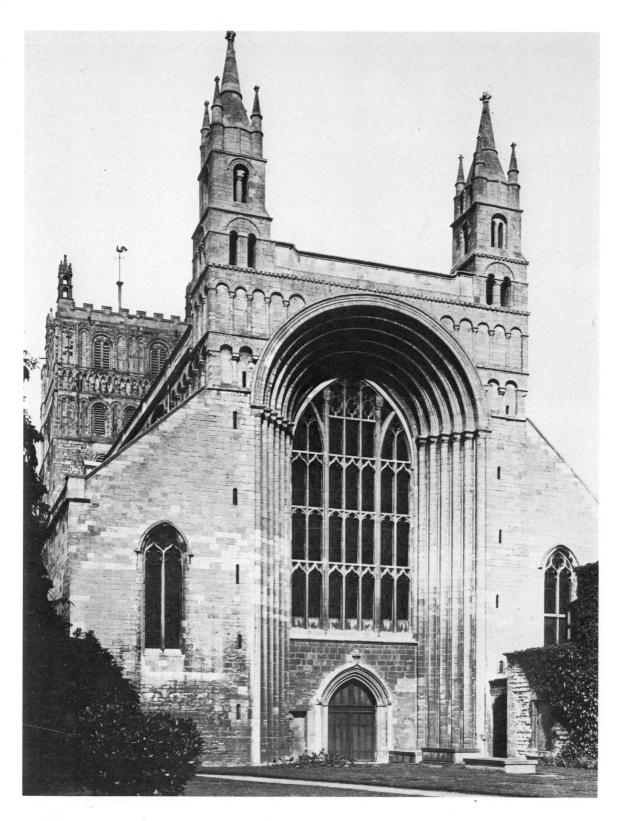

I. Tewskesbury Abbey: West front. *Photo F. H. Crossley*

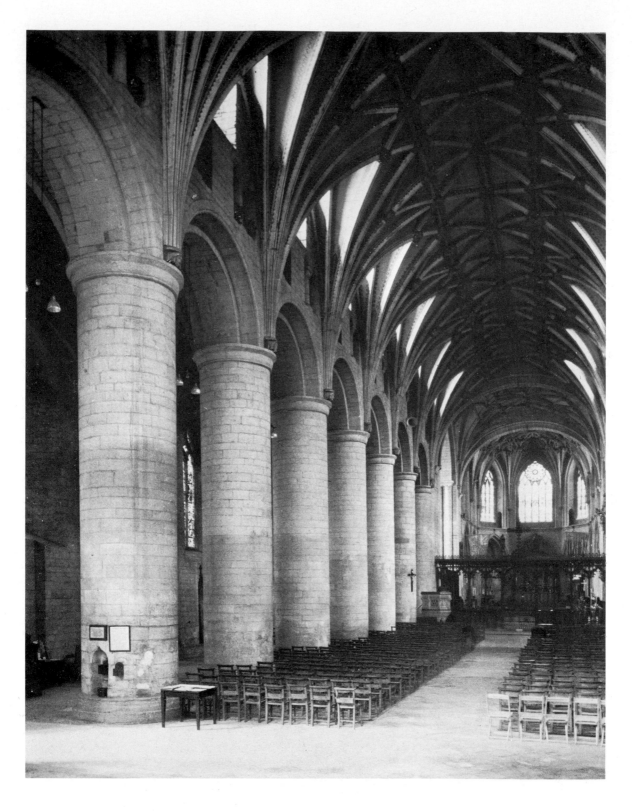

II. Tewkesbury Abbey: nave, looking east. *Photo Courtauld Institute of Art*

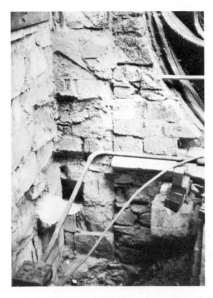

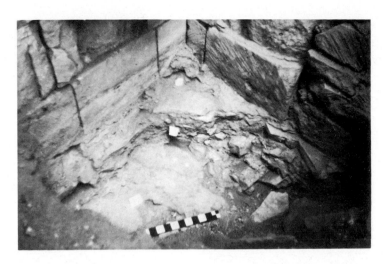

IIIA. Tewkesbury Abbey: corner of north transept and north choir clearstorey after removal of north choir aisle roof

IIIB. Tewkesbury Abbey: corner of north transept and north choir clearstorey showing fragments of lias slab floor set below lowest course of Romanesque masonry

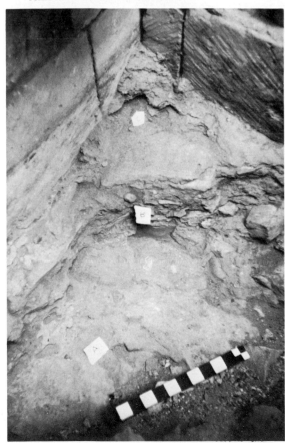

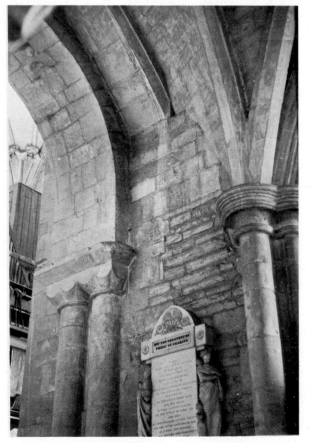

IIIC. Tewkesbury Abbey: corner of north transept (right) and north choir clearstorey (left), A indicates pink mortar of Romanesque vault, B creamy mortar associated with 14th-century work and C pink mortar waste

IIID. Tewkesbury Abbey: west bay of north choir aisle, looking north-west

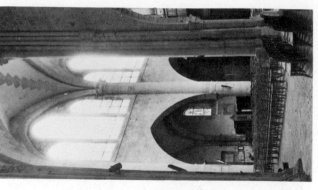

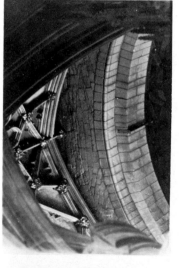

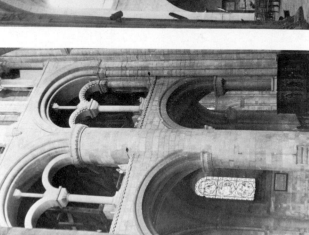

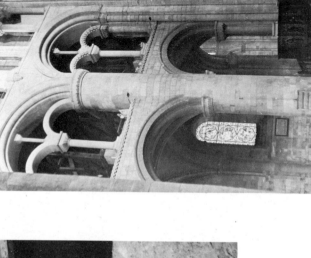

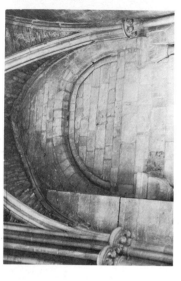

IVₐ. Pershore Abbey: west bay of north choir aisle looking west, showing scar of Romanesque aisle vault

IVв. Tewkesbury Abbey: east face of eastern crossing arch looking west, showing scar of Romanesque aisle vault

IVc. Tewkesbury Abbey: south side of the relieving arch, once above Romanesque choir vault

IVᴅ. Tower of London, St John's Chapel: upper surface of nave vault, looking west

IVᴇ. Romsey Abbey: eastern bay of north nave arcade

IVꜰ. Etampes (Essonne), Notre Dame: south nave elevation

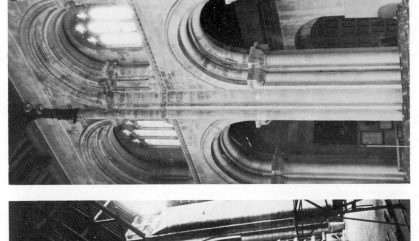

Vc. Dunstable Priory:
western bays of north nave arcade

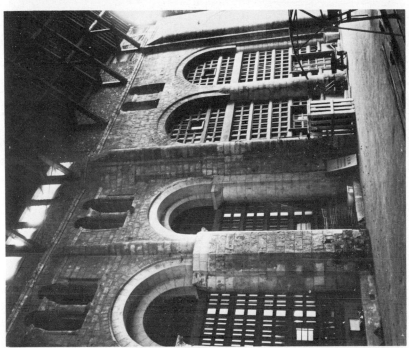

VB. Nogent-le-Rotrou (Eure et Loir), ex Abbey of St Denis:
two western bays of south choir arcade (*left*) and two-bay
screen across entrance to south transept (*right*)

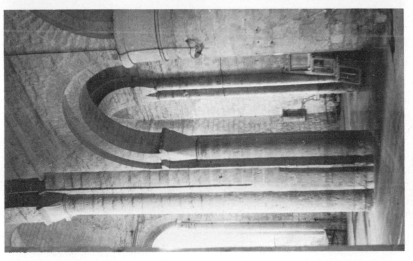

VA. Loudun (Vienne), Ste-Croix: west bay of north
choir arcade with north-east crossing pier,
looking into north transept

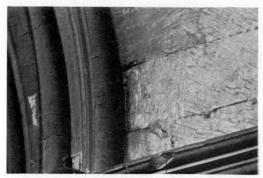

VIA. Tewkesbury Abbey: choir, south arcade, west respond: detail of curved Romanesque stone above 14th-century capital

VIB. Tewkesbury Abbey: opening above choir vault

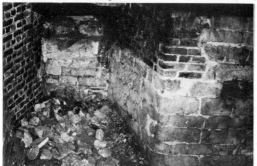

VIc. Tewkesbury Abbey: blocked opening in east wall above north transept vault

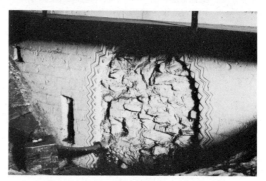

VID. Hereford Cathedral: blocked clerestory window in east wall of south transept

VIE. Tewkesbury Abbey: north transept, east wall – detail of blind arcade

VIF. Souillac (Lot) exterior from east-south-east

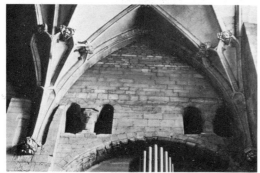

VIG. Tewkesbury Abbey: south transept east wall – detail of south bay

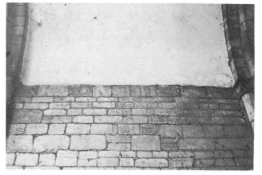

VIH. Tewkesbury Abbey: interior north porch, south wall

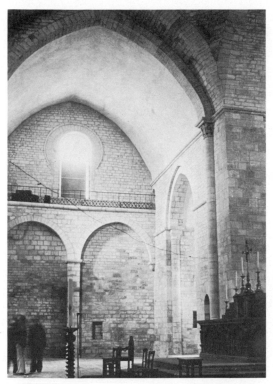

VIIA. Souillac (Lot): interior, north transept

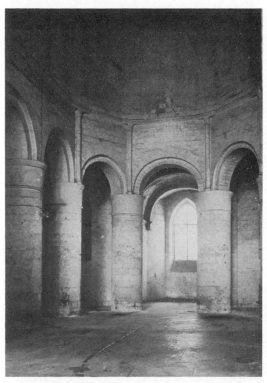

VIIB. Loudun (Vienne), Sainte Croix: choir to east

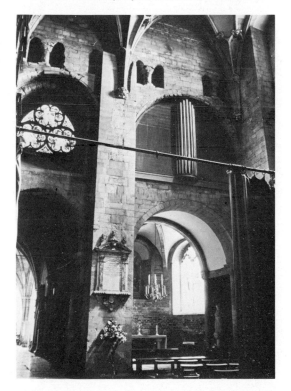

VIIc. Tewkesbury Abbey: south transept, interior to east

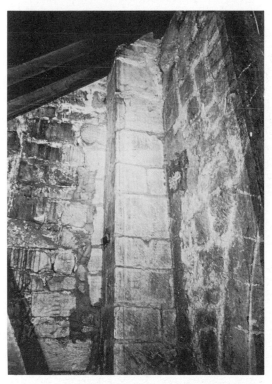

VIID. Gloucester Cathedral: behind north nave triforium, junction with west wall of north transept

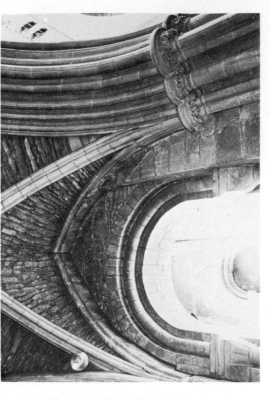

VIIIв. Pershore Abbey: south choir aisle, detail of arch to south transept

VIIID. Pershore Abbey: south transept, south wall above vault showing webbing of former Romanesque barrel vault

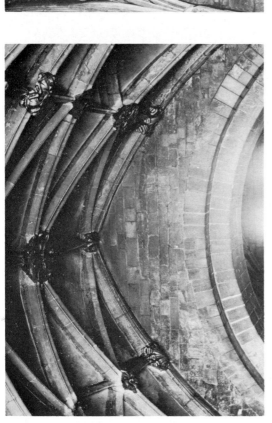

VIIIA. Tewkesbury Abbey: south transept, detail above south crossing arch

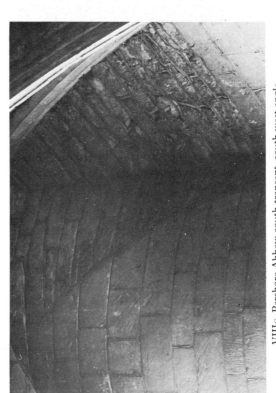

VIIIc. Pershore Abbey: south transept, south-west angle showing line of former Romanesque vault

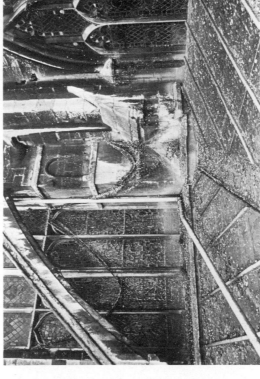

IXᴅ. Gloucester Cathedral: fragment of Romanesque blind arcade to west of north-west clerestory window of choir

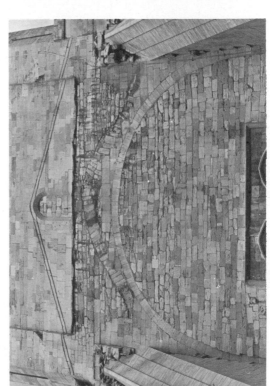

IXᴄ. Pershore Abbey: west crossing arch

IXʙ. Pershore Abbey: angle of north transept and nave

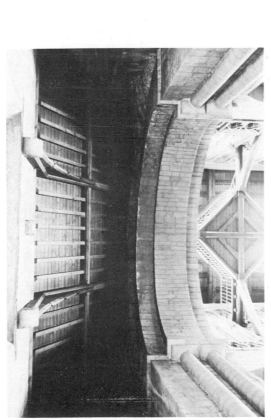

IXᴀ. Pershore Abbey: north transept, detail of former Romanesque barrel vault above north crossing arch

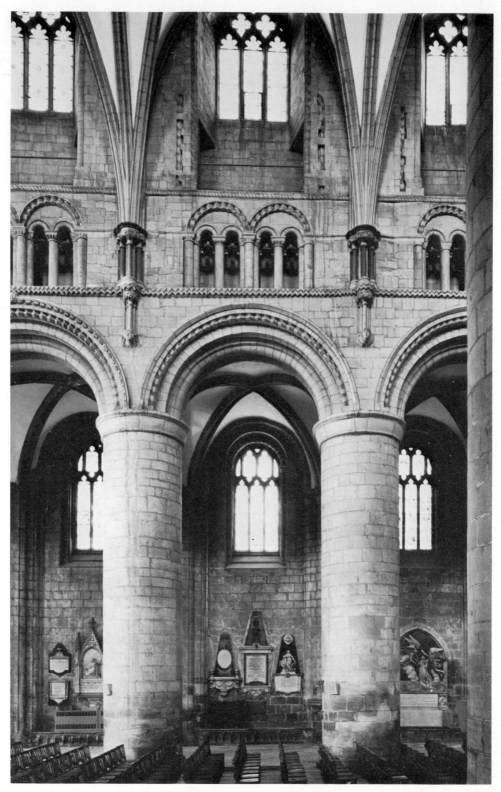

X. Gloucester Cathedral: north side of nave, sixth bay from crossing
Photo Courtauld Institute of Art

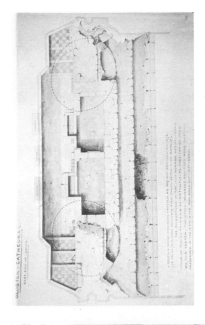

XIc. Gloucester Cathedral: plan, 1872 by F. S. Waller showing eastern apse pier footings and remains of 14th-century High Altar screen.
Courtesy the Dean and Chapter of Gloucester

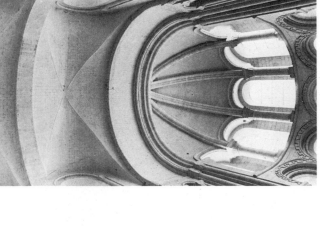

XIf. St-Martin-de-Boscherville: choir vault

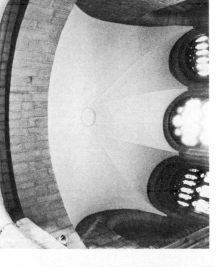

XIb. Gloucester Cathedral: north transept chapel vault

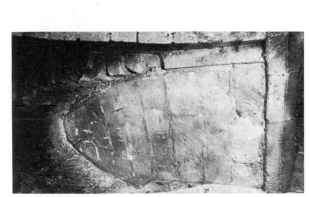

XIe. Winchester Cathedral: vault lunette in ambulatory

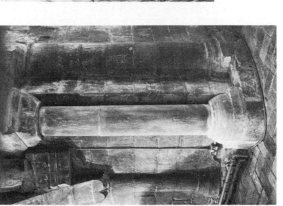

XIa. Gloucester Cathedral: angle of south choir gallery and east gallery of south transept.
(*Centre*) colonette here attributed to 11th-century clearstorey arcade.
(*Left and right*) responds to transverse arches of chapel vaults.

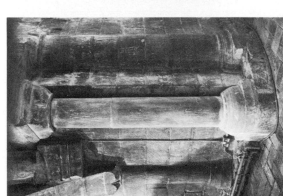

XId. Gloucester Cathedral: south radiating chapel vault

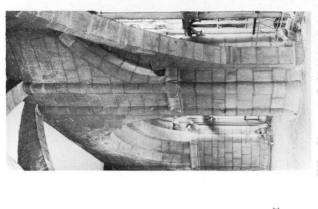

XIIc. Gloucester Cathedral: gallery pier at south-west angle of apse

XIIf. Gloucester Cathedral: junction of north transept and nave clearstorey

XIIb. Tewkesbury Abbey: detail of south transept chapel vault
Photo Courtauld Institute of Art

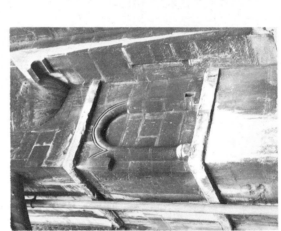

XIIe. Gloucester Cathedral: remains of 11th-century clearstorey arcading at angle between choir and north transept.

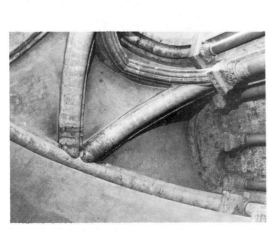

XIIa. Christchurch Priory: south transept chapel vault

XIId. Gloucester Cathedral: south-east angle turret and east clearstorey of south transept

XIIIA. Gloucester Cathedral: responds at south-east
corner of north nave aisle

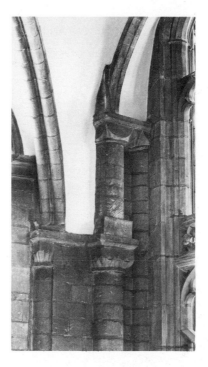

XIIIB. Gloucester Cathedral: responds at
north-east corner of north nave aisle

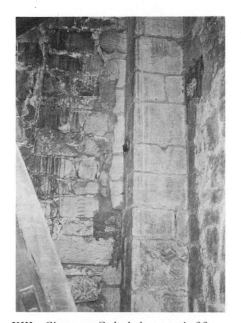

XIIIC. Gloucester Cathedral: respond of former
quadrant arch at south-east corner of roof space
over north naive aisle

XIIID. Gloucester Cathedral: vault of easternmost bay of north nave aisle

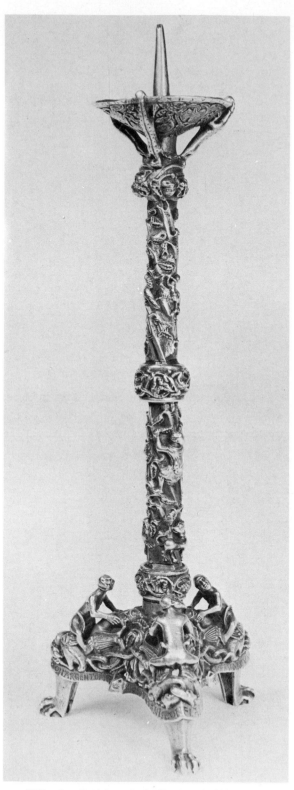

XIVA. The Gloucester Candlestick; London,
Victoria and Albert Museum
Crown Copyright, Victoria and Albert Museum

XIVB. Candlestick made for Bernward of Hildesheim;
Church of St Magdalen, Hildesheim
Photo Rheinisches Bildarchiv

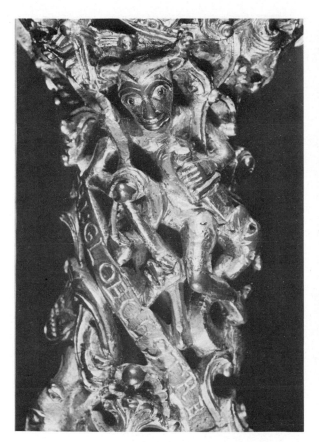

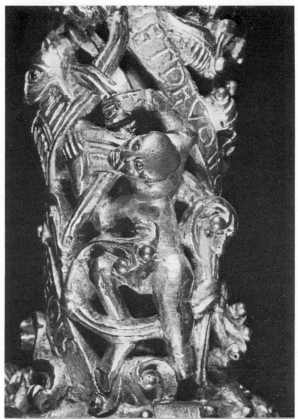

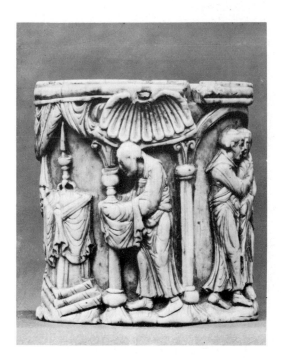

XVA. Gloucester Candlestick: detail lower stem
Copyright, Warburg Institute

XVB. Gloucester Candlestick: detail upper stem
Copyright, Warburg Institute

XVC. Walrus Ivory Pyx, London, Victoria and Albert Museum
Crown Copyright, Victoria and Albert Museum

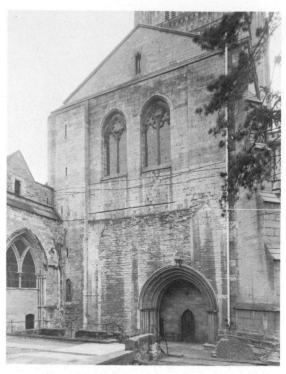

XVIA. Tewkesbury Abbey: north transept, from the north. The site of the nave of the north chapel is in the foreground, with the arch to its chancel on the left
Photo Courtauld Institute of Art

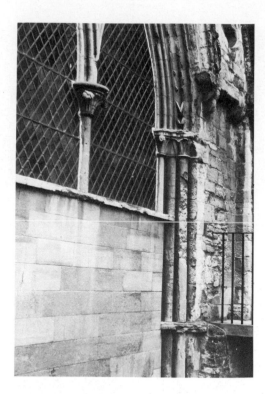

XVIB. Tewkesbury Abbey: north chapel, chancel arch, detail

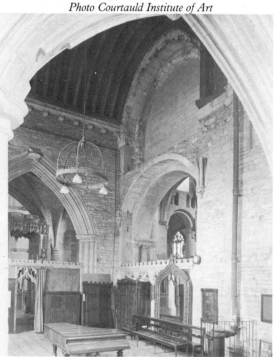

XVIC. Tewkesbury Abbey: east chapel, interior looking south-west. The 14th-century arch to the choir aisle is on the left, and the blocked opening of the Romanesque gallery chapel in the upper centre
Photo Courtauld Institute of Art

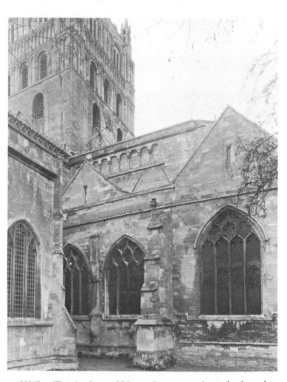

XVID. Tewkesbury Abbey: the east and north chapels from the east. The east chapel is to the left of the central buttress, and the north chapel to the right
Photo Courtauld Institute of Art

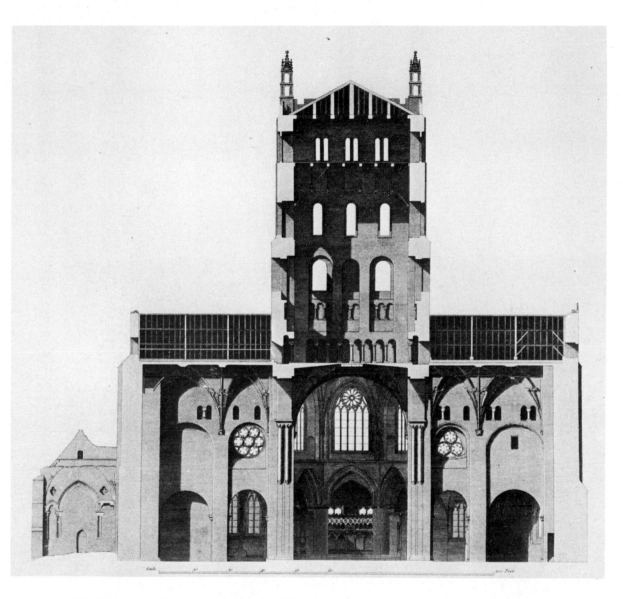

XVII. Tewkesbury Abbey: transverse section *Vetusta Monumenta* Society of Antiquaries of London, Vol. V (1835), Pl. XL. The former gallery openings filled with 13th-century tracery are shown, and also the remains of the north chapel at the left

Society of Antiquaries of London

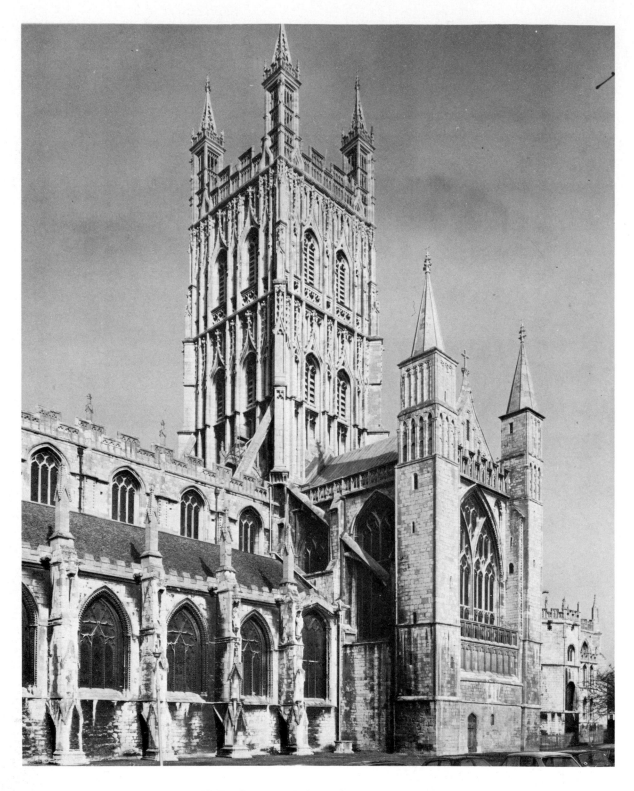

XVIII. Gloucester Cathedral from the south-west
Photo University of Warwick

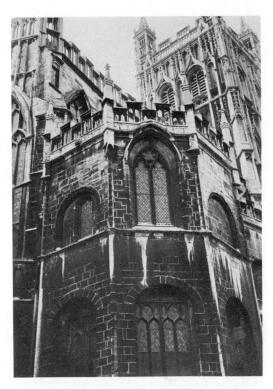

XIXB. Gloucester Cathedral: north-east chapel, exterior

XIXA. Hereford Cathedral: crossing tower, east face, detail

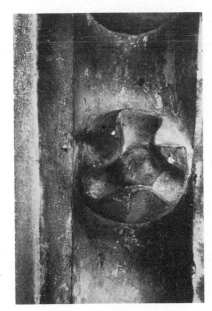

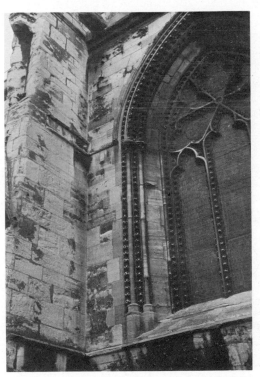

XIXC. Gloucester Cathedral: south transept gallery
chapel, ballflower

XIXD. Gloucester Cathedral: nave south aisle, window
(1966, before cleaning)

XXA. Badgeworth: north chapel, from the north-west (1966)

XXB. Gloucester Cathedral: south transept gallery chapel, interior

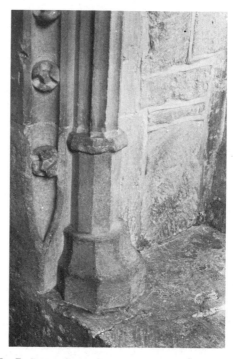

XXC. Badgeworth: north chapel, window frame, detail

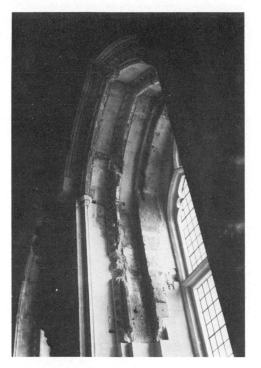

XXIA. Caerphilly Castle: great hall window, detail
(masonry partly renewed)

XXIB. Tewkesbury Abbey: 'Forthampton' tomb recess
and sacristy door
Photo University of Warwick

XXIC. Tewkesbury Abbey: part of a fitting
with ballflower and tendril decoration
Photo University of Warwick

XXID. Tewkesbury Abbey: pieces from a ballflower screen(?)
with shields
Photo University of Warwick

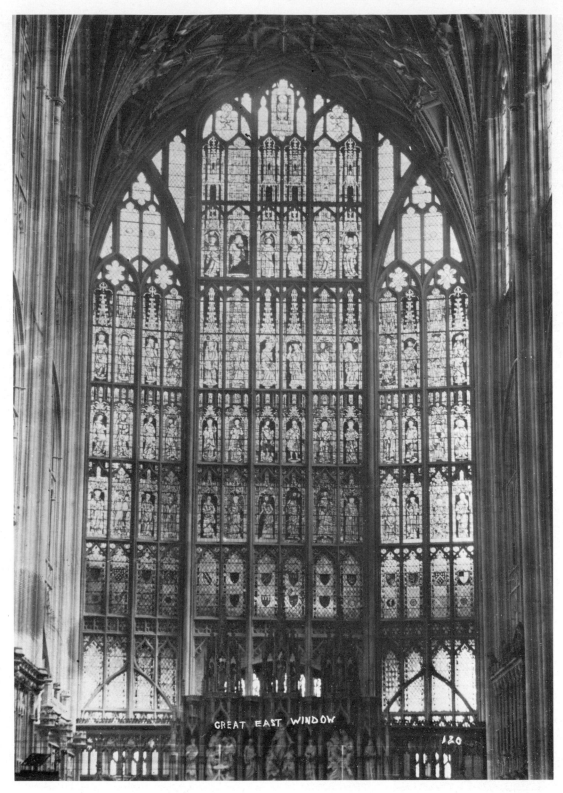

XXII. Gloucester Cathedral: the east window
Photo RCHM England. Crown copyright

XXIIIA. Gloucester Cathedral east window:
SS Margaret and Lawrence

XXIIIB. Gloucester Cathedral
east window: St Peter

XXIIIC. Gloucester Cathedral
east window: St Thomas

XXIIID. Gloucester Cathedral east window:
abbot and bishop

XXIIIE. Bristol Cathedral and east window:
male head
Photos RCHM England. Crown Copyright

XXIVD. Gloucester Cathedral east window: Christ

Photos RCHM England. Crown Copyright

XXIVC. Gloucester Cathedral east window: Virgin Mary

XXIVA. Bristol Cathedral east window: head of Virgin Mary

XXIVB. Deerhurst south aisle, west window: St Catherine

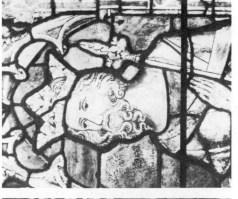

XXVD. Gloucester Cathedral east window: king

XXVC. Tewkesbury Abbey choir clearstorey: king

XXVB. Gloucester Cathedral east window: head of king

XXVA. Bristol Cathedral east window: head of king

XXVG. Tewkesbury Abbey choir clearstorey: group of apostles

XXVF. Wells Cathedral choir clearstorey: king
Photos RCHM England. Crown Copyright

XXVE. Tewkesbury Abbey choir clearstorey: saint

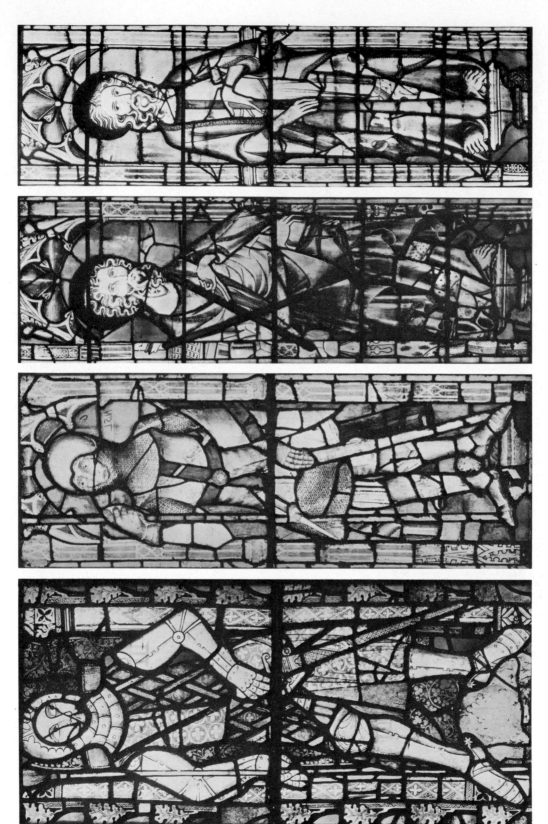

XXVIA. Tewkesbury Abbey choir
clearstory window: Knight

XXVIB. Gloucester Cathedral
east window: St George

XXVIC. Gloucester Cathedral
east window: St James the Less

Photos RCHM England. Crown Copyright

XXVID. Gloucester Cathedral
east window: St Andrew

XXVII. Gloucester Cathedral: choir screen presented by Bishop Benson and designed by William Kent
Engraving: J. Vardy 1744
Photo the author

XXVIIIA. Bishop Benson, English school *c.* 1740
Courtesy See of Gloucester Photo Linda Lane Photography

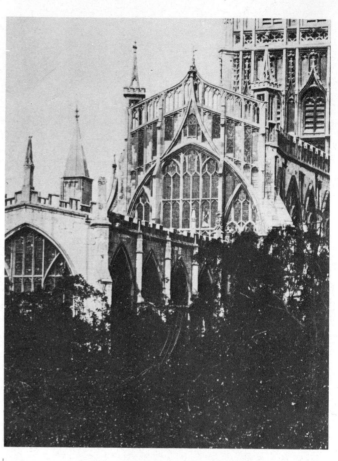

XXVIIIB. Gloucester Cathedral: Lady Chapel as restored by Bishop Benson
Photo c. 1870 National Monuments Record

XXVIIIC. Gloucester Cathedral: nave looking east with screen
presented by Bishop Benson *Engraving: T. Bonnor 1799*
Photo The British Library

XXVIIID. Gloucester Cathedral: Lady Chapel with stucco
facing on reredos added by Bishop Benson
Engraving: T. Bonnor 1807 Photo The British Library